SPATIAL PRACTICES

This book explores 'spatial practices', a loose and expandable set of approaches that embrace the political and the activist, the performative and the curatorial, the architectural and the urban. Acting upon and engaging with the public realm, the field of spatial practices allows people to reconnect with their own sense of agency through engagement in space and place, exploring and prototyping alternative futures in the here and now. The 24 chapters contain essays, visual essays and interviews, featuring contributions from an international set of experimental practitioners including Jeanne van Heeswijk (Netherlands), Teddy Cruz (Estudio Teddy Cruz + Fonna Forman, San Diego), Hector (USA), The Decorators (London) and OOZE (Netherlands). Beautifully designed with full colour illustrations, *Spatial Practices* advances dialogue and collaboration between academics and practitioners and is essential reading for students, researchers and professionals in architecture, urban planning and urban policy.

Melanie Dodd leads Spatial Practices at Central Saint Martins, University of the Arts London, UK, where she is also Associate Dean of Knowledge Exchange. She has previously taught at the University of Cambridge, UK, and RMIT University, Australia.

SPATIAL PRACTICES

Modes of Action and Engagement with the City

Edited by Melanie Dodd

Routledge
Taylor & Francis Group

LONDON AND NEW YORK

First published 2020
by Routledge
2 Park Square, Milton Park, Abingdon, Oxon OX14 4RN

and by Routledge
52 Vanderbilt Avenue, New York, NY 10017

Routledge is an imprint of the Taylor & Francis Group, an informa business

British Library Cataloguing-in-Publication Data
A catalogue record for this book is available from the British Library

Library of Congress Cataloging-in-Publication Data
Names: Dodd, Melanie, editor.
Title: Spatial practices : modes of action and engagement with the city / edited by Melanie Dodd.
Other titles: Spatial practices (Routledge (Firm))
Description: New York : Routledge, 2019. | Includes bibliographical references and index.
Identifiers: LCCN 2019007279| ISBN 9780815351863 (hb : alk. paper) | ISBN 9780815351870 (pb : alk. paper) | ISBN 9781351140041 (ebook : alk. paper)
Subjects: LCSH: Space (Architecture) | Architecture and society.
Classification: LCC NA2765 .S615 2019 | DDC 720.1/03–dc23
LC record available at https://lccn.loc.gov/2019007279

ISBN: 978-0-8153-5186-3 (hbk)
ISBN: 978-0-8153-5187-0 (pbk)
ISBN: 978-1-351-14004-1 (ebk)

Typeset in Univers LT Std
by Servis Filmsetting Ltd, Stockport, Cheshire

Contents

Preface

This book was developed from a series of public events held in the Crossing at Central Saint Martins over three successive years from 2014 to 2016; events which at the time also formed part of the London Festival of Architecture. The 'Contested Space' Round Tables focused on socially and politically engaged spatial practices, and were staged around a public round table in the Spatial Practices Programme Degree Show (Figure 0.1). The contributors included staff, students and visiting practitioners, many of whom associated with the Programme via ongoing roles, workshops or guest residencies. In hindsight, offering a forum of public debates on spatial practices in a privately owned public space (POPS) at the centre of Europe's largest regeneration site in King's Cross was quietly radical. The speakers and audiences deliberately included and accommodated an expansive range of actors from performance artists to community activists, from spatial practitioners to government planners, from writers to developers – not to mention passers-by and the general public who strolled by to listen in. These conversations have provided onward inspiration and this book therefore owes a debt of thanks to all the people who were responsible for co-creating these events, and for the staff, students and audiences who participated.

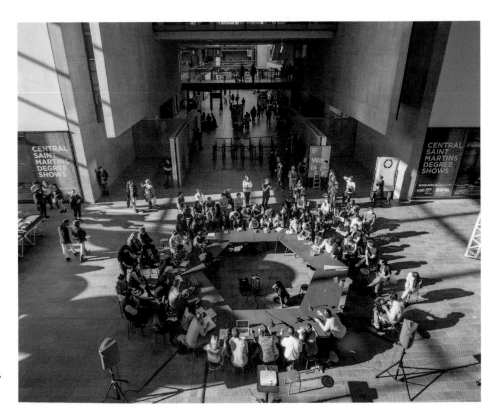

Fig 0.1 Contested Space Round Tables in the Crossing, Central Saint Martins, 2015 (Dodd)

Credits

Thanks to Oscar Brito for co-curation of 'Contested Space' Round Table Series, to Tricia Austin for her collaborative support on making the book proposal, and to Shumi Bose for welcome discussions on editorial approach.

Introduction

Melanie Dodd

The relevance of more reflexive and fluid forms of spatial practice has never been more pertinent. The forces of technology, finance, consumerism and resulting machinations of global labour and capitalism are accelerating, rendering us culturally homogenous but simultaneously in a state of anxiety and uncertainty. The financial crisis of 2008 and events since, have cultivated a sense of powerlessness for many in the west, exposing the limitations of conventional representational democracy in the face of rampant capital and corresponding ecological crisis. Emerging in response are approaches which allow people to reconnect with their own sense of agency through engagement in space and place. At its most urgent, this takes the form of protest, occupation and activism, visceral responses to civil anxiety through forms of spatial resistance which are played out, sometimes fleetingly, in buildings, streets and public spaces. Associated with this, the proliferation of the 'temporary' occupation of space, whether transgressive, sanctioned or celebratory, has also revealed a new wave of experimentation with alternative lifestyles and social interactions, intense production and consumption, and an experimentation with self-built infrastructures over short periods of time. And more broadly, burgeoning personal interests in alternative food production and consumption, a resurgence of the notion of the 'commons' and the search for new forms of community organization, housing and governance, reveal an appetite for the exploration and prototyping of alternative (even utopian) forms of society over longer periods and durations.

Accompanying these trends, critics and theorists reflect on the need for us all to engage in grassroots activism, or what Jeremy Till calls 'radical engagement' where "portents of the decline of democracy should in fact be read as prompts to engage" (Till 2017). Thinkers on the left, like David Harvey, point out that we need to actively reimagine and 'practice' alternatives, arguing that life has become so complicit with neoliberal agendas that we can no longer conceive how we can extricate ourselves. This capacity to reimagine ourselves, post-capitalism, seems rooted in forms of positive spatial action that can envisage and present alternatives of everyday life. These are not necessarily the built and architectural alternatives of twentieth-century modernism, but rather operational alternatives and systems by which we can reboot, shedding our habits and norms as a daily resistance of the status quo. Reimagining in this way is arguably a form of design in the here and now; a sort of spatial and urban project which does not require us to wait for it to be implemented, and which can operate at multiple scales, upon and within existing structures and institutions.

The spatial projects of the 'here and now' involve diverse practice that embraces the political and the activist, but also the performative, the curatorial, the spatial, the architectural and the urban. They involve actors from various backgrounds who don't always fit categories or align to professional disciplines, but who support action and engagement through forms of situated 'spatial' practice. These spatial practitioners are growing in number, often in reaction to rolling contemporary crises – whether that be community activists addressing the loss of public assets, or artists and spatial designers commissioned by municipalities to address the decline of the High Street. This book brings together a set of voices, varied in their contexts and practices but responsive to the broader

urgencies laid out. It is structured around an initial positioning chapter, which sets the context, followed by contributions grouped into three sections, always with an emphasis on the voice of the practitioner.

Operating as a contextual backdrop for the unfolding stories of practice, Chapter 1 unpacks the relationship between space and politics, arguing for a rein-vigorated focus on our detailed understanding of *how* space is political. Providing both an overview of theory on the 'production of space', and the corresponding emergence of new spatial practices in the last 30 years, the chapter speculates on productive frameworks for conceptualizing this territory of practice in ways that do not undermine its forms, or marginalize its agency. Following on from this scene-setting, and as a way to organize the main body of contributions, the book loosely groups contributions into three sections, each outlining specific forms and contexts for modes of 'action' and 'engagement', and each consisting of a series of chapters and interviews which delve into the minutiae of the 'practices' in question.

At one end of the spectrum, the first section of the book describes spatial practices which operate as a mode of 'resistance', in which practitioners employ protest, demonstration or embodied forms of action to occupy space, either to opt out of conventional designation of use and regulation altogether, or as forms of reclaiming and exercising active citizenship. Resistance can be an individual bodily practice, through street protest and squatting, or a subversive or deliberative act of misuse through occupation, but it is often an organized action employed by individuals and communities as a tactic for claiming back control of space that is seen as public, or held 'in common'. In Chapter 2, Carl Fraser makes investigations into performative acts of protest – 'protest practices' in public space – as important mechanisms which define, and 'resist' the economic and spatial terrains of neolib-eral London. He argues that protest is a 'critical spatial practice', in which citizens are able to explore and affect the city, changing the way in which they relate to each other and challenging the institutionalized mechanisms of society. Associated with this unpacking of 'protest practices', in the subsequent chapter, Ursula Dimitriou provides us with a theoretical and political underpinning to the concept of the 'commons' and also an example of how it is practised in the example of Exarcheia, Athens, post-2008. She explores how in contesting the 'enclosure' of the commons a series of elusive, informal and heterogeneous civic and spatial practices of appro-priation has evolved, that render the 'commons as public'. Returning to London, Donna Turnbull, a community activist with Voluntary Action Camden, takes us on a personal journey through central London's gentrification over 30 years via a personal account of experiences in three neighbourhoods, Deptford, Peckham and Somers Town; places subjected to the withdrawal of the state and 'survival of the fittest' localism agendas, in which voluntary spatial activism confronted, and still confronts, neighbourhood planning. Her narrative sets community-based activism in the context of state-based forms of consultation and participation, revealing the gap and arguing for a stronger seat at the table. Responsive to this gap, Daisy Froud is a practitioner who designs tools for co-production between architects, planners and non-professionals, concerned with the cultural relationship between people and place. As a strategist, Daisy has invented a role as an enabling inter-mediary, in which communities are facilitated in the complex process of making new spaces. Alex Warnock-Smith, an architect, develops the theme of the 'enabling intermediary', specifically looking at the emergence of alternative forms of profes-sional design 'services', through an account of the work of 'Support Community Design Building Service' (1976–1992), and Hugo Hinsley, its co-founder. Defined as a 'radical spatial practice', Hugo's commitment to squatting and alternative forms of housing is argued as a form of resistance which disrupts conventional forms of professional architectural service, devising new forms in order to support more marginalized constituencies. Moving to a more recent context, Chapter 7 focuses on the work of the French collective EXYZT (2002–2015) who enacted a form of working on site as a way to bypass the conventional dislocations of architectural

Melanie Dodd

practice that divide ideas and actions, design and construction. In conversation with writer Shumi Bose, co-founder Nicolas Henninger reflects on their very specific approach in which their 'do-it-yourself' or 'hack-space' is simultaneously both practical and performative. Finally, in this section, Oscar Brito, beginning with an overview and critique of the UK Government's 'Big Society' and Localism agendas (2011), constructs a theoretical argument on the production of space as the production of urban citizenship, referring to Lefebvre's and Harvey's 'right to the city', and arguing for the opportunities for new relationships between contemporary self-organized communities and spatial practitioners, via the example of Community Land Trusts, specifically Granby Four Streets in Toxteth.

Having described the contexts in which diverse spatial practices of protest, activism, occupation and resistance are adopted by a range of actors in support of active citizenship, the second section more explicitly introduces the voice of the contemporary spatial practitioner as a player. In this section the modes, mediums, objects and agencies of spatial 'practice' become more self-consciously considered – and designed – within the wider context of socially engaged, or relational, art and design practice for and within the public realm. Whether through self-initiated projects, commissioned artworks or designed interventions, the practices have in common diverse methods of communication, negotiation, participation and collaboration in order to facilitate and engage with the multiple trajectories of co-produced space. Many of the approaches described in this section are located within art, narrative or performance practice, and experiment with temporary spatial interventions that foreground infrastructures that are hidden, or repressed, highlighting contradictions and allowing other voices to surface. The manipulation of objects and spaces through physical forms and adjusted experiences serve as provocations toward imaginary futures; thought and acted upon in the here and now.

In Chapter 9, the founder partner of Ash Sakula, architect Cany Ash, describes her motivations to host and build social life within the contemporary city, through a reflection on the 'Canning Town Caravanserai' (2011–2015). This 'meanwhile' or temporary project, part of a strategy to attract attention and investment to the London Borough of Newham, comprised self-built and scenographic structures for conviviality which coalesced alongside the entrepreneurial and socially engaged curation of events and performances – challenging conventional notions of what an architectural practice might do. In the next chapter, at similar scale and duration, Eva Pfannes and Sylvain Hartenberg (of Rotterdam-based art and architecture practice OOZE) describe 'Of Soil and Water': The 'King's Cross Pond Club' (2015–2016) a 'meanwhile' project in the heart of London's regeneration quarter at King's Cross. As a public art commission, of limited duration, the Pool became both an exquisite and provocative spatial experience as well as an unlikely opportunity to catalyse local residents and users into solidarity through collective protest against its removal. Staying with commissioned art practice, Jeanne van Heeswijk, an influential artist based in Rotterdam working in public space, speaks about her recent project 'Philadelphia Reassembled' (2016–2018) for the Philadelphia Museum of Art, exploring ideas of 'public-ness' and asking, through her practice, how we can 'collectively renegotiate the conditions of our existence'. Her projects are deep and expansive examples of community building, which convene and disseminate narratives via spatial platforms and collective and visualized activities. Following this, a short interlude by Anna Hart and Tilly Fowler (of art collective AiR) is an experimental written piece on 'walking' as an urban spatial practice, reflecting their 'King's Cross Walking Club' (2016) and the embodiment of place through engagement in ordinary spatial and social rhythms. In the next chapter, Juliet Bidgood, an architect and urban designer, presents research on the 'instant city' of the music festival as a way of considering festival culture as a form of spatial practice. In research undertaken with Glastonbury Festival, she reflects on how we might 'learn' from the practices of popular festivals in the creation of successful forms of spatial infrastructure with cohesive social networks, active cultures and partial self-governance. Also influenced

and inspired by both the duration of the temporary but the ambition of city-making, Andreas Lang, of Public Works in London, is in conversation with Markus Bader of raumlabor. As a well-established collective based in Berlin, undertaking art, intervention and urbanism, raumlabor's projects invent new forms of practice as well as physical outcomes that resist conventional definition. Markus discusses the 'Floating University (2018)' and its context, Tempelhof, Berlin, as part of a wider conversation on frameworks of experimentation and urban pedagogy. Building on this approach, Tricia Austin explores the definition and use of spatial 'narratives' as a term, and the creation of 'narrative environments' as a practice, constructing a framework interweaving spatial, narrative and cultural theory, and providing examples of practices and projects. She concludes by making a case for narrative to be used as the basis for critical design that challenges entrenched power relations. In a subsequent short visual chapter, David Chambers and Kevin Haley of young London-based practice Aberrant, talk about 'telling stories' through their own projects, which reconfigure and engage civic space. As architects interested in narrative, action and event, their practice produces both scenographic and mobile infrastructures as dynamic 'actors' in the public realm. Finally, in this second section, The Decorators are in conversation with writer Shumi Bose and Melanie Dodd. As an emerging design collective of psychologists, performers and landscape architects, The Decorators curate interventions and actions to build communities and social networks. Putting conversation at the heart of their process, they examine the means by which they can maintain a critical and meaningful exchange between communities and the urban regeneration forces they are subjected to.

Against the backdrop of these unfolding stories of practice, the third and final section brings together reflections on 'practising space' in the future, considering how wider scale strategic forms of 'disruption' can be means of re-imagining the status quo through the design, redesign or partial replacement of whole systems. This includes not only the tools and methods of spatial practices, but also the systems of education and the professional structures of work, that prepare for and frame these practices in future. Disruptive practices that strategically reverse traditional hierarchies, by placing power or leadership in the hands of the non-professional and citizen, are at the heart of the work of Teddy Cruz and Fonna Forman who are spatial practitioners and academics. Through their practice, partly embedded in University of California, San Diego, they formulate a mode of strategic spatial practice from which a more inclusive meaning of citizenship can be shaped beyond jurisdictional and exclusionary definitions, with a more expansive orientation based on shared values and common interests. Their chapter sets out a Manifesto in the form of '10 Notes', illustrating examples within their own projects. Similarly combative, and in conversation, Liza Fior, co-founder of influential and well-established practice muf Architecture/Art, discusses the way in which the practice's 'fascination' for the 'establishment' as material to be disrupted, drives their approach, and she outlines the difficulty and pleasures of intervening in the physical limits of architecture and urban development. Next and in synergy, Damon Rich and Jae Shin, of design practice Hector, based in Newark, New Jersey, talk about the complexities of working with local authorities and the 'nourishing tradition' of public service of which they are a part, whilst at the same time emphasizing the detail material and spatial practices that really need to structure incisive and effective 'institutional critique'. Fittingly Jeremy Till builds this thread of critique by moving to discuss education, and arguing that the spatial practices described in the book demand new forms of education that move beyond the norms of conservative architectural education completely, grounded in a clear ethical position and a sense of solidarity with others. In the following chapter, Andreas Lang, practitioner with Public Works, works into this territory by laying out ways of intervening in design education. Through examples, he discusses the way in which new approaches to pedagogy and methods of learning can better prepare students through 'situated' forms of engagement that test ideas and assumptions directly in

Melanie Dodd

the field, and so enable engagement with people and institutions as a critical part of a more engaged spatial practice. In the last interview, Finn Williams and Pooja Agrawal describe Public Practice, a new social enterprise based in the UK, established with the ambition to encourage and support spatial practitioners into the public sector, providing new opportunities to work within local authorities for the public good. The discussion frames the way that the contemporary public sector, as well as the civic sector, can and is able to be infiltrated and rethought, through expanded forms of spatial practice. And finally, from The Architecture Lobby – a US-based organization for architectural workers – a chapter by members Aaron Cayer, Peggy Deamer, Shawhin Roudbari and Manuel Shvartzberg Carrió argues that small design practices can be the key to transforming the social dimension of architecture by adopting cooperative structures, offering a more positive model of work-organization than anti-ecological, profit-oriented, speculative development typologies typical of conventional architectural firms.

Threaded through these groupings run a number of common cross-currents of practices – from embodied, immediate and improvised actions, to durational, disruptive and strategic engagements in space and place. The common ground is that they are all defined as 'spatial practices', open to multiple stakeholders, actors and agents spanning disciplinary and societal boundaries. The diversity represented, though a mere snapshot of the field, attempts to unpack and define contemporary spatial practices, and assists in understanding *how* these practices intervene and engage with the dynamic flux of spatial production. Above all, the book is not intended as a definitive manual for how to act. Rather, it embraces the complexity and contestation within which we can operate in the city. It sets out to understand the diversity and multiplicity of practices which can be brought to bear on action and engagement in the spaces of the public realm and the city. And it hopes, optimistically, that adopting these forms of spatial practice may enable us to reconnect to our own sense of agency, reclaim our ability to engage and, in so doing, even allow us to re-imagine futures that are positive, achievable and within our grasp.

References

Harvey, D. (2013) *Rebel Cities*. Brooklyn, NY: Verso
Till, J. (2017) Reality in the balance. *Places Journal* Online (placesjournal.org)

1 Space is always political

Melanie Dodd

Richard Rogers's statement that "architecture is always political"[1] spoken at an event at the UK Houses of Parliament in 2013, was a timely challenge in the light of recent escalating housing crises, social displacement and gentrification. Rogers's words returned to haunt him in 2015, when, after his nomination for the Stirling Prize (for luxury housing at Bankside in London), a public protest took place outside the Royal Institute of British Architects (RIBA) headquarters on Portland Place with his quote plastered over protest banners – this time in ironic backlash. The organization that led this demonstration, Architects for Social Housing (ASH), represents one of a growing number confronting architecture's politics; making an impassioned call to the architectural profession and the wider built environment disciplines to confront social inequalities head on. Recognizing that architecture's politics are complicated by its complicity with capital, and the constraints it is subjected to via the building industry, many would argue that expanded forms of spatial practice move more freely, resisting the neoliberal hegemonies implicit in urban regeneration. And yet, already the parameters are in opposition – architecture versus spatial practice; complicity with capital versus resistance to it – establishing a binary relationship that assumes acting 'politically' requires a certain type of practice; even that it can be planned and understood as 'political' in advance.

This chapter will try to think harder about how 'space' is political, and therefore, *how* spatial practices act politically. The premise that spatial practices – spatial activism, temporary interventions and socially engaged approaches – have the capacity to influence or affect the 'social' or the 'political' is fundamental to the field. Yet these capacities are rarely explored in detail, and such ambitious assertions leave it open to counterclaims that these approaches privilege process over built outcome, and (at worst) perpetuate an ethically dubious 'do-gooding'. Using Lefebvre (1974) as a starting point and Rogers's statement and its repercussions as our contemporary context, this chapter will make a case not just that space is political but *how* it is, or *can be*, political through practice. Importantly this is not about a case for doing politics through space (making a case for a certain type of politics, appropriate for a certain context and situation) but rather about defining the 'political' more broadly in respect to space; and in so doing, providing this publication with a context for its unfolding stories of practice.

Space and the political

What does it mean to say that something is political, and why is it important? The political can be defined as "the process by which people negotiate and compete in the process of making and executing shared or collective decisions" (Hague and Harrop 2013, p. 6). As such, it is an essentially social activity, linked, on the one hand, to the existence of diversity and conflict, and, on the other, to a willingness to cooperate and act collectively. This understanding of the political takes us beyond politics as governance, toward politics as the fundamental underpinning of 'public life' in a civil society (beyond private/personal), in which, as Arendt states, politics is the most important form of human activity because it involves interaction amongst free and equal citizens 'acting in concert' in search of processes of conflict

resolution (Arendt 1958, p. 244). For the purposes of this chapter, we will use the term 'political' to refer to these processes of interaction and the spatial situations that frame and support them.

How can space be political? In the last 50 years, there has been a noticeable shift toward questions of spatiality which has been crucial in reorienting the way in which we can argue space as political. The 'spatial turn' in the 1970s marked a rebalancing of principles of time and space, and the reassertion of space in theory. For many this marked the end of historicism (Soja 1989) in which instead of acting as the mere backdrop for an unfolding time, space became intimately linked to lived experience. The reframing by Michel Foucault and Henri Lefebvre began to move beyond traditional approaches for how we understand space, concerned with either the 'conception' of space (geometric, abstract, mental) or the 'perception' of space (physical, material, concrete). Instead, their conceptualizations moved toward a form of 'realized abstraction'. For Lefebvre, this was captured as a third form of spatial experience in his conceptual triad of perceived (physical), conceived (mental) and 'lived' – where the 'lived' (social) is space that is processed and modified over time and through use. This more comprehensive mode of spatial thinking moved beyond those traditional dualities (objective–subjective, material–mental) to create a "consciously spatial praxis based in a practical and political awareness that we can act to change" (Elden 2007, pp. 105–106) which was also seen by some as a way to "make theory practical" (Soja 2009, p. 21). This may point to the appeal of Lefebvre's work for architects, accommodating explicitly spatial 'practices'. The 'spatial turn' worked across disciplines, as much within art as social theory, political science as geography, and engendered a 're-materialization' in response to the prevailing conceptual dematerialization (of the work of art, for instance), renewing an engagement in cities and the built environment as a source of critical and practical focus.

The reconsiderations of space that emerged with the 'spatial turn' were not intended to become a fixed ideology or methodology. In his own words Lefebvre's work provides us merely with an "orientation" to questions of space. As a theoretician of the burgeoning field of urban sociology, he states that "(social) space is a (social) product" (Lefebvre 1974, p. 35). This means it is not only within the notion of space 'as lived', but rather in the notion of *production* of space in which social and political process is enacted; meaning space is quite obviously political, being both a political product and a political stake; both an outcome of political conflict and struggle, but also a medium or instrument for it. Of course, the opportunities and dangers of linking the production of space with social and political facts is that these principles can be used to create a causal link between space and political objectives. If the 'production' of space allows it to be seen as political, then ultimately space could be misconceived as an instrument to create political effect. But this assumption of a 'causative' link from space to the political is actually a simplification of the more radical positioning being proposed by Lefebvre. Although he was interested in a utopia (meaning, he was interested in political projections of futures), he was focused on forms which do not deny reality but rather explore its potentialities from a perspective of transformation of political and social realities. Lefebvre speaks of a "concrete utopia"; not an ideology, nor a utopia that is outside our social time or space, but one in the here and now. Importantly for those who operate upon and in space, this utopia is not a 'model' and it does not have morphological or formal implications. In conceiving the production of space, Lefebvre did not intend that his analytic work in the conceptual triad be appropriated as propositional tool for action. This would naturally collapse the approach into a new form of abstraction or representation of space (conceived space). Lefebvre's 'right to the city' is instead an understanding of, and a call for, a revolution in our economic, cultural and everyday life and essential to this are forms of participation and self-management, as opposed to projections imposed by technocrats, planners or architects.

Melanie Dodd

Clearly the use of this spatial 'turn of phrase' is not without confusions, multiple meanings and problematic re-appropriations. When used by political and social theorists, it is rarely deployed to express the experience of space, nor the tensions and struggles created in the actual production of space. What's more, for those interested in how space actually 'happens' (designers and practitioners, for example), the gap between a new understanding of the production of space as a powerful concept versus how we practice it down on the ground is still to be spelled out in all its complexity and difficulty.

It's also worth asking how the 'spatial' is conceived by political theorists. Very early interpretations of the 'spaces' of politics (Plato's conceptualizations of city and community, for example) were conceived as alternatives to the indeterminacy of the problematic 'political', privileging static and inert ideas of space. These were spaces of governance and control that fix and contain for order and stability – like the agora. In the twentieth century, conversely, forms of spatiality more appropriate to a political domain of democracy are employed. Arendt uses the term 'public realm' as the place of shared endeavour: "To live together in the world means essentially that a world of things is between those who have it in common, as a table is located between those who sit around it. The world, like every in-between, relates and separates man at the same time" (Arendt 1958, p. 52). This metaphor is a useful description because it acknowledges political space as the space that simultaneously gathers and separates us. This effectively explains the inherent diversity and antagonism of the public realm as a manifestation of freedom. In the creation of such a 'realm of acting and speaking', we create a political domain that is conceived as an ephemeral space which comes into being (as a potentiality) over and over, when people gather. It's therefore a contingent space, and not able to be fixed. As a development of these conceptions of political space, Ernesto Laclau and Chantal Mouffe (1985) conceive political spaces as spaces of antagonism between adversaries, and these are rather seen as multiple and overlaid, an array of 'outsides' or exteriorities as part of an overall ensemble – a domain of coexisting multiplicities. Jacques Rancière goes further in defining the political as a condition of rupture and change, which he calls 'dissensus' to mean a reordering of the senses, or a redistribution of the sensible (Rancière 2010). Art and politics are both forms of dissensus, meaning they are exceptions to the logic of normal rules governing social interaction, where genuine political action involves an emancipation from the conventional frames in which bodies are ordered.

What is important in the way recent political thinkers have used spatial language to explain political processes is that they all try to understand space as defining or encouraging change, and their conceptualizations understand space as constantly 'opening up' new possibilities. What makes space political is when an encounter becomes an interruption in the established order, the opening of a space for something 'other'. The spatial practices of protest, occupation and activism provide clear examples of how this theoretical concept actually hits the ground with political effects. The dimensions of spatial protest and occupation are characterized by the transitory rather than the static; by the contingent rather than the complete; and yet they often have long-term legacies (legislation change, tenancy rights, new forms of governance). These are spatial practices in which the shape and form of the outcome occupies a broad field which is both immediate (performative) and strategic (seeking societal change). The understanding that for space to have political import, it must rupture the existing order, brings us to the next point.

Space versus time

As we have seen, the 'spatial turn' in the social and political sciences provided a reorientation in the way time and space have been conceptualized. Space had been historically conceptualized as the binary opposite of time, where the temporal is seen as active and mobile, and the spatial is conversely static and closed. In terms of its broader societal role this denies it those characteristics that are essential in

order to 'open' it to the political. Many, like Doreen Massey (2005) address the 'spatial turn' full on by providing an argument which is recuperative of 'space' as a force with social and political agency:

> It is my argument, not just that the spatial is political, but rather that thinking the spatial in a particular way can shake up the manner in which certain political questions are formulated, can contribute to political arguments already underway and most deeply, can be an essential element in the imaginative structure which enables in the first place and opening up to the sphere of the political.
>
> (Massey 2005, p. 9)

Within the architectural and spatial domain, the vocabulary that has traditionally described space has been used to limit its agency, albeit for convenience. 'Fixing' space as a concept (likewise as a drawing or representation), reduces it conceptually in terms of constraining its ability to do more than act as a 'container' for actions. Conversely Massey deliberately uses terms which challenge these conventions. And she goes beyond simply stating that space hosts 'multiplicity' and 'plurality', that it is a product of coexistence and interrelations, that it is always under construction – never finished, never closed. She also powerfully identifies it as a realm which provides the opportunities for the political to be enacted and points out that this chimes with progressive new left politics in being a domain of constant shifting subjectivities. In doing so, she states that spatiality may from the beginning be constitutive of political subjectivities, not an outcome or setting for them. This is different to simply drawing relations between the spatial and the political, or understanding that space can be an instrument to create political effect and vice versa. As with spatial practices of protest and activism, space here is an essential ingredient in 'enabling' the political because it is by its very nature, a 'multiplicity'.

Reconceptualizing space as a 'multiplicity' is not just a matter of using a different vocabulary. It sets the scene for re-conceiving spatial practices as an open field of always becoming interconnectedness. Rather than being portrayed as singular narratives, actions upon space join a "simultaneity of stories so far" (Massey 2005, p. 9). This is space conceived not as a product, an outcome or a fixed form, but rather as a myriad of processes already underway, into which we as actors (of many different types) can intervene. And these are not processes which have single linear trajectories but are rather an interconnected system of relationships and contingencies, with "loose ends and missing links" (ibid., p. 12). The stress upon positive multiplicity is important for an appreciation of the spatial, and challenges the "political implications of practising it [space] differently" (ibid., p. 13).

When considering how these reconceptualizations of space are helpful as context for 'practising space differently', the problems of representation are critical; these are the practices of analysing, describing and envisaging space so familiar and essential to the designer. Common vocabularies of architectural drawing and mapping convey the dangers of fixing space; looking at the world in 'cross-section' as a way to make abstract its essential complexity, and 'holding the world still'. If space is an event, it cannot be represented (just like temporality) and it cannot be closed. Space is as challenging to represent as time because 'practised' space is a relational construction, it unfolds through interaction as multiple, overlaid paths. As simultaneously both spatial and temporal, these trajectories render space indeterminate, in a state of 'becoming'. Experimentation in representation (mapping, representation, projection) has flourished in parallel to the 'spatial turn' as spatial practitioners have sought to acknowledge temporality and space together, often blurring the line between representation as projection and representation as intervention itself. These experiments, spanning from Guy Debord's Psychogeographic Maps (1957), to Tschumi's Manhattan Transcripts (1981) and beyond are counter-representations of space in which events, narratives, voices, occupation and

invisible infrastructures are foregrounded, and from which new forms of practice emerge which privilege open-ended, ephemeral and transitory interventions over (or in parallel to) tectonic ones.

The irony is that 'design' itself has the tendency to 'fix' space, foreclosing open-endedness and eliminating chance. Practising space – 'spacing' – means negotiating countless intersecting paths where the focus is on a 'practised relationality', not conceiving abstractions which foreclose outcomes. Although the reconceptualization of space as potentially political seems (for designers, planners, practitioners) to imply that the operation of space can (like its form) be conceived and planned, the gap between the conceptualization of space as political and the actual realization of that through the way it is planned, curated, used and performed is both a challenge and an opportunity.

Practising space

Against this backdrop of precautionary tales, how can spatial practitioners act? The term 'spatial practice' itself has emerged to describe new forms of interdisciplinary practices responding to the contemporary city and the politics of territorial relations. As we have mentioned, spatial practice has been used to describe both the critical analysis of spatial relations, as well as various forms of interventionist strategies. Lefebvre assigned spatial practices to the category of perceived space, the space of social relations and of experiences of daily life; not explicitly designed, as much as 'produced' in daily life. The re-appropriation of the term to refer to a form of propositional practice within and between the realms of art and architecture has been more recent but draws on desires for a more open-ended and socially engaged approach to the design of spaces.

New practitioners of this genre often describe their work as a form of research-based practice. The idea of research per se as an outcome of practice is not new. Research on design methods initially emerged in the 1960s, as a reaction to the modernist regime of functional determinism, and was a response to the increasingly complex entanglements of urban sites and situations in which designers found themselves operating. Participatory Action Research (PAR), for example, is a method that approaches a given situation through research activities, involving participants and existing local social networks, with the intention that research and action must be done 'with' people and not 'on' or 'for' people. Enquiry based on these principles makes sense of the world through collective efforts to transform it and so is a methodology that goes beyond research and becomes propositional: "Action research has been described as a program for change in a social situation, and this is an equally valid description of design" (Swann 2002).

Research-based 'practice', one which allows contingency into a process of designing or projecting of futures, started to become more mainstream in the mid-1990s, often via the work of interdisciplinary practitioners such as socially engaged artists and designers actively pursuing broader spatial or place-based outcomes. Jane Rendell describes this as a 'place between' art and architecture (Rendell 2006, p. 2), referring to an interdisciplinary terrain of practices which are site-specific, concerned with the 'city', and proliferating from the socially engaged 'public art' of the 1980s; an onward metamorphosis of what Rosalyn Krauss has termed the 'expanded field' (Krauss 1979). Seeking to describe this work, Rendell coined the term 'critical spatial practices', which: "describes work that transgresses the limits of art and architecture and engages with both the social and the aesthetic, the public and the private" (Rendell 2006, p. 6). In a comprehensive overview mapping the field, Awan, Schneider and Till (2011) take this further by constructing an argument for 'spatial agency' which, as a term, "proposes a much more expansive field of opportunities in which architects and non-architects can operate" (2011, p. 30). As a means to avoid only framing spatial practices as 'alternative' forms of architectural practice, their term spatial agency focuses less on 'practice' and more on a reconceptualized mode of action which frames how those outside the profession

of architecture also participate in the production of space as a shared enterprise. Hirsch and Miessen (2012) also subsequently provide us with a refined definition of 'critical spatial practice', distinguishing it from architectural production in the way that social issues are paramount. Here the definitions of spatial practices are firstly about what it isn't. For them, it is not architecture. It does not fetishize the physical object (which they argue architecture does) but is rather concerned with the temporary, the informal and the contingent, enhancing and developing tools which expand beyond form and into political process. A key factor in this definition is how 'spatial' is understood as not only something concerning physical space, but also as *effect* on space, constructed out of the relations between people and their built surroundings (relational, or concerned with the relation between things). By adding the term 'critical' this also means such practice should be specifically understood as culturally discursive, a critique or counterpoint to architectural modes of production.

In this way, definitions of spatial practices tend to circle around creating a position *relative* to the discipline and practice of architecture. But introducing a friction or opposition with architectural modes of production and outcomes creates a duality, focusing spatial practice in a binary relationship with architecture, in which it is either/or, laying it open to critique from a growing band of architects and commentators who not only feel that spatial practitioners' claims for political agency are optimistic, but also see this position undermining the realm of architectural production and its capacity to be political.

Relational form

How can we move forward in defining spatial practices, attempting a more inclusive definition that doesn't set it up as a duality against architecture? It's useful at this point to consider the parallel experience of contemporary art practice, which over the past 25 years has been exploring its own 'spatial turn', as observed by a number of critical commentators (Lacey 1995; Bourriaud 2002; Kester 2004). In terms of the 'relational' and socially engaged approaches emerging in interdisciplinary art practice in the 1990s, for Bourriaud – "the very first question has to do with the *material form* of the work" (2002, p. 7). Critically, for many of the practitioners of this domain, this new form of art practice is about intervening in 'situations', not just space; so effectively intervening in the 'production' of space: "Otherwise put, the role of artworks is no longer to form imaginary and utopian realties, but to actually be ways of living and models of action within the existing real" (Bourriaud 2002, p. 13). Relational art is envisaged as tightening the space of human interaction, creating a social interstice, or an arena of exchange, and critical reflections on socially engaged art practice powerfully set out such practices as having not just socially beneficial effects, but also ethical and political objectives.

The compelling argument that 'relational aesthetics' are not a theory of art but a theory of 'form' is helpful in exploring the terrain of spatial practices where form can be defined as a lasting encounter, "keeping together moments of subjectivity" (Bourriaud 2002, pp. 18–20). Using this definition, the contemporary artwork and arguably the outcomes of spatial practice can be seen to extend out from their material facts. The idea of a 'relational form' is therefore useful as a construct through which to understand the outcomes of a spatial practice. This is already well understood by practitioners in the field. Jeanne van Heeswijk, an artist working in public space, refers to her various outputs as 'platforms': "a platform can be a book; an intervention; an action; an occupation. It can be a new legislation. It can be a building. It can be whatever it is. It can be an artwork. And those moments, those platforms, are very important because that's where things become discussable, tangible, critique-able" (see Chapter 11). Form is therefore a dynamic entity in spatial practices; a matrix for a mode of operation which may be critically engaged and propositional through both soft infrastructures of interaction, social

engagement and performance, as well as harder infrastructures of built propositions, structures and physical spaces.

There has however been concern that the ambitions of socially engaged spatial practices to repair the social bond, and to work through the artwork toward constructive social change, are distracting; that the conflation of art with other domains like creativity, citizenship, sociology, politics and ethics shifts emphasis away from artistic (aesthetic, formal) ambitions, towards political ends – which renders these practices open to confusion in terms of evaluation and critique. Are they to be considered as creative artworks, or as works of social justice? The co-option of participation and collaboration as 'tools' in a repertoire of newly expanded artistic practices leaves it open to instrumentalization by the very hegemonic forces that are being resisted. This runs parallel to the critiques of centrist and neoliberal policies and has been well illustrated in the way that participation in public policy and decision-making process was explored and used as a key element of New Labour's modernization propaganda. Rancière (2010) argues that "art's return to politics" and supposed intentions to oppose the system of domination are problematic. His identification of the inherent "cause and effect, intention and consequence" of this argument is that it undermines the truly political: "There is no straight path from the viewing of a spectacle to an understanding of the state of the world, and none from intellectual awareness to political action" (2010, p. 151). In fact, in this way, critical art and spatial practice arguably becomes more a matter of consensus. This 'expectation' or intention of cause and effect closes down its capacity to be political – it is contradictory, meaning that the mode of manifestation is constructed out 'of' the system itself.

This critique has, unfortunately, and probably unfairly, burgeoned as forms of spatial practices have risen to become a new orthodoxy, addressing the way in which practices at the margins of architecture, with claims of social and political agency, have been increasingly co-opted by both government and private enterprise in support of their objectives. The success of temporary and 'mobile' architectural and spatial projects is a case in point, exemplified by the now disbanded French cooperative practice EXYZT, who pioneered a radical approach which involved both self-generated and self-built structures. EXYZT's projects were built, inhabited and occupied by the practitioners and other local actors themselves as part of processes of participatory transformation of vacant city spaces, inspired by mentor Patrick Bouchain. Their incredibly influential experiment 'Metavilla' for the French Pavilion at the Venice Architecture Biennale (2006), for example, has arguably been instrumental in spawning new spatial typologies like 'pop-up' (now ubiquitously used to describe any sort of temporary retail enterprise) and 'meanwhile' (temporary use of a space awaiting development); both terms and practices which are now frequently co-opted by property developers for their own gain. Brenner (2017) carefully questions the approaches of the numerous practitioners who sit under the banner of 'tactical urbanism', finding that they are, conversely, in danger of offering a palliative for neoliberal urbanism rather than any resistance to it. His definitions of tactical urbanism overlap with modes of spatial practices already described and he concludes: "In some cases, tactical urbanisms appear more likely to bolster neoliberal urbanisms by temporarily alleviating (or perhaps merely displacing) some of their disruptive social and spatial effects, but without interrupting the basic rule-regimes." Worse from Schneider:

> the naivety of some of the projects (that was so seductive to begin with) has come to play into the hands of those very neoliberalist and commodifying forces it was critical of to begin with. The radical nature of the urban beach-bar, the pop-up cinema, meanwhile uses, modes of participation and the development of process-based strategies have seemingly become absorbed by the marketing and branding mechanisms of the 'corporate city'.
>
> (Schneider 2018, p. 3)

Space is always political 13

The critique has come full circle to such an extent that it undermines, even threatens, the validity of spatial practices for the very reasons that they initially offered promise: through embracing the provisional and contingent multiplicity of trajectories that can deliberately open space to the political. Of course, even within this critique, there are distinctions and clarifications for ways forward. Many practitioners themselves, for example Teddy Cruz and Fonna Forman, working at the border between Tijuana, Mexico, and California, have called for a more systematic approach that engages with larger scales of operation, the 'apparatus' of society itself and its redesign – understanding that it is not only about designing physical things, but also the protocols and policies that will ensure hospitality and inclusivity over time. Part of the issue is that, as in the case of tactical urbanism, terms like 'participation', 'bottom-up', 'small scale' and 'activist' can be used in a confetti approach that tick-boxes without actually accommodating the serious social and political work that such approaches require to have effective outcomes, which a political strategy of large-scale socio-spatial transformation might support. It's important to reflect on these concerns to help refine a definition of spatial practice, avoiding what are sometimes loose claims and assumptions of social and political effect in an increasingly ethically charged political landscape.

The politics of things

In what way can we delve further into the way spatial practices act 'politically' – mindful of the critiques that have emerged? Part of recent criticism about spatial practices has been in the way its operations are perceived to discredit and downplay conventional aspects of architectural production; that the social process and ethical ambition for participation and engagement liberated in the 'spatial turn' now outweigh any aesthetic and formal concerns in such practice altogether. And perversely, that despite this, there are rarely effective or thorough means to critique the social or political effects being claimed.

These are problematic critiques, and not altogether unfair. In privileging the social and political agency of spatial practices, any conceptualizations of how the 'form' of space has (political) effect have been implicitly (sometimes deliberately) diminished, effectively leading to a swing too far the other way, which has arguably laid spatial practices open to even further marginalization. If the formal and the aesthetic are discredited, how can spatial practices be anything more than a marginal practice, dovetailing with its more 'professional' parent, architectural design, or worse, operating as a duality in opposition against it? Some critics, though sympathetic to a political agenda for architecture, are concerned about the growing discourse of architect as activist because they believe it underestimates the ability of architecture (as building) to be a political project (Aureli 2013). The notion of conceiving of the architectural project as an antidote to the normative and neoliberal dimensions of professional practice seeks to restore the value of a conceptual 'representation' of space as a forceful way to organize the means to political transformation. This could also be seen to chime (albeit in rather discordant ways) with calls for a resurgence of the need for strategic, even systemic, utopian visions – whether implemented through societal change, or specifically through architecture which can provide an antidote to small-scale, temporary and fragmentary projects of the here and now (Brenner 2017; Harvey 2013).

The difference in these conceptualizations of 'practice' and 'project' – between everyday lived action versus anticipated or conceived strategy – is worth exploring. This reconnection to the value of the 'conceptual' project, to Theory with a capital T, apparently swings the pendulum away from spatial practices, and its concern for the temporary, the informal, the ephemeral and the contingent. Unfortunately, in doing so, it only deepens the divide between Architecture with a capital A – and spatial practices; because even though both are apparently dedicated to the transformational potential of space, conceptually their modes and operations for

Melanie Dodd

achieving that are framed as almost diametrically opposite. Are these conceptu-alizations as opposite as they first appear, or can they be reconciled? We need to return to the terrain of what 'form' the social and the political takes, because it is here that the core of the issue really seems to reside. As stated earlier, we need to counter a reductivist reading of cause and effect and other binary simplifications of 'form' versus 'process', because these marginalize and separate practices into com-peting factions, when in fact most contemporary practitioners are generally united in support of a transformatory political project.

Key to this reconciliation is the need to reconceptualize the political 'within' practice itself. Practitioners frequently express unease at being labelled, describing their work as a collection of incremental and small-scale activities undertaken 'at the coal face' of practice. Damon Rich, a practitioner with a range of diverse spatial practices stretching from pedagogy to urban planning, says: "Even though I see value in practices that involve people standing up and saying overtly, 'We are being political' I feel lucky in the work that I've been able to do, being in a real place with a very limited place for gestural politics of that kind" (Rich, in conversation 2018). It's clear that generalist use of these terms disables a deeper description of cause, effect, object, user, subject (a movement of relationality and connectivity between things); dismissing the myriad of 'parts' in favour of a homogenous whole. This marginalizes the intricate banal minutiae of objects and actions in design 'practice' – conversations and meetings, careful surveys and drawings, liaison with all manner of technical collaborators – in favour of an overarching generalization that the prac-tice is 'social' or 'political'. How such practice is social or political often becomes a matter of describing the major design moves, their intended 'effect' upon the user and the deterministic way they will perform, rather than a more complex and asso-ciational framework for what is really going on.

'Theories of practice' are more useful in avoiding these pitfalls and, as a pragmatic materialist, Latour has said "the social is not some glue that could fix everything; it *is* what is glued together" (2005, p. 5). He characterizes practice as a 'tracing of associations' where the associations are "a type of connection between things which are not themselves social." The relevance in considering this approach in the domain of spatial practices is that it avoids the confusion of cause and effect. In defining 'actors' we remove the generalization inherent in the term 'agency', instead allowing action to be read as specific, at the same time as uncertain. As an association between things, it allows the social to be considered through the effects of people, objects, things, upon one another – effectively pre-venting a homogenization of the social or the political and reconceiving it through multiple uncertain entities in play. This increases the granularity of the approach, allows more specificity, more accuracy, and more particularity in respect to how design might, as part of an integrated set of trajectories, short-lived interactions and new associations, perform socially and politically.

Critical to this approach is the notion that objects too have agency:

If action is limited a priori to what 'intentional' meaningful humans do, it is hard to see how a hammer, a basket, a door closer, a cat, a rug, a mug, a list, or a tag could act. They might exist in the domain of material causal relations but not in the 'reflexive' 'symbolic' domain of social relations. By contrast if we stick to our decision to start from the controversies about actors and agencies then anything that does modify a state of affairs by making a difference is an actor.

(Latour 2005, p. 71)

This does not mean that these objects determine the action – that they have a causal relationship with it. But it does introduce the ways that things can influence, encourage and effect actions. This is a critical point in interpreting the agency of spatial practices because it allows an appreciation of the way in which objects of design have a social and political dimension per se. Reorienting toward

an approach which accommodates the physical qualities of material objects also brings us closer to an alignment with contemporary discussions on politics and aesthetics. These arguments help address some of the previous concerns that a political mission is beyond the remit of either spatial or architectural practice; that it distracts from, even marginalizes, the formal and tectonic, even that it is ethically questionable 'do-gooding'. By considering the way practitioners are concerned with the detailed machinations of their 'practice' rather than using overarching labels, we can see that these critiques are simplistic at best. As Yaneva says, an enquiry on ethnographic terms can reveal this:

> A different way of phrasing the political question in design would be to focus on the relations and urban norms the groupings and associations, the agency and scenarios of use, the politics deployed in the performance of buildings, in urban technologies, in design, construction and planning practices. Thus, the question is no longer who acts, decides, chooses, participates and represents, and whether this participation follows democratic procedures, but rather *how specific capacities to act are performed through design and urban practice.*
>
> (Yaneva 2017, p. 6)

Here lies the importance of not defining spatial practices as a priori 'political', but rather exploring the 'political in action' through a materialist reading of the territory of physical apparatus implicated – both human and non-human. As any designer knows, the actual undertakings of design present a complex terrain of actions and objects. Designers engage in open-ended discussions, using sketches, conversations and models, in studio and on sites, with colleagues, the public and users, before, during and after construction. The intricate negotiation circuits of practice 'perform' rather than 'represent' the politics. Critical to this interpretation is the way in which it acknowledges that artefacts, not just actions, can be political. The conceptualization of a network of 'actors' provides a new connectivity for social actions and physical objects so that socially engaged process and physical 'design' can coexist as equally important: "In the process of making, the material world of design is not a passive substrate awaiting the firm hand of human agency; instead it talks back to the designers, it makes them act, turn, dance, run and interact with others and the things at hand with a different pace of speed" (ibid., p. 30).

This repertoire of practices includes not only the hand and the body, but tools, instruments, devices (and spaces) which extend our influences out into the world, to engage with others. These have been termed 'transitional' objects and transitional phenomena, which belong to us as fundamental connective devices threaded back into experience (Winnicott 1970). This notion of 'extension' is a useful one because it understands the matrix of connectivity between a physical thing and its repercussions and effects in the world – acknowledging that our 'consciousness' operates well outside the sphere and containment of our own body, or other physical boundaries. This allows us to envisage practices as a series of extensions between ourselves as actors, and other mechanisms and objects of practice. As Graham and Thrift (2007) state: "Things, in short, disclose a world. When somebody uses a tool or piece of equipment, a referential structure comes about in which the object produced, the material out of which it is made, the future user, and the environment in which it has a place are related to each other." Envisaging spatial practices as a network where everything, animate and inanimate, is 'acting' politically demonstrates how practitioners engage with the multiple 'trajectories' of space, and support open-ended becoming. By understanding and envisaging these as a terrain of animate and inanimate 'things' which act politically, we have a way out of the simplistic and ultimately negative process-versus-form binary, allowing us to reconnect and embrace the myriad forms of spatial practice as composed of both actions and things.

Melanie Dodd

Spatial practices are political practices

Closer to an understanding of how spatial practices operate politically, we need to conclude by moving to a broader societal scale, considering the need for the spatial to open to its transformative (political) potential, without falling into the trap of simplistic causational arguments that discredit its operations. A focus on exploring 'practices' brings us closer to a materialization of how practice operates, not as just intention, but as a fuller operation of actions, objects and things. Arguably we need to resist the abstraction (the representation) of ideas laid over or into space and architecture, and to rather foreground the practicalities, materialities and events that constellate them. By foregrounding the practices of design, we can bring them (both before, during and after construction) more clearly into play as political.

This approach provides a rebalancing in which both the objects and processes of design are equally key, an 'ecology' of practice which redefines the forms of associations between all of its 'beings' – buildings, skills, sites, users, designers, constructors, equipment, models. This shifts us from a single view, one that emphasizes 'autonomy', to the accommodation of the multiple realities of a project. Spatial practitioners motivated by a desire to make projects accommodating multiple audiences would already find that this approach mirrors their own intuitive understandings of space as always in a state of becoming, always unfinished. Rather than resorting to a foundational theory, it offers a tool for telling stories about how spatial practices perform politically, whether 'upon' existing contexts or as part of new situations being constructed. This allows us to study space in the making, redefining a form of practice which is as aware of *how* it produces having a mutual synergy and agency with *what* it produces. For practitioners, this conceptualization usefully distances it from a deterministic, or ideological, schema. As one practitioner says: "This doesn't mean that all architects are aware of this political performance of what they design, nor does it mean that it is only the architect that makes the architecture perform politically in a particular way; but it means that architects in a way are confronted with, at one point, being aware and taking responsibility, or not, of the political performance that their building, design, and practices are part of" (Jaque 2017).

A focus on the 'practising' of spatial practices is also useful because it takes emphasis away from the fixed outcome – the building – and focuses instead on how the construction, occupation and consumption of spaces are interconnected in their production: "Seen in this way, the stable architectural object (architecture-as-noun) is the effect of various doings (architecture-as-verb)." This from Jacobs and Merriman (2011), who perceive a new awakening in 'practices' in social and cultural geography – what they call a 'practice turn': "a shift in emphasis away from thinking through a range of social theoretical 'familiars' (such as structure, system, representation, identity, meaning) towards attending to activity, action, embodiment, as well as shared practical reason."

This emphasis on 'practice' rather than the singular object of a building, fundamentally reorients our terms and acknowledges that spatial practice does not (as some critics would have it) privilege the social actions or processes over the material, but rather allows them all to be understood as a critical set of agencies (human and inanimate), producing and effecting actions and consequences. As Till argues, "dependency is a defining feature of architectural practice" (2009, p. 151) and consequently uncertainty and 'contingency' are to be embraced. This conceptualization concurs with the way spatial practitioners speak about the field or terrain of their sites; they are 'situations' into which 'interventions' have effects, open-ended, not necessarily ideologically preconceived or determined.

This also highlights the need to talk about 'practitioners' rather than just 'practice' and to privilege that what practitioners really 'do' is of greater import than the labels of professional job titles. Envisioning an interpretation that is no longer about the 'objective' outcome of a building, but rather the myriad plural 'productions' of practice, makes sense. This builds recognition that the city is an

interrelated infrastructure of 'things', in constant need of maintenance, repair and attention by an interconnected set of actors and players, contractors, makers, designers, maintenance operatives and users. In the context of the contemporary neoliberal cities hegemonies, how can we argue that such a network of spatial and cultural 'practices', often derided as fragmentary and small-scale forms of resistance, support a genuinely transformational politic?

Following Gramsci, 'hegemony' is produced and reproduced through the 'institutions' that form the superstructure (culture, institutions, power structures, the state). But it is clear that if it can be reproduced in these ways, it can also be disarticulated here too. Radical politics, then, does not promote a 'withdrawal from institutions', but rather an engagement with them, as part of a counter-hegemonic struggle which does not assume one position – only of resistance – but rather nurtures many agonistic struggles *between* adversaries, as an ongoing and internal feature of institutions (Mouffe 2013). The assumption that cultural practices play a role in capitalist productivity means that they can play a role in counter-hegemonic practice too. Again, this is commonly articulated and recognized by practitioners who grapple with the day-to-day commissioning of projects, using ingenuity to articulate new relationships – in the process including those otherwise left out. Liza Fior, founder partner of muf Architecture/Art coined the term 'double-agency' to describe their practice, where, for example at Barking Town Square, she says: "The history of the project outline meant that planning permission was given for the development with minimal requirements for local consultation, yet a fundamental part of the project was a public space in the centre of the town, and so our clients were the local end users. It was at the earliest stage of the project when we first described ourselves as double agents – working for one interest in the hope of working for another" (see Chapter 19).

And it is not only artist/activists who can mobilize but also 'institutions' themselves. A withdrawal from existing institutions denies the possibility of a counter-hegemonic struggle *within* institutions, and wrongly perceives institutions as 'monolithic' representatives of forces to be destroyed. This clear call for 'acting within' the frameworks of institutional hegemony means that critical art and spatial practices need not only have efficacy when taking place 'outside' or in resistance to established normative practice. In fact, failing to see them as embedded within normative practice is a mistake: "To believe that existing institutions cannot become the terrain of contestation is to ignore the tensions that always exist within a given configuration of forces, and the possibility of acting in a way that subverts their form of articulation" (Mouffe 2013).

For the purpose of the discussion here, of course, hegemonic institutions can be read as both galleries, museums, commissioning agencies as well as regeneration departments, local governments, large architectural practices, and even professional bodies, like the RIBA. All of these institutions have the ability to challenge their own norms and customs of patronage, catalysing and sustaining new collisions and contestations. Not least, in all of these situations, we can see that the arts (a cultural commons) can be captured and appropriated by capital, but also sustained by it. In fact, culture's 'special qualities' need to be maintained to sustain their 'value' in the market, because the more easily marketable and marketed they become, the less special and unique they appear. In this potential quandary, lies opportunity (Harvey 2013).

This provides a framework that can reconcile the dualities of complicity versus resistance that have plagued the field, instead seeing spatial practices – including architecture – as a field of operations working across, within *and* between the norms and constraints of the neoliberal city. Ultimately neoliberal operations are complex and contradictory and these contradictions can be exploited by spatial practitioners. The powerful (and optimistic) conclusion is that: "the spaces for transformational politics are there because capital can never afford to close them down" (Harvey 2013, p. 111).

Melanie Dodd

In the unfolding argument for spatial practices as political practices, how do we conclude?

The intention of this scene-setting chapter was not to produce a cast-iron schema for spatial practices, but rather to open up a discussion around certain tensions across current conceptualizations of space and politics that are arguably doing a disservice to how we actually conceive of the *practice* of spatial designers. Primary to this is resisting the unhelpful duality – the 'either/or' – of spatial practices; in which we see spatial practices (only) as a body of marginal practices of 'political' resistance, sitting 'outside' architecture, the profession and the hegemonies of neoliberal society. In contrast, we need to insist on placing spatial practice firmly in the mainstream, able to be both resistant and (disruptively) complicit in ways in which we can manoeuvre toward a cumulatively transformative political practice.

Important also, is to counter the reductivist reading of spatial practices in which 'process' can be political, but 'form' cannot. This simplification not only allows spatial practice to be easily discredited and marginalized by its critics as 'bad architecture', but far more importantly it paralyses a more sophisticated 'designerly' discussion about spatiality; its actions, operations – and not least the physical qualities and capacities of the 'things' produced (from objects to buildings).

And lastly, appropriate to a book highlighting spatial practitioners, it is important to generate operational theories of practice that are both helpful to frame and interpret practice in hindsight, but which can also be optimistic and positive for future practice; to find a way in which to engage with our anxious times, not helplessly, in the face of difficulty, but as a way forward. This means avoiding assumptions that certain sorts of project are to be avoided; or are necessarily problematic because of the context in which they are commissioned, and the values they appear to represent.

Spatial practitioners are increasingly given the opportunity to act within a wider set of contexts than ever before – including within the 'institutional' domain of local government planning and regeneration policy, often partnered with or commissioned by private development. The proliferation of regeneration departments in local authorities and urban governance, symptomatic of our contemporary condition, has actually produced a stream of work which occupies the spaces between technocratic planning and temporary spatial interventions – and which has presented ideal material for a new wave of younger practitioners. What have come to be called 'meanwhile' or 'pop-up' projects, temporary interventions for interim sites, waiting for development, are increasingly sites commissioned to this new breed. Rather than assume these forms and places of practice are sinister (they may well be), and to be avoided at risk of being co-opted by a neoliberal hegemony, we need to be more optimistic for the actions of spatial practitioners seeping into the institutional domains of planning and development process. The design of temporary and 'engaged' environments apparently disguising contentious urban renewal, can, with careful acts of design, act instead to produce provocative and questioning interventions that do quite the opposite – 'perform' the political through spatial practice. Only by confidently operating within the hegemony can we disrupt its operations from the inside out.

Note

1 Reported by Edwin Heathcote, *The Times,* 19 July 2013.

Bibliography

Arendt, H. (1958) *The Human Condition.* Chicago: University of Chicago Press
Aureli, P. (2013) *The City as a Project.* Berlin: Ruby Press
Aureli, P. (2008) *The Project of Autonomy: Politics and Architecture within and against Capitalism.* Princeton, NJ: Princeton Architectural Press

Awan, N., Schneider, T. and Till, J. (2011) *Spatial Agency: Other Ways of Doing Architecture*. Abingdon: Routledge

Bishop, C. (2006) *Participation: Documents of Contemporary Art*. Cambridge, MA: MIT Press

Bourriaud, N. (2002) *Relational Aesthetics*. Dijon, France: Les presses du réel

Brenner, Neil (2017) 'Is "Tactical Urbanism" an Alternative to Neoliberal Urbanism?' in D. Petrescu and K. Trogal (eds) *The Social (Re)Production of Architecture*. Abingdon: Routledge

Cosgrove, D. (2002) *Mappings*. London: Reaktion

Certeau, Michel de (1984) *The Practice of Everyday Life*, trans. Steven Rendall. Berkeley: University of California Press

Deamer, P. (2016) 'Architects, Really' in Nadir Z. Lahiji (ed.) *Can Architecture be an Emancipatory Project?* Alresford, Hants: Zero Books

Dikeç, M. (2012) Space as a mode of political thinking. *Geoforum*, 43(4)

Dikeç, M. (2005) Space, politics, and the political. *Environment and Planning D: Society and Space*, 23

Elden, S. (2007) There is a politics of space because space is political. *Radical Philosophy Review*, 10(2)

Graham, Stephen and Thrift, NJ. (2007) Out of order: understanding repair and maintenance. *Theory, Culture & Society*, 24(3)

Gramsci, Antonio (1971) *Selections from the Prison Notebooks of Antonio Gramsci*. New York: International Publishers

Hague, R. and Harrop, M. (2013) *Comparative Government and Politics*. Basingstoke: Palgrave Macmillan

Harvey, D. (2013) *Rebel Cities*. Brooklyn, NY: Verso

Hirsch, N. and Miessen, M. (2012) *What is Critical Spatial Practice?* Berlin: Sternberg Press

Jacobs, J. and Merriman, P. (2011) Practising architectures. *Social & Cultural Geography*, 12(3)

Jaque, A. (2017) "Architecture is always political." Interview by Nicola Valencia. *ArchDaily*, 30 October

Kester, G. (2004) *Conversation Pieces: Community and Communication in Modern Art*. Berkeley: University of California Press

Krauss, R. (1979) Sculpture in the expanded field. *October*, 8 (Spring)

Lacey, S. (1995) *Mapping the Terrain*. Seattle, WA: Bay Press

Laclau, E. and Mouffe, C. (1985) *Hegemony and Socialist Strategy*, London: Verso

Latour, Bruno (2005) *Reassembling the Social*. Oxford: Oxford University Press

Lefebvre, H. (1991) *The Production of Space*, trans. D. Nicholson-Smith. Oxford: Blackwell (French edition 1974)

Massey, D. (2009) Concepts of space and power in theory and in political practice. *Documents d'anàlisi geogràfica*, 55

Massey, D. (2005) *For Space*. Thousand Oaks, CA: Sage

Mouffe, C. (2013) *Agonistics: Thinking the World Politically*. London: Verso

Mouffe, C. (1993) *The Return of the Political*. London: Verso

Nancy, JL. (1991) *The Inoperative Community*. Minneapolis: University of Minnesota Press

Noë, A. (2009). *Out of Our Heads*. New York: Hill and Wang

Pearson, A. (1999) *Germinal Life: The Difference and Repetition of Deleuze*. London: Routledge

Rancière, J. (2010) *Dissensus: On Politics and Aesthetics*. London: Bloomsbury

Rendell, J. (2006) *Art and Architecture*. London: I.B Tauris

Schneider, T. (2018) 'What If … Or Toward a Progressive Understanding of Socially Engaged Architecture' in F. Karim (ed.) *Routledge Companion to Architecture and Social Engagement*. Abingdon: Routledge

Soja, E. (2009) 'Taking Space Personally' in B. Warf and S. Arias (eds) *The Spatial Turn: Interdisciplinary Perspectives*. London: Routledge

Soja, E. (1989) *Postmodern Geographies: The Reassertion of Space in Critical Social Theory*. London: Verso

Swann, C. (2002) Action research and the practice of design. *Design Issues*, 18(1) Winter

Till, J. (2009) *Architecture Depends*. Cambridge, MA: MIT Press

Warf, B. and Arias, S. (2009) *The Spatial Turn: Interdisciplinary Perspectives*. Abingdon: Routledge

Winnicott, D. (1970) 'Transitional Objects and Transitional Phenomena' in Rosalind Minsky, *Psychoanalysis and Gender*. London: Routledge, 1996

Yaneva, A. (2017) *Five Ways to Make Architecture Political*. London: Bloomsbury

ONE SPATIAL PRACTICES OF RESISTANCE: PROTEST, OCCUPATION AND ACTIVISM

2 Protest as a spatial practice

Carl Fraser

The act of protest is an embedded practice occurring, most often, within public spaces. The nature of these 'public' spaces is contingent on a number of social, political and economic conditions. They are often categorized loosely, and include parks, squares, streets, forecourts, pavements, shopping centres and boulevards. However, both our access to these territories and our perception of what qualifies as public is not static or easily definable and extends beyond the generality of urban constructs or spatial typologies. Public spaces are interwoven into the matrix of our cities and as such are both numerous and varied in size, scale and use. They are the spaces in-between, facilitating numerous flows; the conduit for the daily functioning of the city, often only constrained at their interface with developments which are less publicly accessible.

The reason why protest continues to recur in public spaces is that regardless of the final outcome of the action, it is a practice which creates a degree of reciprocity for its participants when they feel aggrieved, under-represented or marginalized. It creates an outlet, a cumulative moment of social and often political objection. Protest manifests itself in proximity to spaces of power, in accessible locations, allowing its participants to test ideas within an environment with "like-minded" individuals. It is a divisive and unpredictable practice, because at its origin, it necessitates action, and changes the status quo, if even only for a brief period of time. This chapter argues that protest is a critical spatial practice, a reading that emerges from a combination of perspectives. First, it is "an evaluative attitude towards reality, a questioning rather than an acceptance of the world as it is, a taking apart and examining" (Marcuse, 2009, p. 185), and is therefore *critical*. Second, it engages with the socio-spatial; "In other words, we are concerned with the logico-epistemological space, the space of social practice, the space occupied by sensory phenomena, including products of the imagination such as projects and projections, symbols and utopias ... the practico-sensory realm of social space" (Lefebvre, 1974/1991, p. 11). In this way, we are looking at protests which occur in *space* (as opposed to those on virtual or digital platforms). Perhaps most importantly it is a *practice* because protest employs "transverse tactics [which] do not obey the law of the place, for they are not defined or identified by it ... one can distinguish ways of operating – ways of walking, reading, producing, speaking etc." (Certeau, 1984, p. 30). Here, we are interested in protests which become part of a recurring series of actions testing the limitations of the spaces in which they operate.

Well-attended protests which became manifest in the UK (2010–2012) provide examples of this critical spatial practice: specifically Occupy London Stock Exchange (3,000 people), the Off-Duty Police Officers March (20,000), the August Riots (3,000) or the Student Tuition Fee Protests (50,000) (see Figure 2.1). When recalling these actions, our response is immediate as we see them through the prism of our own lived experiences and associations. These particular protests are important in understanding our contemporary validation of acts of dissent, as they operate as a conduit between the Global Economic Crash of 2007/8, the political repositioning and austerity measures that followed, and the global citizen response. They are our most recent seismic fault-line. They also serve to highlight the spaces that we as citizens are able to explore and effect.

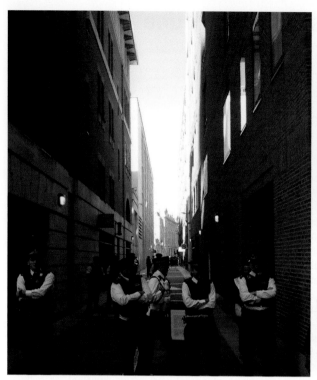
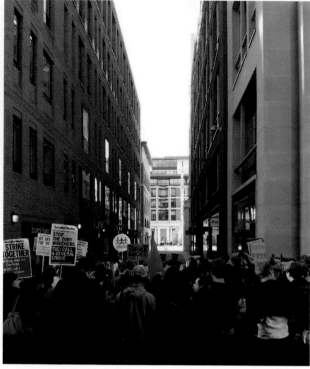

Public(ly accessible) space

The public/private patchwork of contemporary urban space develops as a result of the fragmented and partial nature of development strategies within our cities. Whether facilitated by shifting economic opportunities, political desire or citizen action, change is instigated by powerful forces impacting their desired changes on an existing landscape. Sometimes as by-product, sometimes as objective, these forces of change create "public(ly accessible) space" as opposed to public space. In this reading, access is key. We are referring to locations which can be walked through or transgressed by pedestrians, cyclists, commuters, etc. and that under their standard daily operative state do not require any form of identification-based or checkpoint system as a prerequisite to enter or move through. It is their accessibility that they have in common as opposed to their spatial typology or ownership status. As a result, they are sites which are able to host acts of protest subject to their rules of operation. These conditions of operation, however, are constantly changing as we are living through a time where an ideological shift in the designation of these spaces is taking place. The daily management of public spaces is increasingly falling under the control of private management companies, as Minton (2012) documents in *Ground Control*:

> During the eighties, alongside the 'big bang' architecture of Canary Wharf and Broadgate, the phenomenon of out-of-town shopping centres was the architectural signature of Thatcherism ... Under new Labour ... to find a way around planning restrictions, shopping centres have moved wholesale into the centre of the city ... Today, every town and city is home to these new places, large and small, built on brownfield sites and owned and run by property companies ... But they are also raising a challenge to a type of public life, public culture and democracy in British cities which has been taken for granted for the last 150 years.
>
> (Minton, 2012, p. 17)

Fig 2.1 Occupy: kettled out at Paternoster Square, 2011 (C. Fraser)

Carl Fraser

These developments not only changed the nature of the high street, but the nature of cities at large and the conditions ruling our public spaces, essentially narrowing the definition of permitted activities:

> What they all have in common is the emphasis on security and safety ... But when it comes to the details of how these places will actually be run, which is what determines their character, the information is rarely visible ... Often the plaques include a list of behaviours which are not allowed, such as skateboarding or roll-erblading ... a statement that twenty-four-hour CCTV is in use ... Although there is rarely any mention of it, a whole host of other behaviours are also invariably banned, including filming, political activity such as handing out leaflets, demonstrations, busking, begging ... in some places even eating a sandwich or taking a photograph is forbidden.
>
> (Minton, 2012, pp. 15–17)

The psychological association that citizens have with publicly accessible spaces as a sphere for self-expression and dissidence is therefore being systematically eroded. This shift, outlined extensively by others (Kohn, 2004; Low, 2006; Mitchell, 2014), is not only an established trend but also a comprehensive change to the values manifest in spatial reality. This questions the designation of public space and asks: what is the role that citizen agency and appropriation plays within our contemporary urban cities? Can non-prescribed actions such as protest still inform decisions made by powerful individuals and organizations through the use of public space? And if this is still achievable, what is the role of public spaces in facilitating such transformations?

Critical spatial practices

I will construct an argument that it is reductive to evaluate protest only in terms of political effectiveness or even in terms of the validity of the specific complaint being brought to the public arena. Instead, protest should be considered holistically, as a series of *critical spatial practices*, focusing on the methods of engagement and practices within and where they occur. Their aim is to speak to power and, as such, both the protests themselves and the terrain in which they take place are intrinsically linked to ideas based in "resistance theory", a form of democratic representation conceived by Locke (1689), developed by Rousseau (1762) and modernized by Rawls (1971). The idea of a "social contract" recognizes the role of an *active citizen body* to inform the tacit responsibility that is given to our institutionalized representatives. Within resistance theory lies an inherent necessity that we engage in shared practices of expression in an endeavour to inform and improve society.

Lefebvre (1971/1996) also constructs a theory on the citizen's role in effecting and improving society. He outlines a narrative that explains different historical modes of economic production which validates the role of citizen action. By abstracting this collection of adversarial human processes and power productions; Lefebvre creates a de-politicized method for evaluating social constructs, thereby reframing them, and allowing an assessment which can engage wholeheartedly with the idea of citizen action. This is embodied in Lefebvre's phrase the "right to the city", which encapsulates a number of diverse actions, understood as embedding a psychological approach to "daily life". Lefebvre divides these actions into different fields of human activity – work, leisure and love – which his approach transgresses. Through this process of "living" in the city, shared spaces of "action" are produced through shared experiences. As a result, the right to the city is facilitated to the citizen through action.

There is a cogent historical legacy that brings the analytical element of that theory into consideration. The notion of activating a sense of place through direct "action" is a concept born out of the European revolutions of the 1840s,

which saw the overthrow of contemporaneous absolutist regimes as well as the emergence of constructs of citizen representation which remain relevant to this day. Freedom of the press was established (with a defined role for Journalism), as well as modern constitutions. This was facilitated through the creation of an active public sphere which transformed the collective understanding of citizenship. This was the landscape that so influenced Karl Marx who, whilst constructing the critical theory of "Capital", was bearing witness to the construction of a social model for "popular political participation" in which continued revolutions seemed inevitable.

Divergent ideologies

In direct contrast, today, spatial acts of protest are becoming increasingly distant from our "daily lives" as is the notion of an informed and active citizen body. A perpetual structuring of legislation restricts the use of publicly accessible space, informed by the dominance of neoliberal ideals (free market economics and the politics of perpetual growth) disseminated throughout our cities. Today, a "conception of the public is decoupled from discourses of democratization, citizenship, self-development and connected ever more firmly to consumption, commerce, and social surveillance" (Madden, 2010, p. 188). New laws restricting behaviour which was previously accepted, which orient around gathering in publicly accessible spaces – protest, loitering, homelessness and picketing – not only change behaviour but also mindset as outlined by Mitchell (2010). They become intertwined with our personal interpretations of popular ideas, and the way in which we value the use of our free time. Socialist principles which are embodied in institutionalized ideas such as a free education system, a welfare state, a national health service and social constructs such as legal aid and the third sector are not only being systematically underfunded but, as a result, the public opinion of the importance of these constructs is changing. These consolidate into an overbearing hegemony which encroaches on our perception of acts which are seen as acceptable in our daily lives, and undermine the validity of obstructive actions of protest.

Spatially, this also represents a departure from the historical legacy of protest culminating around bases of power (such as Trafalgar Square, Speakers' Corner, Parliament Square and Paternoster Square, see Figure 2.2), a practice which has been popular and effective for the past 200 years. Once these spaces of antagonistic negotiation are established, the creation of a collective identity can be used to explore popular ideologies. This is where the tension between the sanitization and homogenization of public space and the desire for experimentation with more

Fig 2.2 Five key spaces of protest in London (C. Fraser)

Paternoster Square St Paul's Cathedral Parliament Square Trafalgar Square Speakers' Corner

Carl Fraser

diverse ideas of representation and engagement in the contemporary city clash, with protest being the moment at which this antipathy becomes visible.

Periodic repetition

Publicly accessible space is the arena for protest, because it is the place where we establish our connection to acceptable actions through recurrence. Over time, every society assimilates a collection of activities into identifiable acts which they define as protests. They are informed by laws defining civil and criminal offences and the ability of activists to blur this line with intelligent use of spatial disruption. Occupations, riots, marches, withdrawal of labour and boycotts all play their part, as they are spatial tools of contestation. As such, no society is free from contemplating the role of protest, as it is the spatial embodiment of negotiation which is inevitable in the contested cities in which we live. Societies with an active public sphere understand that there is a level of dissent which periodically occurs.

Although they can be triggered by any egregious event, we typically see well-populated protests at the aftermath of an economic fault-line. This is often followed by an unsatisfactory political response, which is contested through an expression of citizen outrage and direct action. It is a well-established cycle. Emerging out of the post-war period, for example, we saw the British economy in relative decline. In response, the Thatcher government (1975) started to break the economic post-war consensus (diminishing the role of trade unions, state ownership, the welfare state, Keynesian unemployment targets and the social engineering projects of promoting greater equality). In tandem, were similar economic positions in other powerful Western economies, with market crashes of 1973/4, 1987, 1992 and again in 2007/8. The citizen opposition was expressed most vociferously in advocacy movements such as "Stop the City", "Earth First", "Reclaim the Streets" and "Climate Camp" (respectively). These protests became popular manifestations of discontent, as each represented concern over issues that were not being addressed in mainstream political discourse. Each campaigned on a wide breadth of issues, but what they all had in common was an attempt to create political acceptance of the moral and economic imperative of sustainable environmental development. This agenda was being vociferously pursued by these creative protest organizations before it was adopted by the mainstream, and the arena in which these ideas were tested was in these accessible public spaces.

Nevertheless, protest is a practice with dwindling influence in countries which we can loosely define as Western democracies. There are many examples of this, one being the way in which specific acts of dissent have been marginalized. One clear facet of the decline in spatial practices of dissent is the near eradication of the act of squatting, which has been criminalized in cities which defined the practice (Vasudevan, 2017); most noticeably in Berlin, Milan, Madrid, Amsterdam, Copenhagen and London. This demise serves to highlight that for acts of dissidence to be effective they must find a method of contestation which is recognized by incumbent hegemonic forces, such as politicians, the mainstream media or powerful private enterprise with public remit. There is also a polarization of opinions when considering the most effective expression of protest actions. It lies at the juncture between the role that digital protest plays in relation to spatial protest (often misrepresented as the slacktivism vs activism debate). The presence of 1 million people marching towards the square in front of a key institution has a different effect on the public psyche to that of 1 million people signing an online petition. However, digital platforms are invaluable in connecting dissident action across global territories such as seen in Occupy (2011/12) and the Tahrir Square protests that sparked the Arab Spring (2010/11). What public protest provides is visibility outside of a partial (digital) platform and into an arena transgressed by all.

Hegemony

A fissure has developed in the support that protest actions historically received. We can see this anecdotally in the response to popular protests and their different political outcomes, such as the Brixton Riots (1985) or the Poll Tax Riots (1990), in comparison to the more recent protests such as the Million March (2003) or Occupy London Stock Exchange (2010/11) (see Figure 2.3). Not only are these actions less effective in changing government policy, but they occur with dwindling regularity. This reduced status is directly related to the ability of the dominant narrative to influence our ways of thinking and ways of understanding information and knowledge:

> The history of education shows that every class which has sought to take power has prepared itself for power by an autonomous education. The first step in emancipating oneself from political and social slavery is that of freeing the mind. I put forward this new idea: popular schooling should be placed under the control of the great workers' unions. The problem of education is the most important class problem.

> (Gramsci, 1971, p. 77)

Gramsci is writing at the turn of the twentieth century, but the power–knowledge nexus that he examines is still relevant today. At the heart of the problem when considering acts of representation (both enfranchised and of the disenfranchised) is identifying the reasons why citizens actively support politicians and powerful organizations who openly propose to suppress their rights and freedoms. For Gramsci, it was a desire to understand why labourers and peasants would vote for fascists. He identified that hegemonic control is not just constructing a persuasive narrative, but also a 'pervasive' one. The answer lies not in knowledge itself, but the vestiges of 'knowledge production'. Hegemony doesn't just bombard us with illustrations on how to think but subverts the base of what a valid thought process (or argument) is defined as. Controlling the platform on which discussion is based, is both defined by and absorbed into everyday culture, structuring how we understand the parameters of the debate itself. Gramsci is proposing that we

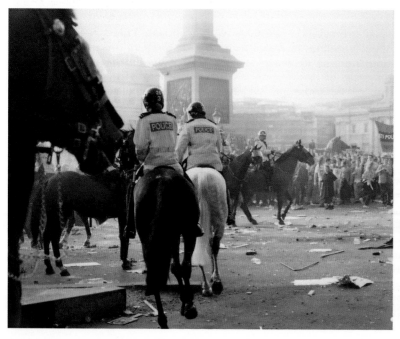 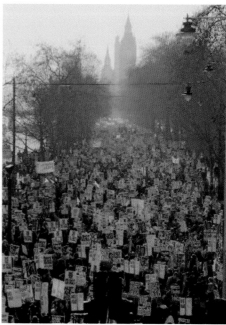

Fig 2.3 Poll Tax Riots, 1990 (Bourne) and Million March, 2003 (Rutherford)

Carl Fraser

develop an awareness that allows us to construct methods to resist this "cultural hegemony", because a significant element of its effectiveness is our unawareness of its processes.

As a result, what is often undervalued today is the role that protest plays in allowing citizens to contest that narrative; whoever is propagating it. We can see this in the spatiality of marches which are an age-old method of showing opposition, at least dating back to the Peasants' Revolt of 1381. Today, there are more sanctioned marches than ever, but this is largely due to the fact that an increasing number of spaces (perhaps most significantly Whitehall and Parliament Square) have been reclassified as protected zones (supported by legislation such as the Serious Organized Crime and Police Act (SOCPA – introduced in 2005), the abusive overreach of the terrorism act by politicians since 2000) and the use of PSPOs (Public Spaces Protection Orders – introduced in 2014) which are used to stop activities that would not otherwise qualify as criminal or civil offences. In principle, the introduction of an 'application process' to protest undermines the notion of publicly accessible spaces and is a significant move away from their inherent spontaneity. This undermines legitimacy, dissuading demographically diverse participation from those who would otherwise engage in a variety of different roles, from novices, returners, repeaters and stalwarts (Saunders, Grasso, Olcese, Rainsford, & Rootes, 2012). What these spatial examples outline, is the ability for the hegemony to completely realign our understanding of the validity of these traditional practices.

Institutionalization

Acts of resistance have always needed to show their versatility, as they exist outside of the institutionalized franchise of representation. Institutionalization creates value, stature and a platform for the ideas and practices within. Although this franchise tends towards growth over time, it is nowhere near complete (such a status may not even be achievable). As such, there is a necessity to operate outside of this franchise as a catalyst for continued change and improvement in citizen representation. However, there is the recurring problem of "circular reasoning", as this new versatility in practice means to become less activist, less subversive, in order to receive justification from within the newly defined popular sphere. The "Official Olympic Protesters", a real role identified by organizers of the 2012 London Olympics where protesters were expected to operate from predetermined zones (similar to smoking areas), was adopted (satirically) by "Space Hijackers". Similarly, the wholesale privatization of squatting (with the proliferation of "property guardian" companies) are both recent examples of just how far enfranchisement has undermined acts of spatial dissent. The shift becomes evident, as each act of protest is treated first as a disruption, with exploration of reasoning being secondary and, in some cases, not considered at all. We can see this with the response to recent strikes proposed by train drivers, flight attendants, firefighters and taxi drivers where the mainstream media helps to propagate the first and thereby most dominant reaction to observers: *how does this disrupt my daily routine?* As non-participating consumers of news, we become disconnected from any narrative exploring cause and effect and, as a result, dismiss justification. We are detached from considering the core questions inherent to such protests such as what standards should we expect for our living and working conditions in an economically advanced society? Similarly, the implicit ontological question: 'how do we define and pursue our values within the society in which we live?' Instead, we are funnelled into a consideration of the individualist microcosm of our daily demands as capitalist consumers. We are less able to ask, let alone answer, the questions above, and thus focus on the latter, at which point our inability to change these forces becomes a self-fulfilling prophecy. With this homogenizing of institutionalized power, it is even more important than ever that protest operates as a tool to challenge these opinions as there is a vacuum of representation at the political level.

Tools

There are, however, still examples of moments when protest can operate in this capacity as catalyst. It is important to state that, as a practice, protest rarely presents a preconceived solution to shoehorn into the current problem. On the contrary, it is itself *method*. A method of highlighting those problems in proximity to those who are responsible for the decisions leading to them. It operates as an act aiming to create a platform, a point of negotiation and potential to change. Its nexus is one of *questioning through action*. As an example, in the aftermath of the Global Economic Crash we saw the European Sovereignty Debt Crisis (2010). In mass protests globally, but especially in some of the affected countries (Greece and Spain), we saw the emergence of protest being the starting point of a citizen-based organized response and the creation of political alternatives. As such, the Syriza (Greece 2004) and Podemos (Spain 2014) movements changed the narrative and hegemony in those countries. In comparison, the problem for Momentum (the left-wing grassroots movement in the UK which aligns itself to the existing Labour party – founded in 2015) is that it is embedded within the existing political nexus. In contrast, Syriza and Podemos constructed their own. It is important to remember that none of these movements is a panacea, since protest can only provide the platform and act as a catalyst. As these protests become movements which become political, they change, and often have their own systemic fault-lines once institutionalized. Even so, they are examples of the validity of protest as the starting point on a journey of hegemonic reform.

Where protests fail (or are thwarted) is often arguably in their trajectory to become movements, and to inform decisions made by incumbent politicians. This brings us back to the notion outlined earlier, that protest must simply be able to be utilized as a tool, and this tool requires a platform in which to work. As such, I see protest as non-hegemonic structure which aims to establish alternative truths about the shared spaces which we inhabit through the use of direct action. Protest actions are often wrongly judged on their success or failure to overturn the policies which they challenge. My contention is instead to analyse what these protest actions facilitate whilst in existence, and how we can learn from these practices as a method to inform our possible futures – both within public space but also in other spaces of contention. The act of protest achieves three distinct outcomes: first, it challenges existing mechanisms of political decision making; second, it develops new forms of opposition; and third, it creates new spaces through its actions which are held in common. Recognizing that 'contention' is an intrinsic element within urban life we can begin to extract the ways in which protest actions transcend their temporal existence.

Application (rights to the city)

Protests which occur in publicly accessible space can arguably be used as a signpost for improving urban possibilities. Returning to the identification first categorized by Lefebvre, and looking at our relation to the spaces where protest occurs, and our ability to access these spaces, we can see the potential for transformation which is embodied within these acts. For Lefebvre, 'the right to the city' is an approach to daily life which transgresses different fields of action (work, leisure and love) as experienced through the city. This is in tune with the idea of ideological social engagement. One of the key perspectives which support this theory is the idea that citizens have 'rights' to spaces and 'mechanisms' to change society, without engaging in the role fulfilled by elected representatives exploring the potential to bypass existing social hierarchies.

For both Harvey (2008) and Lefebvre (1971/1996), 'right' is about access and space to act in a non-prescriptive manner. In 'the right to the city' (Lefebvre, 1971/1996, pp. 65–85) outlines a historical timeline of spatial production and later Harvey explores the mechanism by which citizens can access these systems. Lefebvre identifies lineages throughout history that connect different forms of

'control' that are prevalent within the various modes of production. For Lefebvre, the key phases that define the 'mode' of production and by implementation the pace and scale, are classified as Agricultural, Industrial, Urban and Global. By focusing on the difference between the modes, Lefebvre questions the assumption that the urbanized environment is part of a natural progression or inevitable. He asks serious questions on the 'finality' (or indeed the embedded ideology) of industrialized systems of production. Instead of seeing this trajectory as the product of certain mechanisms, which can be altered, we can choose to engage with *different modes of production*. For Lefebvre, it is the notion of access; moving freely through different urban environs and locating oneself based on 'desire' as opposed to following existing hierarchical constructs, that paves the way for citizens' access to resources – and to create systems of commoning and communality.

For Harvey the 'right to the city' is more in line with identifying finite opportunities: where citizens can gain control over the mechanisms of economic change, and where democracy can be created through expanded use, bringing them under citizen control. To maximize the potential of aligning theory with practice and to utilize these positions in a contemporary context; citizens need to take the opportunity to operate both as individuals, in small groups and to recognize their potential to operate as a global body, larger than that of any of the systems or corporations which attempts to limit them to a singular locality.

Alternative practices

For continued efficacy, I would argue that the act of protest must develop a direct conceptual link which legitimizes its actions in correspondence to more permanent organizations under the umbrella of 'alternative practices'. In turn, these organizations would benefit from seeing themselves as overtly political entities. Their aims require a level of socio-political and spatial engagement, and necessitate negotiation with others that are (by their very nature) politicized constructs with related, but intrinsically different, priorities and focuses. These constructs are important in developing this proactive practice and nurturing its ability to bring together different practitioners to work together. They also need to be accessible to those from different geographic territories (put into practice by groups such as Occupy) to even consider the possibility of resisting the global dominance of large corporations and the ramifications on our daily lives, including the continued development of regional trade agreements, such as the Transatlantic Trade and Investment Partnership (TTIP), which undermine state power and the democratic process. It is therefore necessary to work globally and locally, digitally and physically to maximize the inherent diversity that exists within the practice of protest.

Alternative practices are by their very nature those which developed as a response to the limitations of existing institutionalized practices, and as such include the work of community groups and charities. These can be articulated separately as they operate at each end of the direct-action scale. There are those which are local, informal and whose key participants and resources are not funded. On the other end are those practices that have their wages (or a portion of their resources) funded or subsidized and as a result can attract a greater number of participants and operate with a larger remit. These disparate realities affect the structure, space, scale and time that these alternative practices have to mobilize over their interests.

For those that operate at the smaller scale; their geographic and spatial location (more often than not) is intrinsic to their aims. As such these actions are performed by ground-up organizations such as estate, neighbourhood or community trusts and groups (including those with a faith-based ethos or starting point). By the same analytical construct, a protest is an 'action' performed by a special interest group. This categorization is intentionally broad and covers a wide range of practices whose approach and doctrine will vary and include a wide spectrum of activities. However, what they have in common is that their organizations have formed for non-profitable reasons. This means that their survival is predicated on

donation or voluntary contributions (of finance, labour or skillsets). As a result, their participants are present for ideological reasons – they may have jobs or other commitments which restrict the amount of time that they donate. As such, they often do not have the strategic or collective resources of the established hegemonic practices which they are contesting or informing. In this regard, the efficacy and longevity of their practice is predicated on overcoming this financial deficit through organizational strategies bolstered by social and cultural ties. Through necessity, they have developed a targeted response to a finite issue with temporal immediacy. If they interpret their activities in this manner, then they bear many similarities to acts that may otherwise be separately defined as protests. If they accept the notion that direct (spatial) action is a key element of their efficacy, this would allow rapid mobilization of existing resources embodied in the idea of protest. If co-opted into the mindset these practices would prove invaluable to small groups who often lack the ability to act rapidly and tactically. For these groups to embed their relevance into the community that they wish to improve, it is necessary to identify a level of appropriate organizational action with the same clarity that the public performance of protest inherently engages.

If we look at the other end of the spectrum, registered charities to non-governmental organizations (NGOs) are still within the category of alternative practices as they are providing a key service which is not being provided by government but is important to the quality of the everyday lives of citizens. Prominent examples would include MIND, Shelter, the RSPCA and Greenpeace. There is an efficacy of operating at multiple scales; between the "freedom" that grassroots activities enjoy and the "funding" that institutionalized operations can draw upon. This includes dissemination of information through the practice of civil disobedience and lobbying and informing government action through official outputs such as researched reports.

The value of protest practices is to take a collective and comprehensive approach in actively making the connection between these scales, moving from the street, to the neighbourhood, to the institutionalized funded alternative organization, or even government. Podemos is such an example, the Spanish political party (formed in 2014) that emerged out of the "Indignados" (the indignant) movement of 2011 which formed a popular protest movement which began with the 15-M (15th May) mass action organized over the problems of inequality and representation in Spain. Podemos was the second largest political party in Spain (in 2015), but has since faltered (today being the fourth largest political party), after catalysing the first wave of institutional change. This is because as an established political party it struggles to maintain its responsive relevance (such as its stance on the re-emerging issue of Catalonian independence) (Marcos, 2018). However, its rise outlines that if protest is used strategically, it can realize the potential for the practice of public protest to be the trigger for a broader range of direct action which can operate at multiple urban scales. This can allow a network of related oppositional activities to form which can offer a wider range of participation, from a more disparate range of participants, thus creating more sustainable and pluralistic sets of alternative practices.

Essentially the struggle for validity centres around identifying a level of appropriate organizational structure and galvanization at times which are not scheduled or regular but specific to the organization's aims. Action must be catalysed simultaneously at a number of scales; human, architectural, spatial, urban, national and global. The development of this fluid responsiveness is key to any alternative practice which remains relevant in the face of rampant socio-political change.

Conclusion

The practice of protest is a tool of the outside or under-represented voice. It is the method that we turn to when the enfranchised mechanisms cannot facilitate our needs as citizens. It is an inherent commentary on the imperfection of the democratic

system of representation and a testing ground for alternatives. As a result, protest must always operate simultaneously on two diverse fronts.

Firstly, it must continue to remain relevant to the populace; citizens must feel both aware of, and liberated enough to engage with, these methods as and when it is relevant, as a possible tool to improving their daily lives. There needs to be a fluidity between the role of novice, returner, repeater and stalwart; that conceptually we can move through them as seamlessly as we do guardian, student, worker, educator, observer, consumer or commentator. We do this as a matter of necessity in navigating our contemporary lives. We as citizens need to consider these ways of being not only as our right, but our *responsibility*, if we wish to have any say in the direction in which the societies we live in take. These should not be considered the resort of the radical, as at some point in time all of us require the use of the protest as method to be heard and to advance values that society once considered profane.

Secondly, protest must remain diverse, nuanced and ever changing. As a practice, it lives in direct contention with mechanisms of corralling, containment and control with legislation that restricts the use of publicly accessible space. Thus, the spatial tactics that were effective ten years ago no longer have validity, so continual reciprocal development and adjustment is essential. This means that the practice must engage with new voices and tactics not as a luxury, but as a requirement.

For protest to remain relevant, we have to understand that it is more important than any single right that we have as citizens, as it is one of the key tools to make our rights manifest. The practice inherently engages with what we must 'do' and experiments with new ways of 'being' in space to explore the idea of better realities. It is the practical and spatial embodiment of this principle. It helps create psychological (and sometimes literal) spaces free of hegemony, and for this reason, protest will never lose its relevance as a practice of resistance; a critical spatial practice.

Bibliography

Alter, C. (2018). How the Anti-Trump Resistance Is Organizing Its Outrage. *Time Magazine*, 18 October.

Certeau, M. de (1984). *The Practice of Everyday Life*. (S. Rendall, Trans.). Berkeley: University of California Press.

Foot, M. (1956). *Daily Herald*. (S. Elliott, Ed., & S. Elliott, Compiler) Daily Herald.

Gramsci, A. F. (1929–1935). *Antonio Gramsci: Towards an Intellectual Biography* (1971 ed.). (A. Davidson, Ed.). London: Merlin Press.

Houses of Parliament. (2015). *Trends in Political Participation*. London: Houses of Parliament: Parliamentary Office of Science and Technology.

Kohn, M. (2004). *Brave New Neighborhoods*. New York: Routledge.

Lefebvre, H. (1971). *Writings on Cities* (1996 ed.). (E. L. Eleonore Kofman, Trans.). Oxford: Blackwells.

Lefebvre, H. (1974). *The Production of Space* (English translation first published in 1991). (D. Nicholson-Smith, Trans.). Oxford: Blackwell.

Locke, J. (1689). *Two Treatises of Government* (2017 ed.). (W. Popple, Ed.). Pantianos Classics.

Low, S. M. (2006). The Erosion of Public Space and the Public Realm. *City*, 43–49.

Madden, D. J. (2010). Revisiting the End of Public Space. *City and Community*, 187–207.

Marcos, J. (2018). Four Years On, Spain's Populist Party Podemos Loses Appeal. *El País*, 18 January. (M. Kitson, Trans.) Madrid.

Marcuse, P. (2009). From Critical Urban Theory to the Right to the City. *City*, 13(2/3), 185–197.

Marx, Karl and Engels, Friedrich. (1848). *The Communist Manifesto* (2002 ed.). (G. S. Jones, Ed.). London: Penguin Classics.

Minton, A. (2012). *Ground Control: Fear and Happiness in the Twenty-first-century City*. London: Penguin Books.

Mitchell, D. (2010). The End of Public Space? People's Park, Definitions of the Public, and Democracy. *Annals of the Association of American Geographers*, 85(1), 108–133.

Mitchell, D. (2014). *The Right to the City*. New York: Guilford Press.

Office for National Statistics. (2015). The History of Strikes in the UK. 21 September. London: ONS.

Rawls, J. (1971). *A Theory of Justice*. Cambridge, MA: Harvard University Press.

Rousseau, J.-J. (1762). *The Social Contract* (1998 ed.). (D. Matravers, Ed.). Ware, Herts: Wordsworth Editions.

Saunders, C., Grasso, M., Olcese, C., Rainsford, E. and Rootes, C. (2012). Explaining Differential Protest Participation. *Mobilization*, 17(3), 263–280.

Vasudevan, A. (2017). *The Autonomous City*. London: Verso.

3 Commons as public

Re-inventing public spaces in the centre of Athens

Ursula Dimitriou

December 2008: crisis and innovation

Athens is a city accustomed to demonstrations and protests but the urban insurgencies of December 2008 were different to any other. It was the duration and intensity of the riots, the scale of violence, the amount of participation and the plurality of opinions and civil claims that emerged that differentiated this uprising from previous ones.

On the surface, the murder of a young boy fuelled fustration against alleged police incompetence and brutality.[1] On a deeper level, it "condensed into a single act all dominant measures, politics and ideologies which imprisoned youth in a pre-determined future of antagonism and disappointment" (Stavrides, 2011, p. 9). The initial demonstrations and violent protests against the police soon broadened to encompass protest against youth unemployment, social inequality, corruption, state inadequacy and higher education reforms, among other percieved grievances[2] (Economides and Monastiriotis, 2009). The emergence of the global recession at the same period intensified the urgency of the claims.

The participation in the events of December 2008 took the form of thousands of protesters and rioters coming from every social class and age. Their involvement varied from pacifist silent protests and music performances to burning and looting. Moreover, the demonstrations also included indirect participation in the form of public debates and involvement in assemblies, virtual forums and internet blogs. In other words, the events materialized the relation between social groups and claims in public space, both in terms of theoretical discourses and in the form of urban warfare, actual violent clashes, contestations and evictions that reshaped the urban geography of Athens (see Figure 3.1).

Undoubtedly, December brought violence and destruction in the city centre. However, at the same time, possibilities of renewal and redefinition of the existing conditions emerged through the rupture of urban fabric and social relationships. A number of issues that were in a state of lethargy after the reconstitution of democracy in 1974 in Greece were brought into question, including the proper usage of public spaces, and the 'right to the city' – expanding to political rights and citizenship. And it was exactly this rupture that led to a mushrooming of social movements concerning urban space itself (Portaliou, 2008). New urban movements in Athens went beyond a simple rejection of existing order and confrontation and entered into a collective creation involving a radical change of space and everyday life in the city (Petropoulou, 2010).

Emerging from these urban movements has been the formation of a new type of public space, claimed or re-claimed from the state or the market, whose organization is based on values of critical democracy. Processes of maintenance, organization, networking, communication and management differ from those in statutory public spaces and their characteristics are completely idiosyncratic since almost every term attributed to them – municipal, squatted or autonomous – is contradictory. Furthermore, their users declare the spaces as independent from the state, which renders the application of the term 'public', and therefore 'of the state', problematic. In this sense these 'public spaces' could more coherently and fruitfully be described as 'commons'.

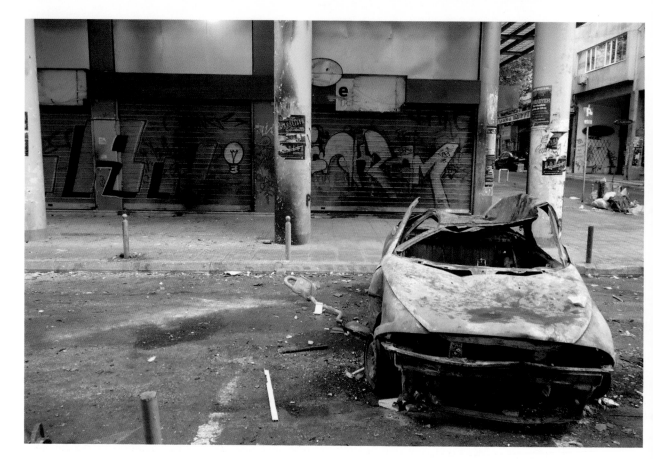

Fig 3.1 Street scene in Exarcheia district of Athens in the aftermath of the December 2008 riots (U. Dimitriou)

Commons and enclosures

The commons is a new use of an old word, meaning 'what we share', and refer-ring to a wealth of assets that are collectively owned or shared between or among populations (Bollier, 2010). During the roman times 'res communes' is distin-guished as one of three categories of property: 'res privatæ', which consisted of things capable of being possessed by an individual or family, 'res publicæ', which consisted of things built and set aside for public use by the state, such as public buildings and roads; and 'res communes', which consisted of natural things, used by all, such as the air, water and wild animals (Berry, 2005). In England under the doctrine of 'res communes' the king could not grant exclusive rights of access to a common resource, rendering the commons as the poorest people's life-support system traditionally providing food, fuel, water and medicinal plants for those who used it (Patel, 2009). The enclosure of commons was first encountered in sixteenth-to eighteenth-century England with the physical enclosure of common land by the landed nobility for wool production. For Marx (1867/2005) the process of expropri-ation and dispossession of commoners taking place through separation of people from their means of production was the process that creates the precondition of capitalist development referred to as "primitive accumulation"

For De Angelis, the resource-based defininition of the commons is too limited as it lacks the social relations that define the commons, and reduces the value of the commoners' struggle (De Angelis, Stavrides, 2010). For De Angelis, conceptu-alizing the commons involves three things at the same time: a common pool of resources (understood as non-commodified means of fulfilling people's need), a community to sustain them, and 'commoning' as a verb, which is the social process that creates and reproduces the commons. Indeed recently the term common has

Ursula Dimitriou

extended from elements of the environment and material resources – the atmosphere, forests, fisheries, oil fields or grazing lands – to shared social creations, scientific research, word languages, creative works, the airwaves, the internet, Wikipedia, information, life commons (e.g. the human genome) and so forth (Hardt and Negri, 2009; Walljasper, 2010), marking a shift from the place/materiality of the commons towards the processes that shape it. Peter Linebaugh (2008) stresses the point that the commons is an 'activity' rather than just a material resource and David Bollier (2010) defines the term as a social dynamic: "A commons arises whenever a given community decides it wishes to manage a resource in a collective manner, with special regard for equitable access, use and sustainability. It is a social form that has long lived in the shadows of our market culture, and now is on the rise."

This shift towards both the immateriality of the resource and the process of commoning is not only a definitional refinement of the term commons but highlights the realities and threats of new types of enclosures. Federici (2012) names the 'new enclosures' as one important reason for bringing the 'apparently archaic idea' of the commons to the centre of political discussion in contemporary social movements. For her the commons and their possible enclosures have made visible a world of communal properties and relations that many had believed to be extinct or had not valued until threatened with privatization, but also new forms of social cooperation that are constantly being produced, including in new areas of life, such as, for example, the internet. Jodi Dean differentiates between the 'commons' and the 'common' in order to denote and grasp forms of enclosures and exploitation specific to communicative capitalism and 'immaterial labour'; characteristics of contemporary capitalism (Casarino, 2008; Dean, 2012), where the commons is finite and characterized by scarcity while in contrast the common is infinite and characterized by surplus. "The common thus designates and takes the place of human labor power (Marx's source of value), now reconceived in the broadest possible terms of the potential of creativity, thought, knowledge and communication as themselves always plural, open and productive" (Dean, 2012, p. 134). Similarly, Michael Hardt (2010) uses the notion of common to draw out the specificity of the neoliberal assault on the people. For Hardt neoliberalism is more than a policy entailing the privatization of public property and services. It is a seizure of what is common – knowledge, languages, images and affects. Hyde (2010) proceeds even further in terms of immateriality in describing a type of commons yet unimagined, unknown, un-designed and unspoken, which is in danger as it might depend on non-enclosed resources in order to come to light.

It is therefore fair to claim that 'commons' are continuously defined, re-defined and re-imagined almost simultaneously through their enclosures or the imminent threat of their enclosures; and the usurpation of the resource in which they are centred: commons as land, commons as material resources, commons as immaterial resources, and commons of things yet to come. However, De Angelis emphasizes that not only do enclosures happen all the time, but also there is constant commoning, a social praxis of the commoners that might defend a common and also produce a common through commoning. This calls for a further refinement of the term as the enclosure of a common, material or immaterial, might also come from within. Stavrides (2011) emphasizes the difference between commons as community and commons as public space. Commons as community is based on an entity of a mainly homogeneous group of similarly minded people affirming their commonalities. This entails the danger of people defining themselves as commoners by excluding others from their milieu, from their own privileged commons and creating in that way a closed community and a closure of the commons. On the contrary, conceptualizing commons on the basis of the public does not focus on similarities but on the very differences between people. Commons as public space is an actual or virtual space where strangers and different people or groups

with diverging forms of life can meet on a purposefully instituted common ground and necessarily entails aspects of continuous negotiation and contest.

The Athenian commons

The discussion about the urban commons and commoning in Athens came to the forefront after December 2008 and materialized in actual spaces after 2009, related to the imminent enclosures of common resources, specifically the city's public spaces.[2] The public spaces of Athens have been diminishing for many decades (Aravantinos and Kosmaki, 1988) yet, increasingly after 2008, the extent of the depletion of the common resource and the threat of imminent enclosures became a matter of concern for a large number of the public. The city's public spaces shifted from the periphery of urban discourse to the main terrain in terms of where and how the 'right to the city' could be exercised. This shift brought awareness of the way public space was produced and perceived, moving it from a 'public good' that is granted from the state to the citizens, to a 'common good' that could be produced by the citizens. The public spaces' enclosure drew attention to the different aspects of value of the resource on material, immaterial and symbolic levels.

The first, material consideration concerned the enclosure of the actual land. The remaining open spaces in the city centre have been increasingly treated by the state as land assets ready for exploitation, either by sale, or by granting them in their entirety or partially for commercial use, therefore jeopardizing the spaces' common use. Under the title of 'regeneration' the municipality has turned almost every available open space in the city centre to underground garages, shopping centres, outdoor extension of cafes and restaurants or football teams' stadia. This is in combination with the further exhaustion of larger green areas surrounding the city through, for example, the placement of a casino in Mount Parnitha, shopping mall and stadium of Panathinaikos in Eleaionas and Olympic works in Faliriko Delta. Moreover, a recently created special crisis fund, the Hellenic Republic Asset Development Fund (HRADF) leverages the state's property, including entire coast lines, archaeological spaces, islands, infrastructure and ports, under non-transparent processes that turn them from public to private trust's portfolio.

At a second level, the resource's immaterial value reflects the relationships, knowledge and networks produced in public space as well as the political emancipation of the citizens. In this dimension the state position is antithetic: it ignores it or devalues it when the space is about to be sold to an investor, characterizing the space as empty or decaying, but has an increasing tendency to repress any bottom-up, emancipating and dissenting political voices that might spring from the same space. Interestingly, the intangibility and immateriality of public space can also be connected to its legislative definition. Kourti (2011) claims that physical public space should conceptually be treated like other intangible public goods since it cannot be divided like other material public goods such as a building or a plot of land that are defined by clear ownership boundaries, without destroying its common use and common access, that lie in the core of its legislative definition.[3]

The third dimension concerns the symbolic and the imaginary potentials of public space and the collective possibilities that we cannot yet imagine or that have not yet taken place. While the second and third dimension seem infinite and impossible to enclose, they are not, since they are dependent on the materiality of the public space, which is finite. Similarly then to Federici's previous comment, the imminent enclosures of public space brought the idea of the commons to the centre of political discussion and "made visible a world of communal properties and relations that many had believed to be extinct or had not valued until threatened with enclosure, extinction or privatisation" (Federici, 2012, n.p.). Consequently these various imminent enclosures brought forth the notion of the public as 'commons' in the Athenian context.

Navarinou Park

Navarinou Park is one of the open space occupations that appeared after December 2008. Some other examples include the park at the junction of Kyprou and Patission Street, occupied after the Mayor of Athens decided to turn the space into underground parking; Parko Drosopoulou that was occupied to prevent the municipality from building the car park; and Agros in Liossia that was occupied in order to prevent the commercialization plans of the municipality. This chapter is focusing on Navarinou Park because it is one of the most long-lived open space occupations and most importantly it is in the centre of the city in a highly contested area; therefore the claims on the space are more intense, diverse and contradictory than in other cases.

The park lies in the heart of Exarcheia, the area where Alexandros was murdered, and the epicentre of the 2008 riots. Exarcheia is a lively and in many ways controversial area in the centre of Athens: an area of different political groups, mainly left-oriented; the political centre of anarchist movement in Greece, an area of students, intellectuals and young people; and finally, an area considered to be a nest of vice, according to the police and most of the mainstream media. The space used to be a parking lot in the junction of Trikoupi, Navarinou and Zoodohou Pigis Street, owned by the Technical Chamber of Greece (TEE). In May 1990, the management committee of TEE asked the municipality of Athens to create a public space in the plot mentioned above, since its position in the urban fabric was extremely interesting. In November 1990 the city council of the municipality of Athens decided unanimously to accept the proposal of TEE, underlining that "the conversion of the plot [to a public space] is necessary because the plot is adequate for a square in a densely built area of Athens, which is significantly lacking public spaces."[4] However, the municipality did not proceed to change the Regulatory Plan or purchase the plot which remained the property of TEE and continued to be used as open air car parking. When the contract between the parking owner and the TEE expired, and since the municipality never took action regarding the specific plot (modification of the plot's usage, or purchase of the plot by the municipality of Athens), TEE expressed the intention to build on the plot.

The social group 'Inhabitants of Exarcheia' together with a number of other organizations reacted against this intention. During an event organized on 7 March 2009, they occupied the plot. A surprisingly large number of people flooded the space and started breaking the asphalt surface to make way for new trees and plants. The occupiers organized music concerts and other activities and promoted their demands via the architect's registration board. During the three following weeks, the plot was guarded by a group of inhabitants, afraid of attacks by neo-fascist groups, or the police. On 30 March the president of TEE Georgios Alavanos and the mayor of Athens Nikitas Kaklamanis finally agreed on exchanging the plot in Exarcheia with a property owned by the municipality in Alexandras Avenue, so that the plot would thereafter belong to the municipality of Athens and could be turned into a public space once the decision was validated by the Ministry of Planning and Built Environment. The users of the space, independent from any organized solidarity, declared their intention to keep guarding the plot until the decision was validated, and the creation of a public space enacted. Up to the current date, the space is still safeguarded, managed, used and shaped by its users.

From the second day of the space occupation until the present day, the park has been overseen by an 'open assembly' that defines the character of the space as self-managed, non-hierarchical and non-commercial. The assembly deals with every issue regarding usage and formation of the space and sets the course of action, meeting at a frequency dependent on the needs of the space. The assembly is open to everybody who wishes to participate and operates on a broad consensus. The participants do not vote and every single idea or proposal gets expressed and negotiated, but the decisions taken are binding for all the users. According to

users, the park is shaped by an 'open solidarity'; it is mouldable and flexible and changes on a day-to-day basis.

Navarinou Park is a highly contested space which materializes the claims of the assembly – as opposed to the plans of the municipality. Theoretically, it still belongs to the state, but is continuously attacked by the police who regularly invade the space and randomly arrest people who frequent there. The arrested citizens are detained for a short period and are in most cases released, since no charges are pressed against them, which makes it rather obvious that the reason for the raids and arrests is to intimidate and discourage the users. During one of the first raids in July 2009, as the police were leaving the park, one police officer wrote on a wall 'we took the park from you' (Anonymous, personal communication, 11 November 2009). The park also expresses the claims of different social and political groups and individuals that are articulated on different levels: symbolic, spatial and functional. Some examples of those claims include anarchists opposed to any type of performances that do not deal with politics and anarchy, claims of homeless people who want to sleep in the playground, drug addicts who want to shoot heroin it the space, nihilists who want to set the neighbourhoods' garbage bins on fire or try out their first Molotov bomb, or adolescents who want to play loud music in the middle of the night. All of these issues are negotiated in the assembly, some of them more successfully than others. Obviously, the function of the assembly should not be idealized since violent clashes, arrests, fights and evictions are continuously occurring in the space. But the park is still there. It gathers a large amount of daily users and gives voice to different social claims, allowing for direct participation in the formation of the space. (See Figure 3.2.)

Commons, autonomous, squatted, public space

Navarinou Park is an idiosyncratic space since almost every term attributed to it is contradictory. It is a public space since it technically belongs to the municipality, nevertheless the municipality did not interfere either in its creation or its maintenance. The park is not designed by an assigned architect in a designated urban plot

Fig 3.2 Video stills, from recorded interviews by the author with users of Navarinou Park, Athens (U. Dimitriou)

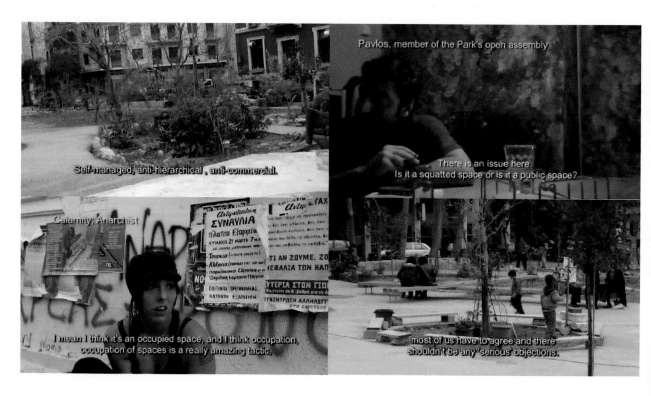

Ursula Dimitriou

as a regular public space but is instead forcefully claimed, designed, built, planted, cleaned and regulated by its users. It is a public space and therefore according to Fraser (1999) it relates to the state, it is communal; it is accessible for everyone; something that affects everyone; a common good or common interest. However, the police, being a regulatory mechanism of the state, attack its users. The users declare the space to be independent and autonomous, yet the water and electricity are taken from the municipal network. It is officially registered as a public space and as such it is legal but it is also a squat, regulated by non-legislated procedures and therefore illegal. It is definitely not a private space and every commercial use in it is strictly forbidden although according to the Greek legislation the municipality can grant parts of any public space to be used commercially as long as the free usage of space is not jeopardized. Without denying all the other definitions of Navarinou Park – public, municipal, squatted and autonomous – it is also a commons. The use of space is open but has specific rules set by the users; it is created and managed in a collective way; the decisions are taken in a horizontal level and it is strictly non-commercial.

Navarinou Park as commons defines a new political space where the existing framework of political participation is challenged and the borders of the political sphere redefined. The design and governance methods of the space 'constitute' the space itself as the embodiment of a political ideal. This ideal differs from the representative institutionalized democracy, and the contribution of the state in the decision-making process is either overlooked or confronted. Moreover, the park, and the rest of Athenian commons, is a space where political practices are defined; on a first level practices within the space itself, on a second level practices launched or fought outside this space, and on a third level practices that form through networking and connecting with other solidarities and socio-political movements (movements that are criticaly positioned towards the official state politics, for example immigration, the legal system, the conditions of socially excluded groups, and ecological issues). By being both the spatial embodiment of a new political ideal and the space where new political practices emerge and disseminate, Navarinou Park becomes a new political space.

Navarinou Park is both a spatial and a political action. It is a product of crisis and an after-effect of a violent urban insurrection that caused destruction, but has also set in motion the processes of social and political emancipation. It is positioned in the centre of a highly contested area and represents an extraordinary spatial experiment where the conflict is negotiated on a daily basis. The processes of commoning in the space have protected and safeguarded the park and its use as an open green space and a common resource.

Nevertheless the commons should be seen not as independent, but in relation to the public space. Firstly because their emergence as a term, as spaces and as practices, comes as a resistance against the perceived usurpation or misuse of the public space by the state, against the institutionalized definition of the public and public sphere, and against what is perceived as an enclosure of the public. In other words they are formulated in critical relationship to the public. Secondly, the commons in question, whether their users accept it or not, are also public spaces. They operate on public soil and the police test their ability to control the space on the same grounds. Furthermore, for their practical viability the commons depend on public resources such as water, electricity, the municipal garbage collecting system, etc., and on public institutions: for example, Navarinou Park is safeguarded against commercialization by a court decision that defines the spaces as public. Therefore, a more appropriate term would be 'commons as public'. This not only denotes the spatial reality of Athenian commons but also constitutes a further refinement of the term commons, one which emphasizes the danger of another possible enclosure, an enclosure from within, where the space becomes the stronghold of a specific community and not a place of public use. The Athenian commons – as spaces and as a network of similar commoning practices – play

an important role in raising awareness of the imminent enclosures threatening the city's public spaces, many of which have not yet taken place. And it is precisely this network of resources, both of spaces and social practices, such as urban parks, alternative methods of political behaviour, social creativity and political resistance that need to be maintained as plural, open and productive, so that the yet unimagined, unknown, un-designed and unspoken commons that depend on those resources might come to light.

Notes

1 A reference to the unprovoked shooting of the 15-year-old student Alexandros Grigoropoulos by police officer Korkoneas. The murder took place on 6 December 2008 in the Exarcheia district of central Athens and triggered three weeks of urban insurgencies and demonstrations in Athens and other Greek cities, and solidarity demonstrations worldwide.
2 The increasing enclosure of the commons via the privatization of public land is not solely a Greek issue. In Britain, during the last four decades, the state – in all its various guises and incarnations – has sold 10 per cent of Britain's land, and 50 per cent of its public land to the private sector (Christophers, 2018).These alarming figures are just another example that highlight the urgency of the topic of the commons and their enclosure in international context.
3 This aspect of the immaterial value of the resource also brings forth possible weaknesses of Ostrom's (1991) and Ciriacy-Wantrup and Bishop's (1975) definition of commons as they are restricted to material resources defined by property rights.
4 Municipal Decision 1673/7.11.90.

Bibliography

Aravantinos, A. and Kosmaki, P. (1988) *Public Open Spaces in the City*. Athens: Symeon Editions.
Berry, D. (2005) Free Software Magazine. *The Commons*.
Bollier, D. (2010) Imagining a New Politics of the Commons, *On the Commons*. www.onthecommons.org/imagining-new-politics-commons#sthash.Z6pNqKCK.KQ180MPY.dpbs (Accessed 24 June 2019).
Casarino, C. (2008) Surplus Common. In: C. Casarino and A. Negri (eds) *In Praise of the Common: A Conversation on Philosophy and Politics*. Minneapolis: University of Minnesota Press.
Christophers, Brett. (2018) *The New Enclosure: The Appropriation of Public Land in Neoliberal Britain*. London: Verso.
Ciriacy-Wantrup, S. V. and Bishop, R. C. (1975) "Common Property" as a Concept in Natural Resources Policy. *Natural Resources Journal*, 15, 713–727.
De Angelis, M. and Stavrides, S. (2010) *On the Commons: A Public Interview with Massimo De Angelis and Stavros Stavrides* [Interview].
Dean, J. (2012) *The Communist Horizon*. London: Verso.
Economides, S. and Monastiriotis, V. (eds) (2009) *The Return of Street Politics? Essays on the December Riots in Greece*. London: Hellenic Observatory, LSE.
Federici, S. (2010) Feminism and the Politics of the Commons In: C. Hughes, S. Peace and K. Van Meter (eds) *Uses of a Worldwind: Movement, Movements, and Contemporary Radical Currents in the United States*. Oakland: AK Press.
Fraser, N. (1999) Rethinking the Public Sphere: A Contribution to the Critique of Actually Existing Democracy. In: C. Calhoun (ed.) *Habermas and the Public Sphere*. Cambridge, MA: MIT Press.
Hardin, G. (1968) The Tragedy of the Commons. *Science*, 13 December, 162(3859), 1243–1248.
Hardt, M. (2010) The Common in Communism. In: C. Douzinas and S. Žižek (eds) *The Idea of Communism*. London: Verso.
Hardt, M. and Negri, A. (2009) *Commonwealth*. Cambridge, MA: Belknap Press.
Hyde, L. (2010) *Common as Air. Revolution, Art and Ownership*. New York: Farrar, Straus and Giroux.
Kourti, P. (2011) *Common use and ownship: An inquiry on two basic characteristics of the political meaning of public space*. Thessaloniki, Technical Chamber of Greece/Department of Central Macedonia, pp. 31–33.
Linebaugh, P. (2008) *The Magna Carta Manifesto: Liberties and Commons for All*. Berkeley: University of California Press.
Marx, K. (1867/2005) *Capital*, vol. 1, Chapter XXXI, Genesis of the Industrial Capitalist. In: *Marx/Engels Collected Works*, vol. 35 (London: Lawrence & Wishart).

Ostrom, E. (1991) *Governing the Commons: The Evolution of Institutions for Collective Action.* Cambridge: Cambridge University Press.

Parkingparko (2010) About the park. *T.ο πάρκινγκ τους, πάρκο μας* [Their parking, our park], (blog).

Patel, R. (2009) *The Value of Nothing: How to Reshape Market Society and Redefine Democracy.* New York: Picador.

Petropoulou, C. (2010) From the December Youth Uprising to the Rebirth of Urban Social Movements: A Space–Time Approach. *International Journal of Urban and Regional Research*, 34(1), 217–224.

Portaliou, E. (2008) Urban Movements in Athens. Notes for postgraduate studies. National Technical University of Athens. http://courses.arch.ntua.gr/121473.html (Accessed 24 June 2019).

Stavrides, S. (2011) Communities of Crisis, Squares in Movement. Professionaldreamers working paper No. 6.

Sotiropoulos, A. (2004) Formal Weakness and Informal Strength: Civil Society in Contemporary Greece. Hellenic Observatory Discussion Paper No.16.

Walljasper, J. (2010) *All That We Share: A Field Guide to the Commons.* New York: The New Press.

4 Poor relations

Community activism as spatial practice

Donna Turnbull

> Don't squeeze us out! Communities want to stay and get a slice of the action.
>
> (Anonymous note pinned to the wall at a community-planning
> workshop. London, 2011)

A contemporary community perspective on London would be of a city in which exorbitant land values have created a feeding frenzy; where cash-strapped local councils mimic private developers, building high-value housing to generate profits; where neighbourhoods are bombarded by national infrastructure projects, private building developments and local government regeneration programmes; and where the public assets that make up spaces and places traditionally used by citizens to meet and mobilize are being lost to pay for essential services – no longer there for the common wealth of citizens but as a commodity in a marketplace that enriches private shareholders and plugs holes in local budgets. Communities resisting the loss of their public realm are treated with derision and contempt like poor relations, not citizens exercising their democratic rights.

The current anger and frustration of so many London communities is unsurprising. If the public already owns the spaces and buildings of a neighbourhood it is not unreasonable to expect that the value they generate should be used for public benefit rather than extracted for shareholders. Campaigns against inappropriate development of investment properties where once there were homes, and lack of regard for community knowledge and stewardship, have mushroomed in neighbourhoods all over the city. But community consultation processes are often deemed tokenistic, serving to patronize and antagonize rather than closing the gap between different narratives in progress. Community activists have the energy and vision to contribute to alternative trajectories toward sustainable neighbourhoods, but political will, design and technical expertise are required to deliver a system in which community activists can participate as enablers of people-centred development. This chapter is a brief journey through three areas of London to reflect upon the changing environment and conditions for community-planning activists. The reflections draw upon a personal experience of local community-led planning and a close perspective on the motivations, achievements and relations that enable or constrain community influence over urban space. This is a perspective which draws on a history of resistance of being 'done to'; and the creative energy of organized activism.

The context for these reflections begins with New Labour's Urban Renaissance vision which introduced a shift in urban policy in 1999 (Rogers,1999). The vision swapped decades of car-based planning and exodus to the suburbs for a new vision of "compact, multi-centred, live/work, socially mixed, well designed and connected, and environmentally sustainable" towns and cities (Rogers, 2002). This was to be delivered by a variety of regeneration partnerships, beginning with the Single Regeneration Budget (SRB), which had emerged in 1993 as a unified programme to bring about economic, physical and social regeneration to local areas. The partnerships gave communities the opportunity to enter formal relationships with government and developers. The 1990s policy emphasis on the role of community in urban regeneration partnerships has, in theory, been progressing in the intervening period. In 2011 the Localism Act[1] introduced a provision for communities to make

a Neighbourhood Plan. Unfortunately, as evidenced in the London described above this has not stimulated the emergence of a more egalitarian city.

Partnership and power in Deptford

Deptford is in the London Borough of Lewisham. It is an urban centre on the river Thames in South-East London, and until recently was largely ignored by anyone who didn't live there. Deptford is located near to the bustling centre of maritime Greenwich. It also has a rich maritime history, but poverty and neglect had made the area less attractive to visitors than its wealthier neighbour. In the 1990s the influx of public funds for urban regeneration enabled communities in Deptford to take control over some of the historic and environmental places and spaces that had been ignored for decades. Today, like every other place in London, Deptford is under threat from global investors and, arguably, weak local government which fails to elevate public benefit above private profit.

The Deptford Discovery Team started in 1994 as a community-based consultancy committed to regeneration without destruction. By 1996 it was an official regeneration partner delivering a £1.6m environmental programme (SRB 2 *Vital Centres and Green Links*) on behalf of environmental charity Groundwork London. The Discovery Team was initiated by local environment and heritage activists. Using community networks and knowledge they set out to harness local energy and expertise for a locally sensitive approach to urban regeneration. The Groundwork contract kicked off a programme of environmental projects all employing the skills and experience of local people. The Discovery Team managed to maintain its campaigning zeal despite formal partnerships with local authorities, and private developers. The relationship with Groundwork London was always uneasy; tensions ran through every affiliation that it took to achieve a more equitable, less destructive approach to neighbourhood regeneration – whether with private business, local authority or institutions. In retrospect, these struggles reflected a healthier approach than the polarized relations we have now between communities and powerful institutions. There seemed to be less fear of reprisal for speaking out, perhaps less partisan influence over debate and decision-making, and for a short time it worked. Notably a second and parallel regeneration programme (SRB 6 *Get Set for Citizenship*) led by Magpie Community Planning Resource Library, an independent charity promoting active citizenship, and the same group of activists, instigated decision-making based on a set of agreed values generated from extensive outreach within the local community (Steele, 2009, pp. 106–107). This was a very different approach to the norm of having decision-makers appointed to regeneration boards on the strength of their status, which are forums where positional power tends to guide decision-making. Magpie had other ideas, and partners with positional power, like Goldsmiths University, were denied a place on the board until they committed to the community values. Their SRB programme proposal was emphatic about regeneration and neighbourhood management based on local people's priorities, and building structures, skills and social capital so that regeneration was managed by local people.

Jess Steele, pioneering Discovery Team member and co-producer of this regeneration approach, remembers a key moment illustrating the disconnect between the attitudes of community activists and those empowered through position, politics and money. During government evaluation, the SRB programme led by Magpie was commended for mass participation and innovative community-led projects. But the evaluation failed to credit the investment in local skills and knowledge that enabled that to happen. The value-based process which put neighbourhood regeneration firmly in the hands of local people was still being ignored. The community-led approach in Deptford created enormous capacity and harnessed community energy, but existing power-holders felt threatened and were unready to listen (Steele, 2016, p. 118). It is a depressing thought that this attitude took root so early in the development of formal partnerships with

communities. Jess's observations are borne out in the neighbourhood renewal programmes that followed the early partnerships. Community-led approaches were mainstreamed and co-opted, but without the all-important underlying values. This was clearly illustrated by two approaches to the same employment project. The original project involved resurrecting a mobile employment service by driving the (until then unused) employment service bus into local housing estates. It was managed and run by residents trained both as creative outreach workers and to give employment advice to their peers. The advice session was based around a cup of tea and a chat, and it got results. People got involved, and they got jobs or took up training. The co-opted version, mainstreamed by government employment agency Job Centre Plus, parked the locked bus on the edge of a housing estate, where government employees gave advice by appointment only. The partnerships with communities, with their creative tensions and a focus away from the usual positional power, were sadly short-lived. The community was demoted to sub-contractor. Magpie went on to work with communities in the Elephant and Castle in south London but by then the partnership funds which enabled a co-produced programme had been replaced by short-term, tightly budgeted consultancy work.

Fast forward to 2018: would it even be possible for a campaigning organization to deliver a regeneration programme? In today's oversensitive political environment, campaigning is derided and undermined and the tensions that contribute to healthy democracy are avoided. The Discovery Team worked in a different climate. Jess Steele describes Deptford at that time as an abandoned place, left behind by state and market. This provided opportunity to deliver community-driven projects: school grounds; community gardens; pocket parks; disused jetties on the Thames; greenways; streetscape. These were the places in between the programmes of public building and housing renewal bankrolled through Public Private Partnerships.[2] Land values in Deptford weren't yet driving up costs and profits enough to attract developers and investors. It was consequently easier to protect and enhance the environment, conserve important historic buildings and sense of place, and promote design that worked for everyone. Land value wasn't needed to replenish public budgets, private developers hadn't cemented their power to dictate development with Economic Viability Assessments,[3] and Deptford wasn't yet a place you might pay upwards of half a million pounds for a studio flat. Prestigious public buildings and spaces were the ambition of local authorities in places neglected for decades. Landmarks like a new public library or a 'Healthy Living Centre'[4] were on the regeneration bucket list. In uneasy but productive tandem communities led projects to revive playgrounds, parks, streetscape, bits of waste land and the ecosystem of Deptford Creek. Shared history, sense of place and environmental responsibility were on their list.

It was difficult for a small community-based group to influence the way larger-scale regeneration was carried out but the survival of the Discovery Team interventions is testimony to the sustainability of places shaped by local people. Their survival is characterized by a strong sense of community ownership and the people who have voluntarily looked after and developed those sites over many years. The McMillan Herb Garden (see Figure 4.1) was developed on wasteland in partnership with the Rachel McMillan School and a local restaurant. After the Discovery Team dissolved in 2004 it became a base for a local sculptor. This tiny garden has hosted live music, children's gardening, and even wine tasting from an annual bottle of wine procured from the garden's vine. The community has changed, the uses have adapted, but many different people have left their mark and looked after the still thriving garden. Developers and their architects cannot design this in, it only comes from real commitment to understand, collaborate and coproduce.

Fig 4.1 The McMillan Herb Garden, Deptford, in May 2014 (D. Turnbull)

In Peckham "things don't just happen"
(Peckham Vision campaign slogan 2017)

Peckham is another South-East London urban centre, in the London Borough of Southwark. Although more central than Deptford it was equally neglected until the 1990s when a massive housing renewal programme, the North Peckham Estate Regeneration was set in motion. Peckham has always attracted artists and other creative types due to the close proximity of Goldsmiths University, and London College of Communications and Camberwell College of Arts (both now part of the University of the Arts, London, established in 2004). Peckham once hosted affordable housing and a plethora of old industrial space for studios and workshops. Today the artists are hanging on, fighting against rising rents in a rapidly changing neighbourhood.

Peckham Vision[5] is a team of active citizens who until recently managed without any formal organizational structure. It has taken a different path to the Deptford Discovery Team and has relied almost entirely on the efforts of volunteers to achieve its aims. Peckham Vision grew from a community campaign running from 2005 to 2009, which questioned the wisdom of demolishing a six-acre site in Peckham town centre for a tram depot. This would have included wiping out local assets, Copeland Park and the Bussey Building (Figure 4.2), which at the time accommodated artists' studios and light industry. Today the creative uses have thrived, and drive Peckham's lively night-time economy. Since 2005, Peckham

Donna Turnbull

Fig 4.2 Copeland Park and the Bussey Building, Peckham (A. C. Manley)

Vision has encouraged informed discussion about development plans for Peckham town centre, and stimulated a variety of ideas for transforming central Rye Lane around Peckham Rye Station. The group has to date influenced just about every building in the station area. The presence of historical buildings in Peckham town centre, with significant reuse potential, has underpinned an ambitious programme of resistance and intervention.

Coordinator and veteran activist Eileen Conn began her journey in the 1970s, campaigning against the destruction of Peckham High Street in the context of proposals for a new Town Hall and a four-lane road carriageway. She has been committed to collaboration with the authorities and developers as the preferred route for Peckham Vision to improve the town centre. The relationship with Southwark Council worked quite well until 2012. A breakdown in relations came after Peckham Vision was excluded from meaningful collaboration on the future of the station square, which the group had led a successful campaign to reinstate. Eileen attributes the breakdown to the attitude of local government marginalizing organized community action, and recognizes that the financial climate of austerity made it harder to shift those attitudes. Consideration for community stewardship and investment in sustainable community-led development are early casualties in hard times. This kind of short-term thinking can set bad precedents that soon become the norm. The community is seen more as a threat or a competitor than an ally, and the authorities inevitably retract. Eileen Conn is an emphatic promoter of and commentator for responsible citizen engagement. Her work with the Third Sector Research Centre[6] has focused on the dynamics of community groups

(Conn, 2011), and the failure of councils and developers to engage these more anarchic peer networks effectively. Ironically, Peckham Vision, a good example of an anarchic peer network unconstrained by organizational infrastructure and a hierarchy, has had significant success influencing planning applications and shaping central Rye Lane – more so perhaps than they would have done with organizational infrastructure constraining their options. The keys to success are sustained community action and monitoring, civic education and community-focused information.

Peckham Vision has used informed publicity to engage local people and expand the network. The various communication streams on different but related issues involve around ten thousand local residents. To date the group has never been a formal regeneration partner and has not taken up the Neighbourhood Planning tools made available through the Localism Act. In Eileen's view, they had always been community planners, and had not encountered immovable barriers. Despite this, and the lack of capacity for communities to deliver Neighbourhood Plans, she considers Neighbourhood Planning to be an important piece of legislation. In effect if Peckham Vision had been able to pursue this direction in 2005, she argues it would now be in a stronger position to deal with the scale of development in the area and the huge number of new planning applications being submitted. Interestingly it is resistance to, not compliance with, planning policy demanded by Neighbourhood Planning that has led to marked improvements in central Rye Lane, Peckham's main shopping street. Peckham Vision's resistance to local development plans, emerging from a different vision, is illustrated in the difference between central Rye Lane and the northern and southern ends of the street. In central Rye Lane historic buildings have been protected and enhanced to create a sense of history and place. Restoration, and smaller interventions, have been carried out sensitively by owners who have been targeted with awareness-raising campaigns. The effect is not like a municipal makeover; it's a lively jumble unified by historic and cultural sensitivities. Outside the range of Peckham Vision influence, building improvements are less considered, disrupting historic building clusters and the unity of the street. It is questionable whether Neighbourhood Planning with all its constraints and conformities could ever deliver an urban realm of the vibrancy driven by the Peckham Vision approach. As Eileen's work on the relations between groups like Peckham Vision and the state reveal, the challenge is to have the mandate and infrastructure to enable formal collaboration whilst remaining in a more anarchic 'energy wave'.

Unsurprisingly achievements are rarely publicly attributed to the group. In 2017 successful campaigning managed to save Peckham Multi Storey (car park) from inappropriate town centre redevelopment as housing. The legacy of community activism is a building with a fairly secure future, housing three existing businesses and new addition, the 'Peckham Levels'[7]. The Levels (Figure 4.3) houses creative, cultural and social spaces on the adapted car parking decks. This is a great illustration of what the tenacity of a community like Peckham Vision can achieve over several years of mobilizing an informed network of local people. It is understandable perhaps that local politicians would not want to admit that campaigning can be the most effective way for communities to get things done. Peckham Multi Storey is something of a coup in a marketized development climate – a publicly owned building taken out of the Local Plan, where it had been earmarked for redevelopment as a high-value site for housing. In its adapted car park form it is never likely to realize the intended levels of profit but provides much better town centre uses.

In contrast, at the other end of Rye Lane the 'Save Peckham Arch' campaign has not fared so well. Southwark Council is proposing the removal of the iconic Peckham Arch to free up space for housing at the entrance to Peckham Square. The arch marked the start of regeneration of Peckham in 1994. It shelters people, a market, the 'Peckham Peace Wall', a gallery, events and entertainment, and

Fig 4.3 The Levels at
Peckham Multi Storey Car
Park (A. C. Manley)

protesters and preachers. The new scheme will reduce public space and introduce potential for complaints from the residents of the proposed housing about noise. This will inhibit public events and remove a democratic public space for spontaneous or creative expression. Social media has helped to galvanize significant objection from local residents through the planning system, and there has been vocal opposition to the scheme at public meetings. But there has been no 'Peckham Vision' style campaign of community development and mass mobilization to save the arch. Comparing this with the achievements of activists in central Rye Lane suggests that the democratic tools of the planning system alone carry little weight against the regeneration juggernaut. The ability to mobilize people for the long term, and sustain campaigns, has arguably become the most effective way for people to shape their neighbourhoods.

Localism in Somers Town

Somers Town is a traditional working-class neighbourhood between Euston and St Pancras Railway Stations, in the London Borough of Camden, with an extraordinary built history of twentieth-century public housing development. The buildings and community have remained relatively intact despite the central London location and despite being surrounded by new developments including the British Library, King's Cross St Pancras Stations, and the Eurostar Rail Terminal. The railway lines, and major highway the Euston Road, have arguably protected the community from the upheavals experienced in similar central neighbourhoods as developers and investors move in. But, as land value has increased, Somers Town is now under threat from both state and market. Since records began the neighbourhood has consistently been ranked near the top of the nation's 'most deprived' list. However that

could be set to change as inflated land values compounded by bad policies threaten to squeeze the existing community out.

The Somers Town Neighbourhood Forum was set up in 2011 to start testing the value of Neighbourhood Planning in a difficult urban setting. Neighbourhood Planning was introduced through the Localism Act of 2011 and gives the right for communities to shape development in their areas through the production of Neighbourhood Development Plans. Residents, supported by local organizations, Somers Town Community Association and Voluntary Action Camden, and veteran community planner Michael Parkes (Pioneer and Director of Planning Aid London in the 1980s) saw an opportunity to engage with planning and development on more equal terms, and with some legal credibility. Residents became involved in the Neighbourhood Forum (Figure 4.4) as an attempt to address years of regeneration failure, and to improve local health and employment prospects. Neighbourhood Planning presented an opportunity to revisit regeneration on more equal terms and give the Somers Town community more control over their future. The aim was to achieve a sustainable neighbourhood where development would benefit residents, not displace them or make them ill. At that point, and until 2016, Somers Town was considered in local planning policy an 'area of more limited change'.[8] The community had suffered the impacts of years of construction work on the Channel Tunnel Rail Link at St Pancras Station and other development in close proximity to their homes. In community planning workshops older people talked of lifetimes of building work and everyone attributed shockingly poor health and mortality rates in Somers Town to the relentless imposition of construction work.

The planning process was challenging to begin with, but in 2013 it started to get even more complicated. Suffering from budget cuts and loss of the government funding promised for rebuilding schools, Camden Council created a development vehicle called the Community Investment Programme (CIP). The approach uses high-value public land to generate profits to build and refurbish schools, housing and other amenities. Somers Town, a neighbourhood of land and buildings mostly in public ownership and in close proximity to national and international transport

Fig 4.4 Neighbourhood Planning in Somers Town (D. Turnbull)

Donna Turnbull

links, became a core part of the programme. The unexpected safeguarding of land in the neighbourhood by HS2 Ltd, the company set up to deliver high speed rail to connect with northern England, and half a dozen other high-value development projects in the pipeline, compounded the situation.

It became increasingly clear that the local planning framework in Camden was not going to accommodate the Somers Town Neighbourhood Plan. It was an obstructive element in the quest to raise money from public assets. To engage in this complicated development environment the Somers Town Neighbourhood Forum required technical knowledge and understanding of land economy probably unprecedented in community-led planning. It was potentially overwhelming. The community recognized Camden Council's need to raise funds, and, with the help of a land valuation workshop, technical support from Michael Parkes and a sympathetic network of pro bono experts, the Neighbourhood Forum devised an alternative vision. This could still achieve a new school, more social housing and maintain the green spaces in the neighbourhood. The alternative scheme was deemed to be unviable by the local council. Not because it couldn't deliver the required community facilities, but because there was no political will to shift from market-led thinking and explore a community-generated development model. Slaney Devlin, local resident and planning activist, became Chair of the Neighbourhood Forum shortly after the alternative vision was presented. Her insight into the Council's CIP vision is that it highlighted the choice to invest in award-winning architecture over the interests of the whole community, and the failure of the Council as a developer. She suggests the CIP vision implied a 'clean up' and reorganization of Somers Town, with all the emphasis on opportunities for schoolchildren. The new school and community facilities will benefit parts of the community, but they may not remain affordable and sustainable enough to remain in community use and control. Already a new leaseholder is being sought for the proposed, but now unneeded, nursery school. The development model is failing, and now in 2018 land in the local park, with permission for a 25-storey tower, is being marketed for sale to pay for the flamboyant community facilities already under construction.

The complicated Neighbourhood Planning process took up a lot of time and energy. Most disappointing is the apparent failure of Neighbourhood Planning to act as a tool within the statutory planning framework for a London community to significantly influence what happens to their neighbourhood. Despite this the experience in Somers Town meant that the Neighbourhood Forum existed as an organized platform to publicize the accumulating developments in the area and mobilize an intelligent resistance. Forum members became well equipped with planning, land valuation and legal knowledge to fight their corner and present viable alternatives to the threats bearing down on their community. The Somers Town Neighbourhood Plan managed to reflect the vitality of activism despite having to absorb some of the dry language and processes of the planning system. It served as a useful campaigning tool along with the whole arsenal of statutory tools like petitions, deputations and planning consultations. Slaney Devlin, taking on enormous risk to challenge Camden Council's failure to adhere to their own policy, initiated a Judicial Review[9] and, despite the failure to reach Judicial Review, Slaney sees Neighbourhood Planning and the related initiatives as a valuable process. Neighbourhood Plan revisions will counteract the excesses of development and assist with promoting approaches that benefit the community. She describes it as a long game – "you can't change a culture overnight" – and is convinced that there will be a better future for Somers Town because of the efforts of local people. The processes of petitioning and planning objection following the CIP planning application mobilized over 1,000 local residents, not as passive signatories but as active participants in resisting a development threat. Slaney cites the conversations that were started then and continue on the streets of Somers Town as vitally important, giving agency to local activism.

Poor relations: community activism

Community activism shapes space

Activism emerges from the margins of mainstream planning and development. It can create an evolving legacy where future activists pick up different threads and continue the work. The results are full of life: the Deptford community projects grown out of abandoned spaces and still growing; the heritage of Peckham town centre re-emerging in new ways for over three decades; the increasing community influence in Somers Town to resist getting 'cleaned-up'. This isn't the kind of space, or stewardship of it, that results from placatory forms of community consultation. It's much more about people building social infrastructure in parallel with making places. In Deptford, Peckham, Somers Town, and all places shaped by energetic activism, people come together to achieve something better, and in doing so enable more connected community. These communities are far more likely, than a collection of isolated individuals, to become involved in other social actions and take up civic responsibilities that sustain a liveable neighbourhood. The activists mentioned in these reflections all participate in other community and civic activities. Organized activism and effective resistance can contribute to a social economy of creativity and mutual aid. The reach of an organization like Peckham Vision, for example, goes far beyond saving buildings. Members are involved in other civic activity, like mediating and managing tensions between competing interests in the town centre, or using their networks to bring people together for local events.

The influence activists can have on space is great because their actions invest in social infrastructure, which should be attractive to our politicians. Organized activism is not there to be appropriated by the mainstream, but activists could be more constructively engaged as a critical friend to provide alternative views and scrutiny. Unfortunately, in London, instead of being engaged in creative dialogue, activists are fighting for liveable neighbourhoods, and for the wellbeing of communities over profits for investors. The planning system in its current form, weighted towards the interests of market-led development, does not provide the opportunity it once did to plan sustainable neighbourhoods. Michael Parkes highlights the values embedded at the beginning of the modern planning system.[10] The 1947 Town and Country Planning Act included a provision for Compensation and Betterment. Revisiting this could inspire a common-sense return to an evenly mixed economy, with an intent to capture the uplift in value from land for public good. Local councils could work more collaboratively with activists who are battling with Neighbourhood Development Plans. They could use the tools of Localism to plan neighbourhood growth in terms of liveability, and housing development in relation to need; capitalizing on vehicles like Community Land Trusts which activists are already promoting, to build homes instead of investment properties. Scaling up Community Land Trusts to deliver more homes would arguably stimulate new types of investment based on existing ethical property development and national investment banks.

A review of the planning system for the twenty-first century which celebrates active citizen involvement and 'planning for good' is essential. The recent Raynesford Review promises some of these principles, including the need to "Secure a fairer balance between the interests of landowners and the public in sharing the uplift in land value derived from development."[11] The planning system is one of the few provisions where people are formally invited, however reluctantly, to actively engage in democratic processes and spatial conversations. It makes a good catalyst for reviewing and resetting relations between citizens and their locally elected representatives. In doing so it provides an opportunity for creating new platforms and terms for the democratic production of space and place – accepting activism as a positive force and creative spatial practice.

Notes

1 The Localism Act 2011 devolved power to local people to define a neighbourhood and make a plan for additional development in that neighbourhood. The plan must conform to local and national planning policy and be adopted by referendum.
2 PPPs are collaborations between public bodies, such as local authorities or central government, and private companies. Introduced in the 1990s to finance the building of schools, hospitals, prisons, etc. without raising taxes.
3 Economic Viability Assessment is used in development plans to give detailed information about the viability of affordable housing. It can be used by developers to justify reducing the number of affordable housing units.
4 The Healthy Living Centre (HLC) programme was launched in 1999 by the National Lottery New Opportunities Fund.
5 Peckham Vision *About* [online]. Available at www.peckhamvision.org
6 Economic and Social Research Council. (2012). *Third Sector Research Centre* [online].
7 Peckham Plex Cinema on the ground floor, and Frank's Bar, and Bold Tendencies (an arts organization) on the roof.
8 London Borough of Camden. (2010). *Camden Local Development Framework (2010–2025) Core Strategy*. London: London Borough of Camden. pp. 40–41.
9 R (Devlin) v. LB Camden. (2017). CO/5992/2016. (Royal Courts of Justice, London).
10 Turnbull, D. and Parkes, M. (2018). In conversation.
11 The Raynsford Review of Planning, published November 2018, identifies how the government can reform the English planning system to make it fairer, better resourced and capable of producing quality outcomes, while still encouraging the production of new homes. It was chaired by former planning minister Nick Raynsford. Available online https://www.tcpa.org.uk/raynsford-review

Bibliography

Conn, E. (2011). *Community Engagement in the Social Eco-system Dance* [pdf]. Birmingham: Third Sector Research Centre. Available at: https://www.birmingham.ac.uk/generic/tsrc/documents/tsrc/discussion-papers/discussion-paper-b-community-engagement.pdf [Accessed 18 June 2018].

Rogers, R. Department of Environment, Transport and the Regions. Urban Task Force. (1999). *Towards an Urban Renaissance*. London: E&FN Spon.

Rogers, R. (2002). Delivering the Urban Renaissance. In: *The Observer Regeneration Conference*. London: The Guardian. [Accessed 7 March 2018].

Steele, J. (2009). Goals and Values of the Regeneration Industry. In: P. Manley Scott, C. Baker, E. Graham (eds) *Remoralizing Britain? Political, Ethical and Theological Perspectives on New Labour*, 1st edn. London: Bloomsbury.

Steele, J. (2016). Doing Politics to Build Power and Change Policy. In: C. Durose, L. Richardson (eds) *Designing Public Policy for Coproduction: Theory, Practice and Change*, 1st edn. Bristol: Policy Press.

5 'Popular planning'
A conversation with Daisy Froud
Melanie Dodd

Mel I'm interested to know how you describe what you do. Do you use the rubric of spatial practices to describe your work?

Daisy I wouldn't describe *myself* as a 'spatial practitioner'. But what I do is completely bound up with the practice of space. I understand existence as fundamentally spatial, and the physical space around us as something that's in a constant state of production, that's never static or fixed, even if it can appear to be. (Sometimes in quite demoralizing ways!) And I do see my job – as being about enabling and empowering others to perceive, or to keep perceiving, the world in that way. Particularly those who don't have conventional forms of power or resource that allow them to act on space in obvious or direct ways. I'm interested in identifying the points where we can intervene to produce different outcomes. If you understand the process, if you understand how you can operate within it, then you are able to have more influence.

Mel You're facilitating people's participation in the production of space?

Daisy Yes. My background is as a translator and interpreter, which definitely has an ongoing influence. I'm always wary of behaving in either a philanthropic or a 'top-down' way. I don't want to 'teach' or 'tell people' how to do these things, or impose my own vision; I just try to enable different ways of seeing things, that then lead to different ways of doing things. I often work with people who have been 'done to' too much. By using the expertise and knowledge that I've acquired, within the spaces that I operate, whether that's an architectural project or teaching, I share some tools or methods for thinking about the world that were once shared with me, for people to use in ways that are useful to them. And actually, it's equally useful to do this for those who *do* hold conventional forms of power, whether they're clients or design teams. Because by encouraging them to be conscious of the way in which they do things, you can remind them of the ethics and politics that they hope to follow and help them to constantly review their practice and decisions against those.

Mel Even if spatial practices as a term isn't one you're using for your own practice, you are 'practising' spatially.

Daisy I think it's a really useful way to think about the world – that all space is practised. Taking the starting point that any spatial form is the result of a decision, whether conscious or unconscious, and that it's a form of agency to be aware of those decisions happening, and then to enable some to be taken differently. I read Lefebvre's *The Production of Space* (1991) in my early twenties and it's remained a favourite book. For example, his idea of 'representational' space: 'the space of inhabitants and users' – space as we experience it as individuals with all its memories and possibilities and

imagination and potential. Everything around us can be seen through so many different filters but we're reared through conventional education or conventional ideologies, not to see that.

Mel Aside to that, why did you read Lefebvre in your early twenties?

Daisy After my languages degree, I started working in environmental campaigning. This was right when climate change was emerging as a major issue and the term 'sustainable development' had just entered popular use. From here, I went into urban environmental work, very localized, because I became interested in how we deal with these questions at an everyday level. There was lots of regeneration money going into estates in that period. I became aware that the architects' approaches weren't necessarily working. We were doing all this amazing work with people on housing estates and in neighbourhoods, analysing their area with them, thinking about what would be the best way to spend the regeneration money, how to take decisions together. And I often felt the architects were instead trying to apply more technocratic and logical interpretations of space – 'what should be provided where'. I became interested in the absence of conventional logic; in a kind of a useful community knowledge, about territorial reality, memory and association. I did an MA in Cultural Memory, and focused on readings concerned with place and memory. Here I came across Lefebvre and then thought, "This is amazing."

Mel What would you say are the overarching ambitions of your current practice – if you like, the driving force?

Daisy I was always politically driven – I did a lot of voluntary and activist work in my early twenties. But over two decades I've got more and more politicized. The crash in 2008 was a big moment. Obviously, with hindsight, it's easy to see that all the issues were lurking before. But at the time – and I graduated the year New Labour came into power – I was a young, well-intentioned practitioner, and there was all this money! The question we asked people was: "How shall we spend this money on your estate?" But in fact, it was the same ideology underneath, we just couldn't see it clearly through all the generosity that was layered on top of it. Now, that has all fallen away, seeing the trajectory we're on, I often feel really cross! Sometimes I've questioned "Should I even do this anymore? Is there any space for real change to be made at the project level?"
 In terms of my *own* trajectory, I'm only half joking when I say that it ends at the anarchist revolution. We've got so fundamentally 'out of kilter' in terms of the way in which – if we understand society as a collective of individuals working out how to survive and live well together – the average citizen has any agency over our immediate lives. Including the way in which space is produced. Making space – by which I mean the conceptual space within a project – that enables, even temporarily, people to do things collectively, and for themselves, is a huge driver. Working with thousands of people over the years has only strengthened my fundamental belief that the average human being is very intelligent and creative. And I'm fascinated by the forms that collective intelligence takes, and the outcomes it generates, when supported through well-designed processes, particularly decision-making processes, understood as technologies. A lot of my work is about constructing imaginative collective learning journeys or investigative journeys.

Mel Do you see the work as part of a longer lineage?

Melanie Dodd

Daisy Yes, I've always been conscious of being within the lineage of a type of 'popular planning'. I first encountered these ideas as a community facilitator in my early twenties, reading books on participatory appraisal and thinking, "Oh yes, this is exactly how we should do it." I mean, it's laughable now, making these poor older ladies do drama warm-up exercises, when they were coming along for the tea and biscuits, but it was meant well! With time, I've become more conscious of a longer lineage: of the participatory design and planning that emerged in the '60s and '70s, of nineteenth-century worker education movements that were neutered by the formalization of education and the establishment of top-down curricula, and of nineteenth-century anarchist movements. All these threads feed in.

Mel Can you talk about a particular project, perhaps one or two, that are typical of how you work. I'm interested in who's commissioning the work from you, in what context and then how practically you actually just do it, what's a day in the life?

Daisy My clients are almost always from the public or charity sectors. Lots of my work is local authority or Greater London Authority commissioned. I had an architectural practice (AOC) for 12 years. These days, sometimes I'm a subcontractor, part of an architect's team. Sometimes I'm employed directly by a local authority or a public body or institution. Occasionally I'm employed directly by a community. On some projects, I work directly with architects on quite traditional master plans or building projects, following RIBA stages. On those I'm the person making sure that whatever participation is happening, whether that's consultation or co-design, that it's done well. I design a strategy and then try to ensure it's delivered, even when reality bites. Sometimes I deliver it myself; sometimes I'm in a 'guardian' role.
 I am always really clear, when pitching, that it is 'engagement' that I do. It is not PR and it's not 'comms'! It's quite insidious how, more and more, 'community engagement' seems actually to be 'communications'. What I do is a form of community politics and I will only take work where there's a genuine commitment to making space for those affected by a project to influence outcomes, and be directly involved in decision making.
 A typical project initially involves identifying all those 'stakeholders': the different communities, or individuals within a community, who haven't necessarily got traditional channels or forms of influence, but who should be involved. Spending some time building initial contacts and relationships so that, before a process is designed, we have some genuine understanding of people's fears, concerns, hopes, ideas, for both the place and the process. Then, I work on designing a process. The 'process design' is a mix of the fixed and the loose. Although it constantly evolves, if you haven't got a solid spine or core at the start, then you can't flex around it – everything just becomes jelly. You at least set out key principles, and identify where key decisions – including those that you know will matter most to the affected communities – are being taken. Then I make sure that the process is designed to allow the right questions to be asked, and opportunities, to be created, to influence those decisions. This initial mapping and charting is fairly rigorous, but then what happens from that point on is very much informed by what happens.
 On more participatory or even co-design projects, the process is often workshop based, using exploratory or deliberative methods. There can be elements of testing, making and co-learning. A recent project

Conversation: Daisy Froud 59

for the Wellcome Collection in Euston was rather luxurious because I could be a 'brief-builder' in residence. They gave me a room in which to run experiments for two weeks exploring different desirable relationships between visitors and collection objects, thinking what that might mean for the design of a new gallery; designing from the small scale to the large scale – in some ways the reverse of the conventional RIBA stages.

In that respect, I enjoy working with muf Architecture/Art and their willingness to think in this way. We did a housing project, Tower Court for Hackney Council, working with Adam Khan Architects too, where we were rehousing existing residents. While on the one hand, the project began with the big picture issues: understanding the scope of the site,

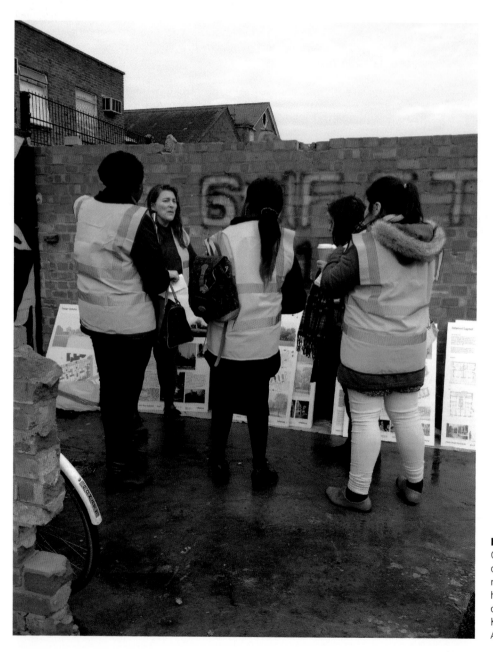

Fig 5.1 Site workshop: Tower Court residents – to collect, discuss and learn from memories of their previous homes, and to plot out new ones at 1:1 scale; with Adam Khan Architects and muf Architecture/Art (Froud)

Melanie Dodd

Fig 5.2 Site workshop: Tower Court residents – to collect, discuss and learn from memories of their previous homes, and to plot out new ones at 1:1 scale; with Adam Khan Architects and muf Architecture/Art (Froud)

exploring height, massing, viability, at the same time we were working very closely with the residents, focusing on what mattered to them at the micro-domestic level. Liza Fior of muf produced small sketches, to capture and validate these everyday moments, helping the small scale be as much a strategic driver on the big project decisions as the large scale. Similarly, at Wellcome, by understanding desired relationships and intimacies with objects, we could then say, "What would that mean for display and storage methods? What would that mean for the room?" and so on.

Conversation: Daisy Froud 61

Fig 5.3 Site workshop: Tower Court residents – to collect, discuss and learn from memories of their previous homes, and to plot out new ones at 1:1 scale; with Adam Khan Architects and muf Architecture/Art (Froud)

Mel Was that working with the public as well?

Daisy Yes! I dislike the 'butterfly collector' stance, where you're using people as subjects to observe and study. For me, it's really important to pool intelligence and experience, and to ask people to reflect for themselves. Rather than taking all the data away and analysing it, apart. For example, at Wellcome, people were keen to engage – the experiments looked fun. But we'd always explain, "If you participate you then do need to commit to staying for 10 minutes afterwards, so I can interview you first about what you did and why, and then about what you think this might mean for the design of the gallery and how it should be used and experienced" – the 'design implications'.

Mel How do you evidence the process and outcomes you have described? Is there a system of recording your findings back into a format that other people can access?

Daisy One of the reasons I like working in architecture is because at the end there is a commitment to producing a 'form' that will endure. And that's a huge responsibility. One works towards a defined outcome, and it's important to evidence the process of how you got there, and how other voices and experiences have shaped that outcome. Reporting on the process is

Melanie Dodd

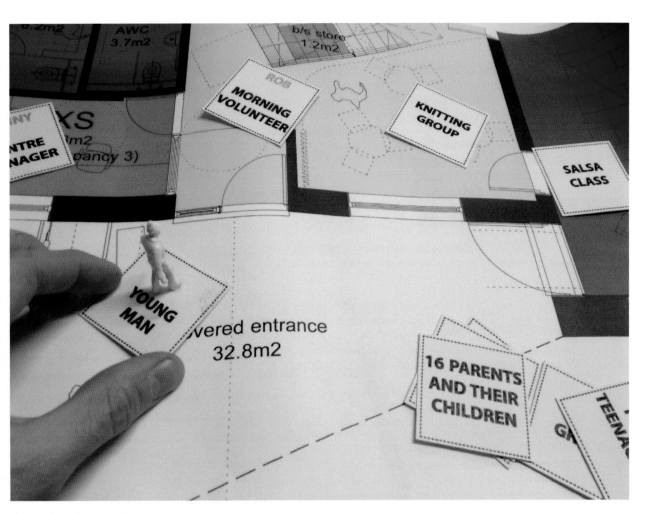

Fig 5.4 Bespoke scenario exercise - to explore ideas about what should go next to what, which activities need more space than others, and how spaces will be used in practice (Froud)

sometimes the most important things that I do. It takes far more time than I'm ever paid for. But it is important to share findings and outcomes transparently. My work involves designing ways to capture findings rigorously and methodically to produce a proper shared evidence base – often just quite straightforward feedback forms or cards – then analysing that properly, and then making sure it is available to all those who contributed. On most projects, I'll then be tracking progress publicly against initial feedback and findings, and against established participant priorities, asking people to score and critique the design team on how well they are doing, so that you can keep learning and improving.

Sometimes the report's usefulness is unexpected. I remember one politically controversial project in south London. Some communities didn't want the project to happen, and their reasons were really quite valid. They used my reports, and the evidence in them, to help stop the project in its initial form, leading to a big rethink by the local authority client and a different and better approach.

Mel Do you think design is a good word for what you do? I mean, you talked about designing the process of engagement, and designing the actual events that you ask people to participate in. You seem to use that word quite comfortably.

Daisy Yes. Understanding 'design' as a process of intentional and creative planning that leads to a form or forms

Mel Do you think your work is political?

Daisy It's definitely political. My 'founding faith' is that I believe the city should be co-produced by all of its citizens. That's not an easy thing to do and its rather utopian. I don't know how politically *effective* my work is. Sometimes I do question, is there really any impact? But I do feel ethically happy with my intentions and choices, even if not always by the outcomes.

Mel What about political with a small 'p'?

Daisy Yes. I like Aureli's distinction in the opening of *Possibility of an Absolute Architecture* (2011) between the Greek city as 'polis' – the place where the citizens (albeit in those days a very small, male section of society) meet to work out how to live, with the aim of urban form being to support society – and then the Roman 'urbs': the city as bureaucratic management of territory. With the latter eventually leading to the invention of the term 'urbanization': a method of efficiently producing the city, initially via the grid, to enable its ongoing expansion. I'm obviously drawn toward the 'polis', questioning what a polis is in a genuinely equal, diverse society. What are the processes and structures that support the 'polis'?

Mel I've got a question about collaboration and the role it plays in your work. It's clear that you work very collaboratively with lots of audiences and stakeholders. Do you ever collaborate with other disciplines, as part of delivering your part of the project, and who are those people?

Daisy Yes. I'm often paired with artists, and I've always welcomed that. My strength is thinking about processes of decision making, which can be quite dry. Collaborating with artists often leads to different physical or material approaches to exploring or taking decisions. Sometimes historically there have been tensions though when artists have felt that their art is being used as a tool to produce an outcome; devaluing the art. Which is an interesting discussion! I'm currently collaborating with artist Verity-Jane Keefe, subcontracted to her on a co-design project in a neighbourhood where she was already an artist-in-residence, and we're working with a community with whom she already has relationships. I've been brought in as someone who understands the nitty-gritty of participatory architectural design. We're operating collaboratively, within a wider team that includes architects, but we're also very clear on who's bringing what experience to the conversation, which works well.

Mel Do you ever find anthropology or ethnography useful disciplines to draw on?

Daisy I have been influenced by anthropological and ethnographical techniques, absorbing them into my own work process. Recently on another Hackney Council housing project with muf and Adam Khan Architects, Marian Court, I ran a workshop with anthropologist Jan Van Duppen. I was struck by how much overlap there was in our approach, but also intrigued by the very specific disciplinary methods of data collection or of asking a question that he employed. I love collaborating for that reason. I brought public archaeologist James Dixon into a project once to work with a community

on analysing their High Street, because it offered a different way of looking. I tend to find that the people who are attracted to collaboration, are themselves the types who are pushing at the boundaries of their own disciplines.

One aspect of other disciplines that I've adopted is a commitment to 'data', realizing its use as a political tool. The more I can cast myself as a scientist with objective information, as opposed to a warm fluffy community worker, the more I am listened to! And this is useful if I'm trying to make somebody with more conventional power do something. In the same way, I make strategic use of professional jargon. For example, I don't particularly like the word stakeholders, but there are lots of contexts where that is the word to use if you want to be taken seriously.

Mel Last question. Are there questions you regularly reflect on as part of doing the work and have you found ways to address them?

Daisy Many! Is this making any difference at all? Is this simply perpetuating the status quo? Am I acting as a distraction or decoy from what is actually going on? Can any of this really make a difference? Yes, all of those questions on a daily basis.

Mel I imagine that you've found a way to comfort yourself? Are there any reflections you can draw on?

Daisy What I definitely do is to try to take any opportunity that arises to influence larger outcomes – such as advising government or shaping policy – given that projects themselves are often so compromised. It can be really difficult; being co-opted is very easy. I've worked really hard to try and learn how to stay myself in these contexts, but also manoeuvre politically, so that I can make quite strong points without seeming like the 'ranting lefty' in the room, getting everyone's back up and then not being invited back. I feel I've got better at that and that it's really important to keep that. I think sharing knowledge and finding ways to make your on-the-ground experience heard is really important. The thing I know I'm good at is making connections, sharing information, structuring decision-making processes, finding ways to enlarge a space of discussion. And I feel that there is some influence to be had through that, as long as you act on bigger strategic levels too wherever you get the opportunity. Just being conscious, having a clear ethical compass, being flexible and responsible. Knowing that the ideal never exists – something that the compromised world of architecture constantly reminds you of – and working out how to live together in the world. Of course, all you can do is keep engaging because even if you did somehow achieve some perfect state for a moment, you still have to keep acting to maintain it. As Doreen Massey, another massive influence on me, both as a kind generous person and as a theorist, always explained it, democracy and democratic space – like all kinds of space – are constantly in a state of evolution and negotiation (see, for example, Massey, 2005). That's the whole point – that IS democracy: the constant encountering and working out.

References

Aureli, Pier Vittorio (2011) *The Possibility of an Absolute Architecture*, Cambridge, MA: MIT Press

Lefebvre, Henri (1991) *The Production of Space* (trans. D. Nicholson-Smith), Oxford: Blackwell

Massey, Doreen (2005) *For Space*, London: Sage Publications.

A long-game of resistance

Hugo Hinsley and Support Community Design Building Service

Alex Warnock-Smith

Support Community Building Design Service was a cooperative spatial practice working in London between 1976 and 1992. Little known in contemporary discourse, Support was pioneering in opening a gateway between architecture and the voluntary sector, enabling community groups to become clients of architects and other professional services. Operating as a cooperative, disallowed by the Royal Institute of British Architects (RIBA) at the time, Support also pioneered new forms of spatial practice and initiated several new legislative structures, many of which contemporary practitioners continue to work with today.

Growing out of an active engagement in the squatting movement of the 1970s, it was foundational to the establishment of the Community Technical Aid Centres (CTACs), providing a local advisory service to community groups, the voluntary sector and local authorities. Support's projects range from housing renewal to children's centres and community buildings across London, as well as many other institutional and legislative creations, yet their work is currently undocumented and hard to find.

The motivation of this chapter is to discover and reveal the work of the practice, to situate it within a wider context of spatial practices of the period, and to take the first steps towards creating a history of Support's work and its impact on the contemporary spatial and political landscape. Not least, the chapter also touches on the career of the late Hugo Hinsley, one of the chief protagonists and founders of the group. From Cambridge scholar to activist squatter; housing architect to public realm advocate, Hugo's career as a spatial practitioner and academic was hugely influential on the landscape of spatial practices in the UK, yet incredibly understated. Other members of Support included: Tom Woolley, Tony Lloyd-Jones, Mark Gimson, Helen Sachs, Amanda Reynolds, Anna Sawyer, Belinda Webb, Helen Teague, John Bussy, Lesley Gibbs, Martin Hughes, Mary Rogers, Nelica Lagro and Pamela Kovachich.

Support's work in providing alternative housing types; establishing new forms of communal living; and expanding the realm of spatial practice to a wider territory of users, was a sustained practice of resistance against the right-wing ideologies of the incoming conservative government. Support was also a practice of 'resistance' at a more fundamental level: the very idea of 'technical aid' was a reaction against the restrictions and privileges of more conventional definitions of 'architectural practice', and Support actively rejected the expectations and definitions of governing bodies such as RIBA and ARCUK (Architects Registration Council UK). "We were radically opposed to the wider professional ethics of the time, and the culture of architectural stardom, which still prevails today" (Tony Lloyd-Jones in interview).

Squatting: an activist practice of resistance

Support emerged not out of a clear intention to establish a business, nor out of an abstract idea of what an architecture practice should be, but out of several quietly radical things that Hugo and his associates were doing as part of the squatting movement. Hugo's interest in squatting originated during his training as an architect, from his experience as a year-out student with the Family Squatting Advisory

Service and the establishment of the homeless charity Shelter in the early 1970s, and his research into the legal and practical methods of squatting in his diploma studies at Cambridge. Hugo was also influenced by Colin Ward's anarchist approaches to the city and support for squatting, direct action and dweller-control in *Housing, An Anarchist Approach* (1976), and by John Turner's research into squatter settlements in South America and his seminal concept and text *Freedom to Build* (Turner and Fichter, 1972), both of which were foundational to the establishment of the graduate school at the Architectural Association, which Hugo, John and others were setting up at the time.

Hugo's early squatting practices should also be considered within the wider context of the 1970s, with key cultural influences including the *Squatters Technical Handbook* (1976); the Ruff Tuff, Cream Puff Estate Agency squatters' bulletin (1975), and the TV drama *Cathy Come Home* (1966). The squatting movement of this period was fuelled by

> increasing disaffection in the UK from the mid-1960s of the central and local government policy towards increasingly large-scale, post-war urban slum clearance and renewal programmes, and the wholesale replacement of older properties in poor condition with what were seen as featureless system-built multi-storey flats. Local authority architecture and planning departments were largely viewed as monolithic and unresponsive to the social upheaval, dispersal and breakdown of traditional communities attributed to their redevelopment plans.
>
> (Jenkins, Milner and Sharpe, 2010, p. 25)

Making use of the 1969 Housing Improvement Grant System, Hugo and his colleagues used their technical and legislative knowledge to squat empty Victorian terraces, apply for squatters' rights, renovate the properties and establish new residents' cooperatives, saving the properties from demolition and securing tenure for people who were previously homeless. "Our aim was to bring homeless people into these properties, then secure their rights and licensing" (Hugo Hinsley in interview with Philip Doumler, 2013). Support was also interested in the potential that squatting and renovation enabled for larger social and spatial transformation, and its members reconfigured many empty Victorian terraces through lateral conversions, altering the typologies and creating "new social frameworks in the streets" (ibid.).

Support did not shy away from the political implications of its work. Its defense of the St Agnes' Place squat reached the broadsheets in 1977, and it won a court case against Lambeth Council by providing evidence to prove there was no technical reason for demolishing parts of the Angell Road Estate. Support's work with squatters and residents' cooperatives coincided with the establishment of Housing Associations and subsequent local authority council housing, with which Support collaborated. Housing became a long-standing concern, and Support worked for several years for Haringey Council, renovating and converting empty housing stock into local authority council housing. (See Figure 6.1.)

Hugo was vehemently against the needless demolition and reconstruction of buildings, particularly in the housing sector, where regeneration is often used as a vehicle for private financial gain. Squatting, for Hugo, was a practice of resistance: resisting the unnecessary demolition of properties, the commercialization of housing provision, the normalization of residential communities and the expulsion of the homeless from the city. Squatting also reveals Hugo's approach to politics and world view, living his practice through a personal, bodily approach, enabling alternatives through establishing new lived realities, and empowering others in the process. Hugo remained committed to squatting and other informal processes of residential living throughout his career, and was an adviser to several tenants' associations, housing cooperatives and other housing groups.

Alex Warnock-Smith

Fig 6.1 Page from Support newsletter, 1 March 1977 (J. Dwyer)

Resisting expectation: cooperative practice and Community Technical Aid Centres

Support was seminal for what it revealed about transformations in forms of practice at the time and attitudes towards the role of the architect, and it is perhaps these aspects of its members' approach that deserve most attention in discussing their work: In their own words:

Support is a group of architects and builders who share the objective of providing alternative architectural and building services to 'community', working class and

progressive organisations. These groups need a different approach to that offered by normal firms. In particular, we are interested in involving groups of building users in the design process so that they can experience and control this creative activity. We also encourage people who want to take on building work themselves or remain in control of building activity.

(Gimson et al., 1977)

(See Figure 6.2.)

SUPPORT INFORMATION LEAFLET November 1977

Support is a group of architects and builders who share the objective of providing alternative architectural and building services to 'community' , working class and progressive organisations .

These groups need a different approach to that offered by normal firms . In particular we are interested in involving groups of building users in the design process so that they can experience and control this creative activity . We also encourage people who want to take on building work themselves or remain in control of building activity .

This work is restricted to some extent by existing codes and rules and we haven't yet evolved an ideal form for the group . In the meantime four of us , most strongly committed , share an office whilst a wider range of contacts have been involved in discussions with some working on particular projects . Members take on work and the professional responsibility individually while we help each other out and discuss the work collectively . We are not just concerned with completing projects and making a living , though these are important , but we are primarily trying to achieve the following :

1. Educating the groups we are working with so that they aren't overawed by profess-ional experts and will press for changes in the way architectural services and other services are controlled and provided .
2. Generalising the experiences , learning lessons from and disseminating information to others about this new way of working and the new techniques we use such as participatory design .
3. Organising meetings of experts and lay people to discuss our work
Examples of meetings so far Job creation schemes doing building work
 Design Defects in council housing (a joint meeting
 with PHAS and Newham Rights Centre)

Projects we are working on include ; the conversion of a church hall with a pensioners group , conversion of an old pub with a youth project , reports on various problems and defects for tenants , squatters and residents groups , advice to a working community in an old warehouse , JCP proposals including a building co-op , advice to various trade union groups . Most of our contacts and requests come through law and advice centres and our own involvement in housing , community and trade union activity. At our weekly meetings we have to review progress on about 20 projects currently .

We are concerned to make Support self sufficient and viable but don't plan much expansion in numbers or work . Most of our 'clients' are poor financially but find some money for our time , often from sources like local authorities or central government . In this way we avoid the contradictions and dependence on grants that 'free' advice services have . We do have difficulty in finding other people who are prepared to commit themselves to this kind of work while there are plenty of opportunities to take on more projects . Instead many groups end up with the limited approach of conventional RIBA practices which sometimes claim to be practising 'community architecture' .

We want to help people set up similar groups to Support elsewhere and as members of the New Architecture Movement we see our work as part of a wider movement . While we often find ourselves acting as an alternative or in direct conflict with local authority architects we are concerned with changing the nature of all architectural practice , making it accountable to building users , not with boosting private practice .

We can be contacted at 27 Clerkenwell Close , London EC1R OAT (01 251 0274)

Mark Gimson , Hugo Hinsley , Colin Taylor and Tom Woolley

Fig 6.2 Support Information Leaflet, November 1977 (J. Dwyer)

Alex Warnock-Smith

Support began as a loose collective of people operating out of two 'advice centres', one in North London and one in South London, until it established the framework for a cooperative in 1982. Inspired by several movements of the period, including the Architects' Revolutionary Council (ARC) and the New Architecture Movement (NAM), it rejected established methods of practice and the expectations of the RIBA and ARCUK on how architects should behave, practise and act, believing these to be outdated and restrictive. Their 1977 Information Leaflet states candidly:

[Our] work is restricted to some extent by existing codes and rules and we haven't yet evolved an ideal form for the group. In the meantime four of us, most strongly committed, share an office whilst a wider range of contacts have been involved in discussions with some working on particular projects. Members take on work and the professional responsibility individually while we help each other out and discuss the work collectively.

(Gimson et al., 1977)

Support was pioneering in campaigning against the RIBA to recognize alternative forms of practice and was the first to set out the legal framework for architects to operate as cooperatives. This was instrumental to the way the group conducted their practice, and enabled them to readdress the relationship between themselves and their clients, between professionals and society: "RIBA required all architectural practices to be a Partnership, under partnership law. Instead, we wanted to set up a multi-disciplinary cooperative, where everyone was equal" (Hugo Hinsley in interview with Philip Doumler, 2013).

Support also launched the vision for Community Technical Aid Centres (CTACs). Funded through local authority grants, the aim of CTACs was specifically to "support organisations at the early stage of a project and allow them to apply for funding with a professionally prepared feasibility study" and then to support the organization in the further design and realization of their project (Jenkins et al., 2010, p. 32). Support was the first CTAC in London, followed by the feminist design cooperative Matrix (1983–1993). CTACs were not-for-profit and multidisciplinary, and offered a wide range of professional services to communities, which was made possible by using the cooperative practice model. CTACs operated as

local resource centres where a wide range of services were offered to individuals and community groups who wanted to have an influence on their built environment. Unlike the related service provided by the Community Architecture Group at the RIBA, CTACs acknowledged the diversity of professions and expertise involved in community development and therefore included organisations that advised on planning, landscaping, engineering, surveying, ecology, environmental education, financial planning, management, administration and graphics, in the belief that a combination of these skills were required to build a community.

(Awan, Schneider and Till, 2011, p. 129)

In 1983 Support established the Association of Community Technical Aid Centres (ACTAC), a non-governmental body that provided resources and advice for CTACs, which attracted over 50 members from across the UK. ACTAC was a registered charity, with the charitable objectives:

(i) To advance public education in the highest standards of the specialist skills needed to develop, maintain or alter buildings or land used for public benefit. (ii) To encourage the preservation, development and improvement of features of general

public amenity or historic interest. (iii) To stimulate public interest in and care for the beauty, history and character of the built and natural environment.

(charitycommission.gov.uk)

In establishing ACTAC, Support was keen to make a formal distinction between technical aid and the wider 'community architecture' movement that its members were critical of, particularly the generic interpretations of community architecture promoted by RIBA and other private practices at the time. Instead, "Support had a clear ideology and direction towards working with emerging forms of community – marxists, feminists, women's groups. The Community Centre, for Support, was intended to be a place where different groups could meet and a space for the generation of new communities and ideas" (Tony Lloyd-Jones in interview).

Support's 1977 Information Leaflet is revealing, when it states:

We want to help people set up similar groups to Support elsewhere and as members of the New Architecture Movement we see our work as part of a wider movement. While we often find ourselves acting as an alternative or in direct conflict with local authority architects we are concerned with changing the nature of all architectural practice, making it accountable to building users, not with boosting private practice. (...) We do have difficulty in finding other people who are prepared to commit themselves to this kind of work. (...) Instead many groups end up with the limited approach of conventional RIBA practices which sometimes claim to be practicing 'community architecture'.

(Gimson et al., 1977)

ACTAC sought to create a shared ethics, agenda, values, resources and discussion space for CTACs and a forum to represent and promote their interests. In many ways, the ACTAC provided the alternative recognition and support that RIBA and ARCUK failed to do at the time: "Support's struggle was part of a resistance against the privileges and restrictions of social class and access to wealth: Community Technical Aid was about community empowerment and widening access to opportunities" (Julia Dwyer in interview).

Support made a significant contribution to the landscape of practice in the UK, providing legitimation for spatial practices to operate under new terms, redefining the architect from privileged professional working for fee-paying clients to community activist and educator, imparting technical skills and knowledge to communities and groups to lead and empower them through complex processes of change and development. "An architect is someone who can skill people, not tell them how to live" (Hugo Hinsley in interview with Philip Doumler, 2013). (See Figure 6.3.)

Practice and policy: resisting the neoliberal city

In assessing their impact on contemporary spatial practice, it is worth returning to the early 1980s and Support's work with the Greater London Council (GLC), where they established several legislative structures to support CTACs and other alternative practices, which continue to be extant today albeit in altered form. Support worked with the GLC to establish the London Community Building Design Service (LCBDS) in 1983, with the specific remit of funding non-fee paying voluntary sector projects. The establishment of the design service was the first time that 'community projects' were given specific designation in local government and provided the funding that enabled CTACs and other practices working in the voluntary sector to exist. Enabling this to happen is perhaps one of Support's most foundational, lasting and understated achievements.

Support's technical aid work was also closely linked to the Greater London Enterprise Board (GLEB), which provided capital funding for community projects

Alex Warnock-Smith

Fig 6.3 *Community Network*
Dirty Money, ACTAC
newsletter, Summer 1991
(J. Dwyer)

COMMUNITY
NETWORK

A magazine for community participation **Summer 1991**

Developers consult communities: who pays wins?
Planning Aid adapts to survive
Community architects: copping out?
How to be happy in the contract culture

DIRTY MONEY

after feasibility stage and later investments into businesses. In 1986, Mary Rogers, who had been key in establishing and running these structures, left Support to run the GLEB. Support also started the Women's Design Service (WDS) (1984), with the specific remit of representing women's needs in relation to issues of space, architecture and the built environment, providing a voice and structure where none existed before. "WDS was thus founded as an overtly feminist organisation in the belief that women's voices were not being heard, and that women were having to live and work in environments that were unsuitable for them" (Awan et al., 2011, p. 212).

Resistance: Hugo Hinsley and Support

The real context in which Support was working was the political and economic climate of London, and the totality of their work can be seen as a sustained practice of resistance against the right-wing ideology of Margaret Thatcher's Conservative government (1979–1990). "The coming to power of a right-wing Conservative government in 1979 serially undermined local authority power as well as seeking to reduce government roles in the economy, promoting private sector and individual initiative" (Jenkins et al., 2010, p. 38).

Hugo continued to resist the privatization of the public realm indefatigably throughout his career. According to Martin Hughes, long-term collaborator and former member of Support, the early Thatcher years were an intense period of activity for spatial practitioners who saw the effects of the neoliberal economy on the city coming ahead of them. "There was a flurry of activity in the early Thatcher days" as Support and other like-minded practitioners were "busy trying to put measures in place to resist the neo-liberalisation of the economy and the privatization of public goods that Thatcher was implementing" (Hughes in interview).

The conservative Thatcher government steadily dismantled the support systems of the voluntary sector, reducing funding for local authorities and for capital projects for voluntary groups. Support's work throughout the 1980s was about establishing defences against the restrictions that the government would in time impose, working quickly to establish new structures and opportunities for spatial practitioners to support community groups and the voluntary sector, before these opportunities were shut down. Despite the abolition of the GLC in 1986, the legacy of the LCBDS and the GLEB, and of the integrated relationship between Support and the local authority, can be seen in the renewed Greater London Authority (GLA), notably Livingstone's Design For London, Khan's Mayors' Design Advisory Group, and the Good Growth Fund; legislative structures that are essential to local governments, local communities and spatial practitioners today.

Support's quiet, determined approach towards social, spatial and political transformation from the late 1970s to the early 1990s was highly influential in the landscape of spatial practice in the UK, opening up new opportunities for architects to work with voluntary sector groups; establishing key legislative and institutional structures to support this work; forging closer links between spatial practice and local government; and enabling new forms and methods of professional practice. Support's resistance to mainstream institutional expectations enabled a wider reorientation of spatial practice, challenging and rethinking the relationship between architects and clients, professionals and society, expanding the realm of spatial practices for generations to come.

Little has been written about Support to date, and its work deserves greater attention and further investigation for what we can learn from its methods and approach. Its direct impact on contemporary spatial practitioners remains understated, but is implicit in the approach of many practitioners today who work closely with local authorities, community and voluntary sector groups. The 1970s and 1980s was an intense period of experimentation in which the established relationships and conventions of practice were challenged and rebuked, and the period contains a rich history in reflecting on how we practise now. The location of Support's work was within and between the structures and workings of practice and its relationship to people and government and it managed to rearrange these structures and open up new opportunities for practices in the future. Support resisted abstract notions and ideals of socially engaged 'community architecture'; instead, it sought to enable alternatives through working directly in reality – in the collective spaces and political energies between people, and the spaces and structures they inhabit. Support's work could be seen as a long-game of resistance, which is essential to any sustained form of transformation, and is a lasting lesson for contemporary practitioners resisting the political and economic pressures and restrictions of today.

Alex Warnock-Smith

Hugo was a tutor, colleague, mentor and friend who was highly influential to my own career and approach as a practitioner-academic, as well as to countless others. Regretfully Hugo died in May 2018, several months before this chapter was finished, and what had been intended to be an interview and active dialogue with Hugo and his former colleagues at Support about his life and work, is now part-eulogy, part-silent history, in which the main protagonist is deafeningly absent. Hugo lived his work; his politics and approach as an architect, urbanist and thinker were embodied in how he practised everyday life. Humble, thoughtful, astute, Hugo was the most modest person, yet opinionated, erudite and direct at the same time: his silent, steady voice all the more powerful for what he chose not to say. From Cambridge scholar to activist squatter; housing architect to public realm advocate; academic to aborigine, Hugo's career was varied, extreme yet incredibly understated. I'm indebted to Hugo's wife Tonia and to his colleagues and friends, Martin Hughes, Tony Lloyd-Jones and Julia Dwyer and others, for their help and advice on researching and writing this chapter, which only begins to tell the story of Hugo's rich and varied career and scratches the surface of his contribution to the architectural profession.

Bibliography

Association of Community Technical Aid Centres, charitycommission.gov.uk

Awan, N, Schneider, T, Till, J (2011) *Spatial Agency. Other Ways of Doing Architecture*. Abingdon: Routledge.

Bourriaud, N (2002) *Relational Aesthetics*. Dijon, France: Les presses du réel.

Gimson, M, Hinsley, H, Taylor, C, Woolley, T (1977) *Support Information Leaflet*, November.

Jenkings, P, Milner, J, Sharpe, T (2010) A brief historical review of community technical aid and community architecture. In: Jenkins, P, Forsyth, L (eds) *Architecture, Participation and Society*. Abingdon: Routledge.

Turner, J, Fichter, R (1972) *Freedom to Build: Dweller Control of the Housing Process*. New York: Macmillan.

Ward, C (1976) *Housing, An Anarchist Approach*. London: Freedom Press.

Interview with Hugo Hinsley, conducted by Philip Doumler, 2013, AA Archives.

Interview with Martin Hughes, conducted by Alex Warnock-Smith, 2018.

Interview with Julia Dwyer, conducted by Alex Warnock-Smith, 2019.

Interview with Tony Lloyd-Jones, conducted by Alex Warnock-Smith, 2019.

'Do-It-Yourself'

A conversation with Nicolas Henninger, EXYZT

Shumi Bose

Shumi So, what do you consider as your 'spatial practice'?

Nicolas 'Spatial practice', as we thought of it through EXYZT, was actually just 'practising'. Or making the space work. Because we started when we were students, the whole project came from being students together. It was not something that was properly organised. We were all just finishing university, and we thought, "Now we've learned all these things, now we need to 'practice' in space. To be in action, in the reality of space, with all the problems it brings."

Shumi The point for you was always to be performative?

Nicolas Yeah, I think so.

Shumi ... and practical?

Nicolas Yes, sure. Practical in a sense! Because when you have to perform in a space, in physical urban space, you encounter lots of practical issues. And from these practical questions, might emerge some new concepts.

Shumi Were you thinking about space at the level of individual agency, or larger? For example, were you looking at the scales of the individual, or the municipal?

Nicolas We were quite aware of the 'relationship' let's say, between the micro and the macro scales. This relationship of yourself in the urban scale, and to architecture. During our studies, the orientation or focus was really around the urban situation, and how people interact with architecture and its spaces, and the space provided and re-created by that interaction. And all of this in relation to political forces, and social forces. So, we were aware that there were ingredients that need to be addressed, or put in perspective, to actually make a proposal into something real. For us the most practical approach was to actually put yourself into a real piece of space, into a plot. That's what our diploma (project) was about.

Shumi You wanted to be more direct. Where did that come from?

Nicolas I think it was from our education actually. It comes from the people you encounter during your studies and for us, that was the people at the Ecole d'Architecture Paris La Villette. We studied mostly in Strasbourg, and then at Paris La Villette, where there was a strong 'art' character. In Paris, the teachers were 'soixante huitards', those from the '60s who were making interventions, performances, installations. And we took all of that on board – to actually deal with real situations.

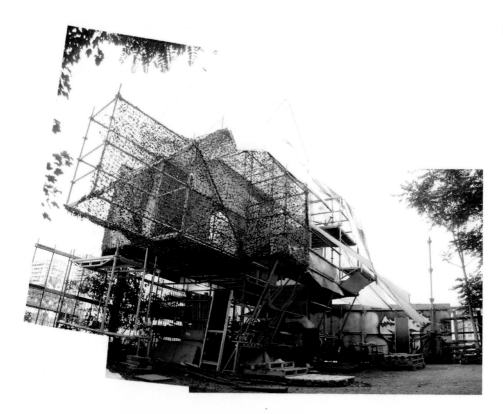

Fig 7.1 RAB Diploma Project, Paris, 2003 (EXYZT)

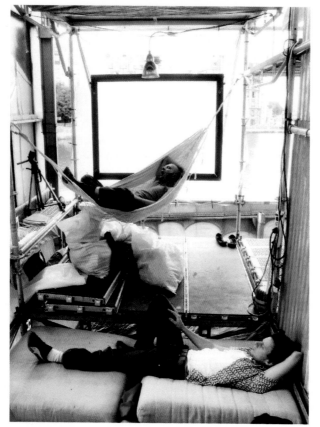

Fig 7.2 RAB Diploma Project, Paris, 2003 (EXYZT)

Shumi Bose

The site for our Diploma Project belonged to a public institution, the Parc de la Villette, in the urban periphery of Paris. We started thinking at a scale that quickly became much bigger. I remember we used to refer to this image that every kid in France knows from *Asterix*. One of the first pictures is the map of France. And then you have this tiny village there within the Roman Empire *[laughs]* You zoom in on it, like the famous video from Eames ...

Shumi *Powers of Ten* (1977)?

Nicolas Yes, the zoom. I'm always fascinated by that.
 Our Diploma Project was really the foundation and the framework for how we would later develop a 'protocol' for how to intervene – which was to inhabit the space. To really interact with it. To create an inhabitable, living structure that allows you to spend time on site. And from that structure, be able to interact with the surroundings and the local dynamics. As mentors in this first project we got the chance to work with Patrick Bouchain and Xavier Juillot who responded to our invitation. Patrick Bouchain, because of his politically engaged and humanist philosophy of architecture 'made by people for the people'. And Xavier Juillot for his in situ interventionism, experience and philosophy.
 For our first project, it was really clear where we had to begin – to build our 'house', and to see how to define our personal space. So we left our apartments, and we moved completely into that site.

Shumi When you say 'we', how many of you were there at this point?

Nicolas We were five. You know, a little group of architects.

Shumi So you built a kind of *'existenz-minimum'* dwelling space.

Nicolas Yes, in a little plot of land within Parc de la Villette. It was an unused space.

Shumi You were squatting?

Nicolas No, no. We had permission, we had to ask the Parc de la Villette if we could use it. But that was pretty easy because we were students, so it was like an arrangement between two institutions, an educational and then a cultural institution.

Shumi That kind of framework helps.

Nicolas It helps, completely, of course. If tomorrow, any student would want to do something like this, if their institutions can back them – it is much easier for them.

Shumi So then let's talk about the next phase: at a certain point you were starting to initiate projects on your own? Without that university framework? How did that go?

Nicolas For a lot of our projects, there was always some sort of organisation. We would normally get a piece of land commissioned by a developer, or an organisation like a municipality. They would 'open the door' of some spaces, so to speak. On Union Street (London, 2008–2014), for example, it was private land – so it was a private landlord who opened the site and

in that case it was also backed by The Architecture Foundation. In another project, the connections came through a trip to Latvia, where I met some people who were in the early phases of developing a cultural space within this neighbourhood so it happened organically. And then, another situation, I met some people in this crazy situation living on ex-military base. I thought, wow, that's great! I kept on going there, and tried to self-initiate projects with them.

Shumi How did you find ways to talk about yourselves and what you do?

Nicolas At that time, I tried to meet a lot of the new collectives and groups forming around Europe, (for example, raumlabor in Berlin), and participate in workshops. Not only in architecture, but also 'hack-space', or 'designer-hacker' collectives. It was the early 2000s and we were all talking about 'open-source', and 'open-city' using the same language but with different mediums. Some developed pervasive media technologies, while others like us were discussing and developing architectural tactics.

Shumi It sounds like you were basically constructing a language, a new language to be able to talk about your work.

Nicolas Yes sort of ... But also creating our own tools, both from a discursive point of view but also from a technological point of view. Being five different characters from the beginning, each of us worked out our own views, and tools. For example, François Wunschel was really into coding and later created '1024 Architecture' with Pier Schneider. In all our conversations and exchanges, we had our different points of interests.

Shumi But you never felt, across the five of you, any pressure to use that formal architectural education to do more 'proper' practice?

Nicolas Maybe one or two of us felt a bit more attracted to 'proper' architectural practice, but we had other money-making activities – like producing CGIs (Computer Generated Imagery) for other 'proper' practices. In the early 2000s there were not so many people who could do that, and as a freelancer you could easily find some work, or a job. Because we needed to pay the bills, you know?

Shumi So presumably your architectural education gave you some skills that you could use for money. But also, some ideas that you could exercise, maybe not for money?

Nicolas Yes, exactly. So that's also why the EXYZT project stayed the way it was, pretty organic, because we didn't have the pressure to turn it into an office. To be able to do these kind of projects, we were all working as freelancers, so suddenly we brought these two together. We created a limited company to sell these CGI renders. Through the CGI company, we could pay the rent of a studio in Paris, and gather a team around us who were also self-employed – in music, in photography and so on. They were paying their share of rent towards the studio too, and were participating in EXYZT projects.

Shumi Fantastic. Like a market cooperative.

Nicolas Yes, it was capitalistic – *and* cooperative. We had to earn enough money to be able to pay for some free time. Even now when teaching students,

I always tell students this – it is crucial to be able to earn enough money and to make time.

Shumi Were you told this at school when you were studying, did you discuss things like working practice and money?

Nicolas Yes, when we had the chance to talk about it. Now, discovering the education system here in London, where you have a student loan and where what you earn needs to cover that, it's hard to see how the sums add up. There are economists who can show how the system controls students; places them into such a situation that they don't have the freedom of choice of how to work.

Shumi Can you speak a bit about the political agency of your practice?

Nicolas The political 'tag' in EXYZT – the 'motto' – was really 'Do It Yourself'. Really, on every level, from the fabrication of your house to being able to hack and code. One of our teachers, Xavier Juillot who helped us in our diploma, was really into that idea. Particularly pushing us to look at the 'production' of architecture, and the way that always depending or relying on others removes you from the ability to create your environment. I think this was a really strong statement for us. It was about the self, you know, "you self-build, you build yourself."

Shumi Was it something for you yourselves? Or was this also an idea that you wanted to give to people who are using the space: "You can build your XYZ, your reality"?

Nicolas Yes. First you build for yourself, and then you are able to share that knowledge you learnt – that was the whole point. Did we succeed? Not sure. Not all the time. But as long as we could do it, all the spaces that we have produced – these spaces would become like 'free zones'. This was 'in between' space, not categorised as private or public, completely blurry.

Shumi Can you explain the Union Street Project?

Nicolas Yes, sure. It's closed now, but it was great space to build and also to teach in, to show how these projects can be possible in London. Union Street started right after our the MetaVilla installation at the Venice Architecture Biennale in 2006. Ricky Burdett was the overall curator of that Biennale, and his team for the Biennale were all from London. One of them was Sarah Ichioka, who later went on to direct the Architecture Foundation in London. In Venice we also met Sara Muzio, and from 2007 together we got in touch with the Foundation, and with Sarah Ichioka, to imagine a project for the London Festival of Architecture (LFA). And so, the protocol was the same as usual – first to locate the spot ...

Shumi And how did you do that?

Nicolas We walked around! For the London Festival of Architecture, the Architecture Foundation was curating the South Bank of the Thames. We went with the curator, Elias Redstone, and wandered from Borough Market to Waterloo and saw a few sites along Union Street. It turned out that Roger Zogolovitch from Solidspace and Lake Estates was a supporting figure of the LFA and was keen to offer us the temporary use of a site he owned.

Shumi Was that the first time that you had played with a commercial real estate developer?

Nicolas Yes, before that our projects were usually curated festival type events, like the Biennale. Or for cultural institutions, you know?

Shumi How did you navigate dealing with a commercial developer?

Nicolas Well, Roger is also an architect, and on the quirky side, rather than a boring type of developer. He was up for it. He was happy to see new things experimented, and hopefully it was not going to cost him too much to let us do that.

Shumi The first year that you worked on the site – this was the rather ambitious Southwark Lido (2008), right?

Nicolas Yes, the Lido was really short. Partly because of the short time frame legally allowed, without having to submit a planning application. So the whole project needed to be less that one month, from day one of construction to the last day – one month. We took this literally, as an exercise, or a challenge. Two weeks to build, two weeks the Lido is open, and one week to take it down.

Shumi But I guess at that time you didn't know that your work on Union Street would carry on for a few years?

Nicolas Right. If we knew, we might have just done the planning application! If I had known more about the technicalities and the advantages of having a full planning permission, I might have argued that it doesn't take much more to say, "we are going run the space for two months, rather than two weeks."

Shumi When did it develop from this one month project to something more substantial?

Fig 7.4 Southwark Lido,
London, 2008 (EXYZT)

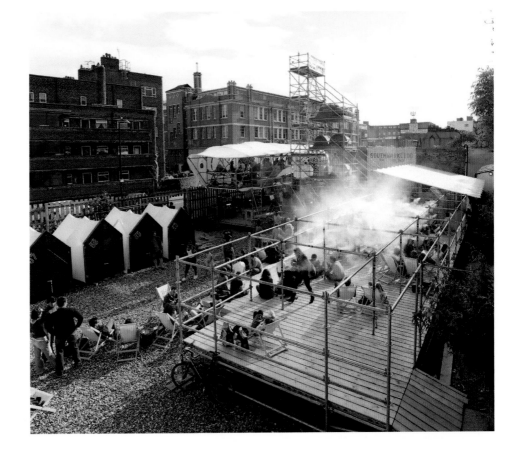

Nicolas Well, that all happened 2008. Two years later, the Architecture Foundation
and Roger got in touch again. The original project had been successful,
it worked well, you know. Everyone was happy. So, two years after they
said, well, why don't we do it again? Copy–Paste. So, we came back to do
'The reUNION' in 2012 (with Sara Muzio, as a co-production with Roger
Zogolovitch). But the site was used again afterwards, with other commis-
sions, between 2008 and 2012. The first was from Wayward Plants: the
Union Street Orchard. They did another project in 2011 as well: the Physic
Garden. So in the end, the site became this space which had the 'paper-
work' to do projects. In terms of legalities, people knew how to deal with
that, and for the Architecture Foundation, it was perfect commissioning
ground.

Shumi You had many things already set up in this next iteration: trust, a local
logistical team, institutional support – and the knowledge of the site as
well. Which do you think was the most successful version?

Nicolas What was great in the first version, the Lido, was that we, in a way,
opened the 'gates' of this space – to allow something else to happen, and
for others to take it on as well. Even if it was not the ideal situation, and
not enough time, it was a 'demonstration'. With 'The reUNION', it was
more mixed. It was less striking as an architectural piece but there was
something ongoing. The group had become quite large – both EXYZT, but
we had also gathered lots of different people. We were not running as an
agency or an office – it was just a potential 'crowd' that we could reach

Conversation: Nicolas Henninger, EXYZT 83

Fig 7.5 City Island, Madrid, 2010 (EXYZT)

out and invite in. People we knew, who would be ready to come in on the next project, the next adventure.

So the other issue was "How do we design in that moment?" You know, that collective moment – is it one or two people who decide everything, and then everyone finds a role in that? The question about how you could do a collective project was really important. And 'The reUNION' was really open, in the sense that we really created a large space with a strong narrative, and then people chipped in different ideas, and donated their time to the project.

Shumi We should also address the fact that EXYZT has now ended. You made a decision to stop after ten years, it would be good to hear about this practice 'lifecycle'.

Nicolas Ten years is quite a long time … you evolve and change from what you expected when you came out of university. At first, maybe you need to be close to each other, as fellow students, then as young fellow professionals for some solidarity. We had a momentum, I would say, until MetaVilla (2006). Part of the group felt strongly that it had to stay organic, that we needed to keep certain freedoms. And I was always defending that the project shouldn't be economically driven. Some thought that we needed strong leaders rather than a horizontal decision process … And so, all of these people had to reflect on how they might deal with that large group. But what was obvious was that people evolved individually through these ten years. How they project themselves into the group, what they project for the group, or for themselves as well. So that creates all sorts of situations of conflict. Which can be super productive if you create a set of rules for these conversations to happen, you know? So we tried to get this collective conversation going. But it was really tiring.

Shumi So was there a crystallised point where you guys decided, "Okay, that's it."

Nicolas Oh, yes. It was one moment. At some point, everyone agreed ... we all wanted different directions, different things. And then one is living in London, and then "Good luck to you in Berlin," others moved to south of France for their family....

Shumi Sure.

Nicolas A part of the group went to Montpellier and got the opportunity to make an exhibition of EXYZT work – so we all thought, "well that's it let's take this opportunity to officially end the collective." So that's what we did, in 2015. And we had this momentum of reflecting, and getting together a last time.

Shumi What was possible in the large group that is not possible now independently? And what is possible now, that was not possible in the large group?

Nicolas: I think the way you evolve, at some point, you just need to face you want, you know ... your own practice. I think that's my personal point of view on this. That is, I wouldn't choose to go back to the large collective. After a strong collective experience like that, you need to somehow reinvent yourself.

Shumi That makes sense.

Nicolas But that's good, you know? You are a bit more in control. You don't have the richness of debate, but at least you're in a position to take decisions and see their effects

Shumi Going back to an earlier question, we identified the tools you liked to use. When I say tools, we could think maybe more esoterically. For example, the networks that you make organically, it seems like this is one very important one?

Nicolas Oh, yeah. I guess for us, one tool was having a meal together, you know, having big dinner together.

Shumi Fantastic.

Nicolas So maybe the table was the tool, you know, to gather the people around. That was really important, because in each project, that was the moment where we would discuss things, at lunch, a break in the middle of the day. Or in the evening, with a bit more wine. Yes, the moment around the table, with wine and cigarettes, was very important.

Founders of EXYZT

Nicolas Henninger, as E
Philippe Rizzotti, as X
Pier Schneider, as Y
François Wunschel, as Z
Gilles Burban, as T

Members

Sara Muzio, architect and film maker
Christophe Goutes, artist

Conversation: Nicolas Henninger, EXYZT

Dagmar Dudinsky, graphic designer
Alexander Roemer, architect and carpenter
Gonzague Lacombe, graphic designer
Stéphanie Grimard, architect
Brice Pelleschi, photographer
Mattia Paco Rizzi, architect
Raf Salis, master technician
Manu Macaigne, carpenter
Fred Keiff, architect and artist
Daya Bakker, architect and carpenter
Bruno Persat, artist and cook
Julien Beller, architect

EXYZT was an association under the French Legislation 1901.

Shumi Bose

8 Reclaiming the city

Bottom-up tactical spatial practices and the production of (social) space

Oscar Brito

There is an increasing awareness from those involved in processes of urban regeneration about the need, opportunities and challenges for promoting and nurturing the participation of local communities as stakeholders. However, there is often the assumption that local communities are passive subjects that need to be involved in a controlled way in the plans and projects initiated and delivered by spatial practitioners and developers. Such assumptions imply a lack of recognition of the agencies that local communities might have in such processes and their social and political implications, not just by the practitioners or developers, but also by the communities themselves. Conversely, there could be more awareness by local communities themselves, of the potential effect that their participation and engagement in processes of urban regeneration might have in the development of their own social and spatial agencies.

This chapter discusses the conceptual implications of the engagement of local communities in the production of their space. The discussion will be articulated with a brief introduction of a relevant political context, followed by the development of a theoretical argument mainly focused around the ideas of Henri Lefebvre about the 'production of space' and 'the rights to the city', which will be related to the analysis of a case study, the community-led urban regeneration at Granby Four Streets in Liverpool, UK.

The participation of local communities in the definition, planning and implementation of urban regeneration processes and their related social impact has often been hindered and inhibited by real or perceived barriers such as institutional, legal and financial frameworks that usually reinforce mechanisms of top-down governance and power structures. The current implementation of models of representative democracy, based on the ideas of the 'social contract' (Purcell, 2003, p. 565) and the inherent delegation of decision-making and governance, generates situations of clientelism that are often instigated and perpetuated for political aims. This has traditionally led to an increasingly passive approach from local communities in relation to their urban environment, expecting their needs to be addressed by public institutions and consequently resulting in a lack of vision and means to assert their own urban agency. For Colin Ward "policy assumes that people are helpless and inert consumers and ignores their ability and their yearnings to shape in their own environment. We are paying today for confusing paternalistic authoritarianism with social responsibility" (Ward, 1985, p. 10).

Is there a context for a 'Big Society'?

The recent financial and political crises, and their effect in the implementation of austerity policies, have increased the need, but also the opportunities, for socially responsible local activism and entrepreneurship. The emphasis on deficit control at different institutional scales, from the central government to local authorities, has pushed the public sector to radically scale back the provision of a wide range of public services demanding an increasing involvement of the third sector. In the specific case of the UK, in the aftermath of the 2008 financial crisis the conservative government promoted certain acts and policies to support the transfer or 'devolution' of power from central government to local governments and local

communities, through the neoliberal idea of the 'Big Society' and polices related to the Localism Act 2011. In his speech on the agenda of the Big Society, David Cameron identified three big strands: 'social action', stating the intention of the central government to "foster and support a new culture of voluntarism, philanthropy, social action"; 'public service reform', promoting the involvement of "new providers like charities, social enterprises and private companies" in the provision of public services; and 'community empowerment', stating the need to promote the feeling within communities and neighbourhoods that "if they club together and get involved they can shape the world around them," involving "the most radical shift in power from central government to neighbourhoods." For Cameron, building the Big Society, therefore, implies a "huge cultural change" (Cameron, 2010) in a way that would contribute to the long-standing neoliberal ambition of "building a leaner, more efficient state" (Cameron, 2013).

The promotion of the Big Society and the Localism Act 2011 were both intended to provide legal, political and financial frameworks to empower local councils and local communities to directly decide and act on a range of issues that directly affect them. From an optimistic point of view, such an approach could be argued to be related to the promotion of a higher degree of citizen participation, as defined by Sherry Arnstein (1969), moving beyond the usual tokenism, delegating power back to local governments and communities and aiming to enable a proper citizen control while reframing, and often reducing, the involvement of central government and the state. However, both the Big Society and the Localism Act 2011 were controversial in their intentions, feasibility and implementation. The actual roots of the Big Society can be linked to the Conservative affiliation to Red Toryism and libertarian paternalism, 'nudging' the third sector to engage in their empowerment whilst stepping into the same playing field as the private sector, thus encouraging a (neoliberal) way of thinking that is aligned to logics of the market economy (Corbett and Walker, 2013). The promotion of the Big Society was perceived as a deceptive neoliberal attempt to reduce the involvement and responsibilities of the state by passing many of its duties to the third sector, particularly in volunteerism, without fully providing the necessary support and resources for this. According to Jules Pipe, then mayor of Hackney Council in London and chair of the London Councils, the Localism Act was often a "cost-shunting exercise", devolving responsibilities without the necessary means or resources; however, it has shown that a "more radical approach" is needed in times of austerity (Pipe, 2013).

Even considering the issues and controversies related to the definition and implementation of the idea of the 'Big Society', it is worth exploring and analysing its potential and implications of reframing the social, political and spatial agencies of local communities. The promotion, and in some instances support, of individual and collective engagement in processes of planning and regeneration, and more generally in the development and improvement of their built environment, could be seen as an attempt to produce a framework for the development and reinforcement of meaningful stakes by local communities on local spatial conditions, having potential ontological repercussions in the way citizenship is defined and developed.

The production of space as the production of urban citizenship

Traditional political systems frame citizenship as a legal status, granting rights and duties based on the participation in implicit or explicit social contracts related to structures of power (Purcell, 2003, p. 565), which could be affected by conditions such as hegemonies, domination and 'clientelism' that inform, and are informed by, the spatial settings in which such citizenship is performed. However, there are alternative views to the idea of citizenship related to the way we develop our relation to the city which consider urban environment and phenomena as the physical, conceptual and relational realms where our social and political identities are developed. Political philosophers and geographers, such as Henri Lefebvre, Edward Soja and David Harvey, advocate for ways of developing and asserting citizenship

through people's participation in spatial practices, attempting to develop conceptual frameworks to analyse the relation between the production of the physical, conceptual, social and political spaces and the definition of our social, political and urban identities and agencies.

For Henri Lefebvre, spatial practices are related to the production of the space defining the spatial settings of a social formation and consequently also the definition of its social space (Lefebvre, 1991). Edward Soja further developed the relation between the production of the material and social spaces, defining spatial practice as "the process of producing the material form of social spatiality, [it] is thus presented as both medium and outcome of human activity, behaviour, and experience" (Soja, 1996, p. 66). According to Lefebvre, spatial practices are also defined as the relation between the different scales of spatial conditions, including the individual 'daily reality', our everyday routines, as well as the 'urban reality', that frame the way we experience the city (Lefebvre, 1991, p. 38). These definitions of spatial practices have been formulated as part of a conceptual triad that Lefebvre originally developed which includes the previously explained spatial practices: representations of space (the intellectual conceptions, and therefore representations, of space that often control its configurations); and spaces of representation (also explained as the lived space, the direct experience of it). The analysis of the relation between spatial practices and the lived spaces of the spaces of representation is relevant to attempt developing a theoretical framework of the potentials and implications of the participation of local communities in the production of their (social) space.

For Lefebvre, the spatial practice of a society "secretes that society's space; in a dialectical interaction; it produces it slowly and surely as it masters and appropriates it" (Lefebvre, 1991, p. 38). Therefore, the engagement of local communities in spatial practices could be approached as a process that could have potential ontological and epistemological implications.

The ontological relation between the way we inhabit space, our engagement in the production of space and the production of meaning and identity was also developed by Martin Heidegger in his essay "Building Dwelling Thinking". Through an 'etymological mining' (Sharr, 2007, p. 37), Heidegger establishes a system of relations between the original meanings of the words 'building', as our transformative acts on our environment, 'dwelling', as the performative acts through which we inhabit a place, and the ontological implications of the meaning of our 'being' in a place. Heidegger relates the way we dwell to the way we perform our existence in a place and, therefore, to the way we are and to the way we inform our identities. Furthermore, according to Heidegger, "the old word *bauen* which says that man is insofar as he *dwells*, this word *bauen*, however also means at the same time to cherish and protect, to preserve and to care for" (Heidegger, 2001, p. 145). Through his analysis, Heidegger relates the acts of building and dwelling with the act of 'care for', emphasizing the value of our actions in the development of a constant nurturing of our attachment to a place.

Urban citizenship and the right to the city

Heidegger's ontological connections between dwelling, as proactive inhabitation, our attachment to a place and the definition of our identity, could be related to the ideas of Lefebvre and David Harvey about urban dwelling and 'the right to the city'. Making reference to Heidegger, Lefebvre explains that being an urban dweller, a citizen, implies more than the fact of living in an urban settlement, emphasizing the need 'to inhabit'. For Lefebvre, the act of inhabitation by an urban dweller has broader social implications, as "'to inhabit' means to take part in a social life, a community, village or city. Urban life had, among other qualities, this attribute" (Lefebvre, 1996, p. 76). For Lefebvre the 'right to the city' is developed by people's relation to the production of space, in its physical, conceptual and experiential aspects in their everyday lives. Lefebvre refers to the everyday relation between the

urban dwellers and the city, the act of inhabitation, as a creative endeavour, considering the city as an 'oeuvre' (Lefebvre, 1996, p. 154). For David Harvey, the right to the city is "a right to change ourselves by changing the city", which could be only approached as a collective endeavour (Harvey, 2008).

Lefebvre relates citizenship (*citadin*) to the condition of being an urban dweller, establishing a relation between urban dwelling and political consciousness (Lefebvre, 1996, p. 77). Lefebvre defines the 'right to the city' as a "cry and a demand" (Lefebvre, 1996, p. 158), an urban citizenship that may be developed through two mutually defined urban rights, which could be also read as duties, those of appropriation and participation (Lefebvre, 1996, p. 174). Appropriation for Lefebvre is not related to ownership of property but to a transformative act, similar to Heidegger's interpretations of 'building', to individual and collective desires that maximize the use value for residents (Lefebvre, 1996, p. 180), re-imagining and re-defining the production of space. Participation is related to the right of taking part in decision-making processes about the transformation of the urban environment which Lefebvre relates to governance and the principle of 'self-management' (Lefebvre, 1996, p. 145) in a way that could be linked to what Sherry Arnstein defined as 'Citizen Control'.

David Harvey, in the introduction to his book *Social Justice and the City*, first published in 1973, proposes some definitions to 'the nature of space' in an attempt to develop a conceptual framework to understand the relations between urban phenomena and society, emphasizing the relative and relational aspects of space. The development of the 'rights to the city', considering the city as the spatial, social and political territories of the collective, implies an engagement in processes of the production of space, in its material and social aspects, which are contingent and relational, and therefore affectable.

Tactical spatial practices and the production of social capital

The ideas of Lefebvre in relation to the processes of appropriation and participation can be better explained in relation to place-making and a more specific approach to it, tactical urbanism. Place-making could be defined as a participatory process of incrementally improving the quality of a place (DUSP MIT, 2013). Place-making involves collaborative processes of participation and appropriation around shared and feasible goals, fostering the generation and reinforcement of opportunities of interaction and exchange within local communities, promoting their civic engagement and empowering through the development of a spatial agency. The reciprocal improvement of the spatial conditions and the quality of life of local communities by their own collective endeavours, particularly in relation to their public and social realms, nurtures a local bounding and attachment, a sense of dwelling, being and care, and therefore a meaningful inhabitation as explained by Heidegger and Lefebvre. Such involvement in the production of space, by collectively appropriating the urban environment as an *oeuvre*, thus asserting our rights to the city, fosters the generation of a shared civic pride that may have social and political implications.

The collective engagement in place-making processes, in the making of places, facilitates the production of social capital, which is defined as the production of "connections among individuals – social networks and the norms of reciprocity and trustworthiness that arise from them" (Putnam, 2000, p. 19). Furthermore, the production of social capital through the production of space provides a concrete experience of social networks and a sense of belonging, knitting the social fabric (Field, 2003). The relation between the development of citizenship and the engagement of individuals and communities in place-making processes, linked to the creation of an improved urban environment and the subsequent production of social capital, could have an effect on the capacity of those communities to negotiate the conflicts and tensions related to integration, inclusion and coexistence. According to Putnam, the production of social capital "enables a community to resolve problems and fosters awareness of the ways in which their fates are interlinked and

Oscar Brito

encourages to be more tolerant, less cynical, and more empathetic" (Putnam, 2000, p. 10). The production of space therefore becomes a relational medium, rather than just the main aim or outcome, of the reinforcement and empowerment of local communities, fostering their sustainability and resilience.

The term tactical urbanism has been used to denote a range of bottom-up temporary urban interventions which are characterized by their immediacy in terms of scale, processes and resources (Lydon and Garcia, 2015). These interventions are aimed to reclaim and 'appropriate' the use of public space by planning and implementing tactics, which could be defined as "calculated actions" that "take advantage of opportunities and depend on them" (De Certeau, 1984, p. 36). The participation of the local communities in tactical urbanism is often initiated as response to gaps and issues in the official urban planning and provision. The engagement in devising and developing actions related to tactical urbanism imply certain positioning against the constraints of an existing urban setting, its potentials and issues, therefore providing the physical, conceptual and even discursive means for the local communities, as stakeholders, to "span the boundaries of democratic participation in urban development processes" (Dean, 2018).

The production of differential spaces and the emergence of 'counterspaces'

Tactical urbanism has been defined as a kind of spatial practice that "embraces an ethic of experimentation and human togetherness to show that alternative ways of being, acting and doing are possible" (Walter and Earl, 2013, p. 147); therefore, the engagement of local communities in such practices offers the means of production of social capital whilst exploring the production of their own social spaces, informing their own lived space. For Edward Soja, the lived spaces are the spaces where perceived conditions of subjection and domination 'overlay' the physical space produced by spatial practices, and therefore are those spaces where the real, the lived and the imagined collide. For Soja, this overlay is the fertile ground for "the generation of 'counterspaces', spaces of resistance to the dominant order arising precisely from their subordinate, peripheral or marginalized positioning" (Soja, 1996, p. 68). The self-initiated and self-managed aspects of tactical urbanism offer local communities opportunities of producing alternative, even if ephemeral, spatial and social settings that, as such, can have certain experimental and even subversive quality from established urban and power structures, potentially producing, even if temporarily, 'counterspaces' that expand the conceptual and political frameworks for the production of space.

The feasibility of the emergence and development of bottom-up, community-led, spatial practices is often constrained by its relation to contexts controlled and dominated by centralized, top-down, neoliberal urbanism. It is mainly in the spatial and temporal gaps of the hegemonic control and governance over the spatial, social, financial and political organization of the territory, in interstitial situations of uncertainty, where such practices arise. It is "by exhausting non-monetary resources – such as derelict spaces, unofficial network and people power – these players succeed in inhabiting another form of city in zones that are temporarily unusable in traditional real-estate terms. Only here, beyond the controlled enclaves, can such temporary, informal and innovative practices unfold" (Oswalt, Obermeyer and Misselwitz, 2013, p. 11).

The interstitial conditions could be related to the relation between what Lefebvre defined as 'abstract space' and 'differential space' (Lefebvre, 1991, pp. 49–53). 'Abstract space' is defined and regulated by the logics of the neoliberal order, and therefore susceptible to be abstracted and commodified, prioritizing its exchange value. 'Differential space', instead, is informed by how its inhabitants use and appropriate it, prioritizing its social value. The differential space is "often a transitory space that can arise from the inherent vulnerabilities of the abstract space" (Leary-Owhin, 2015). In this sense, the emergence of the differential space

may be facilitated in the context of 'weak planning' (Andres, 2012) where the conditions expected by formal planning systems can't be produced. Furthermore, "weak planning is particularly fruitful for the appropriations of differential spaces as boundaries between legal/formal and illegal/informal activities are blurred as are the distribution of powers between the different stakeholders" (Andres, 2012, p. 7). The development of bottom-up spatial practices exploring those blurred boundaries could lead to the production of 'counterspaces', a powerful emergence of the differential space that could be related to the revolutionary potential of Lefebvre's concept of 'heterotopia'. According to David Harvey:

> Lefebvre's concept of heterotopia ... delineates liminal social spaces of possibility where 'something different' is not only possible, but foundational for the defining of revolutionary trajectories. This 'something different' does not necessarily arise out of a conscious plan, but more simply out of what people do, feel, sense and come to articulate as they seek meaning in their daily lives. Such practices create heterotopic spaces all over the place ... the spontaneous coming together in a moment of 'irruption,' when disparate heterotopic groups suddenly see, if only for a fleeting moment, the possibilities of collective action to create something radically different.
>
> (Harvey, 2012, pp. xvii)

For Lefebvre, "only social force, capable of investing itself in the urban through a long political experience, can take charge of the realization of a programme concerning urban society" (Lefebvre, 1996, p. 156). Therefore, community empowerment happens from within, from the ontological and epistemological transformations developed through engagement in processes of participation and appropriation of public and social spaces, and by exposure and interactions, through these processes, to expanded urban, social, political and financial networks. The engagement in processes of urban transformation of incremental complexity enables an increasing assertiveness in the way the local communities can participate in processes of urban regeneration and, consequently, in the way they interact with professional, corporate and public spatial practitioners and agents.

There is often the assumption that professional spatial practitioners have a fundamental role as initiators and promoters of processes of urban and social regeneration. In most cases, the social agency of architecture is overstated, for good or for bad, also by the public opinion and the media, in a simplistic understanding of the complexity of factors informing the social space. According to Lefebvre:

> The architect, the planner, the sociologist, the economist, the philosopher or the politician cannot out of nothingness create new forms and relations. More precisely, the architect is no more a miracle-worker than the sociologist. Neither can create social relations, although under certain favourable conditions they help trends to be formulated (to take shape). Only social life (praxis) in its global capacity possesses such powers – or does not possess them.
>
> (Lefebvre, 2012, pp. 150–151)

Granby Four Streets, seeding differential spaces and social capital

The case of Granby Four Streets (G4S) in Liverpool, UK, is a good demonstration of the necessary role of the participation of local communities in defining, developing and maintaining the social relevance and sustainability of regeneration processes. Granby is a working-class ward of Liverpool characterized by its multiethnicity. It suffered the effects of social and economic decline of the 1970s and the 1980s, and a sustained institutional racial and class discrimination and harassment which led to the Toxteth events in 1981, which were defined by government and press as riots, and as uprisings by the local community, followed by

Oscar Brito

years of 'managed decline', social fragmentation and cleansing by depopulation and dispersal. By the mid-2000s the City Council had managed to cleanse most of the properties in the area, emptying it of most of its original tenants, stripping the 'perceived social stigma' (Thompson, 2015) by demolishing the original Victorian terraces and replacing them, through urban regeneration programmes such as the Housing Market Renewal Pathfinder Programme, with generic lower density estates. Such 'state-led gentrification', aimed to a market-appealing neutrality of, using Lefebvre terms, the 'abstract space'. Only four of the original Granby streets remained, although in a rather dire state with houses still being emptied and boarded, within a general landscape of stagnation, dereliction and institutional neglect. Those Granby Four Streets remained, therefore, in an interstitial condition.

Such continuous social, urban and institutional disdain and exclusion made the remaining community develop its own social and political identity from within, as a way of resistance (Simon, 2018). It took one act of calm defiance, when in 2006 Eleanor Lee, a local resident, decided to appropriate the connection between her doorstep and the public realm by simply adding some plants, asserting her inhabitation of that in-between space with a display of care. That humble spatial practice prompted other residents to follow, starting from the practicalities of removing the junk and cleaning the area, to progressively reclaiming the street fronts and adjacent interstitial spaces through individual and collective actions of guerrilla gardening, urban art and tactical urbanism.

Once the public areas in front of the houses were cleaned, there was an increasing qualitative transformation of the public space into a social space, with residents opening their doors, taking tables out, engaging in conversations, and even setting their own street market, going out from their private backstage to the (shared) frontstage, hence visualizing the community (Simon, 2018). The evidence of their spatial agency, against the real and perceived institutional disdain, reinforced their

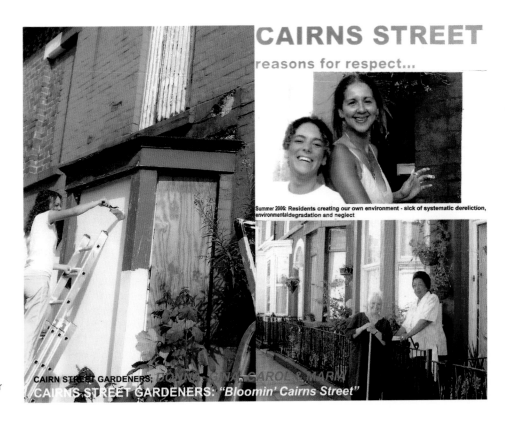

Fig 8.1 Granby Four Streets community – reclaiming their space, 2006 (Eleanor Lee)

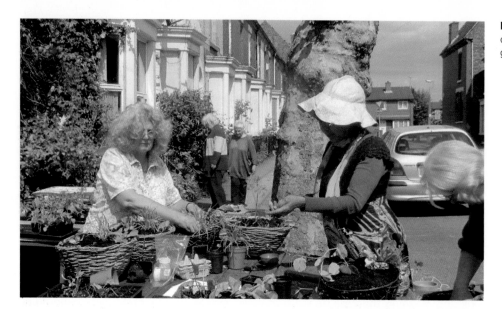

Fig 8.2 Granby Four Streets community – guerrilla gardening, 2008 (Eleanor Lee)

urban and political identity, promoting a sense of self-managed urban commons. Their collective participation in the transformation of the social realm, through their engagement in spatial practices of participation and appropriation, fostered the production of social capital and civic pride (see Figures 8.1 and 8.2).

The reclamation of the space left in the interstices of the abstract space and in the context of 'weak planning' triggered, but also enabled, the appropriation of the production of space by the local community through their use of it and their engagement in its qualitative transformation. Such prioritization on the value for the use of the community is aligned to the production of what Lefebvre defined as 'differential' space, and what Soja defined as 'Thirdspace', as space of physical, social and conceptual confluence, an alternative "way of understanding and acting to change the spatiality of human life, a distinct mode of critical spatial awareness that is appropriate to the new scope and significance being brought about in the rebalanced trialectics of spatiality–historicality–sociality" (Soja, 1996, p. 57).

This subtle, community led, process of regeneration of the G4S started whilst the City Council was still outsourcing a formal regeneration of the area to private developers. The simultaneity of those processes created further tensions with an initial reluctance from the Council to engage with the local community, likely considering such engagement counterproductive to their top-down deterministic approach. Following the financial crisis of 2008, the top-down programmes of urban regeneration came to a forced halt, leaving the local government and private developers out of cash and ideas. This created a failure in the formal planning system, accentuating pre-existing conditions of 'weak planning', fading-out any remaining hope from the local community about the role of the local authorities in addressing the structural drivers of urban stagnation, such as the rehabilitation of the empty and often derelict properties in the area.

In this context, the communal and enterprising mindset developed in the local community so far, made them seek ways to upscale their tactical actions into a more ambitious endeavour of taking ownership of the regeneration of the derelict housing stock in their streets. Exploring alternative ways of accessing landownership, in 2011 the community decided to adopt the model Community Land Trust (CLT), forming the Granby Four Streets Community Land Trust (hereafter G4SCLT). The CLT is a legal mechanism, set up as part of the government Localism Act, and therefore related to its support for the Big Society, through which local residents may get access to land ownership to develop housing and regeneration projects

Oscar Brito

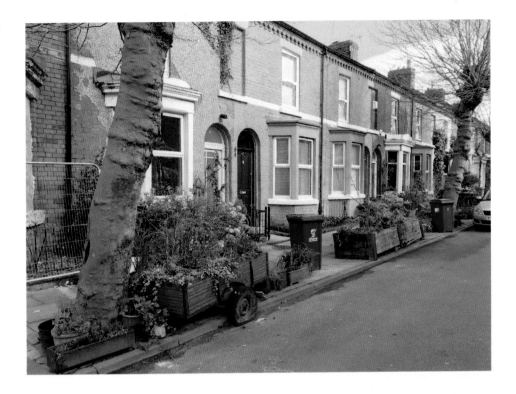

Fig 8.3 Granby Four Streets Community Land Trust, Liverpool, 2018 (Eutropian)

for the interest of their community. The model of the CLT is particularly relevant in the UK as it is aligned to the local model of land ownership, which is detached to the ownership of the buildings constructed on the land, as the land is leased rather than transferred; therefore, allowing local communities to keep a degree of ownership and control of their urban contexts, possibly preventing its commodification (see Figure 8.3).

In the case of G4S, making the most of the CLT was initially beyond their organizational and financial reach (Simon, 2018) but the specific contextual background and situations of G4S became a crucial enabler. The insurgence of the community of G4S against the odds of the urban neglect, their engagement in reclaiming their space and their lived space, attracted the attention of external actors and networks including fundamental financial support from a private investor (HDSI). Having secured financial backing, G4SCLT was perceived by the local government not just as a group of community activists, but as a proper urban developer, engaging in discussions that resulted in the transfer of ten properties at G4S to the G4SCLT, and therefore triggering a proper bottom-up urban regeneration process. Since then, the agency, networking and the visibility of the G4SCLT have continued to grow, including the appointment of Assemble and increasing their access to further support. Now the G4SCLT may evolve to expand their actions within their local community, providing local services to further ensure their resilience in face of the government cuts and austerity policies (Simon, 2018), hence promoting a more comprehensive model of self-reliance. "seeing how we became a group of friends, who improvised pragmatically around what was possible over several years and have achieved, with help, more than we'd thought we ever could. It's been great. And continues" (Ronnie Hughes, founding member of the Granby Four Street Community Land Trust).

The need for double agencies

In the 'right to the city', Lefebvre advocates for "a political programme of urban reform not defined by the framework and the possibilities of prevailing society or

subjugated to a 'realism'" (Lefebvre, 1996, p. 155). In this sense, the engagement of bottom-up spatial practices in tactical urbanism faces some risks in its relation to the neoliberal project. There are risks of being limited to the production of palliative solutions to urban issues linked to conditions of 'weak planning'; to a failure, or even refusal, of delivery from the formal planning procedures in the context of neoliberal austerity (Brenner, 2016); this may be the case in the context of the Big Society and the Localism Act, where there is an expectation for the local communities and the third sector to take over the provision of services that the central government is no longer able, or is no longer prioritizing, to provide. Giving access to local communities to become players in planning processes without providing the right structural and financial resources and support could be seen as a sophisticated tokenism rather than actual citizen-control. There are also risks of being commodified in the context of urban gentrification, where the endeavours of the local communities could be absorbed, or even hijacked, by formal urban agents, such as urban developers, shifting frameworks of value and control from the ethical and communal, to the aesthetic and financial, capitalizing the allure of urban 'authenticity' as a way of compensating the homogenization typical of the 'abstract space'. This is the case of the use of pop-up interventions that mimic temporary urbanism for commercial and promotional uses; and of the use of 'place-making' as slogans to qualify the impact of generic urban developments in a context, often following a process of social and urban cleansing.

The potentials and challenges arising from the bottom-up, collaborative engagement in spatial practices pose key questions about the role of professional spatial practitioners, as facilitators of those practices and as mediators of the dialectics between bottom-up and top-down spatial practices and forms of urban governance. The obvious challenge for the practitioners, considering their usual affiliation to the systems than enable their production as well as the ingrained notions of control and authorship, is how to position themselves in these scenarios and, consequently, how to define their role, and as such, their practice. A potential understanding and approach to the dialectics and tensions between bottom-up and top-down systems is proposed by Eileen Conn based on the 'complexity theory', where different systems which share and contest a 'social eco-system' can avoid the assertion of hegemonies by exploring interactions in an in-between 'space of possibilities'. The space of possibilities could be understood as a heterotopic space, as defined by Lefebvre and Harvey, where the 'adjacent possible' between the different systems could be explored (Conn, 2011). The role of spatial practitioners could be, then, to explore their capacity of negotiating the 'space of possibilities' and of exploring the 'adjacent possible' that would articulate the relations between the two systems, facilitating and empowering, without fully compromising or distorting, the potential that bottom-up practices could have in imagining and developing active citizenships, citizen control, articulating a meaningful participation and appropriation of the production of the social space.

In the context of increasing desire and need of meaningful participation by local communities in processes of urban and social regeneration, there is also an increasing demand, and opportunity, for spatial practitioners to engage in the complex endeavour of developing a double agency. Thus, to develop practices that can facilitate and negotiate open and experimental ways of bottom-up engagement in spatial practices, whilst simultaneously engaging in the production of urban, financial, legal and political frameworks that could effectively enable those participatory practices, beyond interstitial conditions. The role of the spatial practitioners would be, therefore, to promote a 'fundamental change of culture' not just in the communities and the third sector but, more importantly, at the governmental institutions, in order to foster and enable the production of a real 'Big Society'.

Bibliography

Andres, L. (2013). Differential spaces, power hierarchy and collaborative planning: a critique of the role of temporary uses in shaping and making places. *Urban Studies* 50(4), 759–775. First published online 13 August 2012.

Arnstein, S. (1969). A ladder of citizen participation. *Journal of the American Institute of Planners*, 35(4), 216–224.

Brenner, N. (2016). Is tactical urbanism an alternative to neoliberal urbanism? In Brenner, N., *Critique of Urbanization*. Basel: Birkhäuser Verlag, pp. 128–146.

Bundell-Jones, P., Petrescu, D., Till, J. (eds) (2005). *Architecture and Participation*. Abingdon: Spon Press.

Cameron, D. (2010). *Big Society speech*. [online] The National Archives.

Cameron, D. (2013). *Lord Mayor's Banquet speech*. [online] The Telegraph.

Chakrabortty, A. (2018). *How one community beat the system, and rebuilt their shattered streets*. [online] The Guardian.

Conn, E. (2011). Community engagement in the eco-system dance. In Tait, A. and Richardson, K. (eds) *Moving Forward with Complexity*. Litchfield Park, AZ: Emergent Publications.

Corbett, S. and Walker, A. (2013). The Big Society: rediscovery of 'the social' or rhetorical fig-leaf for neo-liberalism? *Critical Social Policy*, 33(3), 451–472. doi:10.1177/0261018312471162.

de Certeau, M. (1984). *The Practice of Everyday Life*. Berkeley: University of California Press.

Dean, M. (2018). *Strategies of community engagement: tactical urbanism*. [online].

DUSP (Department of Urban Studies and Planning) MIT (2013). *Places in the making*. [online].

Field, J. (2003). *Social Capital*. London: Routledge.

Harvey, D. (2008). The right to the city. *New Left Review*, 53, Sept.–Oct., 23–40.

Harvey, D. (2009). *Social Justice and the City*. Athens: University of Georgia Press.

Harvey, D. (2012). *Rebel Cities: From the Right to the City to the Urban Revolution*. New York: Verso.

Heidegger, M. (2001). *Poetry, Language, Thought*. New York: HarperCollins.

Hughes, R. (2018). *Granby 4 Streets*. [online] A Sense of Place.

Kamvasinou, K. (2017). Temporary intervention and long-term legacy: lessons from London case studies. *Journal of Urban Design*, 22(2), 187–207. doi:10.1080/13574809.2015.1071654

Leary-Owhin, M. (2015). *A fresh look at Lefebvre's spatial triad and differential space: a central place in planning theory?*. [online] Researchgate.

Lefebvre, H. (1991). *The Production of Space*. Oxford: Blackwell.

Lefebvre, H. (1996). *Writings on Cities*. Oxford: Blackwell.

Lydon, M. and Garcia, A. (2015). *Tactical Urbanism*. Washington, DC: Island Press/Center for Resource Economics.

Oswalt, P., Overmeyer, K., Misselwitz, P. (2013). *Urban Catalyst: The Power of Temporary Use*. Berlin: DOM Publishers.

Pipe, J. (2013). *Two years on, what has the Localism Act achieved?* [online] The Guardian.

Polyák, L. (2017). *Granby Four Streets CLT – From demolition to regeneration | Cooperative City*. [online] Cooperativecity.org.

Purcell, M. (2003) Citizenship and the right to the global city: reimagining the capitalist world order. *International Journal of Urban and Regional Research*, 27(3), 564–590. doi:10.1111/1468-2427.00467

Putnam, R.D. (2000) *Bowling Alone: The Collapse and Revival of American Community*. New York: Simon and Schuster.

Sharr, A. (2007). *Heidegger for Architects*. London: Routledge.

Simon, M. (2018). Interview with Oscar Brito.

Soja, E. (1996). *Thirdspace*. Oxford: Blackwell.

Thompson, M. (2015). Between boundaries: from commoning and guerrilla gardening to Community Land Trust development in Liverpool. *Antipode*, 47, 1021–1042. doi:10.1111/anti.12154.

Vulliamy, E. (2011). *Toxteth revisited, 30 years after the riots*. [online] The Observer.

Walter, P., Earl, A. (2013). Public pedagogies of arts-based environmental learning and education for adults. *European Journal for Research on the Education and Learning of Adults*, 8, 145–163.

Ward, C. (1985). *When We build Again: Let's Have Housing that Works!*. London: Pluto.

TWO SPATIAL PRACTICES OF INTERVENTION: MODES, MEDIUMS, OBJECTS AND AGENCY

9 The making of the Canning Town Caravanserai

Cany Ash and Ash Sakula

I am an architect. I ran my own practice for ten years and in 1994 formed Ash Sakula with my partner, Robert Sakula. We have been in practice ever since. Our progress does not feel homogenous but rather a series of start-ups, each driven by a desire to bring some structure to the random nature of our commissions. So, in the autumn of 2008, when our arts and regeneration projects evaporated with the global crash and we lost our amazing associates and staff, it was a shock but familiar from a lineage of previous external events. Architects are not indispensable, and the kind of projects our studio is known for demands broad consensus, reserves of optimism from clients and economic stability. With no work on the horizon we started again. We asked ourselves – what were we as architects without clients and budgets?

We had developed the tricks of reorganizing space and helping people to rediscover and reinvent existing buildings and had always been drawn to the 'do almost nothing' option in feasibility studies. The hiatus of 2008 gave us time to explore scarcity as a new lens for looking outwards: not as a puritanical challenge but as a way to find the freedom to practise differently, without the maddening inertia that clients often impose. We spun our own narrative, developing links with collaborators outside architecture, and businesses not so paralysed by recession. We had a large studio floor which we ran as a co-working space to help cover the costs of our tiny agile team. We could survive but to what purpose? We asked ourselves questions about our motivation. Why had we worked so maniacally on our projects, dragging them through the inevitable ruts towards delivery? It was not to turn space into abstract geometries, or intriguing minimalist works of photography. Our central ambition, we realized, was to make a space where communities defined themselves, where different rules were at play, where the temporary nature of a place would allow community to coalesce, not trying to simply draw from existing networks, but casting a new net to draw people together. Harvey imagines this kind of opportunity in *Spaces of Hope*:

> Challenging the rules of community means challenging the very existence of such a collectivity by challenging its rules. It then follows that communities are rarely stable for long. Abundant opportunities exist here for the insurgent architect to promote new rules and/or to shape new spaces ... Part of the attraction of the spatial form utopian tradition is precisely the way in which it creates imaginary space in which completely different rules can be contemplated. And it is interesting to note how the figure of the city periodically re-emerges in political theory as the spatial scale at which ideas and ideals about democracy and belonging can best be articulated.
>
> (Harvey, 2000, p. 239)

We loved an idea of shared space, belonging to nobody but effortlessly ready to host everyone. Public space had become a passion for many of our new friends in this period; many of whom were the 'social enterprise' generation keen to tackle social issues through energetic free thinking; finding unlikely overlaps between disciplines and economic synergies. Spatial practices were central to this spirit of disruption and bottom-up reinvention. These discussions inspired – and still

inspire – our work, opening multiple threads of architectural enquiry. We set out to prove the worth of ill-defined but energetically curated space.

This was the backdrop to the practice-based research we initiated through the Canning Town Caravanserai project which ran for five years from 2010.[1] Before describing the project in any detail, I need to share the reasons we embarked on such a large unfunded venture, and why we feel there is a crucial missing network of similar places: an entire contemporary social infrastructure that doesn't yet exist.

Social isolation and loneliness

Many of the old reasons for gathering and creating loose links with other citizens beyond a core set of family and friends are dwindling. New locally curated events and gatherings are urgently needed to combat loneliness and isolation. As architects, we need to champion this crucial piece of missing infrastructure in the city; spaces that are emotionally intelligent, robust and yet needy in themselves for neighbourhood action. We would argue these spaces should be deliberately unfinished endeavours, achieving moments of perfection at intervals in the eyes of active participants.

These kinds of messy social space are, through their improvised character, at times antithetical to certain funding regimes, but the social value they deliver is now well documented and recognized in policy. While the argument about how to manage the finances, kick-starting and sustaining successful ventures is still at large, unlocking capacity in communities and creating virtuous circles out of the intractable problem of urban isolation feels urgent.

Loneliness saps individual initiative and is particularly prevalent in rapidly growing cities. During the last century 'social isolation' has been one of the key concepts in sociology, specifically in relation to the new experiences of city life (Simmel, 1903), the decline of 'public space' (Sennett, 1974) and the consequent decline of social capital (Putnam, 2000). More recently, social isolation and loneliness have been reported in relation to the growth of digital connectivity (IoT Report 2017), and even through the appointment of a new Minister for Loneliness in 2018. It not only affects the old, who may be physically isolated and ignored, but also the young and middle-aged with all their apparent freedom. People can easily feel their sense of self and self-worth eroded by days spent in generic spaces, on and offline, their social life standardized along age lines and external expectations.[2]

Aerating and challenging the small or unsatisfying circles we may be living in is a creative act which protects our mental health. Digital networks have changed the way we think about sex and finding partners. Meetup, Tindr and other shared interest platforms which bring people face to face, are beginning to fill social cracks in the city fabric, building on old clusters of interest and creating instant encounters. People are reaching out further beyond the barriers created by physical happenstance and embedded timidities. Technology is also bringing the value of proximity into focus and can change one's sense of the city neighbourhood. In throwing open the doors to new intimacies, what do we need to protect in our individual identities, neighbourhood culture and the highly appreciated anonymity afforded by the city?

Conviviality

In *Tools for Conviviality*, Ivan Illich evokes a form of conviviality which is not the English idea of 'tipsy jolliness' but a vision of bottom-up organization that keeps open spaces free from institutional management predicated on a "triadic relationship between persons, tools and a new collectivity." As he says, "such a society, in which modern technologies serve politically interrelated individuals rather than managers, I will call convivial" (Illich, 1973, p. 5). It seems to us as practitioners that conviviality understood in this way might encompass all the tactics people look for in bringing distinctiveness or, in current parlance, authentic place-making to the city. Without the kinds of productive outdoor open-community hangouts that

are able to respond to spontaneous acts of creativity – part garden, part stage, part workshop – we cannot expect to bring about the miracles of improving health, social integration and intergenerational connectivity that are needed to counteract loneliness, racism and the atomization which comes from too few opportunities for self-realization.

Although, often introverted or even territorialized by long-time occupants, traditional allotment gardens allow people to organize local events, grow things and make structures with their hands. Taking this garden setting as an active backdrop to more open models of self-managed space in the city could uncover a much-needed, underexploited form of urban infrastructure. These activated gardens would pepper the city, each with a different starting point and a local story, self-made places eligible for cultural and social funding. Collectively they would be building loose networks among strangers, and creating a softer city. As 'city living rooms' they would welcome those keen to venture out from the claustrophobia of their social bubble – or their lack of one. With regular small budgets for new ideas and events they develop a symbiotic relationship between an array of characters: strong organizers, the talented, the skilled, the mentally fragile, those with patience.

The place or the host

Recently, in Newcastle, I met Anne, a woman in her mid-seventies, who runs the Stag's Head pub on the Byker Wall Estate. It was 11 o'clock on a sunny morning. People were trickling in and taking their places on the benches. Anne is the charismatic ringmaster of the Stag's Head. She knows everybody's name and what they drink. She welcomes them all personally with lively snippets of conversation. More unusually, she cooks two pots of food every day, which are placed on a heated trolley at the end of the bar, and for which she does not charge. One is soup and the other is a different dish each day of the week, in rotation, which she cooks from home. If you want to eat in the privacy of your own home, as Anne says many people do, there is a stack of plates to take the food home and bring back when you come for your afternoon pint. Most of the customers are men on their own, drinking slowly, although she assures me that the bench behind me is the one which the 'lasses like'. This is a living room for the community but it is not a designated community space. The pub survived a fire six years ago. It is a commercial concern, but it lives off a supply of old anecdotes and is always creating new ones. Is this place the pub or the host? They need each other.

'Insurgent architects' or curators of space

Architects typically parachute in and out of neighbourhoods. We try to connect to a few people, but these interactions often take place on the hoof and are then spun into a tale of authentic encounter. Often, the places we work in are notionally empty, with the future being the only focus; the players in this future neighbourhood are not identified or invited in. Considering an alternative to this is important for architects and designers, especially those who want to engage in all scales of urbanism, who want to resist reducing practice to a play of abstract graphics and facadism; and who want to know how to succeed in designing places that have a sense of conviviality and depth.

As a starting point, it is clear that practitioners must widen the scope of their commissions, incorporating richer open-ended questions and research for architect and client groups. This would enable building a culture around a project that is specific to that place, manifested through gathering a database of local people, creating rich digital communications platforms and a growing set of references to other projects. We need to test ideas rapidly, through business planning and service design. We need to be recognized as a safer, more agile pair of hands than the expensive, recently spawned industry of project managers who have huge agency but very little direction. To do this, we need to identify ourselves as multivalent 'curators of space', delivering social value alongside commercial returns.

The Canning Town Caravanserai

Architects also need to foresee the risks of their short periods of patronage in their projects, and plot resilience into their projects' future. We are like taps that get opened and closed as our clients face short political cycles and takeovers in a rapidly shifting economy. We need the ballast of an engaged community, because to work in a vacuum risks failure. This means a close partnership with local people, residents and business from the start. Engagement begins with both open invitations and targeted events, so that a diverse group with differing experiences becomes part of growing a vision and making a place. This vision stretches far beyond the built project into the day-to-day survival of an adaptable convivial place.

Canning Town Caravanserai

In 2007, we learnt that the Olympics were coming to London. London's bid was powered by the idea of 'legacy': it was promised that the energy generated by the games would be channelled into a super-charged form of regeneration, based on generous open spaces.[3] This would bring about a new ecology for east London, which had always borne the brunt of the city's pollution. We started thinking about what kind of London we all wanted and what would be lost and found in east London. The existing zoning of London's suburbs, industrial estates, social housing estates, office facilities and shopping districts made for a dreary urban reality. The re-making of the Lea Valley for the Olympics offered the possibility of a radical reorganization, which could tie together dislocated places and make the city more interesting and complex. However, the process was clearly destroying an ecosystem of small and larger interdependent businesses and the legacy regeneration was also displacing people, rather than finding ways to include them in the aftermath of the Olympics. The process felt mechanistic and top-down to those affected, but widely accepted as the natural outfall of a necessarily tight programme in the run-up to the Games.

This was the atmosphere in 2010 in which an architectural competition was launched. 'Meanwhile London' asked for proposals, together with rough business plans, for three sites in the Royal Docks area of East London. The competition was part of a strategy to attract attention and investment to Newham, 'along an arc of opportunity' wheeling down from Shoreditch. Four winners were picked for the three sites: Industrio[us], a roving upcycling plant around the Royals; the London Pleasure Gardens at Pontoon Dock; Studio Egret West's Royal Docks Baths; and the Canning Town Caravanserai at Canning Town, led by Ash Sakula Architects. Newham Borough Council offered the winning teams the use of the land free of charge (see Figure 9.1).

Most of the sites were available for a very short time around the Olympics but Ash Sakula won our site for up to five years, giving us a place to explore the possibility of a more self-made development with local people: people who had a desire to build, and people who had a desire to organize events and markets. Conceiving it as a trading post and as a place to pass through, loiter or get involved in, we called it the 'Canning Town Caravanserai'. There was a small contest and we won £4,000 Kickstarter money from a community interest company, Meanwhile Space, and quickly got to grips with structuring a volunteer programme, the funding mechanisms we needed, a planning application Newham could accept and the social demands of the project.

Crucially, we understood the need to build a shared narrative around management of the environments we wanted to design and produce. We did not see the management and end-use of space as being outside the business of architecture. It meant that when we took possession of the site in 2010, we were ready to self-initiate a project which could explore a different way of managing space. The research questions we asked ourselves addressed the potential for public spaces to be operated neither for profit, nor run by local authorities. We wanted to investigate the role of spatial invention and curation in the nascent social enterprise and micro-enterprise scene.

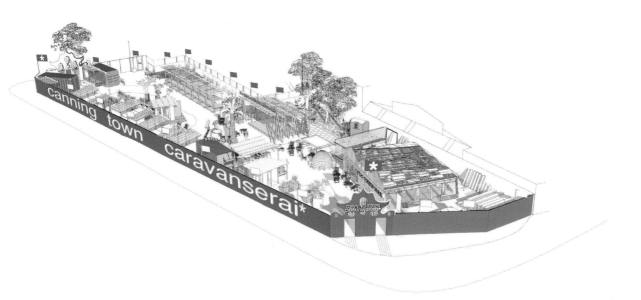

We had a lot of interesting conversations during the competition phase of the project. Sharing a table at the launch of the competition had led to collaboration. Nicolas Henninger and Sara Muzio were part of Patrick Bouchain's EXYZT, which had inspired us with their radical treatment of the French Pavilion MetaVilla at the 2006 Venice Architecture Biennale. Buzzing with digital production, agile lightweight building, non-stop cooking for local people and a team who lived on site in various strange pods, it was a vision of a fully activated inclusive cultural space. Also at our table was Douglas Hine of Spacemakers, who had demonstrated the power of open meetings in building up local micro-enterprise in the previously moribund, now thriving, Brixton Market arcades. It was Sara Muzio who put forward the word 'caravanserai' for the project. This was not a familiar word but one with roots; an old established term for a hostelry and trading post on the medieval Silk Road between Europe and China. It suggested the kind of hosting that the project should offer, describing a place which was open to anyone on the road. It had an entrepreneurial rather than institutional feel, and it gave us a conceptual structure with which to frame the programmatic diversity of trading and events that would work in Canning Town.

We adopted the two-gate caravanserai typology with a south gate and north gate. Making it possible for people to simply walk through the site was transformative, making it into an open space. It was a place in which to invent new kinds of rituals and explore 'out loud' what contemporary public space could be about. We proposed collaborations with local schools and markets, talked with hundreds of people in the area and made a database to stay in touch with everyone. The Caravanserai was to be a place which would welcome all comers, a place where people could meet, eat, drink, garden, perform, spectate, buy, sell, make and learn in an informal setting where every contribution was valued (see Figure 9.2).

After the competition, the team changed form and there were setbacks and challenges to deal with. Support from Newham Council was limited to handing us a list of possible funders. Funding was scarce and we ran on a shoestring. An empty block of flats that stood on the site, which had been offered for use as part of the competition brief, was demolished by the council before we took over. While this move was understandable from a political perspective – to pre-empt accusations of evicting local people to enable occupation by artists – it left us with no services on the site, just empty space with piles of hardcore, and no electricity

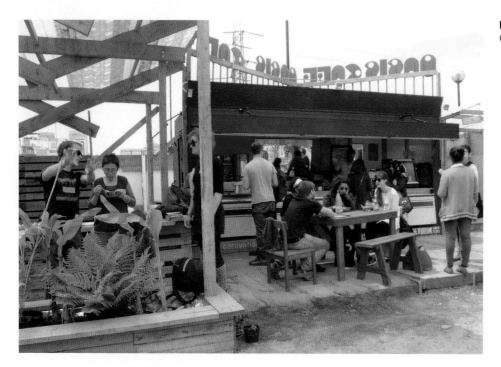

Fig 9.2 Lunchtime at the Caravanserai (Ash Sakula)

or water. We stayed off-grid for the duration of the project, which gave the space a rural feel, but made the project ridiculously difficult to kick-start. We eventually hijacked a water main and opened up an old connection to the sewer. We never got electricity to the site and relied on a rather noisy diesel generator for charging essential tools, lights and sound systems. The lack of power added to the rawness of this collective endeavour: it made the site primitive, almost ancient by firelight. The backdrop of over-electrified but empty Canary Wharf made the Caravanserai modest and counter-cultural by nature. During the day, the challenge of an overly large site in a dusty inhospitable neighbourhood in the churn of construction seemed more daunting. Nevertheless, many people discovering the project were drawn to the idea of making a place, especially when they could see it was open to their own contribution and continually evolving. The temporary nature of the project gave it some urgency. They warmed to the idea of the Caravanserai as a form of alternative reality in this hard corner of Canning Town.

Describing the purpose of the project to a stream of passing locals, a few words worked best for people hurrying past with kids, but they would often return to hear more. The open invitation to be part of the 'new trading post in East London' on the Olympic walking route worked in the first year as the town-like qualities of the site established itself. Caravanserai conversations were often about what didn't work elsewhere. In Victorian times, there was a reforming zeal for clearing away the gravestones to the edges of cemeteries in order to make small parks or sitting out spaces for the urban poor. Today though, Newham's parks seemed relatively empty even in summer. In Canning Town, the people we were meeting were more excited about stimulation than relaxation and intrigued by productive space where things might happen. One person said: "Why would I go to any of those parks? If I sat on a bench, I would look like I'd lost it." The point was that if you didn't play football, have a child under 8, or walked a dog, then a park was just a gap in the city fabric.

It wasn't the same in Westfield, the new shopping centre a few stops up the line in Stratford which had just opened. In a retail environment, your role as a consumer makes sense of your presence. Yet, people felt the pressure of consumption

and after a while were sometimes alienated by it all. Maybe, as Illich wrote, slick finished products make the idea of 'doing your own thing' more remote:

> The city child is born into an environment made up of systems that have a different meaning for their designers than for their clients. The inhabitant of the city is in touch with thousands of systems, but only peripherally with each. He knows how to operate the TV or the telephone, but their workings are hidden from him. Learning by primary experience is restricted to self-adjustment in the midst of packaged commodities. He feels less and less secure in doing his own thing.
>
> (Illich, 1973, p. 39)

And, while it might have been exciting to witness new investment and glamour coming to Stratford, it quickly got boring or frustrating if you could not spend lots of money. Those who engaged regularly expressed the desire to avoid the mainstream financial economy, in fact to turn the tables and spend time making money rather than spending it. This called for a place where you could socialize while selling extra things you no longer needed in your home, bring in food to sell or cook with others, garden your own or shared allotments, perform, or make things. Spending time collectively, especially in a largely self-defined open space, offers a sense of freedom which is hard to find in other ways. Illich recognized this need to gather in a spirit of productivity in defining conviviality:

> I consider conviviality to be individual freedom realized in personal interdependence and, as such, an intrinsic ethical value. I believe that, in any society, as conviviality is reduced below a certain level, no amount of industrial productivity can effectively satisfy the needs it creates among society's members.
>
> (Illich, 1973, p. 12)

Creating and running the Caravanserai

We – the amazing interns, local people and businesses that joined the Caravanserai and the flow of people who moved through Ash Sakula during these years – made some extraordinary things happen on the site. Measuring 1,670 square metres, an empty space surrounded by a high wooden hoarding, the site was a place where work was never completed. The Caravanserai was often rife with tensions arising from dealing with other people's mess, misunderstandings or lack of clear direction and yet, with a good patch of sun or fire at the end of a day, the mood could rapidly change as people looked at the big picture and started to appreciate the intriguing occupation of such a site. It was a special kind of unfinished, provisional but liberating, utopia.

Our interventions seemed at first to have little impact. Our two steel shipping containers were broken into, tools went missing. Materials were scarce and heavy wooden pallets had to be carried one by one to the site. But, gradually, we connected with a network of local site-clearance companies, scaffolders and contractors. One of the roles of the project was to be a local scavenger and this face-to-face work with surrounding businesses was phenomenally successful. There was a hunger to give not just materials but also time and thought to the project, almost as if it brought some tangible meaning to your role in a waste transfer business or sequin factory. Eventually people called us. A huge skip of water was delivered regularly for the garden before we got brave enough to break into the mains. The Good Gym, a new social enterprise that mixed exercise with good deeds, did runs from Canary Wharf and West Ham that ended at the Caravanserai with runners stacking wood and moving earth. The 10-metre 'Long Table' was built, the trading kiosks were completed and we got the bar running in time for the Olympics.

We established a set of hosting rules for the site, starting with the rule that anyone who entered the site was the 'VIP' of the moment and must be greeted respectfully and not ignored. It was for the newcomer to decide whether they

wanted conversation and information or preferred to be left alone to explore on their own. Nobody working on site should be too busy or too important to welcome and host, since this was the primary purpose of the whole project. We discovered that Canning Town was full of chefs and musicians, as well as electricians ready to build a wind turbine, and chatting could sometimes draw in useful skills to the building or the events programme. The art was to find ways to capture and network these interests and help them find a place in the project. We had to stay in touch with dreamers, whose talk often was more impressive than their delivery, and be quick to encourage the more 'timid' advances from someone who meant business and could really bring some regular energy to the project. It became a setting where people would meet mentors for young start-up businesses, or hold language and art classes.

The architectural framing of the Caravanserai was a deliberate scenography in the tradition of a decorated fairground. Profoundly unpretentious, it was built on Middle Eastern charm, with its palm tree, colourful signs and water pools, and was arguably hard to dislike. The word caravanserai took some explaining but the idea of an oasis in the desert made perfect sense in Canning Town. We trod a line between post-industrial tough, with our use of unpainted repurposed materials, and kitsch-pretty, with pink, orange and blue paint creating a form of branding which drew the place together and made it feel less random.

The first things grown on the site were oak trees and chestnut trees, which were donated by a community garden further up the River Lea. They had been planted by children a few years earlier and were still small, but we maximized their effect by planting them into tall triangular pallet-wood containers, which were regularly rearranged in the space to form clumps or circles. It was a useful talking point to indicate these uprooted oak trees when explaining the long-term aims of the temporary project. The real ground was buried under construction detritus; the blocks of flats which had stood on the site seemed to have been squashed flat, with whole windows and electrical cables lurking a few inches below the hardcore, so we couldn't get at the soil. Instead, we designed planting troughs of various heights to suit different people's working heights. They were broad but trapezoidal in plan and allowed for easy gardening in all corners. Some planting was for short cropping, including herbs and many varieties of mint for tea, which were tended by a local Iranian and Afghani couple who were regular cooks on site. Vegetable allotments and big sunflowers transformed the feel of the place in the summer months. There were always grand plans or castles in the air for children's play: aeroplanes emerging from brick walls, free-standing rocket launchers and treehouses. In the end things happened closer to the ground: a large sandpit, long swings under the 'Magic Carpet Theatre', a four-person seesaw, a 'Wendy house', a giant chalk board, and a sand-filled low brick dome with an oculus and strange acoustics. Community gardens have a special power to create intimacy between people. Plants seem to have their own agenda, in their determination to multiply and take over space. They give us reasons to fall into conversation, as well as opportunities to be quiet and busy with watering and tending. Suddenly people would tell you about foraging or phytoremediation or eczema skin plant cream made in their kitchen. We held seed bombing workshops, organized takeaway planting and ran art sessions using plant dyes. A group of wheelchair-users made a gardening club using the raised allotment beds.

The small, house-like spaces we built to house different activities were important in breaking down the scale of the Caravanserai and we lined the site with activity booths and stand-alone kiosks. These spaces could be adopted for a performance or as a small shop, while being intimate enough to hold small-scale workshops. They allowed people to take ownership of a patch and choreograph it themselves. These places added to the complexity and image of collectivity which was important for the project. The smallest enclosure was a tiny boarded site hut, painted blue and white, inherited from a contractor, which became the Wendy

Fig 9.3 Flying Carpet Theatre gathering: the stage was the baulks which sat under the cranes which built the Velodrome and the structure was designed by Ash Sakula, milled offsite and erected with a crew of volunteers (Ash Sakula)

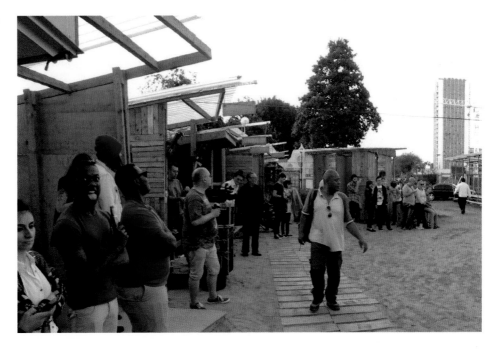

house and puppet stage. Another favourite hang-out for the kids was the built-in-a-weekend brick dome. The most shared but private spaces were the two toilets that took an age to build, but felt almost glamorous with their translucent rice bag and timber graphic always dancing with intriguing shadows. In the accessible toilet, there was a baby-changing niche and rooftop PVs charged a battery which ran the lights (see Figure 9.3).

The very first structure we built was 'London's longest table', built out of scaffolding and sheltered by a high cantilevered and tethered plastic roof. Conceived as both a banquet table and a catwalk, it proved too skinny to be a useful performance space and we quickly moved on to make a larger covered stage, measuring 50 square metres, in which we could keep music equipment dry. In its first year, the Flying Carpet Theatre hosted the National Belly Dancing Championships, a wedding ceremony, the Wild Child Festival for performers over 60 years old, and locally devised plays by Faith Drama, as well as three-day August Festivals hosted by local music venue, Arch One. The letters spelling out its name above the canopy were brass-leafed during one long evening at the long table. We invented a new material with which to form its roof. It was made of polyester saris, bought in the local market, which were set into resin by way of a 30-metre roof production line by a Turkish man with a handlebar moustache who had discovered the Canning Town Caravanserai and wanted to get involved. The Flying Carpet framing was good for relatively clement weather but we wanted more certainty and a longer season for workshops and events out of the rain. We launched a design competition with an illustrated list of all the detritus and spare materials on the site left over from our previous construction and donations. The winning team had to be a partnership between an architect and engineer, and the contest was supported by a host of institutional bodies and press. With amazing ingenuity scrap timber offcuts, steel and fibreglass sheet were used to span across a large sheltered barn called the 'Flitched Yard' which subsequently hosted the Newham Steel Pan Band, weddings, conferences, maker workshops and theatre. These events were supported by a professionally kitted out food truck which enabled us to prepare and serve food in compliance with health and safety legislation. The food truck embedded itself into a larger timber structure containing scullery and toilets (see Figure 9.4).

The Canning Town Caravanserai

Fig 9.4 The Oasis Café Terrace (Ash Sakula)

Conclusion

The Caravanserai could be a difficult thing to describe. A frustrated bus driver who passed it every day, finally made the time to come in, was almost angry on entering, but then amazed by the richness of a place that could exist behind a simple hoarding; the kind of place that could potentially exist in hundreds of interstices of the city. It demonstrated the power of scenography to be more than a backdrop, stepping up to actively frame trade, performance, loitering, eating and drinking. The co-designed and co-produced scenography was clearly an episodic but modern Caravanserai; evidence of what can happen when you connect people's interests and give them the excuse for conversations with strangers. Those strangers would often become new friends, just for the afternoon, no strings attached.

Over the winter of 2015 our lease of the site came to an end. The physical spoils of the Caravanserai were creatively and painstakingly upcycled to local people and other meanwhile sites; the café bought by a local who runs it at Cody Dock, the Flitched Yard and Flying Carpet timbers reconfigured at the Nomadic Gardens, the furniture and furniture-making template to St Katherine's Precinct. The hyper-local legacy fell between stools, Newham were still owners with the costs of stopping fly-tipping and keeping the hoardings intact but had signed the site over to the developers of the new town centre. The developers themselves had shown no interest in the potential of the project. Newham has become more interested in building social capital. We are working with them on a patch of Custom House with local people who knew and appreciated the Caravanserai. It is possible that the project might have a legacy in the way interim use is appreciated and understood in the borough. Across the River Thames we are working on a meanwhile strategy for Woolwich town centre inventing all sorts of uses for some 30 sites from meanwhile builds to the occupation of empty shops and underused car parks. Working at different scales and within time frames of 1 to 15 years, Ash Sakula has learnt how to design suggestively and provocatively. These projects have narratives that are more powerful than the vague spatial aspirations often used to invite engagement and attract potential occupants and operators.

It is exciting that the London Plan, currently in draft, references the benefits of meanwhile occupation and the engagement of local organizations and creative

forces.[4] The research body Centre for London is also positive about tapping into the queued-up spaces waiting to be the 1 per cent of London that is redeveloped every year and write, "there's little doubt that much of what Londoners and visitors will love about future London – its fringe, its social infrastructure, its landmarks – will be conceived, nurtured or trialled in meanwhile spaces." However, the focus of the policy is far from experimental or embedded in communities. Its recommendations are focused on de-risking the process, trusting the private sector to supply opportunities and professionalizing the field: "Scaling up means that meanwhile uses won't always have a local link. But more experienced and larger meanwhile players will also mean lower risk, a larger portfolio of spaces to move onto once an occupation is up, and cross-subsidize other schemes. This is happening in the property guardianship sector, and could become the new standard for the other types of meanwhile use too" (Bosetti and Colthorpe, 2018). This is not a recipe for success. London must resist the habit of inaction, risk-avoidance or expensively micro-managing every last cranny in its fabric, and grow the networks to support a grand plethora of creative social infrastructure which is agile, adaptive and creative.

Notes

1 The motives, history and achievements of the Caravanserai are captured in the website, which evolved alongside the project on site. The Canning Town Caravanserai 2010–2015 was a pilot project, and the Caravanserai a registered charity committed to promoting locally activated hosting and the productive use of vacant sites. caravanserai.org.uk

2 The pioneering neuroscientist, John T. Cacioppo (2008), said: "Loneliness is a bit like pain, hunger and thirst. We don't have opposites for them either, except pain-free, or not hungry, or not thirsty. Loneliness is the same way. It protects our social body. Chronic loneliness is harmful; but short-term loneliness can be positive and necessary because it highlights the need for social connections."

3 Refer to the London Legacy Development Corporation. https://www.queenelizabetholympicpark.co.uk/our-story/the-legacy-corporation

4 Draft New London Plan. https://www.london.gov.uk/what-we-do/planning/london-plan/new-london-plan/draft-new-london-plan/chapter-7-heritage-and-culture/policy-hc5-supporting-londons (Items 7.5.6 and 7.5.7).

References

Bosetti, N., Colthorpe, T. (2018) *Meanwhile, in London: Making Use of London's Empty Space*. Centre for London

Cacioppo, J., Patrick, W. (2008) *Loneliness: Human Nature and the Need for Social Connection*. New York: W.W. Norton

Harvey, D. (2000) *Spaces of Hope*. University of California Press, Berkeley

Illich, I. (1973) *Tools for Conviviality*. Harper and Row

IoT Report (2017) Global Internet of Things Report, https://www.hcltech.com/iot-survey

Putnam, R. (2000) *Bowling Alone*. Simon & Schuster

Sennett, R. (1974) *The Fall of Public Man*. Penguin

Simmel, G. (1903) "The Metropolis and Mental Life" in G Bridge and S Watson, eds. *The Blackwell City Reader*. Oxford and Malden, MA: Wiley-Blackwell, 2002.

Of Soil and Water: King's Cross Pond Club

Eva Pfannes and Sylvain Hartenberg, OOZE

'Of Soil and Water': The King's Cross Pond Club was a public art project by OOZE (Eva Pfannes and Sylvain Hartenberg) and Marjetica Potrč, commissioned by King's Cross Central Limited Partnership. Occupying a temporary site in the midst of the King's Cross construction site in London, it created a micro-ecological environment with a natural swimming pond at its centre.

The pond – the first public natural swimming pond in the UK – was free of chemicals, and purified water by natural processes using plants, nutrient mineralization and a set of filters to supplement natural filtration in a closed-loop cycle. The pond was open to exactly 163 visitors each day, a limit set by the capacity of the plants to filter the water. The enclosed site presented the natural environment in miniature, a *mise en scène* of the processes that occur between humans, water, soil and plants. From the elevated pond, swimmers could watch the evolution of the surrounding neighbourhood and the ever-changing city – looking onto something, but also being looked at while swimming and being vulnerable. Water is the element one is exposed to directly, by smell and taste – the balance of nature within the city becomes instantly palpable (see Figure 10.1).

The swimming pond quickly became a public success for both locals and visitors. Though it was initially intended as a temporary art project, residents formed a campaign to install it as a permanent feature in the King's Cross redevelopment plan, citing the health benefits of natural outdoor swimming and urban green space as well as the social benefits of a shared space. The pond, as well as the efforts to save it, helped form a diverse community where one did not previously exist (see Figure 10.2).

Participation

One could ask if urban society is open to participation. For us participation means 'co-shaping' the space we share together with others we want to engage with, who have a stake in a place. It also means provoking actions, conversations and thoughts in others which can hint at possible futures and which in turn can lead to a demand for spatial changes.

Urban development in general is not readily open to a spontaneous 'co-building' participation which changes the order of space and leaves behind traces. Often the ownership or 'stake' that people have in a place that leads to their engagement is not obvious, and neither are the *rules* of such an engagement. Public space is a space that belongs to everybody and yet not everybody feels concerned, or takes care of it as a citizen.

Depending on the scale of a community and the level of complexity, the level of tolerance for participation varies. Within local communities and more rural situations, informal spontaneous participation is possible. The set of people one needs to make agreements with regarding the location and time frame of engagement is quite clear and limited. A local community is likely to trust a designer's action. In a larger city you cannot just turn up and alter an environment to your own liking; plant a public garden or have a street dinner party. In larger, more complex urban environments participation must operate in more formal channels, engaging with higher-level authorities and multiple tiers of government, e.g. the dominant system

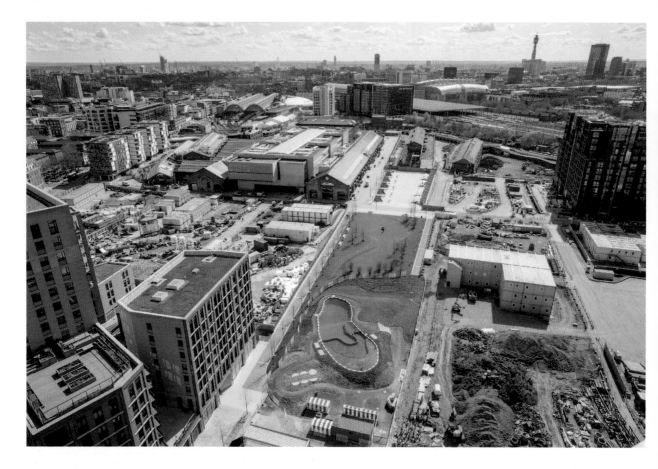

Fig 10.1 Bird's eye view of the King's Cross Pond Club, Spring 2015 (J. Sturrock)

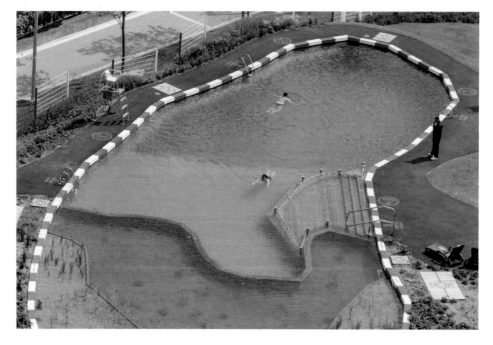

Fig 10.2 Summer 2015 (J. Sturrock)

Eva Pfannes and Sylvain Hartenberg, OOZE

of power. Our society requests formal permission (democratic approval) for public actions concerning larger groups of people.

In more complex situations, notions such as fear, risk, freedom and responsibility take on more weight. Regulations have been established to protect society from the potentially negative consequences of individual actions. In turn, if we (as individuals or a group) want to become active, 'participate' and change something we have to assure each regulatory body that our proposal is safe and we have to identify who takes responsibility and is adequately insured. This widely accepted procedure (democracy) has taken on almost ridiculous dimensions. The freedom of agency, to engage or not, to decide for ourselves what is beneficial and what is hazardous, has been largely taken out of our hands. Some risks have been completely banned from urban environments, while we are expected to live with other, often understated risks.

What is risk, really? Risk means venturing into the unknown. To a certain extent risk is also exciting. Maybe, if asked, some people would rather step out of this comfort zone once in a while, and take back personal responsibility in exchange for the freedom to act. How can we sustain democratic decision-making without letting decision-making and participation become mired in bureaucracy?

Design as an engine

On a practical level this freedom to act, and the responsibility to take action, is not just one for us, the 'author-agents' of the project, but for each stakeholder who has a decisive role during the making – before and during construction and once the project is 'out there'. Every agent has to anticipate the consequences of the proposal and take their share of the responsibility. It is somehow crucial to get all of them on board. Each person or public body that carries the project one step further becomes an agent.

All of the agents together, like a family of agents, then become the 'engine' of the project. And it is often this reinforcement from multiple stakeholders and interests which prevents the projects from collapsing in critical situations. At a certain point in time, when the project gains some traction, it becomes almost like carrying the Olympic torch. Every carrier-agent has an interest and makes sure that the final destination will be reached. Their varied interests are not always the same as ours. So it makes sense to assess what other stakeholders fear, where their interests lie and where are areas of conflict. Often the interest can simply be a (certain, maybe even) childlike curiosity in creating something that has never been done before, which then can turn into pride once successfully completed. We believe this curiosity is something innate to everybody. If you manage to tackle it and bring agents on board, they will take ownership of the idea and feel empowered to develop it further.

In the worst case one forgets to involve a crucial agent and the project stops. In the best case some agents adopt the conceptual message and the experimental method and disregard their fear of an unknown outcome. They then start to promote it in their own language. This is a sure sign that the project has landed and you can move from the driver's position to relax in the back seat. At times this happened to Of Soil and Water: the KX Pond Club. All of the agents literally jumped into the cold water.

Being an agent or driver of such a project has nothing to do with legitimacy. It is not something that is bestowed upon you. It means being committed to achieve that vision and being ready to overcome all of the obstacles. It is about having the initiative and the will to push boundaries and try new things (which are sometimes risky). What is needed is to show proactiveness, and the willingness to support other responsible agents to resolve all the problems that appear along the way.

Agency

The planners at Camden Council needed to be familiarized with the idea of a naturally filtered, chemical-free 'public' swimming pond and the idea that such a method could work just as well as chlorine. Although there was no regulation to address it, they took the risk and gave their agreement on the basis that the project start on a temporary basis and be limited to two years' duration.

The clients embarked on a journey they were going to benefit from after completion, but had to invest more effort and resources as the project ran into unforeseen difficulties. These challenges took different forms in the realization phase: with authorities (see above); with the general logistics on a complex building site; with a last-minute change to the location, etc. Their goal in this case was expected media exposure and the idea of bringing people into the remote northern end of the King's Cross Central site (see Figure 10.3).

The contractors opened themselves to experiment with new technologies and new ways of procurement. They had to improvise at times, which usually does not happen on building sites of this scale, and obviously put in more hours than foreseen.

For the residents the pond became a focus point of the development; something on a human scale they could fight for and which could become 'theirs' at times (like the open community day). Within two months after opening the pond defined their engagement with the developer: They were determined to keep the pond open for a longer time. In fact they were proud that this "wonderful and rare slice of the natural world" attracted people from all backgrounds to their front door and could be a tool of engagement between residents themselves (see Figure 10.4).

This is agency.

This is a pioneer process.

Commissioning with open-ended trajectories

Our projects try to open windows in time and space in which an active engagement is possible. They try to incorporate gaps and empty areas; they try to play on the fact that the precise outcome is unknown. To take the pond as an example, the piece of 'nature' surrounding the pond consists of 80 different species of wild

Fig 10.3 A swimmer with the development site in the background (J. Sturrock)

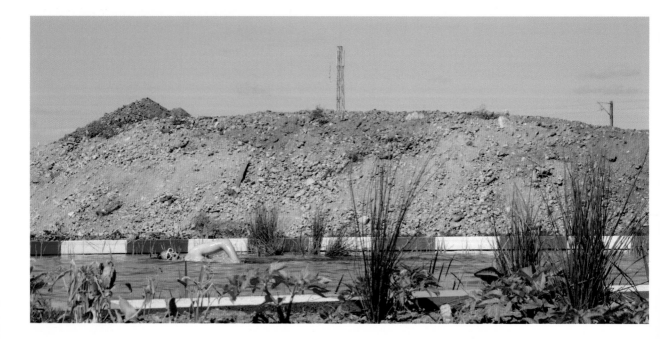

　　　　Eva Pfannes and Sylvain Hartenberg, OOZE

Fig 10.4 Autumn view of the Pond Club (J. Sturrock)

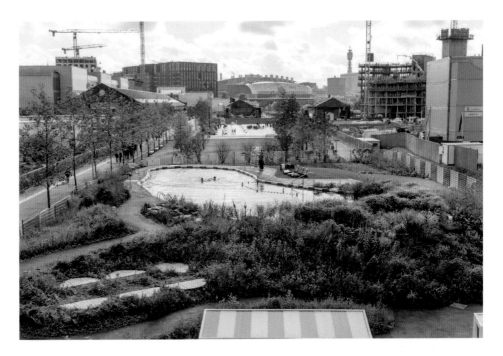

indigenous plants, many of which had been excluded from the urban environment and branded as 'intrusive' weeds. We attempted to cultivate those wild plants with the awareness that they usually choose their habitat themselves. So by no means would we be able to sign a contract with the client which would ensure a 'beautiful' outcome, not only because beauty is subjective, but also because we knew this would be an experiment where some areas would become dry, some plants might disappear and some others flourish unexpectedly. Rather than being an unintended consequence, this is an aesthetic that we nurture and develop. To make the client understand and to communicate this idea to others became a metaphor for the whole project. It was precisely because of this slightly ungroomed, unexpected and surprising plant life that this small enclave became more open to engagement. This informality (within limits) is inviting and raises the curiosity we talked about before.

Petition

As part of the campaign to save the pond, 5,289 individuals signed an online petition addressed to the developers, out of which 1,627 left a comment. Breaking down these comments by the prevalence of certain words, the various positions of participants becomes clear. The most frequent word is expectedly "swim" (730 times), given the utilitarian nature of the pond. But the second most popular word is "love" (342 times), striking an emotional chord and signifying personal attachment to the place. Other frequently used words such as "place" (274) and "oasis" (87) demonstrate the primacy of space in people's minds. Terms like "people" (183) and "community" (131) point to a strong belief in social collectivity and it is perhaps the same collective force that urged individuals to participate in the campaign in the first place. Less ubiquitously mentioned was the pond's novelty with terms such as "unique" (137) and "amazing" (97), as well as references to "nature" (114).

Comments:
5,289 people signed the petition to keep the pond open.
1,627 people left a comment.

Number of times people used the following word:

730 swim
342 love
274 place
200 city
193 great
183 people
181 outdoor
173 health(y)
139 wonderful
137 unique
131 community
114 nature
97 amazing
87 oasis
86 urban
84 good
82 important
81 beautiful
71 fantastic
63 experience
52 environment
47 green
41 wild
27 brilliant

"This is a lovely place to swim. ... I don't see why it has to be closed at all! The plan of regeneration for King's Cross shouldn't be about a temporary nice place but permanent loveliness!"

"It offers a moment of peace and calm amongst the chaos of Kings Cross! One of the few things round King's Cross to make the area really distinctive. It's a wonderful and rare slice of the natural world. I swim here almost every day, and was looking forward to doing so through the winter. Please sign and share!!!"

"This was a really unique way of humanising a massive development and making it relevant to other people. To swim with dragonflies around you in the middle of Kings Cross? It's got style, charm and humour – even if you don't swim in it!"

"Preserve it. People don't want to live in a concrete desert."

"Because this is a place of calm in a crazy space. People don't want high buildings, people want this pond. It reminds people there is more to the world than work, property and money. The simplest things are the best."

"We need more ... not less ... outdoor swimming spaces and especially in our cities."

"I'm signing because this is a beautiful piece of off-beat thinking that is about to be wrecked by developers. To have a pond where you can swim all year round is eccentric and magical and we should preserve it at all costs as one of London's surprising little quirks."

"Kings Cross pond sounds and looks like a lovely public amenity. A catalyst for growing community, enhancing environmental awareness, and fostering a cultural shift toward sustainable development – it is a beacon of beauty in an urban setting. I look forward to visiting London and taking a dip. Please don't 'pave over paradise'!"

"Why scrap such a wonderful amenity for locals and non-locals? Swimming in the pond, and for some time afterwards, makes you feel great. Don't deprive people of this opportunity."

Eva Pfannes and Sylvain Hartenberg, OOZE

"I love the pond!"

"There simply is no place like this in London – the pond itself is brilliantly unique and each visit brings a different experience. Though the pond itself has been well advertised and subject to many great reviews, it somehow still maintains a feeling of secrecy, and from the moment you walk in you know that you are in on something special. The pond gives so much to both the Kings Cross area, and the community that surrounds it. People of all ages enjoy this place – whether that be my 66 year old father, or the 6 year old kid who upon one visit took great pride in showing me the water snails that she had found around the ponds edge. The staff are consistently great and you can tell that everyone who works there really cares about the project and its upkeep. Truly hope that this place is not next to fall victim to the eradication of anything remotely unique in this city. To all whom it concerns – do the right thing and keep it open!"

"Cities need more, not less, natural habitats."

"It's an oasis of calm amongst massive high rises. I work in KX so go there as often as I can. The planting around it is magical and you always see bees and dragonflies. Together with Camley Street Natural Park inner city kids can have access to the wonder of nature."

"I have great memories of swimming in the pond just after it opened – it is unique, quirky, clever. It works on so many levels – art installation, health experience and living science communication. It also reminds us how key water is to our lives and how we can't take it for granted. I've loved returning to London down the years and seeing the regeneration of Kings Cross. The pond exemplifies that."

"It's like nature for us and taking it away will create sadness to people. Why can't people build somewhere else."

"The pond is unique – it's green credentials are juxtaposed with the very industrial building works. As the development gets filled with millions of gallons of concrete we should keep a few gallons of fresh clean water for this amazing pond."

"I love how surreal it is to have an open air swimming pool in the middle of Kings X. It's unusual and novel and well loved. Keep areas interesting and diverse!!!"

"This is a unique work of art, wildlife haven, greenspace and health facility in London. The loss of the pond would be an appalling and totally preventable tragedy for King's Cross and for London."

"Because it really is an oasis in the urban center of a world class city. I've found it a place of relaxation / contemplation / extreme cold. We need more places for people to decompress from the growing pressures of city life – We need to keep it open."

"It's obvious to me that nature belongs in the city and this pool and it's surroundings could potentially be the start of something big to be emulated around the country. Families get so much pleasure of being in and around water, it would be such a travesty to take it all away as it's had such a big impact. Please listen to the community."

"Diversity is needed to avoid urban monocultures."

"This is a brilliant and innovative piece of artwork and sportwork in the heart of busy city. We need pools like this for our health and wellbeing as well as for tourism, the economy and community spirit. Please keep this pool open and share the watery love."

Credits

TITLE: 'Of Soil and Water': The King's Cross Pond Club
AUTHORS: OOZE (Eva Pfannes and Sylvain Hartenberg) and Marjetica Potrč
TEAM: Paula Martinez, Jesse Honsa

CURATORS: Stéphanie Delcroix and Michael Pinsky, RELAY Arts Programme
CLIENT: King's Cross Central Limited Partnership
Project Manager: Ian Freshwater – Argent LLP
WATER ENGINEERING: Biotop and Planungsbüro WasserWerkstatt
SPECIFIC PIONEER LANDSCAPE: Rita Breker-Kremer and Stefanie Strauß
PARTICIPATORY WORKSHOPS & LANDSCAPE MAINTENANCE: Global Generation
MONITORING Central Saint Martins – Students of Spatial Practices Dept.
MAIN CONTRACTOR Carillion
TECHNICAL DRAWINGS: B|D Landscape
NATURAL POOL SYSTEM: Biotop
POOL CONTRACTOR: Kingcombe Aquacare
HARD & PART SOFT LANDSCAPE: Willerby Landscapes
OPERATION: Fusion
PETITION: Imogen Radford Barbara Rich
PETITION QUOTES THANKS TO: Elaine Gikes, Bill Bankes-Jones, Moore Flannery, David Colquhoun, Amanda Read, Jill Ellis, Lucy Taylor, Jaime Kelley, Jane O'Grady, Misbah Arif, Rose Griffiths, Cynthia Lawson, Jo Anne Rampling, Alan Hodgson, Jason Skeats, Lauren Picton, Si Harvey, Jethro Picton, Sophie Talbot, Katrin Owusu Surbiton, John Myatt, Kai Wartiainen, Ximo Peris, Lisa Nut, Alicja Dziergas, Adela Krupova
LOCATION: King's Cross Central is a mixed-use development by Argent LLP, consisting of 67 acres of former railway lands to the north-east of King's Cross Railway Station, and master-planned by Allies and Morrison, Demetious Porphyrios and Townshend Landscape Architects.

11 'Training for the not-yet'

A conversation with Jeanne van Heeswijk

Melanie Dodd

Melanie As an artist working with socially engaged methods, do you feel a connection with the term spatial practice?

Jeanne I always say I'm an artist working in public space, or in the public domain, or in the public. So, in that sense, I'm dealing with issues of publicness. I think spatial practice, or public practice, is thinking about civic imaginaries. This could be ways in which space is imagined, stories are told, space is designed, space is governed, space is financed. All of those belong to how I think about a public practice. It's the context of the work; the working field.

Melanie I would suggest that your work is self-confessedly political. I'm referring to your notions of 'preparing for the not-yet' and 'radicalizing the local'. Can you talk a little bit about what you think is the core social or political agency of your work?

Jeanne My practice is a continuous learning process. Investigating what's needed to take responsibility for the place we live, and how we can collectively renegotiate the conditions of our existence. It seems simple if you write it down like this, but it requires a lifetime of practice. How can we engage and act on the world in order to renegotiate the conditions of our existence? In a lot of places where I work, people feel left out of the way the spaces are formed, shaped, governed and financed. They no longer understand why the spaces they live and work look the way they do. Through my work I try to collectively understand and unravel – or 'de-abstract'. Policies and ideas about how an area will be changed are often developed 10, 20 years in advance. Government agencies prepare the ground, roll out policies, inscribe forms of regulation, but at same time, these plans for change in an area are not clear, nor visible. Abstracting space is something that I think neoliberalism does. In all of my work, what I try to do is to look closely at these processes, and make them tangible so that people can take matters in their own hands, and have a voice in how their immediate environment is shaped. That's why there are always performative actions. Almost like urban acupuncture, actions are a means of investigating why spaces feel 'stuck' in the way they do. How can certain energies flow again? Why do we see certain things emerge and not others?

When I talk about 'radicalizing the local', I mean that it's two-fold. Making emergent; showing those processes, while at the same time re-rooting. That's a double idea. Radicalizing the local to me is a process of actively de-abstracting. Not making visible, but providing opportunities for emergence. What kind of potentialities are embedded in the fabric of an area? How can you then re-root those unearthed potentials in stronger networks? I think for me these performative actions have always been a very important part of my work, and yes, this is a spatial practice.

When I think more broadly about my work, I talk about a 'field of interactions'. In 'Philadelphia Assembled' I spent a year of deep listening, trying to learn the emotional texture of the city. From there, a set of questions were derived and this set of questions formed what I call a 'field of interaction'. This field of interaction is a field that I step into myself. I'm not sole owner, nor the director; I am part of the field. But I'm actively co-initiating the field. The field is always circumscribed by questions. It's a spatial field and it's an emotional field as well. This means to think about cities as more than their streets and houses and regulations, but to bring forth their emotional substrata. The emotions that actually make/form our cities.

I always quote David Harvey when he says we need to "shape cities more like our heart's desire" (2003) – understanding this not as individual desire, but as collective desire. That's one of the most neglected of our human rights, to be able to shape cities after our collective desire. So, the question is how do we shape our collective desire? And how do we actually form a collective? This is very important when thinking about communal practices. I often refer to the idea of "becoming collective." How do you actually become a collective when you do not know what the collective looks like? If you do that in a territory where a territory is fractured, where you do not have homogeneous groups, how do you then become a collective? How do you then work towards collective desires?

My work deals with emotions, new political imaginaries and spatial imaginaries, asking the question what does it mean to live together? I work through the lens of imagination because it's one of the tools in spatial practice that's often undervalued. If we think about collective spatial practice, we need to shift from participation to co-design/co-authorship. We need to create forms of co-authorship in order to decolonize the imagination.

Melanie Yes, you've spoken before about 'consultation' rendering people as consumers; as opposed to a more transformative process of participating collectively, which is more difficult.

Jeanne It's much more difficult because it means that you literally all have to scrutinize yourself. The process of becoming collective is about scrutinizing what it is that we might hold in common, or what we value enough to collectively carry forward. This is where my idea of 'training for the not-yet' started. How do we train ourselves for our present and our future? How do we train for future collectivity – keeping in mind our divergent and shared desires? I'm beginning to unravel these questions by literally creating forms of training that draw upon resistance, resilience and community building. These trainings teach us to 'unlearn' tendencies that block us from collectively organizing and learn different forms of working together – preparing us for whatever will come our way.

What does it mean to 'prepare' for something you do not know, but that is needed for a better future. What are the ways to become prepared? What are the small forms of resistance that, when knitted together, might be able to become a critical mass?

Melanie So, you mean rehearsing small actions which build confidence and collectivity.

Jeanne Yes, small exercises preparing oneself individually and amongst the complexities of the collective. Complexities such as, what does it actually mean to work across race, gender, class and religion? Because if we talk about spatial practices, we also talk about territories, and territories

are very fractured at the moment. How do we think about care and safer space in a situation when there is no caring and where violence is perpetuated daily? I'm talking about 'training' here, because although we talk a lot about 'learning', it is also about the embodiment of these learnings.

Melanie From what direction did you arrive at this form of working, has it been with you from the beginning?

Jeanne I learned through practising in collaboration with very critical colleagues – people who challenge my practice through listening. If you look back, it makes sense, the trajectory, but I've never seen it as a fixed route. I've seen it as learning through doing. Practising while working with people. I speak a lot about this idea of 'letting go' of one's own subject position and allowing other positions to emerge. So, it's not about mastery. It's about an embodied learning process. Breaking oneself and recomposing through others. It's experiencing, working with people, listening, learning, taking on, letting go.

Melanie I think that's really clear from the projects. They are often long in duration and one can imagine the journey undertaken in an individual project is significant.

Jeanne But they are not like that when I start. They're not projected solutions but journeys. They are in movement, rather than preconceived. Many people have described my work – "Oh, so it's a process." And I always say, "I don't think my work is very process based". At the beginning of the journey, there are a set of questions that form a 'field of interactions'. Then, at some point, action and forms emerge and it becomes clear that they need to have a certain platform before you can re-root them again. That platform can be a book; an intervention; an action; an occupation. It can be a new legislation. It can be a building. It can be whatever it needs to be. It can be an artwork. It can be a film. And those moments, those platforms, are very important because that's where things become discussable, tangible, critique-able.

Melanie Yes. The idea of 'process' versus 'form' is often used to describe socially engaged practice. And actually, what you're saying is that those platforms are ...

Jeanne Form in movement ...

Melanie Yes.

Jeanne Yes, they are form. And I always say that in their form they need to be good. If you create a symposium, then it needs to be a damn good symposium. If you write a book, it needs to be a good book. If you make an artwork, occasionally that happens, too, it needs to be a good artwork. If you create a building, it needs to be a good building. If you create a community forum, it needs to be a good community forum too. Those things are not final works but they are forms in movement – feedback loops. And that non-linear quality is very important because our understanding of time is normally linear. In Philadelphia, I learnt more about non-linear time and it has influenced my thinking. As part of this, I try to create different images of what success looks like. Because one of our images of success is this idea of progress. That we're all in 'progress'. So, non-linear time is interesting in that sense. Preparing for the not-yet is also not

linear. It's just training for a change, but that can be maybe influenced from the past, present and future all at once.

Melanie Yes, can you expand?

Jeanne Most people say that something is 'effective', or has effectiveness when it has scale or can be scaled up. This idea of scale belongs very much to a neoliberal linearity of time and progress. How can our trainings fracture scale so that we again can – on the small-scale grain of the local – act? Can we think of training as a non-commodified spatial practice creating new civic imaginaries?

Melanie Do you ever participate specifically in a sort of retrospective analysis of what's happened in the project? These small loops or trainings and how they've had effect?

Jeanne It happens within the length of the project – and the length of the practice. As with an interview like this, I use these moments to do that exercise. So, to think about, is this a practice that would be transferable? For instance, people frequently say to me, "Are you the work? Or is this a methodology, as well? Is there a methodology to the practice?" You could say that Philadelphia Assembled, because of the way it was commissioned, was for the first time a deliberate attempt to look retrospectively at some of my methodologies.

Melanie Can we talk about Philadelphia Assembled? How did that project come about?

Jeanne It began as an invitation by Carlos Basualdo, Chief Curator of Contemporary Art at the Philadelphia Museum of Art. Over the last two decades, we've been in a continuous discussion about socially engaged art practice. He asked me if I would like to work with them on thinking about the relationship between the museum and the city through the lens of my work. Philadelphia Assembled (PHLA) sets out to re-imagine the relationship of an encyclopedic institution to a changing city. PHLA tells a story of radical community building and active resistance, it articulates a collective narrative about the city and some of its most urgent issues. Philadelphia is experiencing sudden and rapid growth and is seeing a shift in racial and economic demographics. In a city that is rapidly changing, we must train ourselves to work collectively.

Melanie How did you construct the project?

Jeanne I did this by actually 'practising' asking questions in public space; making exercises in non-directional confrontations which I call 'Public Faculties'. It's quite common that people work in an area already with an idea about the space, ready to solve a problem. In these cases, your questions become directional because they have purpose. So, in contrast, I find it very helpful to ask open questions and engage in conversation with whomever wants to join. I train for this regularly because it's important for me to practise; these things do not come naturally at first.

Melanie So the Public Faculty is always an important first step in a way?

Jeanne Yes, the idea of unconditional listening into the emotional texture of a place. The Museum of Art in Philadelphia is more than only a building.

Melanie Dodd

The city of Philadelphia is among the five Black cities, and the five poorest cities, in the USA. Although I had been to Philadelphia a few times, I didn't know Philadelphia. So, I used my Faculty 'training' to listen deeply to the emotional texture of the city.

I began by asking people, whom I had worked with in the past or that had a relationship to Philadelphia, to introduce me to somebody in the city (preferably not in the arts). I then asked those new people if I could meet them for a conversation. Over the course of a year, this first group of people hosted me in their houses, at their workplaces, in their gardens. I started these conversations by asking what is the spirit of this changing city? What are the acts of resistance, resilience performed by its inhabitants, past and present? Where are alternatives created? I listened to where the points of contestation are – where friction exists. Do people have agency in this space of tension? Based on our conversation, I had them introduce me to people who they thought I should meet across the city. I travelled the city, through these first conversations and then the referrals – understanding the various cross connections.

What I learned from my previous 'Public Faculties' is that they're not about finding answers, but about actually finding 'questions' that could determine an enquiry, and guide a field of interaction. Through asking these questions in Philadelphia, five themes or words kept emerging – five concepts that people talked about frequently. People started to talk a lot about 'sovereignty'. When people mentioned sovereignty, they talked about empty land, about food movements in the city; building farms; about taking ownership over homes and transitioning neighbourhoods; about independent economies, cooperative economies; about self-determination, about police brutality and the right to body sovereignty. Sovereignty became a word I kept hearing all the time, and so it became one of our 'atmospheres'.

In thinking about Philadelphia and the Museum, I was also thinking about a museum not so much as objects, but as 'atmospheres'. Another book that I was reading at that time was called, *Atmospheres of Democracy* (Latour 2005). I talk about a field of interaction but this idea of 'atmospheres of democracy' was appealing because an atmosphere is porous, like a cloud. We called these fields of interaction 'atmospheres', and we had five in the project: Sovereignty; Reconstructions; Movement; Sanctuary; and Futures.

'Reconstructions' engages with rewriting of personal and historical narratives, and re-imagining the built environment. Literally reconstructing the city through exploring notions of gentrification. One of the people that I spoke to, was Denise Valentine, a Philadelphian born and bred storyteller, of forgotten Black histories; drawing from her own experiences as a Black woman. How do we reclaim the past, and the present, in order to decolonize and liberate the future?

The atmosphere 'Futures' engages with the intersections of decolonization, education and climate change.

'Sanctuary' engages with the notion of Philadelphia as a 'sanctuary city'. Sanctuary cities in America are where city-based law enforcement does not actively help Immigration and Customs report undocumented citizens, so attempting to make it a safer space for immigrants.

'Movement' was then engaging with modes or methodologies of dissemination; performance, production, mapping – what I call the 'platform'. So 'movement' was the platform, you could say.

Another important thing was to look at organizational form; to ask what kind of new organizational and economic forms we can create? And

Fig 11.1 PHLA City Panorama Philadelphia Assembled (Joseph Hu)

Fig 11.2 Toward Sanctuary Dome, Philadelphia Assembled (Joseph Hu)

Melanie Dodd

how do we 'train' these forms together? I organized a team of 'editors' for each of the 'atmospheres.

What was very important was that two people from the Philadelphia Museum staff were part of the editorial team, and that the editorial team worked together one day a week for the whole course of two years. Additionally, equitably dividing the budget was extremely important for this project. About a third of the budget was spent on paying the people involved for their labour. At the start of the project, in 2015 in Philadelphia, living wage was about $18 an hour, so the whole budget was distributed equally in amounts of $18 an hour, which meant that everybody who worked on the project got $18 an hour, including me. The budget was made available to the editors because one of our core values was to be transparent towards budget, capacity and power dynamics.

Each editor created a working group, and these working groups met at various intervals for one and a half years, sometimes bi-monthly, sometimes monthly, to unpack their 'atmosphere' and to build out their field of interaction; to create collectively.

Melanie Did those working groups/editors – did they have a period in which they needed to draw conclusions?

Jeanne They were tasked with two things. One was 'defining' their atmosphere. Then, as part of a public-facing period at the museum from June–August 2017, the intention was to amplify, highlight or build out the atmosphere. We saw this as a moment of transition. From when we were ideating and defining in working group meetings, towards projecting and building out what we wanted to see happen in the city. Here, the working group members started to look at their own affiliations, acts of organizing, and began to locate those throughout the city. In this sense, they each started to 're-imagine' their own local conditions. We did that through 'amplification' – meaning building out, or building up. Not necessarily through creating something new, but amplifying and strengthening the work that was already happening across the city.

Also important, was trying to define value sets. In the USA particularly, there are strong traditions of social justice organizing, and community agreements. In the beginning, with our editors, we had 34 pages of community agreements and we couldn't agree on a set of values that we could collectively hold; that we collectively wanted to sign off on. We finally came up with three values which were ones we could hold as a group: 'Transparency, Collaborative Learning; and Radical Inclusivity'. This last one, Radical Inclusivity, is very important if you have non-homogenous groups because it is about unpacking layers of oppression, honoring differences and commonality.

In this public-facing period, we did almost 60 events in the city, ranging from community work days to performances to installations – creating public platforms to amplify acts of resilience. And at the same time, the groups were collectively building imaginaries of the future by performing their own stories and reworking them together.

Bringing it back to the museum was very important. And we didn't choose to present in the main building on the hill, but the one next to it because I thought it was important to take over the whole ground floor and almost 'hack' the whole space, including the café, the shop, the entrance fee, the public programmer, the gardening – everything.

Mapping was an integral part of the exhibition at the museum. Creating new maps of relationality; new maps of space, spatial arrangement and future spatial possibilities as part of future civic imaginaries. These are maps of the city through the eyes of our collaborators. There is a map for each 'atmosphere' with the timelines, national, local and global. Additionally, there was a timeline that traced the acts of resistance relating to each atmosphere. We called these maps city panoramas. They tell a different story of Philadelphia. Spatially, relationally, politically. People spent days looking at these maps, coming back to look at them again.

The exhibition collectively imagined a 'just' future with complexity and care, both militant and empathic. The exhibition was a collection of objects, stories and prompts. For example, in Sovereignty, Urban Creators, a grassroots collaborative based in North Philadelphia, contributed a birthing sculpture, made by Jeanine Kayembe, which made reference to the D of Doula – giving birth at home and a tradition of strong midwives seen as a sovereign practice by communities of colours. There are also objects related to black independent business and economic sovereignty, about 'body sovereignty' and the right to have a say about the way the body is seen in space. Also, stories related to historic events like the bombing of MOVE, a Black Liberation compound, in 1985. This is an open wound in the city, concerned with its histories, but also its spatial claims on land and sovereignty.

Another important aspect of the exhibition was that our collaborators co-hosted the exhibition. A common site in the museum is that security officers are predominantly low-income people of colour and the

Fig 11.3 Sovereignty A–Z, Philadelphia Assembled (Joseph Hu)

Melanie Dodd

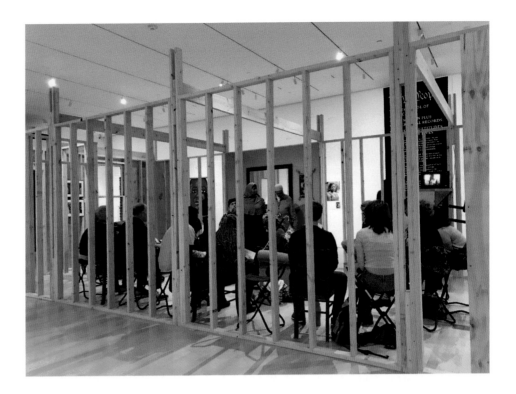

Fig 11.4 Reconstruction Inc. Meeting, Philadelphia Assembled (Janneke Absil)

'docents' white upper middle-class women. We wanted to be attentive to all of the museum's processes. We asked our collaborators to host the space and offer guided tours through the exhibition. You could experience 'Sovereignty' through the eyes of Ramona Africa. Or you could watch 'Futures' through the eyes of Priscilla Bell, showing Taino culture, creating each time a different reading and set of narratives.

We created programming inside the museum on most days the exhibition was open, culminating in a total of 70 programmes during the three-month period. As an example of these programmes, 'Futures' hosted the 'Indigenous People Day', bringing together tribes in the Philadelphia and Pennsylvania region on one platform.

We also took over the café. Our kitchen included 12 community cooks who joined together to create menus of 'survive, resist and victory'. This community cooked food about survival, resistance and victory food because the writer Ntozake Shange wrote a cookbook in Philadelphia, which is called *If God Can Cook You Know I Can*. She said, "Now to me, it's very important, I would like to know how do we celebrate our victories, our very survival? What is it we want for dinner?" What do communities eat to celebrate? To resist, to survive? So, these menus were cooked every day and for the duration of the exhibition, the museum was 'pay what you wish'.

'Training for the not-yet' was a common thread through this whole process of learning and unlearning in the last three and a half years. Through the practising, developing an understanding of how to make a solidarity economy happen. Understanding how to discuss value. How to think about time. My next exhibition opens September 2019, titled 'Trainings for the Not-Yet' as part of a 'Proposition for Non-Fascist Living' at BAK (Utrecht, the Netherlands). Through this exhibition, I will recompile the learnings gathered throughout various parts of my work and reflect on it.

Conversation: Jeanne van Heeswijk

Fig 11.5 PHLA Kitchen, Philadelphia Assembled (Joseph Hu)

You could say that in Philadelphia Assembled we exercised what is needed to become collective. All of these things: timeline exercises, mapping exercises, amplification of existing work, re-knitting of forms of resistance and existence. All of these things you could say are part of a spatial practice.

References

Harvey, D. (2003) 'The Right to the City', *International Journal of Urban and Regional Research* 27(4): 939–941
Latour, B. (2005) *Making Things Public: Atmospheres of Democracy*. Cambridge, MA: MIT Press

Melanie Dodd

5 past 1 until 5 to 2 (on Thursdays)

Anna Hart and Tilly Fowler, AiR

Glass lift

Walking begins with not walking. Standing in a contained space, dangling. Bodies in mid-flight. This box designed as empty space to be filled with bodies is sometimes filled with trolleys of library books and post. Vertical linear movement only. On the way to walking this direction of travel feels different. The non-walking is a preparation to not-knowing. The decision to separate from the desk, computer, interior, a certain type of productivity, has been made. A movement through the city is initiated. A view in motion. A not quite there, but nearly. An anticipation.

Square trees

It hardly ever rains on Thursday lunchtimes. Just twice in one year.

Sweep

Across a year of walking some sightlines are reassuringly constant: the expanse of ceiling as you climb up the abstruse staircase to the international platforms; through the turquoise railings around the pedestrian bridge; into the stone seating circle in the library forecourt. Others change gradually, surprisingly, suddenly, in different ways – a blockage, a security scare, a fire drill, a traffic jam, construction – the emerging bulge of the cancer research centre, the curve of sky dropping away to a rough hoarding edge when the depot is demolished. And by walking the same route in different directions something else appears, just when we think we have covered 'all the ground'.

Pontoon

It both gives and resists with each step, sinking and pushing back. An approaching jogger disturbs the moderate bouncing, landing heavily and at twice the speed, taking two steps for your/my/our one. A big group walking only on one side tips the level to make an unlikely capsize feel possible.

Future for sale

There are two architectural models that we pass. Tasteful untreated wood with gold finishing. On a sunny day in the flagship development the place looks so much like the marketing. Everyone is an extra. Everything is shiny. Beautiful people jog, cycle and walk along the paths. They complete the scene. The interesting looking students. The young and attractive waiting staff with good teeth. Hundreds of metres of computer-generated ivy hoardings.

Otorhinolaryngology

My sister worked in the hospital basement at the time of the fire. We walk past blue signs for out and in patients. And often the bronze memorial plaque at the station. A different time. The same place.

The walks build a map made of sound. We know where there is relief, where there is a wall and a cloak, an opening out and a closing in. Optimum overhearing happens with incursions through lines and clumps of waiting passengers. Under the bridge beside the canal the world is muffled. Beside the coroners it is

silent. (Only once was there a hearse by the doors of the crematorium.) Sirens are interruptions.

In the holidays a few children are in the courtyards. They too are quiet.

Gap

Railings have been pulled apart for desiring paths. The two holes measure the body and the body measures them suggesting possibilities for quotidian border crossings. The process of walking is a joiner – of ideas, rhythms and space.

Embodied knowledge seems wilfully absent in a world of learning outcomes, professional development, and certificates. It is learning as a soft, pliable form that oozes out from the landscape of living, it is muddy, soggy, warm. In contrast much of this piece of city, a 'knowledge quarter', has become a territory for control, order and hard surfaces.

Fountain

The sound of moving water draws our eyes down into a basement garden with a water feature that trickles over trembling ferns. One; the square where we start each week's walk boasts "1,080 individually controlled and lit water jets."

Memorial

There are street memorials to young men (children) that we walk past. Their lives violently ended.

Candles. Photographs. Dead flowers. Messages.

Traffic light

A pause. A rest. A stop.[1] We anticipate some sequences from familiarity, coming to know in particular the inconveniently long one by the library. Some offer propitious opportunity for a view or to corral stragglers. Zebra and pelican crossings offer similar conditions as traffic lights but hold more rights for the pedestrian.

Line

We frequently come across the end of play at the primary school on the corner by the threatened trees. It can feel that the teachers and dinner ladies have waited until we turned a corner to ring the bell. The children are herded into a line before going inside. From free movement to sitting in chairs with (right and wrong) answers.

Subway

Metastasis. The blast of city, of being in the city, of being part of the city, the power of the incidental in the everyday. There are inside publics and outside privates. They intertwine and sometimes try to be something else. The station concourse, the hotel lobby, the publisher's courtyard, the bar beside the basin, the walkways through the flats.

We walk in places where we are not invited but need to go. The builders look surprised. We are told to go away from the balconies with the good southern view and the wooden tables. There is no reason that we cannot walk there except no one else does.

Plantar fascia

The loose paving stone on the towpath tilts against the underside of my foot and leaves a sensation that I can still summon. It was and is so precise.

Revolving door

One person at a time in each wood and glass compartment. Pause and then rush to get into the compartment as it spins in heavy motion. Two is a squeeze. Shuffling round instead of striding, trying not to touch too much. One pushes, the other is

Anna Hart and Tilly Fowler, AiR

pursued by the door coming up behind them. Pockets of warm and cold air are carried in and out.

Embassy
What is this walking? Is it research, art, fieldwork, a sculpture? Lunch? It does not appear to be anything.
> Suspicion is communicated. We must not be busy enough.
> There are many things that are not available to us. Dawn, Dusk, Darkness. The children leaving the playground.
> Different states. Same place.

Curry
There is the sound of a running tap and washing up the cutlery behind the lace curtains. Small pockets of garlic and cumin. We are very close. Just a window, sometimes open, between walkers and dwellers.

Salat
Down the old churchway the door was occasionally open offering a glimpse of pairs of shoes. A list of prayer times handwritten on the door as we walked past.

Triangle
A tiny park, in a tucked away corner on a hill. We walked its three edges. It felt like a trespass, not so much because we felt we were not wanted, but because we almost had not bothered to notice it. What a relief to know that every walk can present something new that you do not necessarily have to look for.

Shit
Dog. Human. Dry. Fresh. Accumulating in the long alley by the convent.

Club
> Why?
> What does it suggest? To whom?
> Purposefulness
> Select few. Who?
> Being sociable while doing something else
> Belonging
> Making time: a time and a place in the week
> No register or booking
> (Someone always comes)

Broom
We see the maintenance. Sweeping. Mending. Men cleaning the outside of the city. We sometimes glimpse women sweeping the stoop.

Oversized wheelbarrow
Are you still walking on Thursdays?
> Yes.

Christmas tree
Can you only consume this by taking part, and/or what relation does consuming have to it?
> Lunchtime/leisure time. Not to buy, not to work.

Chlorine
Two municipal swimming pools. Local residents remembered in the busyness of regeneration. Outside the 1980s brick one you smell the chlorine but never see the

water; through the glass of the new one you see swimmers pacing up and down but rarely catch the smell.

Blockage
Blockages alter a flow. We start to look for them as a way of understanding change. Nothing is fixed. The bar with the revolving door has changed its opening hours to cut off that route. The alleyway by the adventure playground has been blocked off for new infrastructure compounds, and the one by the school as part of the railway development. Who else will mourn the loss of these routes? The towpath and pontoons are closed later in the year diverting people up through an area we had never before thought of as a blockage. The stairwell connecting canal to street is closed while a new one is built, the remedial works that would take years sent us round all the alleyways between the modernist blocks, a corporate event blocked access to the canal.

New bridge
The return.

Over the year there are new possibilities for going out and returning. Returning to a different place over an hour, over the weeks, over the year. A different self.

Fallen ivy
What to do with all this embodied knowledge?
What will become of us and of it?
When?

Hotel carpet
A syrupy thickness. Quieting of footsteps. Doors clicking shut as we pass.

But, after all, we are only gliding smoothly on the surface. The eye is not a miner, not a diver, not a seeker after buried treasure. It floats us smoothly down a stream; resting, pausing, the brain sleeps perhaps as it looks.[2]

But knowing its surface changes the city forever.

Clock (tower)
After a while we could no longer see the station clock from the roof of the squash courts above the community centre overlooking the cement plant.

We do not know like this beyond these 50 minutes. We stay in them but we never reach the river. We cannot reach the sea.

Afterword
There is a wealth of literature about walking and the value it holds for the spatial practitioner. Still, to go for a walk in the middle of a working day, for no explicit purpose other than to walk, feels indulgent. The simplest explanation to offer is that to experience the city with others and without a soundtrack in headphones, a plane of glass between, or the pressure of time/destination, allowed the gathering of an embodied knowledge to counter a deluge of assertions poured on this rapidly changing piece of city. A method of staying in a place guides AiR's research and action – with walking as action in itself, demonstrating care and commitment at human scale.

For 'Kings Cross Walking Club' we walked for a year of Thursday lunchtimes – starting and ending under the square trees outside the art school – a repetitive somatic practice in a particular time and place, connecting across and through it, paying attention to the changing seasons, city and self. An open invitation to this club coalesced individuals from across our communities of the university and the surrounding neighbourhoods to walk, talk and notice things together. Pieces of

Anna Hart and Tilly Fowler, AiR

Fig 12.1 Kings Cross Walking Club (AiR)

time – the lunch break, the year – responded to principle conditions of the everyday to frame this experience of a place.

We were not walking in order to write about it, but now that we have walked we can write to share this method. We have constructed a text to mirror the way we walked – an episodic choreography, a meander through rhythms, textures, objects, intrusions and associations. The subheadings are nominated landmarks, psychic mementos that are elaborated on in the subsequent text. We omit place names to lay out a cityscape that could be somewhere else.

A mix of die-hard every-weekers and curious drop-ins felt, smelt and listened our way around the 52 walks, respectfully breaching social, physical and psychological boundaries of institution, neighbourhood, new, old and changing. We saw and were seen. We found pleasure in discovering the routines of others, simultaneously finding something new in familiar places, even at this same time every week. Our understanding of the city as a continually shifting social and formal entity deepened through repeated walking. We carry an enduring resonance of this place.

Note
1 There were two rules in our walking club – to return everyone to the square by 1.55pm; to stop at a red light.
2 Virginia Woolf, Street Haunting, 1930

13 **Glastonbury**

Instant City

Juliet Bidgood

Since the early 1990s the Glastonbury Festival has grown to become the world's largest greenfield music and arts festival; creating an instant city, populated by 200,000 people, a quarter of whom are volunteers from partner charities. Embedded in its process of making and governance are distinct approaches to creative autonomy and ethics that enable the intensity, diversity and sense of security of the festival experience. As such the festival could be described as an evolved 'spatial practice' where governance and infrastructure flex and interact to provide a supportive web for an 'Instant City'. This chapter explores the ways in which this ephemeral city is structured, the quality and attributes of the space it produces, and how this could offer a paradigm or an alternative model for the new towns it has evolved in parallel with. It is based on special access given by Glastonbury Festival in the summer of 2017.

The intention to explore Glastonbury Festival grew out of an interest in how new large-scale settlements could be designed to be participatory and collaborative and how the cultural dynamic of a place could be made generative rather than supplementary. While it is clear how small-scale neighbourhoods can deploy co-housing models to structure communities in different ways – how can the civic and cultural infrastructure of a new settlement be structured to involve citizens? How can cultural spaces be part of a city's identity from the outset and grow with it? Glastonbury, because of its scale, ambition and radical history, provides an interesting model for considering how the structuring of city spaces could be turned inside out. As the Glastonbury Festival approached its 50th anniversary there was a sense of it being both an established 'place' as well as an innovative and creative entity. Interested in shaping their legacy beyond the festival site Glastonbury Festival offered access and support (in the lead up to and during the festival giving permission to a research team) to document the occupation in use and infrastructure of 'The Farm' using observational drawing and interviews.

For five days of the year Glastonbury Festival is the largest city in Somerset. As an instant or temporary city, the festival creates a space in which all ages of people shape their experiences. Rather than being defined by its ownership regimes, this city is made by how it is occupied and in the sharing and negotiation of territory in which formal and informal cultural and social production are prioritized in the pursuit of pleasure and freedom. The journey to and time spent at Glastonbury is for many people an annual pilgrimage, where there is an opportunity to enter a creative space and celebrate difference. Like enclaves in science fiction Glastonbury is framed by its site boundary which secures the festival site as an otherworldly place, where to enter is to participate. On the opening night the audience completes the assembly of the city, voicing its shared identity in response to the first of many calls of 'Hello Glastonbury'. Offering a sense of freedom is an important driver for how the festival is curated. It is made to seem effortless and its spaces are presented as informal, open and unstructured. However, this temporal experience, like its material cousin, has a specific history and culture and is made from a developed infrastructure and distinct forms of governance that combine as an evolving spatial practice:

Site vehicles:
Ice cream van, Mobility scooter, Baggage trolley, baby buggy (4 wheel), Rucksack wheels, Segue, White van, Tractor and trailer, Delivery vehicles, Land Rovers, Police horse, Wheelbarrow, Electric bike, Pushchairs.

What sets the energizing atmosphere at Glastonbury apart from that of other festivals is the hopeful sense of the individual and collective potential for change. I spent the whole time in anticipation of the next transformative moment, wondering whether it would happen during a particularly electrifying set, a conversation in the Left Field or a random encounter whilst sheltering from the rain under a paper-mâché lion. The revolutionary power of creativity is tangible in every corner of the site.

(Gush, 2015)

The idea of an 'Instant City' belongs to Archigram's triptych of cities that claimed; "urbanism as a term of reference that does not demand a house or a city." Along with the Walking City and Plug-in City, the Instant City would be mobile and would arrive in the form of; "an airship containing all the cultural and educational resources of a metropolis which could land in remote areas giving inhabitants a taste of city life" (Archigram, 1974). Questioning the need for buildings at all, these city concepts drew upon the way ephemeral and mechanical infrastructure support the celebratory spaces of funfairs and carnivals. Although Glastonbury seems to easily fulfil Archigram's description of the Instant City, Owen Hatherley describes how its culture is differently constructed as a result of its inception as, "a point of congregation for alternative lifestyles both in its early 1970s incarnation and its late 70s rebirth" (Hatherley, 2014). Specifically the character of the festival is developed from the framing and negotiation of alternatives and through making room for many creative actors. The festival began at Worthy Farm as the 'Pilton Pop, Blues and Folk Festival' promoted by Michael Eavis in September 1970, headlining T. Rex (who happened to be passing on their way back to London from performing at Butlin's Minehead). The following year the 'Glastonbury Fayre' featured the first Pyramid Stage at a location found by 'dowsing'. Part of its rapidly gathering mythology may be to do with it having been filmed by Nicolas Roeg and David Putnam (Glastonbury Fayre, 1971), footage featured in a later film by Julien Temple (Temple J. (2006) 'Glastonbury, The Mud. The Music. The Mayhem'. Glastonbury Festivals Limited):

Free festivals are practical demonstrations of what society could be like all the time: miniature utopias of joy and communal awareness rising for a few days from a grey morass of mundane, inhibited, paranoid and repressive everyday existence. The most lively young people escape geographically and physically to the 'Never Never Land' of a free festival where they become citizens, indeed rulers, in a new reality.

(Un-authored leaflet from 1980; McKay, 1996, p. 15)

The way that the festival is governed and the role of partner charities and volunteers have been pivotal in its evolution. Early festivals raised money for the Campaign for Nuclear Disarmament (CND). Today £2 million is raised for three partner charities – Oxfam, Greenpeace and Water Aid – that provide and manage 50,000 volunteers and workers at the festival. Independent stage promotors also define the character of the festival. From the early 1990s, as boundary security was increased, the festival grew, adding new stages and sound systems (doubling in size from a gathering of 70,000 people in 1990 to 140,000 in 2002). In addition to the main stages; The Pyramid Stage, The Other Stage, John Peel and West Holts, the festival is created from a series of independently curated enclaves such as: Siverhays, Arcadia, The Park, Block9, Croissant Neuf and Shangri La. These enclaves are serviced by the festival's wholesale economy but are independently designed and organized. The current festival still contains vestiges of its formative countercultural history. To the south of the Old Railway (that links the east and west of the site) are the Green Fields including Green Futures, Healing Fields and the Scared Space. Opposite on the route north towards what is known

to some as 'Babylon' is the contemporary Greenpeace encampment. The festival site is part of, and taps into, a wider mythical landscape. Its identity relates to its place in the Vale of Avalon, a place described in the legend of King Arthur believed to be Glastonbury. In Celtic mythology Avalon is also understood as 'otherworld', a supernatural realm of everlasting youth, beauty, abundance and joy. The festival tangentially embodies this ideal of a world apart from the everyday. It makes a 'rural' city where life is stripped back to something simpler. Alongside the hyper-urban experiences of the larger stages and sound systems there are opportunities to promenade in the country, to take in the festival panorama (from the higher ground) or to become lost in a secret venue in the woods.

The observations at the 2017 Glastonbury Festival were structured with reference to two precedents, both investigations of urban experience that also foreground pleasure; Venturi, Scott Brown, and Izenour's *Learning from Las Vegas* (1972) and muf Architecture/Art's 'A Car Free London' (Shonfield and muf Architecture/Art, 1999). These studies focus on experiential propositions for urbanism at sites that are also framed by distinct jurisdictions, e.g. gambling and congestion charging. *Learning from Las Vegas* remains a formative example of how an analysis of a modern city, in its becoming, identified a distinct way of seeing and interacting with a supposedly un-designed but potent landscape. This research was led by three instructors and nine students of architecture from the Yale School of Art and Architecture over a semester in 1969. Their non-judgemental enquiry into what is architecture/not architecture made the research open to the actuality of Las Vegas. Their work began in the library, progressing as they became guests of the Stardust Hotel for ten days. The research layers observations identifying defining elements like: asphalt, autos, buildings and ceremonial spaces. Derived from the Nolli plan of Rome this describes spatial systems rather than enclosures. Parallel studies in 'iconology' describe how the scale of the motorist's movement and gaze had restructured the language of the city. It hones in on the intertwining of civic and everyday experience – to explore how cities communicate by gaining "insight from the commonplace" (Venturi et al., 1972, p. 3).

'A Car Free London' (1999) was a winning submission prepared by muf Architecture/Art for an Architecture Foundation Competition. Organized in anticipation of the introduction of the congestion charge, the competition aimed to conjure a new attitude to the car and the receding of its dominance of the city. At once analysis and proposal the project asked; "What if the desires carried in the car can be re-discovered in the public realm, would you leave your car at home?" It set out tactics for relocation of the pleasure, security and mobility invested in the car in the public realm. The focus on 'pleasure', on the unruly desiring subject (doing things whether or not they are good) was the beginning of an attempt to extemporize a lyrical pleasure in the city. Deploying security as a driver for urban design builds on the work of Jane Jacobs, expanding on her emphasis on 'eyes on the street'. The focus on mobility can be related to the Smithson's late modernist conflation of physical and social mobility (Strauven, 1998). As in this case the 'mobility' proposed is the ability to cycle west across the city to schools across district boundaries. The emphasis on the overlapping desires for pleasure, security and mobility aimed to cut across the formal and functional elements of the city. As described by Kath Shonfield the individual and private experience of driving is recast to be freely available and small-scale detail is linked to strategy. Like art practice understanding begins with "recording minutely what is, while remaining unworried by what should be" (Shonfield and muf Architecture/Art, 1999, p. 15).

Taken together these examples place emphasis on non-judgemental, open-ended observation of the desires and behaviours shaping the city territories and on the intersection of social and spatial form. Culture, governance and infrastructure are arguably the organizing phenomena that interact to structure the spatial experience at the festival. The intention in looking at these was to understand how the culture of the festival is framed and how its governance shapes

it as a place, against the register plate of its spatial and physical infrastructure. Focusing on these three layers of observation allowed a focus on specific areas of interest, whilst developing and deploying some common methods of enquiry, loosely framed by the question: "What can we learn about the staging of cultural, civic and everyday experiences from Glastonbury Festival's making of an Instant City?"

Visiting the site over a period of time enabled the process of making the city to be observed revealing how its physical infrastructure is successively assembled – from when the 10km perimeter fence encloses the gently sloping bowl of green fields that make up the farm's natural amphitheatre, to the day the gates are opened. In preparation the stages are built and routes are laid out between them in trackways. Hedgerows and streams are wrapped in protective fencing and the signature festival totems, bins and incidental signs, unpacked. 'Do not drive on the grass.' The site is part farm, part festival at least until the grass is cut and the grazing animals put away. All this time the site is steadily occupied by staff who pitch the first tents, assembling a host city. This arrangement of stages, markets and campsites and the organization of the principal and 'behind the scenes' routes between them is defined by the festival masterplan. This is a plan that has grown and adapted, remaining anchored around its first destinations like the farm buildings at its heart or the Pyramid Stage.

A focus on understanding of the dynamic of the festival's assembly through the participation of its audience was set against this backdrop. Observation was devised to record the intimate detail of the festival's occupation and how its identity as an Instant City is remade each year through individual and collective experiences. A shared approach to observation and notation was developed. Rather than attempting to observe the festival as a whole the team sampled areas of activity and recorded how particular spaces were occupied and changed over time. A shared conversation developed as work progressed, testing and refining notation. As well as observing how spaces were used, interviews and participatory interactions were conducted with staff working to provide services, with green politicians and with festival goers. The observations drew on the principles of performativity and space outlined by Erika Fischer-Lichte who describes how learning from performance can highlight how spaces can be created or transformed through use and also how spaces affect us through their location, proportion, material and atmosphere (Fischer-Lichte, 2015). This seemed particularly relevant because of the large-scale and diverse relationships between performers and audiences at the festival. The research was carried out by revisiting selected spaces at different times to observe the dynamic of how they were changed by occupation. This observational sampling was done close at 1:100 scale initially in 10 x 10m frames that were enlarged here and there to suit the spaces being recorded. A notation was devised to record: sitting, walking, dancing, performing – standing watching. And was expanded and adjusted to include the roles people were playing. Researchers were interested too in how audiences become performers, an early experiment by the team was to make a space by dancing alongside the old railway line distracting people from their progress with the crowd and creating a small gathering.

The physical infrastructure of the festival, set out in matter of weeks, defines an 'urban' area that is about 2km square. This is made from components that can easily be stored (sometimes in agricultural buildings on the site), lifted and transported and reused each year. As well as stages, markets, trackway, fencing and lighting – the festival layout is defined by flags and decorated furniture and bins and toilet blocks, some that are set up on permanent cisterns. Around the farm buildings to the north is a service and control centre including recycling and healthcare. As well as a digital map, navigation of the festival is supported by a set of analogue signs and totems. These provide familiar festival landmarks, framing meeting spaces and gateways offering footnotes to the festival experience and staking out its legacy. This infrastructure is animated and made functional

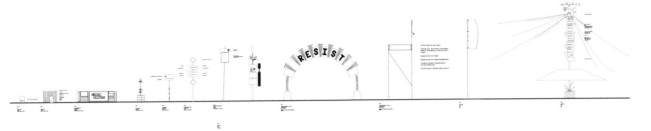

Fig 13.1 Resist and Rise Up, principal signs, icons and directions (Amy O'Shaughnessy)

by volunteers providing stewarding, water, waste collection, toilet cleaning and medical care (Figure 13.1).

To understand the intersections between the servicing and enjoyment of the festival one set of observations focused on a principal route that links campsites to markets and stages and also gives access to recycling, medical care and the staff canteen. Observational studies were made along this main north–south axis exploring how crowd and servicing movement was choreographed and observing the presence of the volunteers alongside the audience. The notation identified roles: punter, crew, police, steward, doctor, fire steward, or Oxfam, Water Aid and Greenpeace. The drawing recorded the significant presence of volunteers and showed how the territorialization of areas by groups of volunteers taking care of amenities provides a sense of security, with teams of volunteers working across distinct routes, zones or visually linked triangulated areas. In the reordered tolerances of the festival landscape, hierarchies between punter and service worker, crew that would not normally be evident in society, are actively upturned and mechanisms are put in place to offer the crew and service worker privileges across the site. The studies also recorded how two stewards used a rope to choreograph pedestrian and service vehicle priority at a crossroads and manage a busy junction between the otherwise ad hoc overlapping pedestrian and vehicle networks. (Figures 13.2 and 13.3.)

Fig 13.2 Rope Gate, Williams Green (6.00pm Friday), 10 x 20m, detailed study of activity – recording the presence of Oxfam, Water Aid, Greenpeace, medical volunteers, security, crew and stewards alongside the audience/participants and site vehicles (Amy O'Shaughnessy and David Kay)

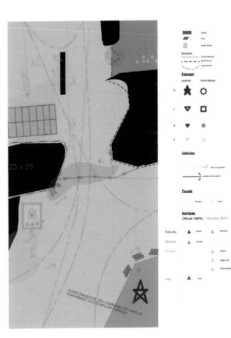

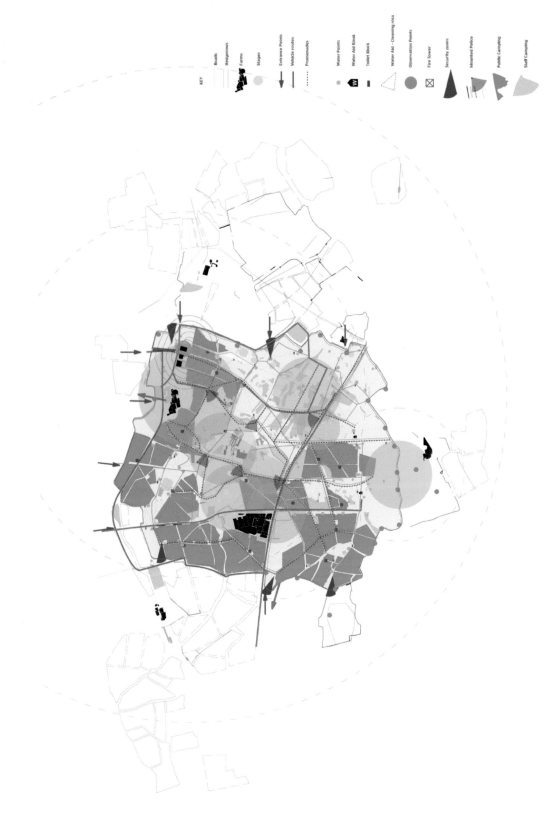

Fig 13.3 Site strategy diagram exploring the intersection (overlaying of) soft and hard infrastructure including: land use, movement, services and security (Amy O'Shaughnessy and David Kay)

Public campsites are located both inside and outside the festival with staff camping inside and alongside stages and markets. Within the zones set out by the festival the public campsites are largely self-organizing. Observations focused on the tensions between formality and informality. All the campsites were found to be highly interactive places. Studies showed how festival goers were first drawn to then eschewed designed social spaces between tents. They left the 'Village Greens' framed with wicker bowers behind and gathered instead in the spaces between groups of tents at a scale and frequency defined by eye contact. Camping was found to have its own particular economies to do with the cost of hiring a tent, the value of a stage view and the reuse value of bought tents. When the festival closes, purchased tents become an encumbrance and their reuse value is unfavourably weighed against the likelihood of being able to successfully disassemble, repack and carry them, or find a place to store them at home.

A set of observations were made at the historic nexus of the festival and explored the nature of the festival's DIY culture rooted in radical green politics – for some the heart and soul of the festival, for some a distant kitsch aesthetic, remnant of a hippy past. This enquiry sought out the civic culture of the 'Instant City' and evidence of the radical legacy of activism, free speech and knowledge sharing. The Speaker's Forum in the Green Fields was documented and interviews were conducted with activists with a long association with the festival. The Speaker's Forum was shown to accommodate a wide range of engagement from audiences drawing in those passing or swelling to include those outside, where the blurred boundaries of the tent were observed to lead to discussions spilling outside. The Speaker's Forum was seen as a festival in microcosm, where speakers hoped to have a formative influence on debate in an alternative space that allowed different things to be said. There was a sense of a resurgence in an interest in the festival as a political space apart, as the organizers noticed that participants were younger than in recent years. Researchers also sought out other spaces where audiences could participate in different ways, finding crowds gathered around a table where people were invited to attempt to scale the underside of the table, or at a craft area where you could join a group to carve a rock, generating a different kind of sound and atmosphere. Through these activities the festival seemed to offer experiences not only of being an individual in a crowd but of being together in a crowd, gathering between tents and at tables around the site.

One of the separately curated venues was studied in more detail. Block9 is a live music and performance venue in the south-eastern corner of the festival. As the first gay nightclub at a UK festival it celebrated its 10th anniversary in 2017. It consists of two nightclub venues enclosed by a third. Housed in large building-like sets are the fictional NYC Downlow (transposed to the Meatpacking District) and the London Underground nightclub. The study observed how the flow of movement into Block9 is reconfigured after 10pm to manage the crowds late at night and restrict access to Maceo's, the staff-only venue hidden inside Block9. The venues choreograph the nightclub queue inside Block9 to stage different kinds of exclusivity and spin out the festival's mythology of secret and hidden venues, offering privileges to volunteers and site staff. Memories of the festival build its identity and it is in part this personally constructed entity that people return to year after year. The role of memory and depiction was investigated through images gathered by three festival goers using disposable cameras. Some are intrepid like Eliza's who at her first Glastonbury set out to explore as much as she could. Their photographs showed visits to Glastonbury's Arcadian landmarks like Glastonbury Hill or Green Futures alongside those to the main stages. A related study of social media posts using the hashtag #Block9 shows how the fictional sets are presented as images of the city and become backdrops to people's personal stories (Figure 13.4). At Glastonbury fiction and reality rub together, fantasy and mythology transcend and are part of the muddy traipsing through 'The Farm'. These studies reveal how

SOCIAL MEDIA IMAGES - EXPLORATIVE COLLAGE DENOTING THE PHOTOS PUBLICLY POSTED FROM 21ST - 26TH JUNE 2017
390 PUBLIC PHOTOGRAPHS USING #BLOCK9

NYC DOWNLOW - 46/390
GENOSYS - 49/390
LONDON UNDERGROUND - 66/390

NYC PERFORMERS - 70/390
POLITICAL VISUALS - 27/390
BLOCK9 INFOGRAPHIC LOGO - 19/390

Fig 13.4 #Block9, explorative collage denoting the photos publicly posted on social media 21–26 June using the #Block9 (Jessica Hartshorne)

the festival is embedded in private memories and fantasies overlaid on the iconic spaces of the city.

Luise Vormitag in her essay on 'alternative urban imaginaries' highlights the role of the speculative depictions like Archigram's 'Instant City' to provoke discussion and draw attention to the potential to interact with how we conceive of cities (Vormitag, 2016). "'Urban imaginaries' then, are complex and partial visions of a place, that are continuously constructed and re-constructed in the dynamic that arises between public signifying and picturing practices on the one hand and private knowledge, experiences, memories on the other." Despite being seemingly effortlessly constructed Glastonbury is actually made from highly articulated and empirically developed structures. Usually the rules that structure our lives are less easy to understand and identify. At the festival, these structures can be seen as constructs that can be adapted, co-opted and subverted. As an Instant City the festival lays bare the extremes of the urban condition, where spatial and social interactions are intensified and can be understood as constructed of order and disorder in equal measure. Rather than a designed culture Glastonbury Festival has an evolving culture informed by the dynamic between the audience, stage promoters and the festival. Its culture is refined by interactions between what is offered, how this is performed by volunteers and experienced by audiences/participants. Here the elaboration of mythology and ethos define culture, not as a brand but as an 'interactive imaginary', where this becomes an informally curated spatial practice in which the infrastructure, the performers and audiences are in dialogue (materially and immaterially) producing space.

Like Las Vegas, Glastonbury shares similarities with Nolli's Rome in its emphasis on public space and porous public rooms. But instead of narrow streets (or the Las Vegas strip) it has wide looping promenades accommodating superfast, fast and slow (mainly pedestrian) movement. The juxtaposition of big and small make it simultaneously fine and coarse grained. When the site appears on television seen from an aerial view, the camera drops down to show the festival laid out and among the crowds at its centre the otherwise hidden hedges and streams appear. Unlike the picturesque country estate, nature is not the primary setting.

Juliet Bidgood

Instead it stages a convergence of rural and urban identities. It is a place of spatial paradoxes that shows by contrast what is concealed or absent in city form, exposing questions about how cities are organized. How then is Glastonbury a model for how you might turn the structuring of city spaces inside out?

First of all, it is important to note that everything inside the festival boundary has an element of performativity to it. It is all theatre and all event; so that the rope gate used by two stewards to organize the junction between the flow of festival experience and its servicing, is part of the festival. This too reveals a general principle about what is behind the scenes, what is back, what is front, what is on top or underneath. Where generally these conventions do not apply to the same degree, back and front are often layered together and exclusivity is a layer you can access, if you can find it.

As in the theatre Glastonbury asks festival goers to suspend disbelief. It lays bare how destinations and landmarks become iconic through lived experience and through their role in place narratives, some fictional. It demonstrates how the culture of a place and its practice can be in flux. How vulnerable civic spaces are alongside the wider drift of everyday events. It shows how spatial diversity and the juxtaposing of big and small can allow different cultural ecologies to be sustained and evolve. It reveals how complex interactions can be reconfigured, for example, to largely exclude vehicles from an urban area and make its primary movement structure pedestrian. Importantly though it is how the festival is identified and framed that makes it distinctive; Glastonbury has a clear vision, identity and ethos, producing a dynamic framework to enable creative autonomy, testing and learning to generate diverse experiences. It supports cycles of innovation, so that stage promoters return each year with new ideas and different ways of servicing the festival are constantly developed – these innovations are often taken up in other places.

The research honing in on the detail of occupation highlighted the larger urban spatial strategies at play. These studies found a participatory political culture linked to the formative landscapes of the festival. Linked to this is a system of signs and artefacts that map out a set of routes and destinations, journeys into the landscape, onto the valley sides. The research demonstrated how governance and infrastructure were intertwined, as the socially organized structures of volunteer work were part of the infrastructure delivering essential services but also providing security and wellbeing. The forms of governance lead to different organizational hierarchies that rather than being representational, are actual. The host city of festival managers, stage promoters, partner charities and volunteers sets the stage for and takes care of the civic and social experience of the city. Jes Vagnby & Peter Schultz-Jørgensen describe how the Rosskilde Festival in Denmark is informing the co-creation of a permanent neighbourhood by establishing partnerships that allow "urban culture to flourish in a dynamic way on a democratic foundation" (2012, p. 15). The festival's spatial practices begin to tell us how cultural spaces could be part of a city's identity from the outset and breathe life into urban form. From the principle of providing a spatial framework, defined by a skeletal (both handmade and generic) physical infrastructure to inviting a highly organized multi-scaled participatory volunteer economy. By managing a framework for autonomously curated creative and civic spaces with capacity for innovation and renewal to providing an infrastructure that gives opportunities for participants to enjoy a series of journeys – both intensely public and seemingly secret or exclusive.

Glastonbury offers a counter-proposal for the articulation of city form and identity. Against its seemingly slight physical infrastructure a complex city is choreographed. This choreography of events, instead of being the soft structure, augmenting how things appear – makes the city. The city is driven by pleasure but contains the potential for participatory political reflection. Its forms of governance foreground cultural independence and creativity while making the servicing of the city socially and economically instrumental. The role of governance (in particular)

is exposed as being generative in place making – securing a sense of security and freedom. The roles and status of individuals, groups and communities are adjusted and rescaled giving people the opportunity to work in teams and participate. As a celebration it entails empowering volunteers to act ethically and to have agency by hosting areas of the city, giving advice and taking care. At a time when cultural and social charities and institutions have an increasingly fragile or sacrificial presence in the urban landscape, Glastonbury offers a model for seeing the city as an "organic entity" where places can be structured through a spatial practice where different value systems meaningfully coexist, creating civic landscapes that are at once mythological, political, ecological and sonic.

> As much as I love what is an incredible selection of sights and sounds, let's face it it's the music that joins the dots, I love the whole social thing just as much. You know, like-minded people getting along, in what is for all intents and purposes a self-policed, autonomous city for basically four days, of what is the biggest music festival in the world. And it comes with unexpected possibilities, discoveries around every corner. It really is something very special (when the weather is good). I also love the way it can be so many different things to so many different people because it works on a multitude of different levels. A big musical clock with cultural wheels and creative cogs that work together to create the best of times and for that Michael and Emily Eavis the Don salutes you. Now all we've got to do is get people to pick up all the crap they leave behind. I mean how are you going to change the world if you can't change your bad habits.
>
> (Letts, 2017)

Acknowledgements

This research was carried out as an extra-curricular project preceding the final year of study of the MArch at Central St Martins. It was led and supported by Juliet Bidgood and Melanie Dodd. The research team included: Billy Adams, Ciara Fitzpatrick, Jessica Hartshorne, David Kay, Conor Morris, Shamiso Oneka and Amy O'Shaughnessy, who also made individual contributions to this account. With thanks to Glastonbury Festival Ltd and the invaluable advice and support given by partnerships manager Robert Richards and site designer Jackie Slade.

References

Archigram: The Walking City, Living Pod and the Instant City (1974) V&A Collection, Museum no. CIRC. 472–1974

Fischer-Lichte, E. (2015) Performativity and Space. In: Wolfrum, S. and Frhr. v. Brandis, N. (eds) *Performative Urbanism*, pp. 31–38. Berlin: Jovis

Gush, H. (2015) Glastonbury: A Living Installation. V&A Blog: vam.ac.uk

Hatherley, O. (2014) Glastonbury: the pop-up city that plays home to 200,000 for the weekend. *The Guardian*, 23 June

Letts, D. (2017) Culture Clash Radio. R6 2.07.17

McKay, G. (1996) *Senseless Acts of Beauty: Cultures of Resistance Since the Sixties*. London: Verso Books

Shonfield, K. and muf Architecture/Art (1999) *This Is What We Do*. London: Ellipsis

Strauven, F. (1998) *Aldo Van Eyck: The Shape of Relativity*. Amsterdam: Architectura & Natura Press

Vagnby, J. and Schultz-Jørgensen, P. (2012) Citizens as urban co-producers. *UD 122: The Urban Design Group*

Venturi, R., Scott Brown, D. and Izenour, S. (1972) *Learning from Las Vegas*. Cambridge, MA: MIT Press

Vormitag, L. (2016) Illustrating alternative urban imaginaries. Illustration Research Symposium, Edinburgh

'As if a cloud had come down'
A conversation with Markus Bader, raumlabor

Andreas Lang

Andreas Can you describe what raumlabor is and how you relate to the term, 'spatial practitioner'.

Markus I first came across this idea of 'naming' architecture differently in 2003, when ARCH+[1] organized a big conference under the title of 'Off-Architecture'. Everybody went on stage and said, "I'm not off, I'm on", really opposing this terminology. So, I was very happy when the term 'spatial agency'[2] arrived – it looked more feasible, more interesting, more likable. And more suitable for what I felt we are doing. We are a group of nine people with a background in architecture that work on – in a wider sense – 'urban questions'.

Andreas Where's the distinction for you, between urban and spatial?

Markus I am interested in the question of 'scale' that resonates with the term 'urban practice'. When we were invited to do 'temporary' urban interventions, I was interested to avoid the 'temporary' and to shift from this very limited description of a possible action, to a wider claim for practice, talking about 'city-making' in a more profound way. What raumlabor does happens at '1:1'. We take care in working with the context; working with a spatial proposition in that context, but beyond that also working with people, bringing in questions and connecting layers together with the perspective of a wider time frame. To be both super involved and at the same time talking about strategic questions, connected to the different networks of decision-making and power structures so that this discussion will actually resonate in the future of this place.

Andreas Tell me a little bit about how you're structured, as a studio?

Markus Formally raumlabor does not exist. In a very recent raumlabor meeting, there was a majority vote to start an association with the name 'raumlabor' that brings the nine of us together. This hasn't been implemented yet. But, this would be a dramatic change from being fairly informal and trust-based, as a basis of collaboration.

Andreas And can you describe the 'trust-based' system that you've been running for the last 19 years?

Markus Between nine people in the group everybody is more or less involved in two or three projects, and we do these projects in teams of two or three. The idea was to discuss each other's ideas through realization (of projects), rather than on an ideological or conceptual level. It was part of an early learning where we thought, 'How can we create working conditions that also respect and appreciate creativity and diversity, more than a competitive model between ourselves?'

Andreas Why do you think that forming a legal body would have undermined this?

Markus When I compare to people that are more involved in formal structures, a lot of discussion is actually about 'what' they want to do. Because (for us) all the economic decision-making is situated within the projects it is delegated into the sub-groups that run the projects. And this is also the basis of the economy of raumlabor. Everything is somehow earned through project work and we all know what limitations this also means. We all know the terror of the boring meeting and we try to avoid that by focusing on what we are interested in, what angers or excites us – and try to avoid talking about organizational issues when we meet.

Andreas And does it work?

Markus Yes, I think so. It allocates very different ways of working. We always felt that as soon as we discuss becoming one economic entity, we would also have to set up common rules on how money is spent or where it is invested, or how we evaluate our work in terms of money. And we very quickly realized that there are very different points of view on that topic. This open way of working in teams, that are based on the unwritten agreement that you do your best, under a common label, has really prevented us from the ideological trap – to limit what raumlabor is, and what it isn't and create sharp distinctions. We recently discussed that you could also describe raumlabor as a 'commons': a common entity which is an immaterial one, but which feeds everybody and is a place of transversal exchange. If you see that as resource, then everybody has access to the benefits and invests in it.

Andreas I enjoyed looking at Floating University on your website – this idea of bringing together all these different parts of the discipline: the dialogue, the communing, the curating, the event structures, the making, the cooking, the building the architectural space – unlike other practitioners who identify much more through the output of a product. How do you address bigger scales of, not only of the city, but also of politics?

Markus There's definitely an interest to discuss things beyond the frame that we set up. Referring to Floating University, I read it as a prototype, or even of a possible extension of existing institutions. A way of doing things differently, rather than just a 'pop-up' that created a fantastic energy for one summer.

Andreas Can you just explain what the Floating University is?

Markus The Floating University has been described as an 'offshore campus for discussing city-making'. This offshore campus has a place and that's Tempelhofer Feld, a piece of existing open infrastructure that is literally a rainwater retention pool. This basin is sunken into a ring of green, plants and trees and because of that, it's extremely removed from any kind of urban atmosphere or stress. In the middle of this lake is a set of different spatial constellations. Very open, very simply made, but very carefully arranged that allow for different activities like workshops, conferences, lectures, but also collective cooking, building, a tools workshop. The atmosphere of this 'open frame' was part of the strength of the project, especially if you come from academia, with its closed rooms, doors, corridors. It looked much more like something unusual, open, half-finished.

Andreas Lang

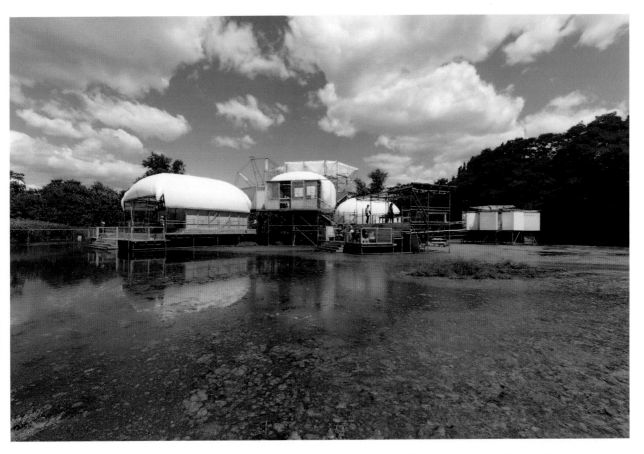

Fig 14.1 The Floating University, Main Building, rainwater retention pool: as if a cloud had come down, and revealed its inner architecture is made to host people in conversation, action and exchange (raumlabor, Markus Bader)

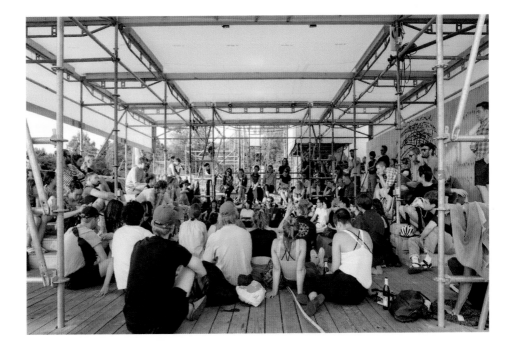

Fig 14.2 Full House in the Floating University Auditorium: one of the many modes of encounter (raumlabor, Markus Bader: Making Futures: Lena Giovanazzi)

Conversation: Markus Bader, raumlabor 149

The Floating University can be read as a fantastic 'in-between'. This is what you definitely discover (in the Floating University). You see so many people coming in, opening their eyes, and embracing this atmosphere of openness and of possibility. And the 1:1 scale is very important. We didn't use a conceptual approach – 'how would it be if our city would be different?' but really put the effort into producing the kind of space – so that you feel it when you're there.

Andreas This 'in-between' is a good way to describe your spatial practice because it's about constantly opening these 'in-between' moments?

Markus Yes, these moments that can be inhabited collectively, and from this common experience, used to ask questions about the city. Using this 'in-between' situation as a counter-experience to the parallel process of how the normative city works.

Andreas You have described your work in an interesting way: "Reframing parts of our activities as 'learning' connects this part of the practice with other sets of protocols." This is a kind of re-framing of practice through the idea of pedagogy. I'm curious what the Open Raumlabor University is, and what space it opens?

Markus 'raumlabor' is a 'programmatic' name (meaning 'space laboratory'). It was about an interest in connecting space with the idea of a 'laboratory' – a space to experiment, to test, to 'find out'. This is still underlined in our approach and in most of our projects. But then after a while, we realized that if we try to be an office, we actually had a lot of discussions about how we're not, or how we're failing to be a really good office. We're still precarious, we still don't have enough money to set up stable structures, nobody has a proper pension plan, all these things that you would associate to offices. But what we managed to do is to keep this 'space' running, so in many ways, we operate much more loosely. If you are a proper office, then you could see that as a deficit. The question is, if it's not a deficit how else could we see these structures that we adopted? And this brought us to this idea of a 'university', a learning environment.

Andreas How do you use Open Raumlabor University, is it a lens?

Markus It's a way of addressing the question of what is produced. Obviously, we don't produce material value because nothing that we made has ever been sold. So, we produce something else. For a while I thought it's maybe 'meaning', a cultural output and in a way you could also say, it's theory in practice. It's a theoretical practice as we don't produce long-term fixed structures.

What also resonates for me in the Raumlabor University is from a very early raumlabor experience – the 'Hotel Neustadt', a formative project from 2003. It was about putting a theatre festival into an empty high-rise building in Halle Neustadt, a shrinking East German city. And the use of a Hotel 'protocol' was to translate something like a crazy, creative, chaotic mix of activities into a frame that everybody can access – a Hotel. This was the moment of the discovery of the power of the 'protocol'. Like if we say, "This is a Theater" you know how to behave. And if you say, "Okay this is a Hotel" you enter the building, you look for a reception, you have expectations and behaviours that are attached to that. And then in Hotel Neustadt of course you could sleep, but the rooms were done by youngsters in a way that you wouldn't expect. The 'how' was actually

Andreas Lang

dramatically changed. The protocol of the Hotel somehow proved to be a very good starting point for everybody to 'enter'.

With the Open Raumlabor University I see a certain parallel. We don't want to copy an existing institution or university by setting up departments, but rather claim that these mixed activities are what our university could be.

Andreas How do you see the politics of your practice?

Markus If you engage with the city, that's automatically a political question – the city is a structured form of living together with inherent power structures, decision structures. Like that, we're intrinsically involved in having a political role.

Andreas But I guess in some projects it's maybe more obvious.

Markus In Berlin, 'Haus der Statistik' and 'Tempelhof' are two super interesting case studies. In a way 'Haus der Statistik' has been initiated through demonstration protest, but then was very quickly carried into a coalition agreement between our governing parties. It is now in the process of being designed; with the question, how to turn some of this big building into something like a civic, self-organized project.

Andreas And your role within it?

Markus The initiator, yes, but the initiator, and many other roles – the programmer, the caretaker, the one who sweeps the floor, the employer, the entertainer, the moderator, the cook, the fixer.

Andreas But when it spills over into projects like 'Haus der Statistik', there's so many actors involved?

Fig 14.3 Lets draw all our dreams and imaginaries into one drawing of the Tempelhof Airfield's future park (raumlabor, Thomas Rustemeyer)

Fig 14.4 Haus der Statistik, Die Werkstatt: the place for negotiation and collaborative development (raumlabor, Markus Bader)

Markus I like this idea of abandoning hierarchies; this idea that everything is equally important. Of course, it asks you to take on different roles and use the openness of these different roles to act differently, to ask questions differently.

Andreas How does it play out in the kind of space, like Tempelhof for example?

Markus 'Tempelhof' is interesting because our proposal was realized, and then of course reinterpreted, repurposed. Our proposal was to design this future park, not only through a top-down design process but through 'use'. To involve an experimental practice on the ground with citizens that basically do what they want – and to see this as a learning process for how a park could operate differently from one being maintained by the city. And it was really a question around the discourse of commoning – how can we implement forms of commoning into larger structures that occupy the public–private divide?

 The so called 'pioneer' process was born; several pioneers started to use parts of the former airfield as a park and manage it on the base of a long-term contract. We proposed this as a way to discuss the city – but not only through participation, where planning professionals and administration representatives proclaim their goals and ask for feedback from the public, which in Berlin, very commonly ends, leads to confrontation. And for a while I thought, okay this is really not working, the administration, and the planning professionals are not using this potential of the experts (pioneers) on site by just not involving them into the decision-making. I talked about this process as a failure for a while but now I would say, its more ambiguous; the city is not a black and white project, but a process, a dynamic. For example, 'Allmende Kontor': there are 800 people attached to this 'pioneer field' who learn how to self-organize and self-manage a common area and keep it open for the public. I really appreciate this as

Fig 14.5 What if our public spaces encouraged appropriation, encounter and empatic moments? 'Happy Pluralities' is a work examining the Bollard's potential as a meeting place (raumlabor, Markus Bader)

Fig 14.6 How to transform an airport into public space? Raumlabor contributed the 'pioneer use strategy' arguing for urban development based on trust, action on the ground, exchange and respectful negotiation. Public spaces are placed to encounter the other. The Knot, 2010 (Joanna Erbal)

an amazing outcome. Even though it didn't scale up into the vision for Tempelhof Airfield, it's fantastic in itself.

Andreas But did it, because there was a referendum?

Markus With the referendum (2014), the people of Berlin voted for a 'Tempelhof Law' which freezes the status quo – and of course the heated confrontational discussion around the referendum was, 'Do you want to sell off the park to the people that can afford it? Or is it a park for everybody and we should maintain it as it is?'

Andreas Do you see your intervention with the 'pioneer fields', your introduction of the openness of this process and the referendum, as linked?

Markus Absolutely, many of the actors that strongly lobbied for a referendum were actually part of the pioneer process. Members of the city administration have admitted that they completely misjudged the opportunity for a possible merger of ideas or to embrace the pioneer process as a platform to meet and discuss, and to de-escalate tensions. This referendum as a policy tool is very new to Berlin, no one had any experience with it. It was widely perceived as a disaster for city politics that the people would actually vote against the government, against advice to build up some parts of the park, and against a master plan that has been in the making since the 1990s. From an administrative perspective, a lot of work that had been invested into the project was lost. The vote can be interpreted as a vote of distrust in the government to take care of fundamental concerns of wide parts of the population: to live in an affordable place. After the financial crisis vast amounts of capital flowed into the city, creating a housing market boom and sharply rising prices for housing. A feeling grew, that people with money take the 'city' away from 'me' as the population.

All this resonated in the referendum on Tempelhof. I would now say that the law emerged because the process we had designed was not really embraced. Our idea was to prevent the confrontation, and instead design dialogue and cooperation. But if the actors from both sides don't cooperate, we are back in conflict. I also wonder to what extent this cooperative approach works against potential energies that are more revolutionary. In the above scenario, the power structures in the city are changing. Those moments of disruption create an interesting in-between for negotiations to take place.

Andreas You are a professor in UDK (Universität der Künste Berlin) now, but the way I understand the Floating University is a way of opening a space 'outside' of academia?

Markus For me there is a serious question about how we teach architecture. Many architecture schools work by talking about architecture as a building, and not addressing the question of 'what is the question?' Already cutting short the responsibility and the potential in the discipline. If we argue with Bruno Latour's 'terrestrial manifesto'[3] that it's not about a dichotomy between local and global but the extraterrestrial and the terrestrial, and as the extraterrestrial is not available, we have to finally acknowledge that we are all limited to this one planet. The way we treat everything in our 'business as usual' model is destructive and not sustainable. I guess everybody agrees with this and still the mechanisms are not radical enough to evoke change. Architecture as a profession involved in city-making could potentially contribute much more. It starts with energy efficiency and, thinking about the built object lifespan, reuse, but it's a complex issue and that's why it is so important to broaden the dialogue, to develop discourses across discourses, to connect and talk to people from other disciplines. 'How do we create the space where we can bring in what we already acquired as expertise, but open it up to people from other fields to look for common approaches?' Even if we install solar panels on all roofs and facades and build with wood we are still not going to be at a point where architecture starts to be sustainable.

I'm interested to question how we discuss architecture in architecture schools and involve students in the idea that 'everything is equally important'. With our student group in Floating University we talked about

design from the perspective of the kitchen: we were building the kitchen, we were running the kitchen, we were acting as hosts in the space, we were setting up platforms for discussions, we were curating. We could start an interesting discussion 'if we leave behind the expertise of the exquisite kitchen design what do we have instead?' Perhaps we have somebody who's able to navigate between these different expertises and translate from one expert to the other. Someone not intimidated by the professional codes of the different disciplines but rather, somehow be familiar to exist in an in-between.

Andreas Do you think these transversal moments – do you think they should remain moments – or do you think it is about large-scale reorganization?

Markus Well both. You could still work on a very theoretical question and still cook for everybody in the studio, understanding this as a parallel production of knowledge.

Andreas In your book, *Explorations in Urban Practice* (2017)[4] you are very clear about your methods, and you have the "As If" interventions: "Doing 'As if' is very much doing itself." Can you describe this 'As if' because it seems to be a recurring method?

Markus 'As if' is done and then removed. In the example of Urban School Ruhr (2016) the artist Valentina Karga installed a heatable bench in the city centre. Heat came from fire and the fire heated the bench in a "rocket stove technique," a technique widely used in places with very limited access to resources. I was intrigued by the questions an installation like this asks, especially in relation to the location: "Who likes heat? Who's going to take care of the fire? How do we deal with our fire regulations and fears that come from dramatic historic traumas of fire? How do we deal with people's concerns – if this is a warm place then maybe drug addicts, the homeless and those on the fringes of society would gather?" The 'As if' can be seen as a way to put ideas into practice. Everybody sees it's only half as bad (as feared) and then it can be negotiated. The 'As if' is trying to build coalitions. I'm not fan of black and white politics. Instead I like to find ways to bring out potentials. We know not everybody in administrations is against everything that the citizens propose, and not every citizen is able to invent a new public space protocol or intervention. It's really about extending the boundaries of the different fields of actors.

Andreas One thing I'd like you to explain to me, what is it that you discuss at dinner? The reason I ask is because there's a lot of emphasis in the book on trust in the agency of conversation dialogue, discursive dinners, finding new languages?

Markus That's a starting point for theory and practice in dialogue. We share a common moment in space that includes us as 'bodies', eating and cooking and taking care of this part of our presence, and at the same time we feed our brains with spicy languages. What interests me in the 'discursive dinner' is that it creates different scales of encounter. One can shift from talking about a recipe to talking about the world, or talking about football. With formal input and Q&A, we shift more towards an academic format and then shift back more to an informal format during the next course, maybe reflecting on that. We have different scales of engagement in a discursive dinner which pulsate very organically.

Conversation: Markus Bader, raumlabor

And you need somebody who takes care of the dynamic of this common experience: taking care of the dynamics of a place instead of designing a place. I think it's really along that line that the designer works – on the spatial set-ups, the ingredients, the idea of which recipes can we do, the lighting situation as well as moderating the discussion so that everybody who gives an input gets the attention and the interest of everybody present.

Notes

1 Mikolas Kunan, https://www.archplus.net/home/archiv/ausgabe/46,167,1,0.html
2 Nishat Awan, Tatjana Schneider and Jeremy Till, *Spatial Agency: Other Ways of Doing Architecture* (Abingdon, Routledge, 2011).
3 In B. Latour, *Down to Earth: Politics in the New Climatic Regime* (Cambridge: Polity Press, 2018).
4 *Explorations in Urban Practice* (2017) is the travel diary of the Urban School Ruhr organized by Raumlabor Berlin in the Ruhr Valley, Germany.

15 Spatial narratives

A critical position

Tricia Austin

Spatial narratives are stories *about* space and stories *embedded in* and expressed *through* space. The former are constituted by written, filmic, graphic and performative stories that are circulated in the public sphere through print, screen and audio. The latter appear in space through environmental graphics, projections, performance, mobile social and locative media, augmented reality but also, importantly, through the physical forms of the built environment. Structures, shapes and materials evoke histories, identities and meanings. The tangible dimensions of the built environment also combine with regulatory systems and cultures of inhabitation to communicate in an implicit way. Histories, identities and meanings are often heavily contested, so spatial narratives form an important dimension of spatial practices, a dimension, for example, where market forces and resistance to market forces collide. This chapter explores spatial narratives in order to contextualize the design of 'critical narrative environments', which constitute a specific approach to spatial narrative that challenges prevailing neoliberal assumptions within spatial practices. Critical narrative environments seek ways to enhance the agency of individuals and groups in civil society, democratizing the ways in which space is conceived, constructed and lived.

As a form of spatial practice, the creation of 'narrative environments' draws on literary, spatial and political theories.[1] This approach takes narrative to be a deliberate construct which communicates a story over time to a specific audience whereby, through dynamic alliances, actions and struggles, someone or something changes from one state to another. It sees narratives as a means to communicate underlying messages purposefully and engage critically with meaning production in specific environments. As a result, it follows that a critical narrative environment is a story *intentionally* embedded *in* the environment, expressed *through* multiple implicit and explicit means. These include the materials, structures, forms, qualities of light and rhythms of spaces but also the textual, or image-based graphics, film, sound, digital means and human interaction in the space. The design of narrative environments follows Lefebvre (1991) who argues that spaces are not simply a matter of physical dimensions and material structures. Rather, in being intentionally constructed, spaces embody and shape particular configurations of ethical, political and cultural relations.

Narrative environments comprise specific content, arranged in story form, made available in, and through, specific places. As transmedia narrative theorist Marie Laure Ryan (2016) points out, learning about a story in situ adds a huge sense of presence and power to that story. Being there and experiencing a story in space is, after all, a long-established practice underpinning, for example, religious pilgrimages, visits to historic sites or extraordinary landscape but, it is suggested here, that there is also opportunity to insert revealing, provocative or reflective narratives into everyday practices. It should not be forgotten that audiences also play an important role in the construction of meaning. Audiences will interpret the story from their own perspectives, sometimes integrating it into their own life narratives (Bruner, 2004). In the participatory design of narrative environments, audiences actually become co-authors and, as a consequence, the story or stories told embrace a more plural, and potentially more democratic, approach than

Spatial narratives: a critical position 157

traditional, single-authored stories because they represent multiple voices. As a result there is a growing exploratory strand of participatory design in critical narrative environments.

This chapter contextualizes the design of narrative environments by examining a variety of projects to demonstrate how top-down, market-driven spatial narratives, that produce a flood of seductive and immersive experiences, can be challenged and subverted demonstrating the value of critical narrative environments.

The discussion starts by examining the use of narrative in architecture as architecture is a dominant discipline within spatial practices. The text highlights the looseness of the term narrative in architectural discourse and makes a plea for more precision. It concludes that the language of architectural form is fundamentally abstract and architecture communicates through implicit metaphors and formal qualities and suggests architects need to look beyond the confines of their discipline to embrace narrative as is developed here. This then opens up the discussion of narrative in other spatial practices looking firstly at prevailing urban development narratives that circulate in print and film and how they have spawned critical counter-narratives in music, print and video that expose issues at play beyond narrow market-driven concerns. This is followed by an account of how digital media is using narrative tropes and has created further complex dimensions that are shaping the field of spatial practices. It shows how digital media are already having profound effects on our physical environment, social relations and political discourse and are set to continue so increasingly in the future.

The chapter concludes with case studies of embedded narrative environments that provide examples of critical practice arising from multidisciplinary collaboration across architecture, graphics, performance and fine art. The case studies integrate both implicit and explicit communications, making narrative interventions in the everyday to highlight political and social issues, challenging and subverting dominant market-led ideologies and prompting further responses and action.

Architecture and spatial narrative

The temporal character of narrative does not at first seem to align closely with architecture, if architecture is seen as a practice that produces fixed, enduring structures, or "frozen music" as Goethe and Schelling famously said. However, there are notable examples of architects and urban planners that have conceived of the temporal dimensions of architecture and urban design. One thread emerges from Le Corbusier's (1964) notion of the architectural promenade, which he first mentions in his description of the Villa Savoye at Poissy in 1928. Le Corbusier's ideas are echoed in Philip Johnson's essay on processional architecture published in 1965. These essays explore the experience *of* architecture and they link quite closely to the theories of the construction of mental models of space by inhabitants which were developed by urban planners Kevin Lynch (1960) and G. Cullen (1971). However, time and space are just two dimensions of spatial narrative. Spatial narrative, as defined earlier, comprises a triple sequence of movement: the progression of *content,* through *space*, and over *time*, with a *deliberate intention* to communicate a story.

A number of architects have explored how content and sequence in architecture might be understood. Aldo Rossi (1931–1997) was interested in how memory is embedded in built forms, drawing an analogy between urban design and theatre (Livesey, 1994, 115–121). Architect John Hejduk (1929–2000) described how buildings become characters in the architectural process (Vilder, 1994). Jonathan Hale (2017) describes some buildings as actively telling a story of their own use, for example, by the way steps are worn away by users over the years. Richard Sennett (1990, 192), makes an argument for narrative space referring to Mikhail Bakhtin's (1981, 84) concept of 'chronotope', in other words, the inseparability of time and space. Sennett suggests that the urban environment needs to be designed to allow for events to begin and unfold. In his vivid description of Manhattan, Sennett suggests planners should lift fixed zoning, allowing encounters in spaces which "are

simple enough to permit constant alteration" (1990, 191–196). He maintains narratives of place emerge as these displacements are advanced, resisted or negotiated. While these are profound insights, Sennett and these others describe a form of unfolding spatial identity rather than a specific story deliberately told.

Architects and spatial designers interested in narrative often look to the work of Bernard Tschumi (1995) who produced influential reflections on sequential, experiential space. Tschumi challenges convention by arguing that action and event should be considered part of architectural discourse. He translates devices such as plotting, foreshadowing and fading into architectural form. However, he uses these literary and filmic devices to make innovations to the physical form of the building rather than spatialize a particular story.

Through his teaching in 1970s at the Architectural Association, Tschumi inspired a group of young architects to form a loose knit collective, Narrative Architecture Today (NATO) (Jamieson and Poyner, 2017). One of the members, Carlos Villanueva Brandt, explains he and fellow architect Mark Prizeman worked in the 1970s with the grittiness of the streets, found their way into abandoned warehouses, made films and objects mixing low culture and high culture in the spirit of punk. They assert their narratives were open-ended; people could interpret them as they wished. By contrast, Nigel Coates (2012), who coined the name NATO, used classical references to make overt metaphors working within architecture and fashion. He conceived of the city not as layers of planning, but as layers of narrative, and maintained that architecture cannot help but express the cultural eco-system that makes cities. Whilst NATO challenged many architectural conventions and produced a significant body of experimental work, it is argued here that their adherence to the implicit nature of narrative did not produce fully fledged spatial narrative as defined above.

This brings us to the present where these multiple threads and the recent widespread adoption of the word narrative in management, media and political discourse have contributed to rather loose applications of the term narrative in architectural education and professional practice. The ambiguity of the term diminishes its potential as a significant tool for the communication of critical spatial practice. The word is being used to mean many different things: the histories or identities of a site, the intent and the justification of an architectural proposition and even speculative future scenarios depicted in storyboards, printed visualizations and moving image. Narrative tropes, such as personas, sequence and metaphor, are frequently used. While these examples of story elements contribute to a degree of spatial narrativity or storyness (Austin, 2012), they arguably do not qualify as spatial narratives because they do not contain rising action, struggle and dénouement; in other words, they do not form an overall story structure.

Buildings implicitly embody ideas (Ampatzidou and Molenda, 2014) but architecture, in itself, is not a fully narrative medium. That is not to say that architecture is just a passive backdrop against which plots play out. Space actively guides and shapes people's behaviour and imagination, for example, evoking welcome at thresholds (Zumthor, 2015). Architecture is *one* of the skillsets needed to communicate stories in space but fully fledged spatial narrative requires *multidisciplinary* collaboration at all stages of design so that narrative content is fashioned, integrated into the spatial environment and expressed both implicitly and explicitly.

Subverting the sales story

Moving from the use of narrative in architecture to its exploitation in urban development, slick animations and voiceovers or polished computer-generated narratives are carefully crafted by visualizers working for urban developers, local authorities and commercial architects. The appealing representations encourage commercial investors, house buyers, visitors and local residents to sign up to a vision about locations that mythologize the space and side-step social and environmental issues and political frictions. These visualizations, populated by well-dressed but nondescript

people, strolling under sunny skies in immaculate, sanitized spaces, are used in client pitches, company websites, the architectural press and as large posters on the hoardings of building sites. These idealized scenes repeatedly express certain core values: the ecstasy of renewal, the marvels of technical innovation, the pleasures of immersion and the assumption of social cohesion, a world where people are free to eat, drink, shop and play, the ultimate consumer lifestyle, all thanks to property companies acting as de facto municipalities (Moore, 2014).

Despite the recognition that these visual myths are sales tools, they seep into the public sphere and circulate, spawn affiliations, and reinforce the overwhelmingly positive messages until there is broad consensus about the identity of particular redevelopment locations. This process cries out to be challenged and subverted. In September 2017, as part of the annual London Design Festival, 'designjunction', an explicitly commercial showcase of interior and product design, was held in and around Granary Square, the centre of the King's Cross development. The exhibition was part of the programme of events that developers, Argent PLC, runs in and around Granary Square to reinforce its identity as an upmarket leisure destination. In turn, the design festival reinforced the developer's link with design innovation and creativity. On their website 'designjunction' described how the raw industrial location of King's Cross redevelopment area provides an immersive environment for the exhibition, so that the exhibition became 'more than' a trade show. Here we see two PR narratives merging to reinforce one another, leveraging notions of creativity, heritage, renewal, innovation and immersion, the last becoming the current buzzword. Other partners reiterated the message. New London Architecture organized neighbourhood tours during the event, as it continues to do, that "highlight the dramatic renewal of King's Cross Central ... into a vibrant new neighbourhood for living, working, learning and play" (New London Architecture, 2018), while Edwin Heathcote, of the *Financial Times* wrote, "The King's Cross site is the perfect mix of grittiness and shininess, simultaneously a symbol of London's industrial and engineering past and the creative present" (Heathcote, 2013). Thus, the narrative of King's Cross is established and reinforced through formal and tacit alliances between the developers, the exhibitors, architectural organizations and the press which together result in the increase of the market value of the land.

The words narrative and story have also been widely appropriated by city redevelopment and branding consortia, for example, "the narrative of the masterplan" (Buro Happold, 2017) or "experience masterplanning" (Allan, Hobkinson and Hanna, 2017) which combines commercial placemaking with place branding. Although the stated goal is to create better, more sustainable places, the underlying drivers are brand promotion and, ultimately, financial profit. The tools used are urban design, property management marketing and value propositions that tell stories and transform local culture into a commercial asset. This process is about selling an image and filling people's minds with market-related aspirations rather than providing places for people to think their own thoughts (Pimlott, 2018). This approach conspicuously fails to address urgent or long-term socio-economic divides, environmental or socio-economic policy issues.

Some have tried to subvert these commercial narratives. For example, in 2010 the London Borough of Newham's strategy, as expressed in the video *London's Regeneration Supernova*, spawned a critical response, 'Music for Masterplanning' by Alberto Duman, the 2016 Leverhulme Trust artist in residence, which critiqued the development of Docklands, in other words the lack of planning for well-paid jobs for local people, top-down lack of consultation, toxic waste and illegal dumping. Throughout 2016, 'Music for Masterplanning' developed a fictional playlist and mastered 17 different soundtracks composed and recorded by people living or working in the so-called 'Arc of Opportunity'. Duman made the tracks freely available on several digital streaming and download platforms: Spotify, Soundcloud and Bandcamp. Duman (2014) discusses 'the spectacle of capital', suggesting the corporate production of urban narratives creates manufactured urban vitality turning

culture into another business asset. In their book, *Regeneration Songs: Sounds of Investment and Loss in East London,* Minton, Duman, James and Hancox (2018) critique the effects of global capital foreign investment on cities worldwide.

A key influence on critical visual narratives about corporate dominance in recent years has been Adbusters, a global collective of anti-consumerist, pro-environment artists, designers and activists, based in Vancouver, Canada, which takes inspiration from the Situationists and their concept of détournement. Détournement entails taking a well-known symbol that evokes an associated narrative into another context to subvert its meaning. One example, 'Subverting the city with adbusting' (Fuhrmann, 2017) involved replacing adverts with printed artwork in Berlin's Kreuzberg-District. This action disrupts commercial discourse and engages the passers-by in different kinds of dialogue. Adbusters has, since its foundation in 1989, created publications that critique corporate communications by generating spoof ads, posters and products. It also runs campaigns such as 'Buy Nothing Day' and notably initiated Occupy Wall Street that supports direct action to highlight economic systems that perpetuate grossly uneven wealth distribution.

Guardian journalist Chris Michael (2016) discusses a series of US short films which parody the process of gentrification. For example, a video called 'Bushwick, Brooklyn' shown on *Saturday Night Live* is staged in New York's notorious Bushwick area. It shows three young black men hanging out on the corner of a street talking and gesturing in gangland mode but instead of discussing drugs, crime and violence they are sharing tips about nannies, ski trips, brunch, dog-walking, and knitting Christmas sweaters. Here humorous narrative is used as a powerful tool to highlight the complexity of urban social divides. There is a twist near the end of the video when one of the characters describes a dispute over artisanal mayonnaise which he resolves by shooting the other person dead. This undermines the scenario of acculturation that has been set up. The apparently civilized conversational topics enter into a two-way relationship with violence. The gang members have adopted consumerist lifestyle talk but nevertheless continue to engage in casual violence and murder. This suggests an analogy with gentrification. The vernacular of the urban fabric has changed but fails to address persistent violence that arises from social inequality and division.

Narrative is crucial to the notion of property. Some property brands are now more valuable than the property itself. Property is vital to the way space is developed. Property development is as much to do with narrative as it is to do with space. That is why approaching it as narrative in the realm of music, print activism and video parody is a valid way to engage in critical spatial practices. This critical practice challenges the pervasive and simplistic narratives of social amelioration through urban development and reveals just how complex are the ties between physical space and social space.

Digital détournement

Urban development and other brand narratives are also spatialized through mobile digital media and locative software that comprise digital maps, news sources, apps, blogs, games, commercial websites and social media. For example, identifying a location on your mobile phone is increasingly synchronized with sales messages for products or experiences. "Public spaces often become brand spaces as our experiences within them are mediated by search engines, social media check-ins and review platforms" (Kravets et al., 2018, 169). Meanwhile, in recent years, e-commerce has devastated high streets, reducing footfall, causing shops to close and effacing the identities of towns and suburbs. Businesses and governmental organizations are now relying more on data harvested about user habits to provide transport infrastructure and the supply of goods to locations. This, in turn, is being fed into the extensive, coordinated shipping activities that support dispersed global manufacturing and distribution. It is clear the digital is not just an additional layer to our lives, it is having a profound and global influence on the physical world.

Nevertheless, digital media are also used very effectively to subvert the torrents of marketing babble. The beauty of mobile digital technology is its connectivity, flexibility, scalability and hackability and its power, partly through narrative integrated into physical space. An example is 'The Shed in Dulwich', a restaurant that reached number one on Tripadvisor. The only problem for guests was that it did not exist. It was a hoax by journalist Oobah Butler for *Vice* magazine (2018), who sought to challenge TripAdvisor's hegemony in dispensing travel advice. On a larger scale, in more explicitly political realms, online critique connects many to many (Cresswell, 2002) and, in turn, leads to online and physical collective action (Castells, 2012).

The cultural sector is also exploring how the digital can enable new forms of spatial narrative. Museums have pioneered location-based mobile apps that enable audiences at specific sites to access content about the history of that location to bring it to life in a physically and emotionally engaging way using 'augmented reality' (AR). AR makes use of internet connectivity, location awareness and cameras on smartphones to allow people to view digital images and information layered onto the 'real' physical environment. In 2011, the US design company, Local Projects, created an AR app 'Explore 9/11' (Segall, 2011) for the 9/11 Memorial and Museum, New York. The app enables people to look at Ground Zero through their mobile phones and see video taken from those exact places at the time of the attack overlaid onto the present environment. These are all extraordinarily powerful narrative experiences. However, they do not use the full interactive capabilities of digital media. They push narratives out to users. It can be argued they represent the commodification of history and culture as towns and cities try to enhance their place-based reputation or brand to attract tourists through their history and culture.

Artist B.C. Biermann (2014) has explored more activist and open systems giving options, for example, to users to "resurface" buildings so that people can see what they might look like 20 years from now. Other open, user-centered digital systems exploring the city through wayfinding can also be viewed as spatial narrative. Serendipitor,[2] for example, is a navigation app that prompts chance discoveries. However, AR has also prompted a dystopian vision of urban space, such as that envisaged by filmmaker Keiichi Matsuda in his video *Hyper-Reality* (Winston, 2016). Here is an urban space saturated with AR, designed as an anonymous backdrop with few material or formal design qualities so that media can be projected onto it and continuously updated. In this world, everyone is sealed in their own self-referential system steered by giant technology companies that have harvested data about people's preferences.

On the other hand, location-based mobile technologies can bring people together in game-based spatial narratives. Pokémon Go, released in 2016, is probably the most successful geolocated AR game to date.[3] Excitement was caused by the opportunity for all to participate, exercise and develop new friendships (Bonas et al., 2017). Players said it gave them and their friends a kind of 'licence' to be in various places that they would not normally go, like parks and residential streets late at night. However, some Pokémon Go players have invaded government offices, hospitals and intruded into people's homes. Players were accused of treating the whole city as an urban playground without taking into account social, racial and legal barriers. This highlights that public spaces are not equally accessible to everyone. Manaugh (2016) writes about how some players caused physical damage which led to the consideration of new zoning laws, 'geofencing' augmented reality. This kind of thinking has promoted the debate on who governs the augmented city and the politics and etiquette of gamified spatial narratives. In 2018, Chilean artist Sebastian Errazuriz vandalized Jeff Koons's virtual 'Balloon Dog' using virtual graffiti on his own app as part of a "stance against an imminent AR corporate invasion" (Sayer, 2018). Another concern is the business model. AR geolocated games can collect and sell data on users' movements. This has opened

up questions of big data and urbanism and potential for the commercialization of digital geography.

In the future critical narrative spatial interventions will need to consider the inseparable connections among narrative, commercial brands, physical space and digital space. The multidimensional entanglement of, for example, personal and social identity or legal, political and cultural authority, exacerbated by the commercial nature of technological enterprise, provides material for critical narrative environment design practice. In addition to the complexity of the ties between physical space and social space, as noted in the previous section, this highlights that designers working in the field of spatial practices will need to be alert to the digital intensification and its rearticulation of social, legal, political and environmental questions.

Embedded narrative environments and critical practice

Critical narrative environments work by intentionally activating the metaphors implicit in scale, material, form, sequence and so on, bringing them into play with the explicit communications in image and text, video and human behaviour. In this field, critical practitioners deliberately synthesize narrative content, the physical and sometimes digital world unfolding stories and prompting stories to be interpreted by users in space and over time.

These spatial narratives literally 'take place' producing action and interaction between people, things, space and media. They reveal hidden or overlooked stories and/or set up fictional parodies in the everyday, in order to build agency among ordinary people and question the world as we know it. The examples below include interventions by students, professional designers and artists. The interventions are located in different kinds of spaces: housing estates, libraries, public realm and markets but each one involves a triple unfolding of content, space and time. The interventions act as enablers and disruptors. They bring attention to, and actively tackle, societal issues such as isolation in the city, social divides and marginalization, gentrification and environmental, economic and cultural sustainability.

Julie Howell's project 'Nowhere to be Seen' (Howell, 2016) is an intervention on the large, deprived Stonebridge housing estate in north-west London. The project not only highlights the isolation of elderly people living in social housing but also provides a means to overcome that isolation. Howell worked closely with Hyde Housing who introduced her to residents. Over time she gained the trust of the community, photographed them (Figure 15.1) and engaged them in participating in an installation. Out of 42 'at risk' residents invited to participate, 23 agreed to take part. Howell programmed each of these 23 residents' lamps using Arduino software to gently dim and light up according to their individual breathing patterns and, on 23 November 2015, each participant put their lamp in their window. All the windows pulsed gently signalling life inside the flat and the stark and unhospitable estate was transformed into an engaging, evocative and poetic space (Howell, 2017). This was the opening event to raise awareness of the elderly community among the residents as a whole. Howell went on to establish a new public meeting space within the Hyde Housing office and the residents co-developed a photography project inspired by the light installation. This resulted in the 'Stonebridge People Library' where huge portraits of the elderly residents hang (Figure 15.2). There is also a collection of images, stories and aspirations of people who live on and around the estate. Neighbours on the estate can access the material and meet at specially designed events. Howell's work co-created a site-specific positive narrative of belonging. The overarching message is articulated through both the physical transformation of the space in the light installation, the large powerful images, the written blogs and the face-to-face interaction. The content is open to individual interpretation by the residents. The project unfolds over time and leads directly to active mitigation of the dire urban landscape and entrenched social isolation.[4]

Fig 15.1 Stonebridge Estate project by Julie Howell: Bernie expressing her loneliness (J. Howell)

Fig 15.2 'Nowhere to be Seen', Stonebridge People Library by Julie Howell (J. Howell)

Staying with libraries, Takayuki Ishii developed an intervention 'Street Grammar' in the Chelsea Library, London. The project challenged widespread negative assumptions and treatment of homeless people. Ishii spent a great deal of time getting to know the homeless community who frequent the library as a warm, safe, public space. He collected their words, philosophies, observations and life stories and made booklets and insets among the books on the shelves. He aimed to reach library users on the other side of the social divide, through a subtle, place-based installation.[5] In 2015 Ishii formed a company, Creative Garden,[6] and has received government funding in Japan to undertake several socially engaged projects. In 2018, he moved to the town of Nagahama, to develop Shitateya-to-Shokunin (Tailor

Tricia Austin

Fig 15.3 'Shitateya-to-Shokunin' by Takayuki Ishii, Dekoyashiki Daikokuya (T. Ishii)

and Artisans). Here the livelihood of local craftspeople is threatened by diminishing demand for their products such as silk yarn fabric. Ishii is running workshops, co-designing products (Figure 15.3) and exhibitions with the craftspeople to find ways to sustain and communicate their cultural heritage but also to find ways to use their skills to develop new products and ensure the community's economic resilience.

Moving on to public realm Anna Lincoln's 'Island Board Walk', initiated in 2016, uncovers local heritage on the Isle of Dogs in London in stark contrast to the market-driven narrative of Canary Wharf, a centre for global financial services. Lincoln worked with local residents, schools and local community organizations to generate content which is displayed on neglected and defaced interpretation boards installed in the public realm throughout the island in the 1990s. Lincoln also made an accompanying audio trail featuring interviews with local residents and incorporating their many different perspectives. Island Board Walk shows how heritage is fluid, in constant reconstruction and how participatory design can help to secure community ownership of local heritage to sustain a shared sense of place in city regeneration. The project is ongoing, in partnership with the Island History Trust and George Green's School where pupils regularly get involved as part of their curriculum. As a result of Lincoln's fundraising efforts Canary Wharf Group is helping to support a strong group of residents and council members which meets regularly to discuss the future of the boards and how best to interpret the history of the Isle of Dogs. Canary Wharf invited Lincoln back to curate a display inside the Canary Wharf shopping centre in 2018, 'Women at Work' (Figure 15.4) was inspired by one of the updated boards. It celebrates the working lives of island women and promotes alternative histories.[7]

An example of spatial narrative at a built scale is Ridley's restaurant (Levene, 2011), designed and implemented by a multidisciplinary design collective, the Decorators, in collaboration with Atelier Chan Chan. Ridley's restaurant was a temporary two-storey construction with a kitchen on the ground floor and dining area on the first floor. One of the novelties was that the dining area consisted of

Fig 15.4 'Women at Work', Canary Wharf by Anna Lincoln: Buddy Penn explains to visitors what is going on in the photograph and shares her memories of life working on the Isle of Dogs (A. Lincoln)

one large communal table, the top of which was winched down to the kitchen at the end of each course to be refilled in the kitchen and winched up with the next course. This provided an unfolding scenographic dimension to the experience. The project explored different ways to support the local economy. All the cooks were local chefs and the produce was sourced in the market. The diners, who applied online, paid a moderate fee which included a voucher for the market to encourage them to use the market. Diners were selected to mix long-standing local residents, newcomers and people from outside the neighbourhood. The goal was to bring different communities together for spontaneous exchange and raise awareness of the dynamics of the locale. It was a critical intervention that communicated multiple narratives of alternative social order of integration and economic support, a hub of for mutual exchange rather than a profit-based initiative. It eradicated the difference between designer, producer and consumer, everyone played a key part, and the narrative was also expressed through the novel architecture, which did not aim to be a commodity.

Urban-scale narrative environments have been implemented by street artists such as JR. JR is a French artist renowned for pasting giant black and white photographic portraits of ordinary people on a range of architectural-scale surfaces outdoors in the public spaces. The monumental images often occupy the same space as the very people he is depicting. He pastes on walls, rooftops, the side of trains and container ships. His work sets out to address urgent social, political and environmental issues through large-scale representations in the cityscape. He has worked all over the world. One of his early works 'Women Are Heroes' took place in Africa, Brazil, India and Cambodia. The huge images of women's eyes stare out across the city in a dramatic and thought-provoking way. JR says the goal of that project was to "highlight the dignity of women who occupy crucial roles in societies, and find themselves victims of wartime, street crime, sexual assault, and religious and political extremism" (JR, 2008). Although 'Women Are Heroes' is very

dramatic and resonant, a more fully narrative intervention was 'A Child Caught Between the U.S.–Mexico Border' which took place in October 2017. JR installed a 70ft image of a 1-year-old Mexican boy peering over the Mexican–US border fence. Hundreds of people came to see it from both sides of the border and exchanged cameras through the fence to take pictures. JR then instigated a cross-border picnic with a table extending on both sides. During this performative narrative environment people from each side of the border sat together, shared the same food and the same water in a gesture that symbolically dissolved the wall.

Larger urban-scale city narratives are usually framed by governments and/or urban developers however there are examples of initiatives which come close to being embedded spatial narratives, for example, Regen Villages in the Netherlands, "will collect and store its own water and energy, grow its own food, and process much of its own waste. Also: no cars" (Peters, 2018). It is a significant intervention in urban design. It has the potential for the triple movement of stories of sustainable living unfolding through the space over time and could produce transformation urgently needed in response to one of the world's most burning issues, climate change.

The examples above illustrate the value of deliberately embedded narrative environment as critical socially engaged design to highlight, reveal, provoke both thought and action on specific matters of concern. They show, through practice, the multidisciplinary character of the design of narrative environments, combining implicit and explicit narratives intervening in the everyday, genuinely putting into play critical thinking and questioning, involving real people in real situations.

Narrative is one our most powerful communication tools. Indeed, as writer George Monbiot (2016) says, stories enable us to navigate the world and interpret its complexities and contradictions. He continues by arguing that those who tell the most compelling stories run the world. Once a powerful story has talken hold in people's imaginations the simple presentations of facts will not dislodge their belief in the story. He argues the two most powerful political narratives circulating since the second half of the twentieth century are Keynesian social democracy and neoliberalism. Both of these have the same narrative structure, they are both restoration stories. Monbiot (2017) summarizes this structure as follows,

Disorder afflicts the land, caused by powerful and nefarious forces working against the interests of humanity. The hero – who might be one person or a group of people – revolts against this disorder, fights the nefarious forces, overcomes them despite great odds and restores order.

It follows that there is an urgent need for new stories to problematize the accepted stories, to reveal power relations inherent in those stories and to stimulate debate. Monbiot's insight needs to be extended beyond print and online media and political discourse to include physical, material and built environments.

Spatial narratives are equally as powerful as the media narratives discussed by Monbiot. Like any other story-forms, spatial narratives can be used to persuade, manipulate or deceive but, crucially, they can also be used as a critical tool to reveal the patterns of knowledge, desire and power at play in a particular location. Critical narrative environments can not only comment and contest but also unveil, disrupt and challenge vested interests and power relations through their shaping of everyday actions and interactions. Such environments can be understood to constitute, in the words of Hannah Arendt (1958, 199–207), a public 'space of appearance' where actors can reveal their political character in, and through, interaction.

Notes

1 The principles of narrative environments rely on literary theorists including A.J. Greimas, Seymour Chatman, H. Porter Abbott, David Hermann, Marie Laure Ryan; spatial theorists including Maurice

Merleau-Ponty, Henri Lefebvre, Doreen Massey and Bruno Latour. The discipline also draws on political theory, including that of Hannah Arendt.

2 Serendipitor was developed by Mark Shepard, at V2_ Institute for the Unstable Media as part of a joint artist residency with Eyebeam Art+Technology Center. Serendipitor is a component of the Sentient City Survival Kit, a project of Creative Capital. For other alternative digital wayfinding systems see https://popupcity.net/top-5-apps-for-exploring-the-city

3 There are numerous geolocated games in addition Pokémon Go. See https://dasbox.be/encyclopedia-of-location-based-games/

4 Collaborators on 'Nowhere to be Seen' were: the estate's residents; Tom Gardiner, Hyde Housing Projects; Vernetta Beswick, Housing Officer; Patrick McKay, Community Leader; Lea Nagano, Motion Graphics; Mamiko Yamazaki, Graphic Design; Mamta Khanna, Rendering; Ekta Raheja, 3D Drawing; Citra Otoktaviana, Storyboarding.

5 Collaborators on 'Street Grammar' were: Georgina Manly, concept development; Agnieszka Szypicyn, graphic design; Jeremy Hunt, adviser.

6 creativegarden.jp or hello@creativegarden.jp

7 'Island Board Walk' collaborators: Friends of Island History Trust; George Green's School; Massey Shaw Education Trust; The National Maritime Museum; Tower Hamlets Council; Canal and River Trust; Anna Savva, writer audio trail; Arif Wahid, photographer; Mike Seaborne, photographer. The project was sponsored by the Canary Wharf Group.

Bibliography

Adbusters (2018) *Adbusters*. Online. Available HTTP: http://adbusters.org/ Accessed 9 August 2018.

Allan, M., Hobkinson, R. and Hanna, J. (2017) How to Integrate Placemaking and Branding Through Experience Masterplanning. *The Brand Observer*. Online. Available HTTP: https://placebrandobserver.com/experience-masterplanning-how-to-guide/ Accessed 9 August 2018.

Ampatzidou, C. and Molenda, A. (2014) Building Stories – the architectural design process as narrative. In 'Digital Storytelling in Times of Crisis' [Conference], Athens. Online. Available HTTP: www.cristina-ampatzidou.com/building-stories-the-architectural-design-process-as-narrative-conference-paper Accessed 9 August 2018.

Arendt, H. (1958) *The Human Condition*. Chicago, IL: University of Chicago Press.

Austin, P. (2012) Scales of Narrativity. In S. MacLeod, L. Hanks, and J. Hale (eds) *Museum Making, Narratives, Architecture and Exhibitions*. London: Routledge, pp.107–118.

Bakhtin, M. (1981) *The Dialogic Imagination*. Austin: University of Texas Press.

Biermann, B.C. (2014) Experimental Augmented Reality 'FUTURE CITY'. *H: Designing Imagined Futures* [Website]. Online. Available HTTP: https://www.heavy.io/future-city Accessed 9 August 2018.

Bonas (2017) Look on the Bright Side (of Media Effects): Pokémon Go as a Catalyst for Positive Life. *Media Psychology*, 21(2), 263–287. Online. Available HTTP: https://www.tandfonline.com/doi/full/10.1080/15213269.2017.1305280?src=recsys Accessed 9 August 2018.

Bruner, J. (2004) Life as Narrative. *Social Research*, 71(33), 691–710.

Buro Happold (2017) Designing Buildings Wiki – Masterplanning. *Buro Happold Engineering*. Online. Available HTTP: https://www.designingbuildings.co.uk/wiki/Masterplanning Accessed 9 August 2018.

Castells, M. (2012) *Networks of Outrage and Hope: Social Movements in the Internet Age*. New York: Wiley.

Coates, N. (2012) *Narrative Architecture*. Chichester: Wiley.

Cresswell, T. (2002) Introduction: Theorising Place. In G. Verstraete and T. Cresswell (eds) *Mobilising Place, Placing Mobility: The Politics of Presentation in a Globalized World*. Amsterdam: Rodopi, pp. 11–32.

Cullen, G. (1971) *The Concise Townscape*. Oxford: The Architectural Press, p. 9.

Duman, A. (2014) Beauty and the Beast: Capital Forces and Cultural Production. *The Architectural Review*. Online. Available HTTP: https://www.architectural-review.com/essays/beauty-and-the-beast-capital-forces-and-cultural-production/8660904.article Accessed 9 August 2018.

Duman, A. (2016) Music for Masterplanning – Sounds from the Arc of Opportunity. Music for Masterplanning [Video]. Online. Available HTTP: https://www.youtube.com/watch?v=oViCH0KCOQc Accessed 9 August 2018.

Fuhrmann, P. (2017) Anonymous Group Adbusting Billboards in Berlin. *ParcCitypatory* [Website]. Online. Available HTTP: http://parcitypatory.org/2017/12/30/adbusting/ Accessed 9 August 2018.

Hale, J. (2017) *Merleau-Ponty for Architects*. New York: Routledge.

Heathcote, E. (2013) A Place for Cyberspace. *Financial Times*. Online. Available HTTP: https://www.ft.com/content/31ff7e18-661b-11e2-bb67-00144feab49a Accessed 9 August 2018.

Howell, J. (2016) The Stonebridge People Library. *Julie Howell* [Website]. Online. Available HTTP: https://www.juliehowell.space/the-stonebridge-people Accessed 9 August 2018.

Howell, J. (2017) 'Breathing Lights' – Addressing Social Isolation – The Stonebridge Estate – Brent – North London [Video]. Online. Available HTTP: https://vimeo.com/206255836 Accessed 9 August 2018.

Jamieson, C. and Poyner, R. (2017) *NATO: Narrative Architecture in Postmodern London*. London: Routledge.

Johnson, P. (1965) *Whence & Whither: The Processional Element in Architecture*. New Haven, CT: Yale University, School of Art and Architecture.

JR. (2008) Women Are Heroes [Video] Online. Available HTTP: https://www.jr-art.net/videos/women-are-heroes-by-jr Accessed 17 December 2018.

Kravets, O. (eds) (2018) *The SAGE Handbook of Consumer Culture*. London: Sage.

KX (2017) designjunction 2017. *KX* [Website]. Online. Available HTTP: https://www.kingscross.co.uk/event/designjunction-2017 Accessed 9 August 2018.

Le Corbusier and Pierre Jeanneret (1964) *The Complete Architectural Works Volume II: 1929–1934*. London: Thames & Hudson.

Lefebvre, H. (1991) *The Construction of Space*. Oxford: Wiley-Blackwell.

Lesmes, L. and Hellberg, F. (2016) VIRTUAL SEMIOTICS//////// SPACE POPULAR///////////. Reorient Xpress [Video] Online. Available HTTP: https://www.youtube.com/watch?v=_c4RyoTbGgY Accessed 9 August 2018.

Levene, J. (2011) Thank You Jessie for This Great Piece You Made of Ridley's. *Ridley's* [Website]. Online. Available HTTP: www.ridleys.org Accessed 9 August 2018.

Livesey, G. (1994) Fictional Cities. In Stephen Parcell and Alberto Perez-Gomez (eds) *Chora*. Vol. 1 *Intervals in the Philosophy of Architecture*. Montreal: McGill-Queen's University Press.

Lynch, K. (1960) *The Image of the City*. Cambridge, MA: MIT Press.

Manaugh, G. (2016) How Augmented Reality Will Reshape Cities. *Motherboard*. Website Online. Available HTTP: https://motherboard.vice.com/en_us/article/ezpamw/zoning-for-pokemon-go-and-augmented-reality Accessed 9 August 2018.

Michael, C. (2016) From Settlers of Brooklyn to SoDoSoPa: The Best Gentrification Parodies. *The Guardian*. Online. Available HTTP: https://www.theguardian.com/cities/2016/dec/09/best-gentrification-parodies-snl-south-park-key-peele Accessed 9 August 2018.

Minton, A., Duman, A., James, M. and Hancox, D. (2018) *Regeneration Songs: Sounds of Investment and Loss in East London*. London: Penguin Random House.

Monbiot, G. (2016) *How Did We Get Into This Mess?: Politics, Equality, Nature*. London: Verso.

Monbiot, G. (2017) How Do We Get Out of This Mess? *The Guardian*, 9 September. Online. Available HTTP: https://www.theguardian.com/books/2017/sep/09/george-monbiot-how-de-we-get-out-of-this-mess Accessed 19 December 2018.

Moore, R. (2014) All Hail the New King's Cross – But Can Other Developers Repeat the Trick? *The Guardian* [Website]. Online. Available HTTP: https://www.theguardian.com/artanddesign/2014/oct/12/regeneration-kings-cross-can-other-developers-repeat-trick Accessed 9 August 2018.

New London Architecture (2018) New London Neighbourhood Tour – King's Cross. *New London Architecture* [Website]. Online. Available HTTP: www.newlondonarchitecture.org/whats-on/events/2018/july-2018/new-london-neighbourhood-tour--kings-cross Accessed 9 August 2018.

Peters, A. (2018) The World's First "High-Tech Eco Village" Will Reinvent Suburbs. *Fast Company* [Website]. Online. Available HTTP: https://www.fastcompany.com/90207375/the-worlds-first-high-tech-eco-village-will-reinvent-suburbs Accessed 9 August 2018.

Pimlott, M. (2018) Interiority and the Conditions of Interior. *Interiority*, 1(1), 5–20 [Website]. Online. Available HTTP: http://interiority.eng.ui.ac.id/index.php/journal/article/view/5 Accessed 9 August 2018.

Ryan, M., Foote, K. and Azaryahu, M. (2016) *Narrative Space/Spatializing Narrative: Where Narrative Theory and Geography Meet*. Columbus: Ohio State University.

Samuel, F. (2010) *Le Corbusier and the Architectural Promenade*. Basel: Birkhäuser.

Sayer, J. (2018) Who's in Charge of the Augmented City? *Citylab* [Website] Online. Available HTTP: https://www.citylab.com/design/2018/03/whos-in-charge-of-the-augmented-city/554324/ Accessed 9 August 2018.

Segall, L. (2011) Explore 9/11 through the Eyes of Your iPhone. Online. Available HTTP: https://money.cnn.com/2011/09/07/technology/911_apps/index.htm Accessed 9 August 2018.

Spatial narratives: a critical position

Sennett, R. (1990) *The Conscience of the Eye: Design and the Social Life of Cities*. New York: Norton.

Thompson, V. (2003) Telling 'Spatial Stories': Urban Space and Bourgeois Identity in Early Nineteenth-Century Paris. *Journal of Modern History*, 75(3), pp. 523–556.

VICE (2018) I Made My Shed the Number One Restaurant in London. *VICE video*. Online. Available HTTP: https://www.facebook.com/VICEVideo/videos/1904867753160598/ Accessed 9 August 2018.

Vilder, A. (1994) *The Architectural Uncanny: Essays in the Modern Unhomely*. Cambridge, MA: MIT Press.

Winston, A. (2016) Keiichi Matsuda's Hyper-Reality Film Blurs Real and Virtual Worlds. *Dezeen* [Website]. Online. Available HTTP: https://www.dezeen.com/2016/05/23/keiichi-matsuda-hyper-reality-film-dystopian-future-digital-interfaces-augmented-reality/ Accessed 9 August 2018.

Zumthor, P. (2015) *Atmospheres: Architectural Environments – Surrounding Objects*. Basel: Birkhäuser.

Tricia Austin

Telling stories

Interactions and experiences on the civic stage

David Chambers and Kevin Haley, Aberrant

Architecture is the art of articulating spaces but it has the capacity to do more. People should be able to add to the story of a project, place or city, through their experiences and engagements. Narrative, as architect Nigel Coates writes, "has a particular meaning beyond an overarching theme. It denotes a sensibility and a way of working that sets out to incorporate human nature into its method" (Coates, 2012, pp. 11). We are storytellers and our characters – those people who use and interact with our buildings – are part of the creative process. This is a short story about our approach to architecture told via a selection of our projects, from the Civic Stage (2016) to the Roaming Market (2013) and The Tiny Travelling Theatre (2012).

The Civic Stage is 'public art meets public infrastructure' – an outdoor platform for conviviality, spontaneous activity and social interaction. It stands in the middle of Swansea's Museum Park, amid the Maritime Quarter, staring back at the neo-classical facade of Swansea Museum – the oldest museum in Wales dating back to 1841. It's a disruption to the architectural fabric, divorced visually from the context, but not from the narrative. The question of its function is similarly fluid. Based on our engagement and research with local people, we envisaged patterns of use and behaviour, but we avoid being overly prescriptive. The Civic Stage, as it stands today, opens up to the green, inviting activities and events including musical performances, fashion shows, pop-up shops and exchanges, as well as

Fig 16.1 The Civic Stage, Swansea (Aberrant)

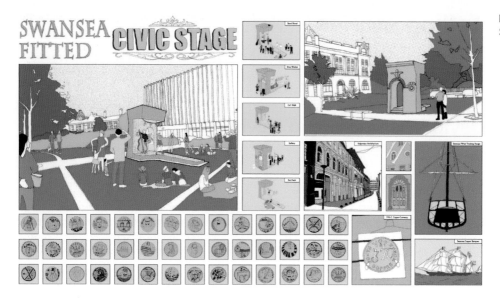

Fig 16.2 Narrative of the Civic Stage, Swansea (Aberrant)

other unexpected inhabitations. Satisfaction comes from returning to the site and seeing our script being rewritten (see Figures 16.1 and 16.2).

'Stories-so-far'

The starting place for the Civic Stage was to engage with the context; to gather what we describe as local intelligence. When engaging with any context, it's clear that place is always 'under construction'. Places are composed of multiple layers or trajectories, as Doreen Massey writes in her book *For Space* (2005), and these 'layers' of local intelligence range from historical, cultural and economic factors to the informal social structures of the people who live, work and play in any given area. Engaging local context and the interweaving of these story 'layers' or ingredients makes each project unique. An inherently collaborative approach, 'capturing a piece for everyone', creates an engaged audience for a project that endures beyond completion. Capturing multiple voices also ensures greater diversity.

During the development of the Civic Stage we conducted a research residency at Swansea's Mission Gallery: six months on site, undertaking a series of conversations and workshops with local organizations, artists, users and passers-by. From this we learned about the Welsh city's history as a world-centre of copper smelting and production. A large proportion of this copper ore came from Valparaíso, Chile, and Valparaíso was actually described in the mid-nineteenth century as a 'suburb of Swansea'. Around the same period, local copper barons would mint their own coins as a way of paying their workforce. Honouring this early form of local currency, the Civic Stage's surfaces are richly embellished with a grid of individually designed coins. Each coin features a unique design contributed by members of local community groups. But these "stories-so-far", as Massey calls them, are not always easy to identify or control. Is it even possible for two white men, coming from similar social and educational backgrounds, to truly engage with all of the stories that surround any given site? For instance, while researching the Civic Stage project, we became aware of a local campaign to erect a life-sized bronze memorial to Swansea-born polar explorer Edgar Evans on the same site. What's more, we were told that this traditional proposal had the backing of the fundraising committee. Claims need to be thoroughly tested as they have the potential to include or deprive others of their own histories and stories. As Massey states, "The 'locals' (even if they can be provisionally defined) are not always 'right', nor is abiding by their majority opinion always the most democratic course to adopt" (Massey, 2005,

pp. 163–164). But engaging with the public also inevitably invites moments of levity and irreverence. At one of our poorly attended public consultations a member of the public asked what would happen if someone urinated on the artwork (the Civic Stage is near to Swansea's infamous bar street). It's designed to shed all water, we replied; primarily rain but also urine. Hearing this the questioner then wanted to know if we had in fact designed a urinal.

Public engagement by no means circumvents the traditional design and approvals process for any architectural project. The Civic Stage originated from a public arts programme with local, national and European funding. At the same time as we engaged with the public at the contemporary art gallery, we established a stakeholder steering group, comprised of representatives from local council departments, residency groups, arts consultants and galleries. We met at various key stages of the project and sought input and feedback on our research and subsequent design. Swansea Council's planning director at the time missed all of our meetings. Indeed, he only reviewed the project for the first time when it was about to be submitted for planning. He didn't like the proposal (he even rubbished the proposed site). Consequently, we had to go back to the drawing board at the very last minute. Our revised proposal incorporated aspects of the original idea, but the hasty redesign undermined our collaborative and lengthy design process. A local election, taking place halfway through the fabrication stage, brought in new stakeholders with little interest in the previous administration's public art commissions. Subsequent delays risked missing a deadline to spend grant money that was part funding the project. Suggestions were made that the half-finished piece could be transported to site and craned into place temporarily, so that an inspector could drive past and state that 'yes indeed the grant money had been spent on time'. The idea was that the piece would then be removed and transported back to the workshop, to be finished. It can be tempting, when discussing design projects, to describe a smooth gestation process, but the reality is often less so.

Architecture as 'actor'

Like other of our projects, the Civic Stage is both a permanent fixture and a flexible platform, consisting of three interconnected sections, which users are encouraged to adapt. In a similar way, the Roaming Market was a mobile structure for Lower Marsh Market in Waterloo, London. Inspired by forgotten market structures it incorporates a covered seating area with built-in chess board. The rooftop acts as a stage for hosting events and performances. These scripted uses are only truly tested when the architecture performs. In this case, the architecture becomes an 'actor', provoking and facilitating activities, ad-libbing; giving new meaning and identity to a place and writing new chapters in the story. Suggesting that architecture can be designed to shape human action, Ignacio Farías (2010, p. 3) describes how Latour's Actor-Network Theory supports the "active role of non-human actors in the assemblage of the world" inspiring users to challenge existing prescribed behaviours and allow people to disrupt the orthodoxy of the public realm and occupy the city in a celebratory or 'carnivalesque' way.

The literary theorist Mikhail Bakhtin considered action and event as 'carnivalesque' (1984); a means to challenge the pre-existing order, to temporarily disregard social and spatial hierarchies and to rethink the way things are normally done. Alongside the Roaming Market, the Tiny Travelling Theatre is another example of the 'carnivalesque'. This mobile theatre, designed for London's Clerkenwell Design Week and inspired by accounts of the neighbourhood's theatrical history, provides a miniature auditorium with seating for six people and an enclosed setting for a series of intimate one-off performances, ranging from theatre and comedy to music; an assortment of musical instruments and props encourages audience participation, while a rooftop sound funnel provides outsiders with a hint of what's unfolding within. Often, post-completion, we find that these new uses and occupations are unexpected. Although we developed a programme of events, like

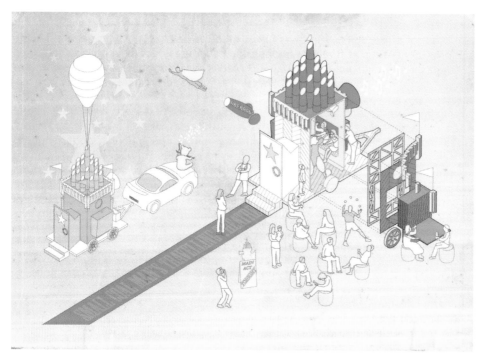

Fig 16.3 The Tiny Travelling Theatre (Aberrant)

Fig 16.4 Concept drawing of the Tiny Travelling Theatre (Aberrant)

David Chambers and Kevin Haley, Aberrant

fortune-telling, to animate the project, the Roaming Market itself grew organically into the world's smallest restaurant, featuring an open-air rooftop kitchen and an intimate two-person dining booth underneath.

Identifying and building on 'stories-so-far', engaging the public in the design process, deploying 'carnivalesque' tactics and understanding architecture as an 'actor', challenge accepted ways to develop architectural projects. They also reinterpret how people can use, occupy and experience the built environment. "Buildings are not static objects, but 'moving projects', which certainly do not stop moving when built" (Farías, 2010, p. 4). They have a dynamic role in the co-evolution of both the built environment and society at large, their design serving to mediate human relationships. Up to now, our projects, from the Tiny Travelling Theatre to the Civic Stage, have been minor players, upstaging for a brief moment the direction and pace of urban redevelopment. The question we get asked the most is whether we will stay true to this approach when we get commissioned to design larger more permanent commissions. Our answer is always the same. Without a doubt the approach is scalable, and while there might be different challenges to face at a larger scale, we want all of our projects, large or small, to have the potential to engender lasting change by seeking broader input and engaging previously unheard voices.

References

Bakhtin, Mikhail (1984) *Problems of Dostoevsky's Poetics*. Minneapolis: University of Minnesota Press

Coates, N. (2012) *Narrative Architecture*. London: John Wiley

Farías, I., Bender, T. (2010) *Urban Assemblages: How Actor-Network Theory Changes Urban Studies*. Abingdon: Routledge

Massey, D. (2005) *For Space*. London: Sage

17 'Rehearsing fictions'
A conversation with The Decorators
Melanie Dodd and Shumi Bose

Mel Speaking in the context of a book about spatial practices, how would you define what you do?

Suzanne It starts with being collaborative across different practices – landscape architect, spatial designer, psychologist, and architect. We started working together ten years ago at Central Saint Martins, with a shared curiosity about space and what happens in spaces. Each of us brings our individual curiosities to uncover what a space is about. You can go to a space and spend a short amount of time there, and get one kind of reading, but if you spend a long time you get to see a much broader sense of what kind of relationships are happening, and that defines the way that we work; giving 'time' to the practice.

Xavi As much as we work with objects, buildings and structures, we work with people. Our practice is about trying to engage with others, it involves lots of phone calls, arranging meetings and pulling people together to have a discussion as much as it is about creating the space for that discussion to take place.

Suzanne In J.G. Ballard's book, *Sound Sweep*, a fictional novel, he talks about the layers of the city 'building up' and how they have to 'hoover it out'. We see that in our work, all those layers of history that have built up.

Mariana Spatial practices is definitely a term that is interesting to us because it allows us to think of an expanded practice of architecture. Perhaps I'm more conscious of this because I come from architectural education. But because we come from different disciplines and because with each project we adopt new methodologies and learn to 'become' other things – for example, we have had to run restaurants, become restaurateurs, or producers – we have had to become other things that are very distant from our original disciplinary training. Spatial practice is useful because it is much more encompassing than other terms such as architecture or interior design alone.

In terms of what we do, I'm also very interested in fiction. Many years ago, when we did Ridley's, Xavi said, "Well, what we did is a rehearsal." We 'rehearse' the possibility in a public space. Although fiction is a literary genre, it's interesting to think about it as a tool of practice because it allows us to imagine possibilities and to test them. We can test them by 'rehearsing' small but fully functioning systems. These projects enact the possibility in a given context for a specific group of people in a specific site. It's very different from the kind of 'fiction' that is practised in architectural education, or in 3D modelling, or in film or cinema, because it's a fiction that has to do with getting your hands dirty, working on the ground, and working in collaboration with many people. So, it's very messy in that sense.

Suzanne In our everyday lives, we have habits in the way that we behave, our day-to-day normal rituals and we don't question them, we just do. Our work is often trying to explode those rituals of the everyday, inserting spatial scenarios that get people to act and play in different ways. And by inviting people into a restaurant, a boxing match or whatever it was, people think in a different way. That's where the narrative and the spatial emerges; we create a spatial scenario for people to come and play out different roles.

Shumi In terms of overarching ambitions, you mentioned the earlier work was perhaps trying to be provocative – trying to shake people out of their normal rhythms and routines. Is that still the overarching aim of the practice? Or do you think it's evolved?

Xavi I think, fundamentally what has changed in the practice is that in the beginning we were 'doing everything' – producing self-initiated projects: coming up with a situation; deciding what site; what conditions to explore and what context to respond to. But when you start receiving commissions there is a brief, there is an intention, there is a client and there are a series of outcomes and aims that you need to respond to. And I think that's what has actually changed. I think the ambition is similar. The values and the methodologies are much the same – listening, spending time in a place, trying to find out what's happening and creating new relationships that spark a proposal or an outcome. What has shifted is the starting point.

Fig 17.1 Ridley's Temporary Restaurant: a full view of Ridley's at night, when the rest of Ridley Road Market had packed up (Dosfotos)

Suzanne With the Ridley's project, traders said to us, "this is a market, if you are here you buy, you trade, you sell." That really made us think – "what's

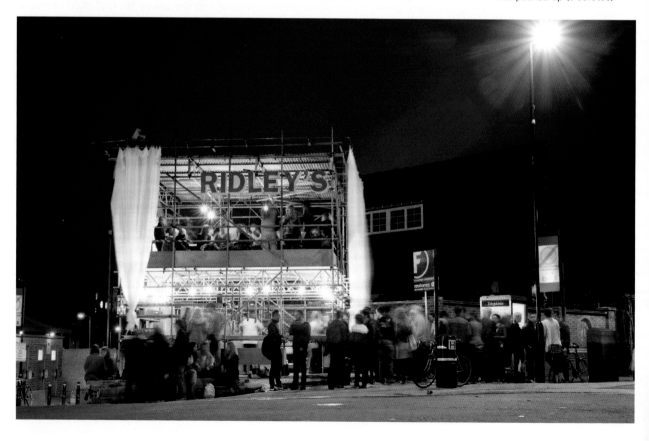

Melanie Dodd and Shumi Bose

our medium of exchange?" And at that point it was an ability to design and make a project happen. That's something that we're questioning all the time. "What are we bringing to this space? Who is it for? Why are we doing this?" That's what becomes difficult as we develop into a business and need to respond to briefs.

Mariana A really important aspect that is particular to our practice is that we work as much with spatial programming as we do with spatial design – we like to question what activities happen in the place and put equal efforts and equal time into programming and designing. We are interested in programme because programme is what defines what happens in a place. We don't think that programme is something that is predetermined, but we think that projects like ours can contribute to changing certain habits and routines as Suzanne was saying. And sometimes when you get a commission to do a project, there's already a vision for that site and a certain understanding of what might happen in that site and that for us is a challenge – how can we continue to work on programme and proposed, events and uses or misuses (in these cases)? At the moment in the practice we're expanding the kinds of context that we're working with, and questioning specifically the places of regeneration and the extent to which you can really put sites and uses into question. Or should we just resign and say "Well architects have absolutely no power here"?

Mel How much do you think the context of this work has then shaped negatively and positively what you've done?

Suzanne In the beginning Ridley's was completely self-initiated, and it was wild in terms of not really knowing what we were doing. We had just set up a studio and we had done a couple of projects, but we were also all making money from different sources. And there was a vision suddenly; it was a restaurant, it was two storeys – which was absolutely ridiculous in hindsight. It was all about the energy of just getting the thing done, and we made it happen. It was wonderful because everything about it was questioned and interrogated, and for us it was just a successful project. There wasn't an intention for legacy really. But then what was interesting, and we didn't realize at the time, was that the project existed within the context of the wider Hackney–Dalston redevelopment, and we were 'put on the map'. And so that's how we ended up working with GLA [the Greater London Authority] further.

Xavi I don't think we were so aware this might be seen as a 'meanwhile' project in the context of regeneration. Zoe Chan (the architect who owned the site) just invited us in and said "Let's do a project together." As the project developed we started waking up – Hackney Council hadn't granted all the permissions, but all of a sudden we appeared in a book as a project being promoted by them. Or the Estate Agent came and put up a sign that this site is For Sale: "Come and see. Look, look what you can do with a five x five metre space – it's two storeys, there is a kitchen, you can have 20 people dining, you can have the Evening Standard come and take pictures!" So, by doing the project, we were really learning first-hand what the impact or consequences of such an action could be.

Shumi What were some of the most unexpected things like that that you found?

Xavi Well, the Environmental Health application for example. We had to get permission (as a facility serving food) but we would have never passed this

test. Environmental health called us about one year after Ridley's was taken down to inform us that they were going to come and do an inspection! So obviously the 'system' was not ready for 'meanwhile' projects at that time, around eight years ago. Now there are more structures and if you apply for a 'pop-up' restaurant, someone will come and check it quickly.

Shumi So how did you feel about all this publicity from 'pop-up' that you were suddenly the poster child for?

Suzanne Great. 'We got loads of work!'. (*laughter*)

Mariana Well for me it is important to keep the tactical spirit throughout. You're working in a context, and certain visions that have been set out for that context. You're called in because you have the ability to generate activity, interest for that site and you're able to communicate with the people who live, work, and pass by that site. And, so then – what do you do with that? Often the kinds of proposals that we make for 'meanwhile' spaces and the 'futures' of the sites in which we work are based on our findings and what we believe would be positive for that place. But, then it's a question of whether our proposals are taken seriously. And the ways in which they go on to inform the actual plans for those sites. It's really a question (for our work).

There is a book by David Kirby, *Lab Coats in Hollywood*[1] where he talks about how in cinema directors have used science fiction films for small companies to test out products. Such as the projected computer screen they swipe with their hands in *Minority Report*. And that's what he calls 'free product placement'. So, the film on the one hand gets these products for free. On the other hand, technology companies can develop prototypes. But who's winning from this situation? Is it the film director that's setting out a vision for where these technologies are situated? Is it the company that earns by naturalizing these proposals and making them seem normal and acceptable, presenting them in a social context? Sometimes it feels the same with city councils. The city council and developers have a particular vision for a site. We come in and do tests, and rehearsals. We have a vision that is not necessarily aligned with theirs. And, somehow there's a moment in time when the two things coincide. But whose vision is going to thrive? I don't know.

Suzanne Our next project, 'Chrisp Street on Air' was directly commissioned by the GLA, and that was an amazing project for us because there wasn't a strong discussion about legacy – it was more about questioning. We got to play and explore, and use methodologies which were theatrical, which we thought were valuable. The actual outcomes were quite experimental.

Xavi What was interesting here is that we were invited at a crucial moment – at a very early stage of Chrisp Street Regeneration. It wasn't a developed brief at that stage, and the GLA and London Borough of Tower Hamlets didn't know exactly how that area was going to be developed. So, we did something that was about people literally experiencing an alternative market for real. It was about the shaping of this new future for Chrisp Street.

Shumi Just out of curiosity, what do you think the authorities did get out of it?

Xavi I think 'impact' is about how you carry on with those projects; what happens the day after. It's true that the day after our project finished,

Chrisp Street Market was exactly the same as it was before. Which is actually not so bad! But what I mean is that the impact or ambition of the project was beyond Chrisp Street – how many markets are there in the UK that are in the same situation? Perhaps they are not really working, people are not going there to buy their fruit and veg anymore. So, it's about testing beyond one situation, where the site becomes a case study for broader research.

Mariana At that time, we were really interested in the market as a public space. Markets were usually located in streets in the UK, but in the postwar period (in the UK) new markets really opened up public squares as civic space. And we wanted to ask with this project, "Okay, so if the market of commercial activity, of shopping, isn't really thriving, what else could we reclaim space for?" And we thought, "What if the market becomes a cultural space?" And we did a series of cinema screenings. "What if the market becomes a venue for community events?" And we need a boxing tournament there. These tests could be useful then to think about markets more generally.

Mel You've talked about ideas around 'fiction' and projects being 'rehearsals' which is quite counter to the sort of typical disciplinary design method – design as a solution to a problem. Do you see projects as performances in their own right?

Suzanne That is something that we are always questioning. In terms of running our business, the words 'engagement', 'consultancy' or 'consultation' irk us because of what they potentially mean. But because our skills of curiosity, social interest, wanting to talk to people – are good for engagement – we get put onto these teams. And we are constantly trying to figure out, is this who we are? Sometimes we try to 'redirect briefs' – there is an artistic framework which allows it to be wide open, but actually these are real social questions that need answers – being pushed

Fig 17.2 Chrisp Street on Air, boxing: an outdoor boxing tournament was organized with the local boxing club to emphasize the use of Chrisp Street Market as a public and civic space at the heart of community life (Dosfotos)

Conversation: The Decorators

Fig 17.3 Chrisp Street on Air, the Future Market Show: the mobile radio stall we set up for Chrisp Street on Air brought the stories and discussions about the relevance of Chrisp Street Market out into the public spaces of the Lansbury Estate (Dosfotos)

to find answers; to count the number of people we have engaged; to evaluate how much their well-being increases because they've taken part in our project. With one project we are working on at the moment, we are operating a co-design process, which we are being asked to evaluate using the 'Theory of Change' which is a 'well-being' analysis – so assessing '0 to 10 how do you feel now, and then what is your happiness levels after taking part?' It is all quite valuable but it's important to figure out how to 'measure' without taking the integrity away from the process.

Mariana But equally, I don't think that the practice of 'rehearsal' is one that is disconnected from a commitment to the future of a place. I think the fictional – whether in literature or in spatial design – has a critical function and we're interested in that. After you've seen what a place 'could be', you can never return to normal. So that idea that, the next day things go back to how they were before, it's maybe not possible – even if the intervention happens for an instant in time – because people engaged with it and that was meaningful.

Mel That is an important critical function to the work, then?

Suzanne I think interrogation is extremely important. A lot of the places we're working with are so diverse, such a range of people, characters and cultures. But actually, the places where the briefs are coming from are not diverse.

Xavi We've been working for a long time on how we make our practice more diverse. We have tried different methods to open up that discussion – which is a very difficult thing to do, just because of the way we look, for a start! So, we've been trying this out with a couple of projects: instead of us talking to people, we've been training community members to do interviews themselves. It takes double the time for us, because you have

Fig 17.4 Thames Ward Radio: local residents carrying out interviews as part of the audio training workshops for the Thames Ward Radio Project. Thames Ward Radio, Barking & Degenham, 2018 (The Decorators)

to train someone else. But already, that brings in results that we would otherwise never be able to find.

Mel Hearing you talk about the diversity of your practice in that way – examining your own privileges – do you do that back to your clients?

Mariana Absolutely. At the moment we are, for example, working with the National Trust. And what we are interrogating, in part, is precisely how diverse their audience is, and how we might, through our projects, help the institution to open up to new publics.

Xavi I think it's embedded in the fact that we all come from all over (the world). Carolina comes from Colombia, and was raised in the UK; the rest of us are all from different parts of Europe. I think these conversations about who we are in relation to others, has been part of our practice since the start. We've always asked ourselves "Who are we to answer your question?"

Mariana Yes, how can we have a critical practice if we aren't self-critical?

Suzanne I think it's really essential. But you know, it always depends on our clients. Recently we tried to work with developers. And it's just not been very successful. They've got different motivations, different aims. They have some boxes to tick but don't bring integrity to socially driven processes. We've clashed on things like methodology, because they just don't get it.

Xavi The developers are wondering – what kind of budget do you come under? What kind of documents would we expect from you? In what section do you appear in the planning application? We would hear, 'We love you. We love your work, but there is actually no pot of money allocated to you.' Every discipline has its pot of money. But without a fixed practice, you don't come under any of them.

Conversation: The Decorators

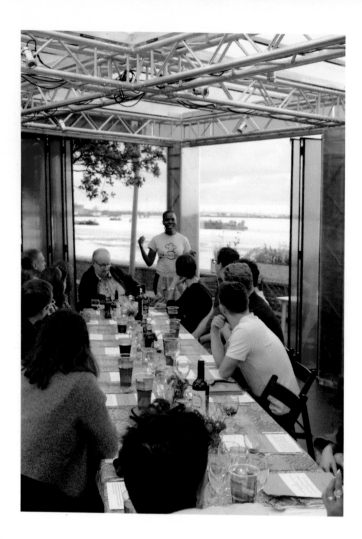

Mel Who are your most recent sort of clients?

Xavi We've been working a lot with museums and other cultural institutions, for example, the National Trust. For us the best commissions are the ones that allow you to explore, test things, be more radical.

Suzanne The Stanley Picker Research Fellowship (awarded to The Decorators in 2018) is a great bonus.

Mariana And also, it allows us to reflect a little bit on the practice so far. The Fellowship, for example, is a really good context for us to reflect back – at least that's what we're using it for.

Mel Do you consider the work 'political', as such? Do you feel that the practices could be seen to have some sort of agency, socially or politically?

Mariana For me, it's very clear that the work is political. Because for us – and I think we all agree with this – it's engaged with thinking about alternative possibilities. What we do is to bring many voices into the conversation. Those may not be the voices that are the dominant voices; they are voices that are marginal, that aren't necessarily part of the picture. These efforts

 Melanie Dodd and Shumi Bose

are constant, while our work tries to bring those perspectives to the fore, elevating them and making them visible. I think we are fundamentally political because we are privileging the perspective of those who are not usually considered.

Shumi But I guess in the nature of the work, are you intentionally political?

Suzanne Explicitly, no. But there is always the question about what is political? And where do those political conversations take place? This is what the 'Chrisp Street on Air' radio was about, to have conversations about life, day-to-day life. Which is political. And it was exactly about trying to bring those conversations down from seven floors up, into our shared public spaces.

Mariana I think the effort is to listen to those who aren't always listened to. And that, in a way, is sort of reclaiming the role of the public, and the publicness of space. We're not questioning the current political system – but perhaps we are questioning what public space is, how it is used, and the extent to which it is representative; how open it is.

Note
1 Refer D. Kirby (1984) *Lab Coats in Hollywood: Science, Scientists, and Cinema* (The MIT Press).

THREE SPATIAL PRACTICES WITHIN THE CITY: STRATEGY, DISRUPTION AND CRITIQUE

Disruptive praxis

Critical proximities at the border: 10 notes on the redistribution of knowledges across walls

Teddy Cruz and Fonna Forman

Global closure, local urgency: rethinking hospitality

Any conversation about spatial practices and the city today must begin with confronting social-economic inequality and exclusion, prioritizing them as the main provocations around which all urban agendas must be reorganized. As urban thinkers we must engage this political project head-on, challenging the neoliberal hegemony that has been imposed on the city in recent decades, exerting a violent blow to our collective economic, social and natural resources, with the ultimate consequence of an ever-widening gap between rich and poor.

For those of us working to produce more equitable, inclusive and open cities in the United States and across the world, the narratives and actions spewing from Washington DC since the 2017 presidential election represent the most hideous convergence of exclusionary political and economic agendas that we have witnessed in our lifetime. The popular appeal of these divisive narratives in disturbingly large segments of American society is perhaps the most terrifying part of the story: decades of sublimated intolerance and racism given new life in a populist explosion of nationalism and xenophobia, with a fervour unmatched since the middle of the twentieth century.

These dynamics in American politics take on a particular urgency in the US–Mexico border region, especially at its most trafficked juncture, San Diego–Tijuana, where we live and work. Here the rubber hits the road, so to speak – where the promise of a higher and stronger border wall coupled with even more repressive infrastructures of surveillance and control gets very real. In this moment of peril and unprecedented fear for immigrants, the immediate task is to protect these communities from public reprisal and overt political repression. While many cities across the United States have joined the populist wave, it is reassuring that many others have declared themselves 'sanctuaries' for immigrants and fortresses of resistance against attempts by the US federal government to violate the human rights and dignity of the most vulnerable people in our society. As we write, our president has committed 'the military' to protect the border until 'his wall' is built, signalling an unprecedented use of force in a civilian zone, adding grave unpredictability to the cross-border collaborative relations that many of us have been stewarding in the last years.

Of course, this frightening resurgence of nativism and border hysteria is not exclusively a US phenomenon, but has gripped geo-politics across the globe, from Brexit to far-right movements like Lega in Italy and Alternative für Deutschland (see Figure 18.1).

It is urgent today that we reassert a global ethical commitment of hospitality to the 'stranger in distress', and to intervene at the very sites of contact between the nation and the other: *the host city*. Hospitality is the first gesture, an essential charitable opening, a first step in creating a more inclusive and welcoming society, when the immigrant arrives. Immigrants from places ravaged by war, persecution and poverty have immediate needs of food and water, medicine and shelter. Providing these needs is the proper charitable response of an ethical

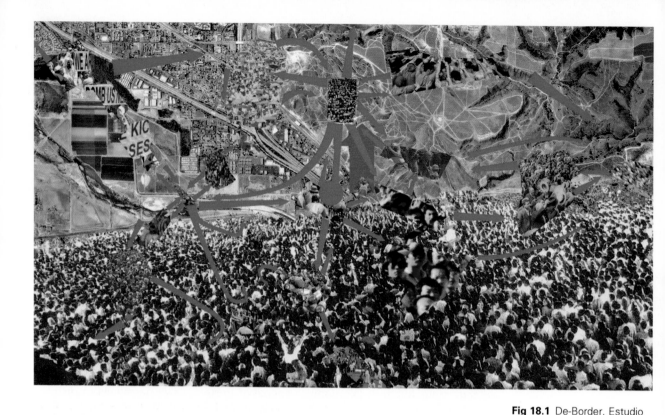

Fig 18.1 De-Border, Estudio Teddy Cruz + Fonna Forman, 2008

society. But as needs become more complex over time, charity is not the appropriate model for building an inclusive society. We need to expand the meaning of hospitality, and consider its social and spatial consequences over time. We need to transform the city into an infrastructure of inclusion and integration, and this demands transformation in the spatial and programmatic arrangements of the host city. Inclusivity means integrating the immigrant and her children into the social, economic and political realities of the city, creating spaces for meaningful participation in the civic life of the community, and opportunities for education, as well as psychological and spiritual health. Real inclusion is more than a hospitable embrace; it is a process through which we ourselves transform alongside the other.

In our practice, designing inclusive cities is not only, or primarily, about spatial intervention, but about constructing processes for visualizing the conflicts and contradictions our spatial projects would tackle, as well as the programmatic framework to reorganize institutional protocols, knowledges and resources. Our projects always begin with scripts and diagrams that visualize the obstacles and opportunities latent in the city itself. On the one hand, how to disrupt local and global social and economic policies that have spatialized exclusion and marginalization, while on the other, how to imagine new interfaces between top-down and bottom-up institutions and agencies to produce the political, social and economic frameworks for inclusion, committed to the proposition that it is not only about designing physical things, but also the protocols and policies that will ensure hospitality and inclusivity over time.

From critical distance to critical proximity: expanding artistic practices

In the context of these global dynamics, we are witnessing the consolidation of the most blatant politics of unaccountability, the shrinking of social and public institutions and not a single proposal or action suggesting a different approach,

Teddy Cruz and Fonna Forman

different arrangements. Working in our silos we can become paralysed, since the crisis is so complex, a multi-headed monster, requiring so many different ways of knowing and doing to intervene. We see the moment primarily as an institutional crisis: the inability of institutions to question their ways of thinking, their exclusionary policies, the rigidity of their own protocols and silos. How are we to reorganize as artists, architects and communities to perform a more *effective project* that can enable institutional transformation? We emphasize 'effective project' because what we need is a more *functional* set of operations that can reconnect our artistic practices and academic research to the urgency of the everyday embedded in the crisis of urbanization – in order to produce new housing paradigms, other modes of socio-economic sustainability, and conceptions of public space and infrastructure. At this moment, this means that our work needs to complicate itself by infiltrating existing institutional protocols, negotiating modest alterations, and being persuasive enough to transform top-down urban policy and economy.

The revision of our own artistic procedures is essential today. Current debate in art and architecture today on what it means to be 'critical' is an important point of entry. On the one hand, many continue to defend art and architecture in terms of apolitical formalism, self-referential projects of hyper-aesthetics pursued for the sake of aesthetics, embracing the notion of the avant-garde as autonomous action, understood as 'critical' because of its *distance* from institutions in its research of experimental form. On the other hand, some have sought to step out of this autonomy in order to engage the socio-political and economic domains that have remained peripheral to the specializations of art and architecture, questioning our professions' powerlessness in the context of the world's most pressing current crises.

These emerging latter practices seek, instead, for a project of *critical proximity* with institutions, encroaching into them to transform them from the inside out in order to produce new aesthetic categories to problematize the relations between the social, the political, and the formal, and questioning the unconditional love affair of our creative fields in the last years with a system of economic excess that was needed to legitimize artistic autonomy. How to reconnect artistic experimentation and social responsibility – a major aspiration of the historic avant-garde – must become central again for critical spatial practices in today's debate about the (death of) public (thinking).

What we seek, then, are expanded modes of practice, engaging an equally expanded definition of the civic, where artists and architects assume responsibility for imagining counter-spatial procedures, and political and economic structures to produce new modes of sociability and encounter. Without altering the exclusionary policies that have produced the current crises, our professions will continue to be subordinated to the visionless and homogeneous environments defined by the bottom-line urbanism of the developer's spreadsheet and the neo-conservative politics and economics of a hyper-individualistic ownership society.

Proximity, then, is not only a geographical or spatial concept – but it is also an institutional and political one. In the 1970s Peter Berger advocated what he saw as the foundational principles of the avant-garde: a commitment to taking a 'critical distance' from the corporate, colonization of art, and becoming critical from the outside (Berger, 1974). While stepping outside and gaining a less embedded vantage obviously has its merits, we believe that today's urgencies also require a 'critical proximity' – new strategies of radical infiltration into institutions. We need to penetrate locally into the mechanisms that are producing our current havoc, and identify ways to alter them. We are not willing to step aside and surrender public institutions to the forces and flows of capitalism and nationalism. We believe art and architecture have a social responsibility to enter into institutional logics for a more just organization and distribution of resources and knowledges, a new collective imagination.

Disruptive praxis: critical proximities

A new civic imagination: learning from Latin America

In our practice at the border, we have been investigating both top-down and bottom-up practices that have advanced new forms of critical proximity in the pursuit of more equitable ends in the city. (Forman and Cruz, 2015).[1] What unifies these practices, whether from the activist collective on the ground, or the municipal agency from above, is that being critical means drilling deeper into the specificity of urban conflict, getting close to the ground in other words, and mobilizing that knowledge to restore urban dignity and civic life.

In contrast with institutional closure across the United States and Europe, where austerity and isolationism has eroded public thinking, we have been inspired in recent decades by several major cities in Latin America, which transformed themselves through a robust reinvention of civic life – through more inclusive and collaborative strategies of municipal governance, targeted investment in social and civic priorities, and a massive mobilization of civic energy from the bottom up.[2]

Bogotá and Medellín, Colombia, for example, tackled conflict, violence and poverty through experiments in participatory civic culture, collaborative municipal governance and planning, progressive taxation, and the coordination of massive cross-sector investments in public infrastructure and social services in the poorest and most violent neighbourhoods. These cities became legendary for the ways they intervened into the city's behavioural patterns. They insisted that investments in public infrastructure were only half the story. A corresponding transformation of public culture and sentiment from the bottom up, through new forms of urban pedagogy and community engagement, was key to sustainable urban transformation.

One of the common threads across many of these Latin American cases is the belief that confronting urban violence with 'law and order' will not work, that laws do not change mores, that physical force does not produce new public values. Both typically perpetuate division and resentment. The Colombian cities fought violence and apathy not with walls, surveillance and guns but with community processes, to restore trust between the public and institutions and to inspire a model of shared responsibility across sectors. They also demonstrated that partnerships between research universities, progressive municipalities and community-based non-profits were essential in democratizing knowledge, activating a more participatory citizenship culture and ultimately producing dramatic improvements in quality of life for the most marginalized populations. This is the greatest lesson we have sought to reproduce across the San Diego–Tijuana border: to deploy the idea of citizenship as a unifying principle that reorients collective and participatory capacities with a common sense of purpose, despite jurisdictional division and social alienation.

Learning from Bogotá: restoring a citizenship culture

In the mid-1990s Bogotá was a battleground of crime syndicates, paramilitary, left-wing guerillas and military aggression, the epicentre of some of the most intractable conflicts on the planet.

When Antanas Mockus, a philosopher and former university rector, became mayor in 1995, the city was unravelling from corruption, poverty and severe infrastructural failure. He came into office in a period of intense violence and urban chaos, and has become legendary for the ways he intervened into the behavioural patterns of the city to construct a new citizenship culture. Mockus insisted that before transforming the physical city, we needed to transform social behaviour – that urban transformation is as much about changing patterns of public trust and social cooperation from the bottom up as it is about changing urban, public health and environmental policy from the top down. Investments in public infrastructure and the deepening of social service commitments were only half the story. Top-down intervention was key, but a corresponding transformation of what Mockus called "citizenship culture," changing hearts from the bottom up through performative pedagogical tactics, was the key to sustainable urban transformation in Bogotá. Designing new forms of urban pedagogy is an essential critical site for

artistic investigation and practice today, and Mockus remains one of our most important models.

Mockus approached the problem as none of his predecessors ever had. Instead of guns and tanks and 'law and order' Mockus came with a new idea about changing the hearts and minds of citizens – to repair civic dysfunction from the bottom up. He wanted to activate a sense of civic belonging in a city that had become a war of all against all. He believed that changing Bogotá must begin with changing social attitudes, and 'interiorizing' a new collective consciousness. He rejected the conventional idea that violence can end violence, and he embraced lessons from theories of radical pedagogy, like that of Brazilian Paulo Freire (Freire, 1970), that community process is the most effective strategy for reconnecting citizens with one another, no matter how difficult and impenetrable the culture of violence might be. Violating what is often understood as the imperative for political neutrality on ethical matters, Mockus declared emphatically the moral norms that should regulate all social relations in the city: that human life is sacred, that radical inequality is unjust, that adequate education and health are human rights, and that gender discrimination is intolerable, among other things. And he developed a corresponding urban pedagogy of performative interventions to demonstrate precisely what he meant, inspiring generations of civic actors, urbanists and artists across Latin America and the world to think more creatively about engaging social behaviour. Mockus reoriented public policy by nurturing a new *citizenship culture*, grounded in a moral claim that all human beings, regardless of formal legal citizenship, regardless of race, have dignity, deserve equal respect and basic quality of life.

Mockus played a major role in reconstructing trust between institutions and publics during this period of conflict and violence, and inspired a new approach to civic participation and institution building where arts and culture became engines of community engagement. Bogotá is typically recognized by urbanists and planners today for the successes of Mayor Enrique Peñalosa, who succeeded Mockus, and pioneered the TransMilenio Bus Rapid Transit network – at the time, the most advanced multi-nodal transportation intervention in the world. But what is too rarely acknowledged is that these physical public works interventions could not have happened without Mockus's work softening the ground, by cultivating new social norms and citizenship culture.

These provocations inspired us to invite Antanas Mockus to the San Diego–Tijuana border to collaborate with us and the municipalities on both sides of the border to develop an initiative on a *Cross-Border Citizenship Culture*. There is no space here to expand on this project (we have written extensively about it elsewhere – see Forman and Cruz, 2018a) but it is important to note that citizenship culture as an organizing principle remains central to our work at the border, focused on identifying and visualizing the shared values and norms, the common interests and sense of mutual responsibility that flow often invisibly across contested zones and divided communities; and around which a new cross-border conception of citizenship can be formed – beyond the arbitrary jurisdictional boundaries that too rigidly define cityhood, and beyond the identitarian politics of the nation-state.

As neighbourhood-based violence across the world has been exacerbated by the resurgence of racism, police brutality, exclusionary urban policy and now anti-immigration ideology, injustice in the city has deepened. We believe that a more inclusive citizenship culture, based on empathy and inclusion, rather than divisive categories that dehumanize the other, must be the foundation of a new public imagination.

Learning from Medellín: public space educates!

More recently we have witnessed the celebrated urban transformation of Medellín, Colombia, once regarded "the most dangerous city on the planet," a site of severe inequality and violence. Twenty years later, Medellín is the scene of an egalitarian

urban transformation that has captured the attention of urbanists, architects and planners across the world (Forman and Cruz, 2018b, pp. 189–215).

Medellín's interventions were activated through municipal experiments in 'social urbanism', an approach coined by the city's former director of Urban Projects, Alejandro Echeverri, which combined top-down collaborative municipal governance and planning – the coordination of massive cross-sector investments in public infrastructure, with bottom-up public education and social services in the poorest and most violent *slums* in the city, curating dignified spaces for the exercise of civic participation.

When mathematician Sergio Fajardo became mayor in 2005, the very first thing he declared was that Medellín would not build in the centre, where the votes are, but in the periphery, where the necessities are. Fajardo committed to transforming Medellín into 'the most educated' city in Colombia, insisting that social justice depended not only on the redistribution of resources but also on the redistribution of knowledges. Violence limits opportunities, knowledge and social inclusion open them. Fajardo transformed his mayoral office into an urban think tank, to consolidate fragmented policies and agendas, summon the knowledges and resources of government, academia, community leadership and the private sector, all framed by a renewed commitment to civic action. This enabled a new era of swift, intelligent public investment in space and infrastructure in the city's most precarious zones. Public infrastructure became a physical manifestation of civic commitment to inclusion, a mediating space that performs egalitarian purposes. This manifested most clearly in Fajardo's famous 'Library Parks' projects, that moved the discussion of public space from a neutral urban commodity animated by random encounter to the deliberate democratization of space. Fajardo committed to designing each park or public space in tandem with pedagogic support systems, injecting specific tactical programming into abstract open space to enable civic activity, education, vocational training, cultural production and small-scale economic development.

The message we have taken from Medellín is that cities affected by violence and conflict cannot move forward with physical projects alone, but must involve the reorganization of social and economic resources. Medellín is an exemplary case of inclusive political processes that stimulated a new civic consciousness and reoriented the surplus value of economic growth from the private to the public. In the context of global austerity, cities like Medellín and Bogotá advanced a new way of thinking collectively about urban life and public goods that we have lost, not only in the United States but across Europe as well. In other words, for these cities, urban transformation is as much about changing patterns of public trust and social cooperation from the bottom up as it is about changing urban policy from the top down.

In recent years, we have led a special research and visualization project in collaboration with Colombian architect Alejandro Echeverri and German graphic designer Matthias Görlich called *The Medellín Diagram* as a tool to help visualize and manifest the political and civic processes that enabled Medellín's transformation (see Figure 18.2).

The Diagram is designed as an instrument for municipalities and publics elsewhere eager to learn from Medellín's achievements. We demonstrate that it is not by emulating buildings and transport systems that cities across the globe can begin to approximate the inclusive urbanization that transformed this city. The key is to understand process, and its sustainability over time. So, while Medellín has rightfully captured global attention for the excellence of its public architecture and infrastructure; the Diagram reveals that it was first a political project, through which institutions reimagined themselves, and cross-sector collaborations facilitated new interfaces between top-down and bottom-bottom knowledges and resources. It is this reorganization of the political and the civic that enabled Medellín's urban projects to be conceived, designed, funded, built, programmed and maintained. From the perspective of participatory democracy and social justice, Medellín is a

Fig 18.2 *The Medellín Diagram*, Teddy Cruz, Fonna Forman, Alejandro Echeverri and Matthias Görlich, 2012

story about how a public restored urban dignity, activated collective agency, and reclaimed the future of its own city.

The 'translation' of the 'procedural complexity' behind these institutional transformations and their physical effect in transforming public infrastructure is an important initiative because they represent critical alternatives to the unsustainable metropolitan growth that has characterized cities everywhere, and give us important clues as to how critical architecture or urban projects must be also accompanied by a critical transformation of the political itself. In other words, it is not only social and political architectures that critical spatial practices ultimately seek, but the *construction of the social and the political* itself: a radical institutional transformation that prioritizes public as opposed to private interests, in the formation of the future city.

Localizing the global: rethinking human rights and citizenship at the US–Mexico border

We have taken these civic and political lessons back to the San Diego–Tijuana border region, the largest binational metropolitan region in the world, and a microcosm of an increasingly 'walled world'. Physical border walls like ours cater to nationalist passions and serve as barriers against the 'barbarian invasion'. For the past decades, we have been telling a very different story about our region. We resist the criminalization of the US–Mexico border in the current political climate, and have declared it instead a site of urban and political creativity from which to disrupt our very understanding of belonging, identity and citizenship. We believe that the most compelling ideas about the future of cities today will emerge from peripheral communities in sites of conflict, such as the San Diego–Tijuana border region, where human resilience and adaptation manifest in the ingenious reinvention of everyday life. In these zones, survival strategies shape new social, cultural, economic and political dynamics that become models, and ideally catalysts, for alternative urban policies that enable more inclusive, sustainable patterns of urban growth.

We see border zones as laboratories for rethinking global citizenship. Public perception of the border as a barrier separating oppositions has been shaped by a politics of fragmentation and division. But identity in this part of the world is

Disruptive praxis: critical proximities

actually shaped by the hybridity and porosity of everyday life, the transgressive flows and circulations that continually move back and forth across the wall. A key dimension of our work has been rethinking citizenship in this contested region of flows – disrupting and opposing conventional jurisdictional or identitarian definitions of belonging that divide communities and nation-states, with a broader and more encompassing lens that views shared practices, norms, interests and aspirations as essential criteria of community – all of which typically flow unimpeded across border walls like ours.

We must move the ubiquitous discussion of 'global justice' toward particular sites of need, and the institutions best situated to address them. This entails that we critically engage the assumption that 'global' is a spatial concept that refers to challenges 'out there' as the appropriate site of action – and that we refocus instead on global challenges 'right here' – *wherever right here happens to be*. If global justice demands urgent action, then we must address concrete circumstances and needs as they manifest in particular contexts, as they are understood and articulated by those experiencing them, and by the institutions closest to the ground best situated to interpret and effectively respond to them. Our emphasis on the particular should not be interpreted as a claim that institutions at local or regional scales can 'go it alone', without the support and knowledge, as well as resources, of institutions at broader scales. But from the perspective of global justice and the need for urgent interventions to remediate poverty, it is essential that we forge new correspondences between human rights and the rights to the city, between global and local knowledges, capacities and actions.

Additionally, there has been too little attention paid by global policy-makers to how human rights are understood in local contexts, how they are implemented, taught and enacted from the bottom up. Human rights are too often taught like a catechism to be memorized, rather than as a set of actions, or practices, that have relevant cultural and political meaning. Teaching a child to recite her rights, without situating them in the context of structures and practices that are recognizable, and without facilitating a culture in which she can claim and enact those rights collectively with others, will ultimately do very little to protect her.

Giving teeth to human rights is more than declaring them in a document, or establishing mechanisms of enforcement from above. Human rights need local comprehension, articulation and bottom-up, collective mechanisms of implementation. In our work, we have been committed to a more grounded practice of human rights, and a transformative approach to human rights pedagogy where rights gain meaning for rights-bearers in context. In other words, we have been interested in facilitating the interface between human rights as a universal ideal and the bottom-up practices that enact rights as living commitments.

Top-down/bottom-up: a crisis of knowledge transfer

Exploring these correspondences between the universal and the particular, the global and local is a large and important project – how the top-down and the bottom-up integrate their knowledges and strategies to confront poverty and injustice across the globe. We are faced today with a crisis of knowledge-transfer between institutions, fields of specialization and publics. Knowledge that remains siloed and self-referential perpetuates existing power structures and disparities. As Medellín demonstrates: social justice today cannot be only about redistributing resources, but must also redistribute knowledges.

We believe that the meeting of top-down and bottom-up knowledges can produce new strategies of artistic and architectural intervention in the city, as well as new methods of interdisciplinary education, research and practice. This interface between top-down and bottom-up resources and knowledges depends on a two-way dynamic that needs mediation: in one direction, how specific, bottom-up urban activism can have enough resolution and political agency to trickle upward to transform top-down institutional structures; and, in the other direction, how

Teddy Cruz and Fonna Forman

top-down resources can reach sites of marginalization, transforming normative ideas of civic infrastructure by absorbing the creative intelligence embedded in informal urban dynamics. This transferring of urban knowledge, from bottom-up intelligence to formal institutions and back, in the construction of urban justice, needs to be curated and facilitated. This is a new space of operation for architectural and artistic practices, requiring better understanding of the potential of *informal urbanization*.

One of the most important issues underlying our research and practice has been to produce new conceptions and interpretations of the informal. Instead of a fixed image, I see the informal as a functional set of urban operations that allow the transgression of imposed political boundaries and top-down economic models. We are interested in a practice of translation of the actual operative procedures behind informal settlements into new tactics of urban intervention. We see the informal not as a noun but as a verb, which detonates traditional notions of site specificity and context into a more complex system of hidden socio-economic exchanges. Primarily, because of our work in marginal neighbourhoods in San Diego and Tijuana, we see the informal as the site of a new interpretation of community and citizenship, understanding the informal not as an aesthetic category but as praxis. This is the reason we are interested in the emergent urban configurations produced out of social emergency, and the performative role of individuals constructing their own spaces.

In this context, we see our primary role as researchers in horizontal terms – as mediators, curators, facilitators who translate both bottom-up and top-down knowledges. There's a lot to say here. But what we've discovered again and again is that marginalized border neighbourhoods have constructed ingenious participatory strategies of urban sustainability, resilience and adaptation. In conditions of scarcity and precariousness, these neighbourhoods are sites of exemplary democratic creativity, hardly commensurate with the racist narratives through which they are too often depicted. Surely there is crime; poverty does that to communities. But there is concrete evidence of participatory democratic possibility embedded in these local, bottom-up social and economic practices that needs documentation and translation. This ingenuity is typically off the radar of planning institutions, and other institutions with power and resources. These informal social, economic and political knowledges need to trickle up, to inspire policy-makers to rethink their approaches to equitable urbanization. We see ourselves as translators and facilitators of this bottom-up knowledge through new strategies of partnership and scholarship.

An investment in urban pedagogy – the transfer of knowledge across governments and communities – is the key to constructing 'citizenship culture' as the basis for an inclusive urbanization and new conceptions of public space. Because of this, designing new curatorial practices for knowledge exchange is an important critical site for artistic investigation and practice today. The conventional structures and protocols of academic institutions and urban planning agencies are typically at odds with these kinds of activist-practices which are, by their very nature, organic and extra-academic and trans-institutional. We believe critical spatial practices should challenge conventional institutional structures of pedagogy. We believe new modes of teaching and learning are essential. Today's social challenges are not confined to disciplines, nor can their solutions be. We believe universities should commit to teaching students how to engage communities with epistemic openness, and how to become interdisciplinary thinkers and problem-solvers, with skills to analyse social disparity through multiple lenses, to communicate across disciplinary language silos, and to collaborate with each other and with a diverse field of partners.

From vertical to horizontal: democratizing knowledge

In our work at the border, we have been particularly interested in the role that universities can play, facilitating the exchange of knowledges between marginalized

communities and institutions, bringing the mandates of global justice into the world, and mobilizing rapid and effective strategies to address urgent deprivations at the scale of cities and regions.

We reject a vertical conception of charity or 'applied research' – where the university is seen as the bearer of resources and knowledge and the community a passive recipient or a mere subject of data gathering. Instead we embrace a collaborative, or lateral, model of *engagement*, in which university and community relate as *partners* both contributing resources and knowledges, and actively participating in collaborative research, learning and problem solving. Tipping the model from a vertical to a horizontal relationship is an ethical move. Operating from the base of a public research university holds special opportunities and challenges. From the last century, academics speak in ever smaller and more specialized circles, in disciplines that often overlook the potential impact of our ideas on the world. Many academics who care about social equity spend their careers writing and debating about justice and equality and rights and freedom and agency – and policies to address these things – without meaningful contact with the world they are writing and debating about. Wouldn't it be helpful to have better ways of knowing what these challenges and aspirations mean to real people, how they structure real practices and real agendas?

The issue is even more urgent when it comes to academic claims about marginalized people. If we claim to advance ideas in defence of the marginalized, why do we spend so little time engaging marginalized people, listening to their voices? We obviously cannot all be anthropologists, but a more anthropological sensibility would be helpful. University scholarship is infused with assumptions that we know more, that only we are 'trained', that only we have languages to convey complex ideas and practices, and analytical tools to make sense of and 'fix' the chaotic tangle of real life. An engagement with worlds of practice reveals, however, that these assumptions are plain wrong, that we do not know everything we think we know, and that we have possibly more to learn from the world than it does from us.

Cross-border community stations: transgressive public space infrastructure at the US–Mexico border

Expanding on our research in Bogotá and Medellín, Colombia, where citizenship was mobilized through cultural action, and public space was operationalized as the site to construct it, we founded the UC San Diego Cross-Border Community Stations, a network of field-based research and teaching hubs located in immigrant neighbourhoods across the border region, where experiential learning, research and teaching is conducted *collaboratively* with under-represented communities, advancing a new model of long-term community–university partnership (see Figure 18.3). Community Stations are a platform for reciprocal knowledge production, linking the specialized knowledge of our campus, UC San Diego, with the community-based knowledge embedded in immigrant communities on both sides of the border. The premise is that both universities and communities have knowledges and resources to contribute in the search for solutions to deep social, environmental and economic disparities across this geography of division and conflict.

We are committed to an embedded infrastructure of public spaces that spatialize long-term partnerships with community-based agencies. We have become dissatisfied in recent years with the uptick of ephemeral acts of resistance, and short-term artistic and cultural interventions in our own region, that dip in and out of the conflict, since the energy that produces them quickly dissipates. While we are often inspired by these hugely creative gestures, they tend to be short-lived in their impact. What happens the day after? Recent explosions of emancipatory energy around the world have lacked the organizational processes to carry the movement into practical action. So, we have been arguing for a more rooted infrastructure of partnerships that are spatialized through a network of public spaces

Teddy Cruz and Fonna Forman

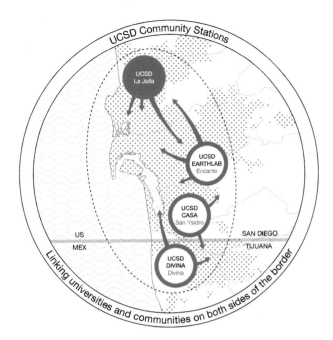

Fig 18.3 The UCSD Community Stations, Estudio Teddy Cruz + Fonna Forman, 2018

that educate, taking a longer view of resistance, strategic thinking and anticipatory planning. Universities with resources should take the lead investing in these spaces, not only as a gesture of public responsibility, but also because these sites become venues for research, experiential education and cultural co-production, as well as instruments for new forms of community and economic development. On these grounds, we have mobilized the resources and local capacities of our own research university as leverage for our community partners to have access to public lands (see Figure 18.4). In essence, we have discovered that the Cross-Border Community Station is not only a project of collaborative education but a model of shared urban intervention, through which our community partners can co-develop their own housing and public spaces.

The Cross-Border Community Stations transform vacant and neglected urban sites and spaces into active civic classrooms – spaces of knowledge, cultural production, participatory research and display – that are collaboratively curated between community and university, linking education and research, local economy and political agency in marginalized neighbourhoods. Essential to this effort is the co-production of new arts and cultural programmes to become instruments for civic engagement, increasing community capacities for political action, as well as engines to incentivize new neighbourhood-based economies, as the stations enable new points of access to higher education and career pathways for youth across these under-represented and demographically diverse immigrant neighbourhoods.

A central assumption of the UCSD Cross-Border Community Stations model is that university–community engagement is a *reciprocal* activity. While the university enters into the field (both enriching its public mission and sharing its knowledge and resources), the field also enters into the campus (sharing community-based knowledge and changing the nature of pedagogy and programming on the campus). A key component of the Cross-Border Community Stations is the idea of *Public Scholarship*, which enables well-respected community leaders to spend time with us on campus each academic year to engage with faculty and students, co-teach courses, lead workshops, and find other innovative ways of sharing their community-based experiences and knowledges to shape a new community-engaged curriculum. The practical and ethical knowledge that these voices bring

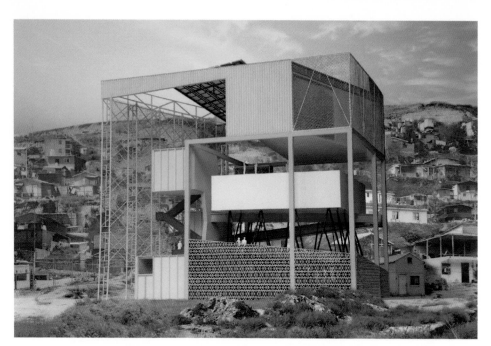

into the university enable the transformation of pedagogical methods and protocols to amplify and problematize the relationship between theory and practice, research and action. The programmes and courses couple university faculty with community practitioners, who co-teach by establishing circulations between the neighbourhoods and the campus, sharing their experiences and knowledges, grounded in the physical spaces from which these experiences and knowledges emerge.

The activities and programmes that we co-curate with our community partners seek to produce new interfaces between the neighbourhood, the classroom and civic agencies. These include the formation of a *Public Mentorship Programme* that pairs college students with youth in neighbourhoods to serve as ambassadors of each other's environments; a *Public Pedagogy Programme*, which enables new modes of visualization for community-based workshops and advocacy planning; and *the Civic Engagement Credits,* which incentivize students to circulate through spaces in the city where urban policy decisions are made.

Civic imagination: increasing community capacity for political action

In the last years, we have committed to mobilizing interventions into normative, institutional and spatial processes in the city, questioning the role of architecture and urban planning, art and the humanities in engaging the major problems of urban development today. It is not enough for architecture and urban planning to camouflage, with hyper-aesthetics and forms of beautification, the exclusionary politics and economics of urban development. At this moment, it is not buildings but the fundamental reorganization of socio-economic relations that must motivate the expansion of democratization and urbanization. We are also critical of social science, and its obsession with quantification, without a sense of giving us any qualitative way out of the problem. In other words, it is not enough to reveal the socio-economic histories and injustices that have produced our crises, but it is essential that theory and practice become instruments to construct specific strategies for transcending them. Social science must become more committed to increasing public knowledge, to communicating its research to those who can make use of it, and working with communities to develop policy proposals and counter-urban development strategies.

What this suggests is a double project for many of us, one that exposes the institutional mechanisms that have systematically and through often overtly racist and nationalist policies produced the stigmas, and the political and economic forces that perpetuate marginalization; but also, one that simultaneously intervenes. This double-imperative manifests itself in our work through the critical reorientation of knowledge flows between the top-down and the bottom-up dynamics: in one direction, how bottom-up urban alterations and creative acts of citizenship can transform top-down institutional structures; and, in the other direction, how top-down resources can reach sites of marginalization, elevating the creative intelligence embedded in informal dynamics. This critical interface between top-down and bottom-up resources and knowledges is essential at a time when the extreme left and the extreme right have all joined forces in their mistrust of government.

We believe in progressive governance. Critical spatial practices can play an essential role in shaping the agenda for the future of the city by pressing for new and more accountable, inclusive and collaborative forms of progressive governance. This can only happen by unleashing the informed and committed electoral power of young, immigrant and minority communities across our cities. For these reasons, one of the most important sites of intervention of our time is civic education in public space. We need to activate public spaces – not as physical amenities for leisure and consumption, but infused with the protocols and tools for inclusion, knowledge production and political agency. What is urgent today, is the restoration of the linkages between government, social networks and cultural institutions to reconstruct a new civic imagination.

Notes

1 See also Fonna Forman and Teddy Cruz, *Top-Down / Bottom-Up: The Political and Architectural Practice of Estudio Teddy Cruz + Fonna Forman*. Berlin: Hatje Cantz, forthcoming.
2 The discussion that follows draws from Fonna Forman and Teddy Cruz, "Latin America and a New Political Leadership: Experimental Acts of Co-Existence," in *Public Servants: Art and the Crisis of the Common Good*, eds. Johanna Burton, Shannon Jackson and Dominic Willsdon (Cambridge, MA: MIT Press, 2017), pp. 71–90.

References

Berger, P. (1974) *The Theory of the Avant-Garde*. Minneapolis: University of Minnesota Press
Forman, F. and Cruz, T. (2015) "Changing Practice: Engaging Informal Public Demands" in *Informal Market Worlds – Reader: The Architecture of Economic Pressure*, eds. Helge Mooshammer, Peter Mörtenböck, Teddy Cruz and Fonna Forman. Rotterdam: nai010 Publishers
Forman, F. and Cruz, T. (2018a) "Leadership"; and Forman, F. "Social Norms and the Cross-Border Citizen: From Adam Smith to Antanas Mockus," pp. 333–356, in *Cultural Agents Reloaded: The Legacy of Antanas Mockus*, ed. Carlo Tognato. Cambridge, MA: Harvard University Press
Forman, F. and Cruz, T. (2018b) "Global Justice at the Municipal Scale: The Case of Medellín, Colombia," pp. 189–215, in *Institutional Cosmopolitanism*, ed. Luis Cabrera. New York: Oxford University Press
Freire, P. (1970) *Pedagogy of the Oppressed*. New York: Continuum

19 'Fuzzy edges'

A conversation with Liza Fior, muf Architecture/Art

Melanie Dodd

Mel All sorts of terms have been coined to describe forms of alternative architectural practices in the last 30 years. In many, muf is used as an exemplar, a testament to over 20 years of practice in which you have been instrumental to the developing field. Do you find the term spatial practices useful to describe and position work?

Liza Resisting definition can give you freedom. Resisting definition means you can be dismissed. We called our first book *This is What We Do: A muf Manual* (2001) because we wanted to get as close to a 'Reader's Digest Book of Home Improvements', as we could, something which drew you in. Ironically this straightforward useful handbook was in fact a volume of aspirational, fantastical ambition. I don't know if it's age, and a lack of tolerance but when looking at some work one thinks "OK but what about the urgency?" There is an urgency to engage, and there are a number of ways of responding to the state we operate in. You can go and camp out in front of parliament; you can, in the case of Henrietta Cullinan, become a peace worker and go to Afghanistan and get arrested; and in our case, you can go to meetings of commercial property developer and managers (currently Land Sec and Stanhope) and try to make small adjustments to 'turning the tanker'. Tiny, tiny little calibrations to alter the tanker's direction.

Mel What's been muf's terms of practice through the undertaking of actual projects? I am thinking of phrases like design of 'public realm' and 'intersections between the lived and the built' as very consistent points of definition. These seem to deliberately straddle more normative definitions of the architectural project?

Liza None of these actions are better than the other, but I suppose what has happened in our practice – and we have to take full responsibility for it – is that first of all we were trying to articulate for ourselves what we could do together. And the articulating for ourselves what we could do together, sounds like a manifesto of intent. Then we spent the next 20 years finding out if the aspirations in that manifesto of intent that we had made, can actually play out now. Funnily enough, only this morning Katherine (Clarke) and I were discussing Design Codes for Haringey and asking: "Should private development have different paving on 'their' side of the street?" Unfortunately, private development *does* have different paving to the street because a landscape practice in this particular case, decided to differentiate privately owned public space with special paving. The question we discussed was, "should that private paving 'project' into the public street" and then we said "No, I think we need a 'female condom' here, so the public highway penetrates the private, and in doing so articulates your right to the city." The penetration of one space with another was a spatial trope we used in our first (unsuccessful) competition for

Walsall Art Gallery. Your 'right to the city' can be played out with tents, or with paving. muf's tiny little acts of resistance play out in different ways; we draw them, we propose them and sometimes we enact them.

Mel Yes – spatial practice as resistance perhaps?

Liza I like the term (quote) "architecture is more than architecture" because the limitations of the discipline can be addressed. There are many architects who operate as kind of fund managers; 'architecture' as fund management. You assist in how to shape somebody's investment. That is one mode of operation.

Mel Before 'spatial agency' you coined the term 'double agency'. What does that mean and how do you personally put it into practice?

Liza Yes, double agency is possibly revealing of the fact that muf's practice would have been more suitable in the early 1950s, when there was a social project, and some money to do it. In that first 'making sense' of our own complicity, we came up with the double agent – that you accept a brief with a narrow definition of public space and then expand the brief and find a wider client of users of that space – working for that public as the clients/users of the space. This is the double agency of accepting the brief from the person 'paying' for it, but expanding the brief with unsolicited research to design for the people 'using' it. That was the conceit of double agency. But of course, you could equally say this was just 'brief obedience'. If a project brief is a public space, then you're not expanding the brief, you're just fulfilling it – even if there was initially a much narrower expectation – in a sort of intentionally innocent, pious, way. I think muf has a kind of moral imperative which makes us really annoying and – in that sense, one could say, not post-modern. Looking for the right thing to do in a situation, and having a sort of overdeveloped sense of fairness.

Mel Do you think that's changed over time, or been a constant?

Liza Weirdly enough, it is a constant. I think that's been 'the' constant. The difference has been in becoming cleverer, and not getting sacked as early on in the processes as we perhaps used to. Hanging in there. Being slightly better at understanding when to keep our mouth shut; slightly better at knowing when something's completely impossible; and thinking that actually more of the projects do 'work'. However much we are still 'feeling in the dark' and getting bruised, trying to find out what you can do – we do seem to manage to stay in the room a bit longer.

Mel What are the habits on one hand, and mechanisms on the other, of double agency?

Liza I would say that some things make double agency easier. Policy has caught up 'somewhat'; we finally have some tools in the emerging policy of the London Plan which I think we can take some credit for, because muf's work is mentioned in special planning guidance for London. The fact that you can now refer to legislation, to do the things you would do any way ...

Mel Early on, did you find that was there or not? For example, pre-GLA (Greater London Authority)?

| Liza | No. It wasn't there. No, because in the early work, rule breaking was creative. There was a pleasure in – metaphorically speaking – finding the service duct, which allows you to get from A to B in a concealed way rather than walking through the door because if you'd walk through the door, you'd be shoved out again. The very early work, where the only justification for the investment in the public realm was if you could demonstrate it brought inward investment with it, was all about circumnavigating these limits. Every time people say "no" we still draw on those skills. Where it is really problematic at this moment in time is in dealing with austerity and with lack of funding, and in how much you are complicit in that austerity. So if you are replacing jobs with volunteers that's wrong. Community-run libraries as the way to replace a library that has closed is wrong. Similarly, the first project we've done with the NHS (National Health Service), had to respond to zero staff time whatsoever, so a play area couldn't have any moving parts at all, not even a pencil. A ludicrous energy went into thinking of how to circumnavigate that, because the definition of play is that it needs loose parts. I had meetings where I thought "This is mad" – but then I also thought, "Well somebody better do something because otherwise you're going to have a touch screen." The solution there was to make the child itself the loose part, and so all the elements are to do with light, reflection, refraction. We are privileged we can retreat to the studio – the energy required to deal with austerity is vast for all who have to deal with it. The example above is an object lesson in the pressures upon the public realm, which are only amplified for individuals.

Although it's not exciting to commission muf now (unless you're very square), I suppose like French polishing, we are – through sheer repetition – better at finding the metaphorical ventilation duct that you crawl through to get from A to B. There is a repeating and refinement in working together a long time. Yes, so, we've invented a new table, a drawing table without pencils. Detail to strategy to detail again, describes the moves with greater and greater precision. This could be said to be an inverse operation to the usual trajectory of scaling up of commissions from exhibition design to a concert hall. This is rather a honing in, being quicker to feel your way. We have got better and better at finding route maps to take on design build contracts. |
|---|---|
| Mel | Some say if you're going to act in resistance of neoliberalism you can't possibly be involved in the mainstream, and vice versa. Yet I would say muf seem quite successful in not conforming to that binary? |
| Liza | There could be an alternative question here which is "What *is* your 'pervy' fascination with the establishment?" I think the fascination with the establishment is gaining an understanding of 'how the cookie crumbles'; taking something apart to see how something works. That is maybe one aspect. The second is gendered, I'm sure. If you're kept out of something, your distance means you see more of its edges. You can see more of the edges if you are distant from it. For example, we both have a certain chip on the shoulder – and for me the ice in my heart might be my experience of standing in the free school meal queue, with a different coloured lunch ticket as a small child; my 18 months as a single parent, playing knock down ginger on Basil Spence's doorstep when he made a proposal to knock my house down. I think it's quite childish. It's like a childish sense of fairness. In different ways, those are things which Katherine, and others who have worked at muf, and who we've worked with, including you, are interested in. That sense that an alternative is possible, but also alongside that, perhaps not being that skilled at being 'heard'. |

Conversation: Liza Fior, muf Architecture/Art

I suppose what muf can say, or what I can say is, we usually visualize things spatially, and that can be set of power relations, as much as a project. The project is always a 'project', at any point in the process. The luxury of the publication *This is What We Do: A muf Manual* (2001) was that we had this pause to be able to articulate all the different ways that a project is a 'project': whether it's the questioning of a brief, or a built thing.

Mel Do you think a mantra of 'alternative' or critical practices sets up an opposition to architectural practice or the 'profession' which is not always helpful? I'm also thinking about architectural education, here.

Liza I try to say to students, without much success, "You don't have to be able to 'do' everything that you're criticizing in the profession, but you need to be able to do a few things. Because otherwise your work will become kitsch if you don't." Meaning, the work just takes on the 'language' of critique, rather than being critical. That is a danger for students, in working critically, it becomes stylistic. The language of resistance becomes this language of making fixed, something which actually needs to be committed to. That's kind of why urban farming currently seems to be more like a 'command' in Photoshop, when instead, we should at least expect a student to come with a tomato they've grown, in order to see what it takes.

 I am still formulating this point, but public bodies do not give 'revenue' funding, because they want 'one-off' design projects, or 'gig economy' architecture. That's why 'meanwhile' uses are seen as attractive. But the strength of the 'provisional', is only when it is a 'continuous provision' – like the edges of hedgerows. They are continuously tended – they are 'permanent capital'; permanent acts of care and maintenance. I think that's why so much is so unsatisfactory in London at the moment is these small one-off payments, which can only make something provisional because of the limited scale of the capital investment. There is an inability to support the continual repeated layering of the provisional, so that it is substantive.

Mel Yes, the 'continuous provision' of the public realm, as architecture?

Liza Yes, the public realm is like a big rained-on room or a very low building as high as the foundations are deep with a very large articulated roof. We are often not named when part of collaborative teams. If we went back to the beginning to this idea of categorizing – no matter what muf did, it wasn't enough. It was never enough, nothing was enough. So, I do think that our work has a completely different rubric that it is calibrated by. Perhaps we should do a diagram of the square meterage of public realm. If you then layer it in 3.5-metre vertical intervals, it would make a tower. Would, at that point, it be taken seriously as architecture, at that point? We know we're annoying, how uncharmingly annoying we are – but this undermining of what is such a huge effort; and the weariness of how hard it is, the underfunding and the sheer difficulty – Katherine and I somehow can take a sort of weird masochistic entertainment in it. And it is still difficult – how ridiculous.

Mel Where developers or local authorities have approached you, do you think they have been after something specific from you – something that they don't get from others?

Liza	If we don't get sacked people are very appreciative afterwards. And it becomes quite touching. We were told that one of our local authority clients said "we call Liza our Jane Jacobs, our conscience." But no client wants to have your conscience giving you a guilt trip every day of the week. Those that stick with us seem to have joy in what we do. And I suppose we have to just think that our commitment to public realm is because, that *seemed* to be the site most 'used' by those who do not have the opportunity to brief the architect. And in thinking about the qualitative, we cannot *not* talk about the last ten years of government. Many of the issues in London are to do with housing targets which are set by central government. Because – like making 'quince paste', where you have to have a huge number of quinces to make this very small amount of condensed jam, in order to get social housing – you have to build that much crap. These things are structural and maybe by working with the public realm we are working with one 'other' version of output, that comes from it.
Mel	Even located within the establishment of architecture, disturbing it and disrupting it seems quite important.
Liza	It's been very interesting working on a project recently in Haringey, not long after the ending of a public/private partnership with LendLease, when certainties have suddenly shifted in Council. It's been fun because Katherine and I have been working on the project together, and if you like, this is a project where it is particularly helpful to draw on the lessons of thinking about intersectionality, to be able to 'check your privilege' and recognize how *unheard* many residents felt themselves to be. We check our privilege and we wedge a door open to try to bring in people and things that aren't in the brief. That's an example of our methodology that is *always* enacted. That is the 'expanded field', actually expanding the number of people at the table. Recognizing that phrases like 'co-design' are used for that expansion but also that those things are complex. The real battle for muf was finding out how we could work together in the studio, and having vaguely learned how to do that, it then does mean you have some skills and transferable knowledge.
Mel	What projects wouldn't you do?
Liza	We didn't say yes to Gazprom. I got an email inviting muf to put ourselves forward from the Russian company Gazprom, the world's largest oil producer; to build a Children's Science Centre. That might have been a perfect project to calibrate complicity against compromise, but we had that recognition that to make good work, it cannot be done superficially. Perhaps if I lived in Russia ... Like designing the privately owned publicly accessible open space, for example. It is that recognition, that say if there is a corporate tower of offices, someone is always 'cleaning the shit'. And if you put a bench in the sun, maybe there is somewhere to sit for a second before you have to get back on your bus to make breakfast for your children, is that work worth doing? It is easier if you get specific. These "Is this worth it?" questions are ones Katherine and I continually ask of projects.
Mel	What projects have been absolutely exemplary in how they have materialized, and what made them so?
Liza	Projects such as 'Barking Town Square' (2010), 'Altab Ali Park' (2011), 'Art Camp' (2012), 'Making Space in Dalston' (2009) are all formally, materially

and in their methodology, exemplary in terms of – with whom, the compromises embraced, the spaces created, how they are appropriated. Because their coming into being also had to be constructed. But there are also exemplary moments within project. There's these moments where threads coalesce toward making a move. There is a sketch in the muf manual of this idea of 'condensing' an idea into a spatial relationship – and then many projects sitting within that exemplar. From your question, I have an image of multiple threads coming to a knot and then emerging out again. I think there are emblematic moments with a project.

Mel Particular moments that embody a strategy?

Liza Moments like the landscape which is flipped to become play space when a child enters it. For example, the puddle, in front of our British Pavilion at the Venice Biennale (2010). And once a child is in it you see "Oh yes, they've designed it for play." But it sits under the nose of whoever commissioned it. It's going to be interesting in London because some of these moments may become policy and will that codifying destroy it? This transformation from research and creative intent to 'product' has happened before. To again use the example of 'play', there was a great deal of research around the value of natural environments used for play. After publications and lobbying a play strategy was introduced, grants were given for natural play settings. Designers were commissioned, it was embraced – a tree trunk and an old boulder can be cheaper than swings. The challenge is to develop methodologies which can be embraced but not diluted.

Recent examples of this have been reconsidering other tired rubrics of planning such as 'active ground floors'. "How do you bring the value of the penthouse to the ground?" We are using the language of value in property to look again at rules which are not examined critically – for example the requirement for *active* ground floors – not huge vinyl advertisements for a croissant on a supermarket window. I think what we are doing is we are returning to some really early work about 'fuzzy edges'. The 'fuzzy edges' of architecture, of the building. Where does a building as artefact stop, and the public realm begin?

Mel Yes, an idea that you keep refining – the enclosure or edge of a project – that you push in and push out. A sense of projects having lives beyond their physical limits.

Liza The idea of the 'extended building' can operate at all scales – responsive to setting and use, extending in two directions with its fuzzy edges; operating in fuzzy edges, making fuzzy edges,

Mel Do you think that also goes to the fascination with the establishment, and the physical limits of architecture?

Liza Because there's kind of been pushing and pulling, in the city work?

Mel Yes, you constantly disrupt and stretch the edges.

Liza But I think that's like trying to navigate a dark room, banging into sharp corners in furniture to work out where the door is, how bruised do you get? The establishment is always found in muf's work, as a material to be worked with. Our practice can be described 'as research'. We practise in order to research. It's more like ethnography, where you put yourself into

 Melanie Dodd

Fig 19.1 Keep Above the Line in 2017 (muf)

CONTRIBUTION

**KEEP ABOVE
THE LINE
IN 2017**

COMPROMISE

COMPLICITY

a situation and then you understand it. But unlike ethnography and unlike anthropology and unlike archaeology we disturb the ground. We don't 'tip-toe' enough. We probably should tip-toe more.

Note
Shortly after this interview I read the book *Living a Feminist Life* by Sarah Ahmed. I recommend it to anyone who is feeling marginalized for being stroppy. Discover the universal in a struggle which seems personal.

20

'Design for organizing'
A conversation with Damon Rich and Jae Shin, Hector
Melanie Dodd and Shumi Bose

Mel In the context of a book entitled *Spatial Practices*, we are first interested to ask what you think about that rubric.

Jae We're honoured to be included as spatial practitioners. I like that it's not a premature victory declaration, like naming your field 'Urban Design' when it's not at all clear that can be accomplished. It also helpfully resists putting some special magic or agency of art and design centre stage, and prompts consideration of how those of us with a foot or two in art school relate to other players on the field; between allies and antagonists, we're never alone in our agendas. And the way 'spatial practice' might include all kinds of actors – heroes, paper pushers, villains – was also something we had in mind when registering the name Hector.

Damon It's like that East Harlem 5th grader's epic comeback to her classmate's criticism that a Mexican person shouldn't design the building for BET: a new scheme for a combined global BET-Univision headquarters explained with "You can't have your own private built environment!"

Mel You describe your work at Hector as 'urban design, planning and civic arts'. How do you define the territories and definitions of your practice?

Damon We've designed parks, a memorial, one speculative building, a few neighbourhood plans. Hector is a small and recently founded practice, so we tried out a mighty and classical name. As a verb, 'hector' also describes lots of activity around the built environment: 'bully, intimidate, browbeat, harass, torment, plague, coerce, strong-arm, threaten, and menace'. You know, 'spatial practices'. Though we're in a moment where architecture and planning are celebrated, especially within our disciplines, as agents of dignity and liberation, today movements like Black Lives Matter call us to heed not only the fast violence of shooting or incarceration but the slow violence of urban renewal, planned shrinkage, residential displacement, and the power dynamics of these planning and architectural projects. In other words, whether we like it or not, we are in hectoring businesses.

Jae Recognizing that, we try to understand architecture and design problems in the context of democracy problems, how decisions get made that have to be made together. You can't have your own private built environment. We've been lucky to get a reputation as designers and planners who have a sense of working with community organizers. A client let us know we got the job because he thought we wouldn't be surprised that people who lived in his neighbourhood could actually do things. We like working with community organizers, advocates, and local governments – organizations rooted in specific places, in the thick of things, with missions to bring together individuals towards collective action.

Mel Yes, I am interested in how the political is present in your work. Perhaps political with a small 'p'.

Jae As urban designers, we work between policies and materials, stretching threads from the vague but good intentions of planning document bullet points to paving specifications for public space, or legal requirements for public access to private waterfront development. The main politics of the work is pretty direct: who drives comfortably versus who gets killed crossing an intersection that's unsafe by design; who benefits from the service of a sewage treatment plant versus who develops asthma from diesel truck exhaust. Learning about traditions of community organizing has anchored my understanding of the political context and content of design projects: building and using people power, negotiating concrete wins, making appeals in terms of how people understand their self-interests, trying to weave more than lead.

Damon One way to imagine that design has something to offer a community in the process of organizing, comes from a story we heard from Chicago organizer Shel Trapp while making a video about the origins of the Community Reinvestment Act. Shel had been a reverend, and then decided that you don't make change by praying and ministering, you make change by kicking ass. And in this story from his early organizing days (which are always failure stories) he started off by knocking on doors, asking, "any problems in the neighbourhood that you would want to talk about?" And people would say, "no" because if people don't think they can change something they're probably not going to think about it very much. He was getting nowhere, until he decided to start lying. He would notice a pothole in the street and say, "well the person two doors down was saying that pothole is a real problem." And the person would say, "oh yes, I will come to a meeting about the pothole." This moment of fabrication is based on understanding the situation; being observant of the physical environment, but then also not necessarily trying to live up to some ideal of transparency.

Shumi You have said that one of the most important things that we do, is 'producing the public'. This assumes that the public is not something that exists per se but something you might have to nurture and educate.

Jae We were probably describing how important it is to learn to imagine the public not as something floating out there to be ensnared, but something that must be patiently, sometimes painfully, assembled and nurtured by door-knocking, 'flyering', assembling email lists, monthly meetings. It's our job to understand enough about the design, construction, and operation of a park or community centre to align its production with the slow and fragile work of organizing – all this work of putting people together to create political force. When it works, the thing we design becomes imbued with and visible as a spirit or sign of self-determination.
 Creating a public requires abstraction, connecting individuals into organizations, imagining and pursuing goals. You need to build shared understandings of how change might happen, break down useful knowledge. Connected to community organizing, the tradition of popular education has also guided our work. For us, this perspective begins from curiosity and consideration for understandings and beliefs of people with whom you're in conversation, rooting analysis in lived experience, and paying close attention to the relationships between learning and taking action. In the US, some associated names are Ella Baker, Septima Clark,

Melanie Dodd and Shumi Bose

Myles Horton, and many more, who have insisted on the importance of education for liberation while struggling, and not only indoctrination. So instead of 'political design', we prefer 'design for organizing'.

Mel I agree we need to be careful in talking about being 'political' not to disable a closer understanding of what it really takes to 'do politics' down at the level of the public sector, in everyday life, at the level of street design and kerbs, for example.

Damon Yes, think about the constituencies of the kerb, the designs of which I always take time to appreciate here in London with their elegant radial swoops. There are the traffic engineers, sworn to always keep kerbs between pedestrians and roadway traffic; the sewer overseers who want to break kerbs to divert stormwater from overflowing pipes; private property owners petitioning for kerb cuts to facilitate vehicular access; the on-street parker hoping to preserve kerb space for cars. As a designer, Hector swoons at these built examples of sociality, things that make so many visible accommodations to rampant desires.

Jae We use the name 'place politics' to describe this broad field of people, organizations, and businesses out there pursuing agendas for the built environment; architects and planners alongside skate park advocates, environmentalists, preservationists, liberations, housing think tanks, all kinds of spatial practices. So one question for our projects is how to sustain and bolster this local ecology of place politics.

Mel Are there recurrent dilemmas for you, where you end up questioning the efficacy of what you're doing?

Jae Though we wouldn't have it any other way, we do go through this with so many projects. Meeting after meeting to coordinate resident groups and urban designers, talking to water department engineers to convince them to give us a place to sit, maybe a few benches, next to the green infrastructure they are making. I'm routinely struck by the sheer messiness and frequent arbitrary headwinds of practice. It's not much like the ideals I learned about in architecture school where you have a taut premise, poetic investigation, and elegant solution. The so-called 'design idea' plays such specific and variable roles, rarely the overall animator of any situation. And you lose on so many of the things that would have been nice, that you don't want to think so much about it.

 We were forced to reflect a bit last year in putting together a small survey exhibition at the Yerba Buena Center for the Arts in San Francisco with Lucía Sanromán and Martin Strickland, covering ten years of work. One conclusion was that Hector is dedicated to the messiness of practice, and the theoretical significance of the mess. The museum sits on the roof of the city's convention centre, and exists as part of the community benefits provided along with the displacement and disruption of the convention centre, so was an appropriate venue for reflecting on our hope that social desire can find fulfilment in urban design.

Damon We wanted to bring the kind of slow-burn, mind-bending drama of collective action and conflict in shaping the environment that we've savoured in planning board hearings, community benefit negotiations, and developer–politician panel discussions. So down with dreams of a push-button future where conflict evaporates, whether through Fun Palace or Uber, and up with the radical democracy of negotiating in public.

Conversation: Damon Rich and Jae Shin, Hector **213**

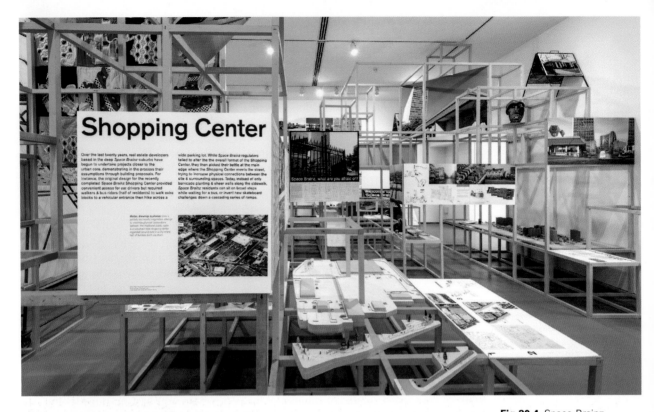

Shopping Center

Over the last twenty years, real estate developers based in the deep *Space Brainz* suburbs have begun to undertake projects closer to the urban core, demonstrating in the process their assumptions through building proposals. For instance, the original design for the recently completed *Space Brainz Shopping Center* provided convenient access for car drivers but required walkers & bus riders (half of residents) to walk extra blocks to a vehicular entrance then hike across a wide parking lot. While *Space Brainz* regulators failed to alter the the overall format of the Shopping Center, they then picked their battle at the main edge where the Shopping Center meets the street, trying to increase physical connections between the site & surrounding spaces. Today, instead of only barricade planting & sheer walls along the sidewalk, *Space Brainz* residents can sit on broad steps while waiting for a bus, or invent new skateboard challenges down a cascading series of ramps.

Note: drawings & photos show a partially successful negotiation attempt to interchange formal connections between the traditional static, well-subsidised slow slopping lanes organised around parking & a city-wide hall of fantasy doth via door.

Fig 20.4 Space Brainz installation view, Yerba Buena Center for the Arts, San Francisco, 2017 (Hector)

Fig 20.5 Space Brainz Display System, Yerba Buena Center for the Arts, San Francisco, 2017 (Hector)

Melanie Dodd and Shumi Bose

Mel What are some of the practices that you think are most invaluable? Can you tell us about a particular project to explain?

Jae As Trump was elected in 2016 we were hired by an emerging coalition of neighbourhood groups in southeast Philadelphia, Pennsylvania. As talk of building walls and Muslim bans was in the headlines, our clients wanted to organize a constituency for a neighbourhood plan and redesign of Mifflin Square, the neighbourhood's four-acre park. In a working-class neighbourhood since the 1890s (I think you'd call it 'terraced' here), it has been settled in the last 40 years by many immigrants, speaking at least 13 languages, with varying relations to government – we heard stories about how new arrivals were sometimes conned into paying to enter the public park. So a first challenge was to start a conversation about who owned the park, how it worked now, how it could be better, and how that could happen – what it might look like for the neighbourhood to organize around rebuilding the park.

Damon In collaboration with 13 teenagers, we began by documenting existing conditions, analysing past plans, breaking down development processes, financing, and construction, and projecting potential futures for the site, like many design processes. Together we worked for six weeks

Fig 20.1 Mifflin Square Park Concept Design, Philadelphia, 2018 (Hector)

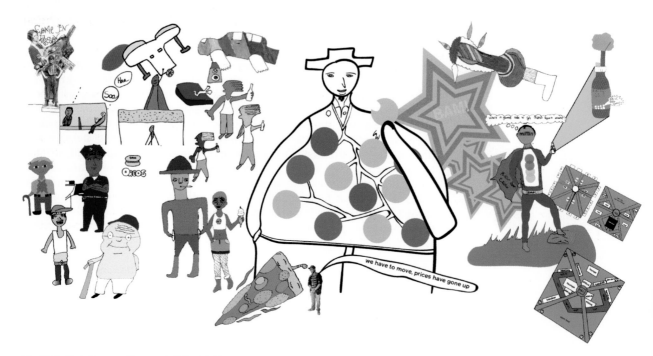

Fig 20.2 Park Powers Postcard, Philadelphia, 2018 (Hector)

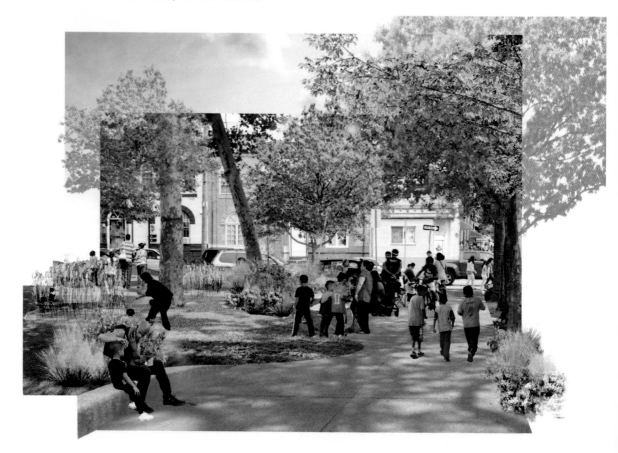

Fig 20.3 Mifflin Square Park Concept Design (Hector)

Melanie Dodd and Shumi Bose

as neighbourhood investigators hot on the trail of 'What does Southeast Philly have to do to get Mifflin Square Park rebuilt how it wants?' Students sardonically loved learning that their apparent innocence was being pressed into service by adults to ferret out information and win sympathy.

Jae Teenagers are so tuned to the meanings and shades of human judgement and domination, they didn't hesitate to question the outlook and motivations of the people entrusted to design, build, and operate their city's public spaces. This disillusionment and pleasure in violating adult discretion really energized the start of the wider neighbourhood discussion about the park.

Damon So tramping around the city meeting patrician park advocates, civil servant project managers, elected officials, and neighbourhood organization leaders, we'd physically trace out the lines of the park's social context. Like combining an applied civics course for students, cross-city communication channels for local groups and city agencies, and intelligence gathering for designers. We shared our findings through large drawings to get people talking about things like "Park Dreams and Nightmares" (named in homage to the Meek Mill lyric) and "Who Run Philly Parks?" Students came up with wild figures for social reality, like a large man who ingests neighbourhood organizations so they form a single body superhero to fix the park. When presented back to the residents and decision-makers who informed their creation, they further fertilize the discussions, disagreements, and ambitions of place politics.

Jae Later in the same project, we had the challenge to bring together and work with residents, sometimes in Swahili, Karen, English, and Khmer, to try to strengthen working relationships and come to some shared understandings. In these sessions, people used all kinds of funny objects – blocks, plastic flowers, beads, animal figurines, tiles, feathers – to describe and unpack spaces and meanings. We'd build dioramas of favourite childhood places and visions of the park's future. The Park Powers project with teenagers relied on empirical and analytic tools, while here the important contribution from design was more like open-ended play, projecting of all kinds of emotional qualities and values onto these objects, just like objects in the park itself. At the best moments, these design-mediated conversations hit on points of unexpected solidarity, nuggets of promise for new publics. Even at the worst, or at least most uncomfortable, sensitive issues of turf, exclusion, otherness and racialization were put on the table, aspects of the site that would either be addressed directly by the new design or be perpetuated by it.

Mel You've spoken about a 'nourishing tradition of community design' in the States which I think is clearly important to the work that you do. Could you talk about that tradition?

Damon First we look back to struggles around housing, urban development, and regulation at the end of the nineteenth century. One of my first exhibition designs with Center for Urban Pedagogy was about the political organizing behind early legal requirements for toilets inside of multi-family dwellings! The establishment of these new social tools of design over the first half of the twentieth century in the face of the stresses of urbanization, from building regulations to zoning codes to public housing authorities and redevelopment agencies, extended possibilities of environmental self-government. While certainly used by powerful interests to oppress,

these design technologies forged interfaces between democratic governance and the built environment.

Jae We're inspired by multi-dexterous practitioners like Lawrence Veiller who worked in the buildings department as a plan inspector, designed model tenements, sponsored affordable housing design competitions, and wrote housing regulations. Because of this work, even with its elite bias and many blind spots, private property gained new social qualities and possibilities. Cities could democratically decide on minimum rules for building themselves, rendering otherwise mundane architectural features like fire escapes, air shafts, and hallway bathrooms as figures of collective will for shaping the environment.

Damon This arc later passes to traditions of community design and advocacy planning, a national network of community design centres still linked today through the Association for Community Design. These initiatives, often university-based, incubated models of designers working with neighbourhood organizations and nonprofits, at first contesting large-scale government redevelopment projects, and later in the 1970s trying to deal with the withdrawal of public resources from cities.

Mel It's clear your work stretches from the individual scale to the municipal planning scale. Can you conclude with thoughts on the agency of the work in the scales it operates?

Jae We've had the chance to see first-hand how something actually happens, how a park design or a zoning plan gets shaped by money, politics, and force. These experiences make us sceptical of the growing participation industry and some generalized calls for participatory or responsible design. For us, the real question is, responsible to whom? Maybe we don't need responsible design so much as a serious reworking of 'to whom' design responds. To the degree we're interested in things like zoning, finance, and law, it's to achieve the ends. That is, making the systems within which the necessary abstraction of social desire can be translated – or at least 'connected' post facto – to the material shapes of everyday life, each a figure for the other.

 Melanie Dodd and Shumi Bose

21

Solidarity and freedom

Educating for spatial practices

Jeremy Till

> There is no change without risk ... and no freedom without solidarity.
>
> (Barack Obama, 2014)

The most common question I am asked at the end of lectures that I have given on spatial agency – the term developed with Tatjana Schneider to describe 'other ways of doing architecture' – is: how do we enact the principles you have set out? (Awan, Schneider and Till, 2011). My answer is always the same: it has to start with education. If, as many of the authors in the book argue, spatial practices require a different set of tools, tactics, ethics and behaviours from those demanded by standard architectural practice, then it follows that spatial practices need a different education. This chapter asks what that might look like.

It is tempting to start with an open page, to set out a completely new way of thinking about spatial education. However, the norms of current architectural education are so powerful and so consistent that they first have to be addressed; otherwise they may cast a pall over any new pedagogic constructions. My critique of architectural education may be trenchant, but it starts from a position of optimism. As an educator, I have to be an optimist. If I didn't believe that the next generation of practitioners might be better equipped to face the turbulence of the contemporary scene than the present generation, then I should stop educating. This is particularly the case in design education. Few design students set out to make the world a worse place; they all share a hope of productive transformation. In the case of architecture students, my concern is that the contexts, methods and priorities of those transformations are too often misplaced or misguided. Nonetheless, my optimism is retained in the belief that with some realignment of their education, architecture students are well placed to engage with the complexities of spatial production, and with it the reimagination of social relations. But first we need to find a way through the obstructions of current architectural education.

The conservative avant-garde

"Architectural education is deeply conservative!"

I open lectures on architectural education with this blunt provocation. It gains quick attention because it is so counter-indicative. A silent rebuke – "How could we be conservative?" – comes back through the body language of students and staff alike. The students because they don't want to be told that what they thought was the epitome of cool is quite the opposite. The staff because their very identity, and so livelihood, is tied to their ability to project something fresh. It is therefore necessary to justify my provocation.

The charge of conservatism is not surprising for one simple reason: architectural education is notoriously unreflective of itself. While there are thousands of books that investigate, theorize, explicate and critique the disciplines and projects of architecture, you can count on the fingers of two hands the books that substantively interrogate architectural education (Anthony, 1991; Dutton, 1991; Crinson and Lubbock, 1994; Harriss and Froud, 2015). In contrast to this lack of

a critical bibliography, a surplus of yearbooks, histories and festschrifts emerge from individual institutions as accretions of hagiography. Undisturbed by the intrusion of the critical gaze, architectural education evolves in a vacuum. The visual overload of the yearbooks presents endlessly changing images of freshness and difference, but the underlying condition is one of stasis. "Architectural pedagogy has become stale," writes Beatriz Colomina and her colleagues, "... schools spin old wheels as if something is happening but so little is going on" (Colomina et al., 2012).

It was ever thus. Le Corbusier writes about how "schools (of architecture) are the product of nineteenth century theories.... In an epoch of total disorder in which nothing today is like what it was yesterday ... they are against life; they represent memory, security, lethargy. In particular they have killed architecture by operating in a vacuum" (Corbusier, 1947, p. 114). Seventy years on, the internal rituals have not changed much, while the world beyond has got still more agitated, or in Zygmunt Bauman's terms, modernity has become ever more liquid (Bauman, 1997). It is exactly this startling disjunction between internalized structures of education and external realities that needs to be addressed if we are to move towards an education that is fit not just for architectural practice but also the expanded field of spatial practices.

As Le Corbusier notes, architecture schools were locked into a nineteenth-century model of education evolving out of the Beaux-Arts. Although the Bauhaus and other later movements might have disrupted the outward appearance of the products of architecture schools, a resilient strain of master–student relationship remains as the dominant pedagogic formation. Joan Ockman writes in her compelling history of US architecture schools "the intense interpersonal relationship between the student and the instructor ... remains at the heart of a form of education that has revolved around the design studio since the Beaux-Arts epoch" (Ockman, 2012, p. 29). The intensity of the design studio and accompanying asymmetry of power in the master–student relationship, is simply taken for granted and so left unquestioned, but it brings with it cultures and rituals that inflect on the whole educational experience, and in turn on the whole discipline of architecture. While most of these traits are well known, they remain largely unspoken, so it is worth quickly tracing through the symptoms of these cultures and rituals.

First is the continuation of the 'unit' or 'studio' system of teaching, in which tutors lead students down a determined path. It is a system that grows out of the Beaux-Arts atelier system and perpetuates a mimetic culture, in which the student is beholden to the principles of the master. The unit system, with its power structures so clearly manifested, flies in the face of all the tenets of critical pedagogy, in so much as it exemplifies the 'transmission' model of education. Where critical pedagogy interrogates the structures and relationships of education with the aim of empowering the individual student, the transmission model portrays the student as the passive receptor of the tutor's dominant knowledge base (Freire, 1996). In the case of architectural education, a pact is tacitly accepted in which students become the agents by which the knowledge base is then made apparent, and so exchangeable, through its aestheticization.

The unit system is overseen by the financialization of higher education. Murray Fraser traces how Alvin Boyarsky's Architectural Association (AA) in the early 1970s, with the establishment of the unit system in which tutors on precarious contracts fought for students, established a clearly market-based ethos into architectural education (Fraser, 2014). The unit system crystallized the exchange between student and tutor into a set of cultural and then economic transactions that still drive architecture schools today. The start of year presentations are quite patently trading places, establishing the role of the students as consumers and the unit tutors as salesmen. Boyarksy was shamelessly open about the game he had initiated. "People at the AA have one thing in common ... they're all predatory creatures" (as quoted in: Sunwoo, 2012, p. 33). The staff prey on best students and

Jeremy Till

the students on the best staff, entering into a tacit pact of mutual benefit. In order to raise their value in the institutional marketplace, the leading academies stack their offer with stars to lead their units and studios. This establishes the fallacy that good designers are de facto good teachers, when probably the most common correlation is that the more famous the tutor is for their external work, the less interrupted is the transmission and the more slavish the mimesis.

The trading currency of this system of exchange is the architectural drawing. They fill the students' portfolios as their calling cards; examiners, prize-givers and validating bodies pore over them as their primary means of assessment; drawings constitute the tutors' and the institution's shop window. There is also the identification of the drawing with the individual, so that the work of the single hand is privileged over any collaborative engagement, and with this the attribution of architectural production to the lone genius is promulgated.

And then there is the accompanying ritual of the crit or jury, a system of review that is apparently resistant to any change. I ask educators in schools around the world: "If you are so innovative, then why does almost every school of architecture use the exact same structure for reviewing work?" More often than not the response is the same: "But what else is there?" "You're designers, for god's sake," I respond irascibly, "*design* another setting!" But little has shifted over the centuries. We tried at the University of Sheffield in the 2000s, driven by the insights of Rosie Parnell and Rachel Sara, but this remains relatively isolated as an exemplar (Doidge, Sara and Parnell, 2000). The crit is accompanied by other rituals and other cultures. That of sacrifice. That of internalized language and codes. The acceptance of asymmetric power in so many of the relationships. All these and many more are embedded in architectural education; tribal cultures and rituals that further isolate it from the realities beyond (Stevens, 1998).

Many of the traits I have sketched above could be described as conservative. The holding to orthodox pedagogies, the complicity with neoliberal orthodoxies, the libertarian cult of the individual, the asymmetry of power, the dominance of the visual, the sway of the crit and so on. These conservative cultures are, however, masked by a thin veneer of the avant-garde. Within the avant-garde "the illusion of consistent change and innovation disguises a more profound level of consistency" (Orton and Pollock, 1996, p. 142). As many have argued, it becomes the fate of avant-gardes to circle around, and so institutionalize, their internal obsessions and self-defined terms. In this they become remote from, and so lose, their initial impulse of radical engagement (Bürger, 1984; Călinescu, 1987). This is the destiny of some architectural education; the avant-garde surface is necessary to maintain a front of marketable freshness, while the concealed stasis allows the dominant power structures to remain in place. But all this comes at a cost, most obviously to the students but also to the development of the discipline as a whole.

My premise here is simple and direct: architecture education in its isolation is educating for something that is not architecture. This is not to open up the age-old sore that education is not preparing students for practice, an instrumental demand for skills provision in which the profession requires graduates who are immediately available to sustain the disciplinary status quo. No, my charge is more serious and more tragic than this. In its isolation from the realities of the context of practice, education is failing on many fronts, most manifestly in its impotence to formulate alternatives and/or points of resistance to the status quo, and so in its inability to reimagine spatial practices. "In forever postponing and never confronting the shock of practice – god forbid we ever realize our own insignificance – it induces a strange state of schizophrenia," writes an equally despairing Reinier de Graaf. "On the one hand the aspiring architect is encouraged to entertain almost megalomaniac ambitions, on the other he is left largely unprepared for the world upon which he projects this megalomania. I am not talking about a lack of technical or professional competence here, but rather about the ability to come to terms with a society wholly indifferent to his ideals" (Graaf, 2015, p. 87).

Solidarity and freedom

A double impasse has been reached: on the one hand, education caught in the headlights of its irrelevance, on the other, practice with no tools for resistance or reinvention, and so equally sidelined. The present system is failing all round, but most profoundly in any duty of care to our students in so much that it appears not only to perpetuate false myths about what architecture might be capable of, but also leaving the practice they will enter unexamined as it descends into marginality. This points to the need for a radically revised form of education which moves beyond the fixed assumptions of architecture and into the wider field of spatial practices.

Expanding education

If architectural education is not fit for the purpose of the realities and contexts of architectural practice, then surely it is still less fit for the expanded realities and contexts of spatial practice? Although Melanie Dodd in her opening chapter of this book rightly resists arriving at a singular definition of spatial practices, she points to a number of common traits: the engagement with the political; a move outwards from architectural form alone; an acceptance of the contingent; a collaborative approach; and a working through of spatial relations as social relations. The sketch of orthodox architectural education that I have outlined above is at best insufficient to deliver these qualities, at worst is in complete denial of them. Anything political is submerged in the avant-garde rush to freshness. The concentration on the image fixates on the final form over what comes before and after that form. The determinate and slavish model of the unit/studio system does not allow for contingency. The celebration of the individual eschews collaboration. And, finally, how can one engage in the social in any meaningful way when the social construction of the pedagogy is so distorted by the asymmetries of power?

In the face of an apparent incompatibility of the established tropes of architectural education with the needs and values of spatial practices, then maybe the best way forward is to start afresh in the spirit of Audre Lorde's famous formulation "for the master's tools will never dismantle the master's house": to take the premises of spatial practice and reverse engineer a pedagogy from them. However, the result will leave the current systems untouched, and set spatial practice aside from mainstream architecture, just at the time when it needs to intervene in and disrupt the centre. As Melanie Dodd argues, it is not productive to set up a binary relationship: an either/or of spatial practices/architecture. Spatial practice is not a discipline apart from architecture, and not a completely new pedagogic model, but rather can be understood as an extension of spatial production beyond just the building (Awan, Schneider and Till, 2011). There is an attendant danger that if one starts afresh, then the unique strengths and character inherent in architecture education might be abandoned, in particular the development of spatial intelligence. An expanded and reformulated pedagogic model for spatial practice would be relevant to, and inflect back on, architectural education, most clearly by allying that spatial intelligence to the social field. An education for spatial practices acts as a much-needed source of critique and then revitalization of the current patterns of architectural education. To achieve this, I do not propose a curriculum or a structure, because that would again be over determinate and insensitive to particular contexts. Rather I suggest some principles that might guide education for spatial practices: first an ethical frame, and second an understanding of distance versus engagement.

An ethic of solidarity

I have elsewhere developed a critique of ethics in architectural practice, arguing that the stifling of ethical discourse in architectural practice leads to a profession removed from the social constitution of space (see Chapter 10, 'Imperfect Ethics' in: Till, 2009). If, following Zygmunt Bauman and Emmanuel Levinas, ethics are defined as to "assume responsibility for the Other," then the denial of ethics within architectural debate conceals others, as social beings (Bauman, 2000, p. 15). They

are reduced to abstractions: clients as monetary providers, contractors as suppliers of services, users as elements of function. Any contested human aspects are suppressed. Spatial practices at their core are concerned with exactly these contingent contexts where the human meets the spatial, and so spatial practices and their attendant education require an ethical frame.

The word 'frame' is used here rather than the more common 'code'. Ethical codes tend to be overly prescriptive, based on universals, or else reductive, in so much as it is impossible to cover all aspects of human behaviour and so codes descend to the lowest common denominator; this latter is the state of most professional codes of conduct. A frame on the other hand is something to look through and then ask questions of what one sees, throwing back on the individual or institution the responsibility to make the best possible ethical sense of each context. Without the ethical frame, difficult questions are not asked; with it, the social and the spatial are inevitably charged with a human and political dimension. In particular I want to argue that this frame should be based on the notion of an ethic of solidarity. The term comes from a short essay by the US feminist theorist Nancy Fraser. In contrast to the abstraction of the social, Fraser's approach addresses what she calls "the collective concrete other." To quote at some length:

> The stress is on the cultural specificity of the narrative resources available to individuals and groups for the construction of individual life-stories or group identities and solidarities.
>
> (Fraser, 1985, p. 428)

This immediately resonates with spatial practice's engagement with the specific spatial contexts and their social dimension. Fraser is then clear that such engagements should not be in terms of individual imposition (a trait often associated with standard architectural practice):

> There is no projection of one's own perspective onto the place where another should be. There is dialogic interaction with actual others, although these are encountered less as unique individuals than as members of groups or collectivities with culturally specific identities, solidarities and forms of life.
>
> (Fraser, 1985, p. 428)

These interactions are necessarily framed by ethical considerations: "the elaboration of the standpoint of the collective concrete other leads to an ethic of solidarity."

Such an ethic of solidarity can be used to frame both education for spatial practices and spatial practices as a form of action. In terms of education, it acts as a frame to understand and adjust the internalized processes of education. If taken seriously, an ethic of solidarity has the potential to rethink education in a radical manner. This is not to add ethics or social responsibility to the list of other criteria that a student should meet. Given the segmented nature of the current criteria, at least in the UK, just adding another potentially token fragment will not disrupt the core assumptions of the existing ones. Rather we need to view all these criteria, and the processes by which they are met, through a frame of an ethics of solidarity.

Most obviously such a frame would reconstruct power relations in the unit and crit system. With the first, the principle of solidarity with a concrete collective (the student body) would immediately dissolve the platform of control and display that the current unit system provides for its tutors. Of course, power will be always be present in any educational exchange because of established hierarchies and the spectre of future assessment, but the ethical frame demands that this power is first acknowledged and then dealt with responsibly. In the case of the crit/jury, the ethic of solidarity would shift all concern to the students' situation – to their human dynamics (fragility, hope, fear of the unknown, sophistication as citizens vs incompleteness in terms of skills) and their needs as putative spatial practitioners rather

Solidarity and freedom

than their wants as educational consumers. Attention is shifted from the crit/jury as a platform for the vanity of the tutors, to a shared space of mutual exchange. Beyond this, an ethic of solidarity would simply not tolerate any neo-colonial traits with which the standard overseas field trip – a feature of so many unit and studio structures – are associated, and instead point to grounded interaction as the point of departure for projects. But most of all an ethic of solidarity would prick the bubble of isolation within which architectural education has developed its strange rituals and cultures, because the whole basis of solidarity is based on empathetic and political engagement with others. It necessarily externalizes education, bringing it out to face the realities of the world. With this, the internalized codes and behaviours of the architecture academy are exposed for what they are: conservative and intolerant.

Detachment and engagement

The charge may now come back that in arguing for an engagement based on solidarity we will lose exactly what is most precious about any form of education, namely the space to speculate unfettered by everyday demands, the space of freedom. Why restrict the imaginative possibilities of our students? Didn't you understand the poignancy of Plato's retreat to the charmed garden of the academy? The status quo is moribund; we need to be allowed to dream of new futures!

All of these provocations point to a condition of detachment as a prerequisite for the architectural academy to pursue its self-defined goals. My riposte to this is shared with Reinier de Graaf: "The creation of an educational bubble, even when invoked in the name of protecting academic integrity, seems a self-defeating purpose" (Graaf, 2015, p. 87). Why create a bubble, if in its removal from reality, it cannot contain the tools to unpick the formations of the outside world and its practices?

If it is true that these hermetic worlds are also deeply conservative, then the obverse holds, namely that the truly radical can only be found in true engagement. It may appear that a paradox is being presented here. To propose an engagement with reality as the radical option is to fly in the face of the received notion of the academy as a place of free thought. But in the isolation of the architectural academy, the purported freedom to speculate is a false freedom as it has nothing to rub up against; a frictionless world results, in which projects assume a charmed life that is beyond testing and realization. One of the problems with the detachment of the architectural academy is that it confuses speculation with critique, as if the freedom that is granted to think beyond limits comes with an attendant critique of those limits. The academy is in the uniquely privileged position to think about and through the structures of reality whilst not being fully ensnared by them. But this privilege should not be abused; the critique is best played back out in an engagement that might disturb some norms.

This suggests a movement between detachment and engagement in educating for spatial practices. Such a movement is advocated by the philosopher Maurice Merleau-Ponty when he writes in his inaugural professorial address: "one must be able to withdraw and gain distance in order to become fully engaged" (Merleau-Ponty, 1963, p. 60). A withdrawal to a position from which the structures of reality can be more clearly understood, and then a re-encounter with that reality now equipped with the instruments and visions to be able to reimagine it. In this I agree with de Graaf when he argues that education could be the place where we turn "practice *itself* into the object of thinking ... architecture *needs* a real knowledge of practice if it is to produce any meaningful critique of that same practice" (Graaf, 2015). In thinking through the conditions and restrictions of practice, one can find alternatives; an educational opportunity opens up for the development of new forms of spatial practice moving out of the norms of architecture. In this, de Graaf is not advocating "a form of surrender" to the demands of practice – as it might be depicted by the bubble dwellers – "but simply an enlarged curiosity."

Curiosity is indeed a prerequisite for any inventive education; it is also a natural ally of solidarity. How can one find solidarity unless one is curious about others? But also, remembering the epigraph from Barack Obama with which this chapter is headed, how can one find freedom without solidarity?

Equipped with a curiosity about the realities of architectural practice, students will fast become aware of its constraints, and with the privilege of distance will be able to speculate on ways of negotiating these constraints. This negotiation needs to be done in the spirit that "constraint does not only limit possible elements, it is also opportunity" (Prigogine and Stengers, 1981, p. 1076). Again, educating for spatial practices is not found as a carte blanche, but through a response to the restrictions and dominations of current models of architectural education and practice.

My sense is that there is a real urgency to move to new forms of education based around the principles and values of spatial practices. This is not simply to do with concerns over the increasing marginalization of architecture as a discipline, and the role its education may be playing in this process. The issue is more pressing than that of a single discipline. When one makes the connection between social justice and spatial justice, then opportunities and necessities open up for a new form of practitioner who is adept at making those connections across disciplinary boundaries and in a collaborative manner. Spatial practices here assume an urgent political role in engaging with the fundamental democratic concerns of how space and its attendant dominations on the one hand, and freedoms on the other, might play out on the lives of citizens. If we follow Barack Obama's call that there is no freedom without solidarity, then my identification of solidarity as core of education for spatial practices becomes part of a wider emancipatory political project.

References

Anthony, K. (1991) *Design Juries on Trial*. New York: Van Rostrand Reinhold.

Awan, N., Schneider, T. and Till, J. (2011) *Spatial Agency: Other Ways of Doing Architecture*. London: Routledge.

Bauman, Z. (1997) *Liquid Modernity*. Cambridge: Polity Press.

Bauman, Z. (2000) *Alone Again: Ethics After Certainty*. London: Demos.

Bürger, P. (1984) *Theory of the Avant-Garde*. Minneapolis: University of Minnesota Press.

Călinescu, M. (1987) *Five Faces of Modernity: Modernism, Avant-Garde, Decadence, Kitsch, Postmodernism*. Revised edition. Durham, NC: Duke University Press.

Colomina, B. *et al.* (2012) Radical Pedagogies in Architectural Education, *Architectural Review*. Available at: https://www.architectural-review.com/today/radical-pedagogies-in-architectural-education/8636066.article (Accessed: 9 August 2018).

Corbusier, L. (1947) *When the Cathedrals Were White: A Journey to the Country of the Timid People*. London: Routledge.

Crinson, M. and Lubbock, J. (1994) *Architecture, Art or Profession? Three Hundred Years of Architectural Education in Britain*. Manchester: Manchester University Press.

Doidge, C., Sara, R. and Parnell, R. (2000) *The Crit*. Oxford: Architectural Press.

Dutton, T. A. (1991) *Voices in Architectural Education: Cultural Politics and Pedagogy*. New York: Bergin & Garvey.

Fraser, M. (2014) Is Studio Culture Dead?, *Architects Journal*, 25 July.

Fraser, N. (1985) Toward a Discourse of Ethic Theory, *PRAXIS International*, 5(4), 425–429.

Freire, P. (1996) *Pedagogy of the Oppressed*. London: Penguin.

Graaf, R. de (2015) I Will Learn You Architecture!, *Volume*, 16 October, pp. 84–91.

Harriss, H. and Froud, D. (eds) (2015) *Radical Pedagogies: Architectural Education and the British Tradition*. Newcastle upon Tyne: RIBA Publishing.

Merleau-Ponty, M. (1963) *In Praise of Philosophy*. Evanston, IL: Northwestern University Press.

Obama, B. (2014) Remarks by President Obama at the 25th Anniversary of Freedom Day – Warsaw, Poland, 6 April.

Ockman, J. (2012) *Architecture School: Three Centuries of Educating Architects in North America*. Cambridge, MA: MIT Press.

Orton, F. and Pollock, G. (1996) Avant-Gardes and Partisans Reviewed, in *Avant-Gardes and Partisans Reviewed*. Manchester: Manchester University Press, pp. 141–164.

Prigogine, I. and Stengers, I. (1981) 'Vincolo', in *Enciclopedia Einaudi*. Turin: Einaudi, pp. 1064–1080.

Stevens, G. (1998) *The Favored Circle: The Social Foundations of Architectural Distinction*. Cambridge, MA: MIT Press.

Sunwoo, I. (2012) From the "Well-Laid Table" to the "Market Place:" The Architectural Association Unit System, *Journal of Architectural Education*, 65(2), 24–41. doi: 10.1111/j.1531-314X.2011.01196.x.

Till, J. (2009) *Architecture Depends*. Cambridge, MA: MIT Press.

22 Pedagogical tools for civic practice

Andreas Lang

In his essay 'Reconstituting the Possible' David Pinder (2015), discussing Henri Lefebvre's (2003) ideas on utopia, argues that without addressing social relations and their transformation, the invention of spatial forms can't provide adequate solutions to the urban problematic.

How do we teach and educate architects to rethink space through understanding social relations? How can we formulate a pedagogy in which the architecture student becomes an operative agent in the field of social relations? In the same text, and referring again to Lefebvre, Pinder argues that everyday life is "the inevitable starting point for the realization of the possible" (Pinder, 2015, p. 42).

Grounding future visions in a close understanding of existing social relations is important in order to imagine their transformation. If the creation of new social relationships becomes the building block for new forms of spatial practice, we need to understand the student as an active agent in the field, not as a passive observer but as someone who has a first-hand understanding of the complexity and transformative capacity of social relations. For students to become active in this field we need to look at forms of learning which foreground multiple social relations instead of the singular student/tutor relationship which is the norm promoted by many architectural educators.

The educator and psychotherapist Ruth Cohn worked primarily with groups, and was looking for ways in which learning in groups can take place through activation by live dialogue, leading to more personal engagement and, ultimately, she argues, to more self-determination. Ruth Cohn's methods draw heavily from the ideas of social learning. "Social learning is defined as learning through observation of other people's behaviour. It is a process of social change in which people learn from each other in ways that can benefit a wider social-ecological system" (Edinyang, 2016, pp. 40–45). Creating meaning through one's work is important in order to get a sense of self-determination. It is also part of the construction of subjectivity: how we see the world, how we understand our own agency, and how this forms our own identity. Ruth Cohn's intention was that 'health' was not only personal well-being, but also a broader sense of political and ethical responsibility for others. Having survived the holocaust by fleeing Germany to Switzerland it might not seem unusual for her to link health to political participation, and to link the student's learning and their individual pursuit with active citizenship and well-being. However, it is a link rarely made in architectural education. The politics of the students and their projects is seldom a point of discussion yet, if we follow this argument, they should be intrinsically connected.

Architecture works on large scales, projecting ideas into speculative futures. It operates from distance and through abstraction, both in its conception and in its execution. Architectural education often sees this world of abstraction as the space in which the architect's imagination is at work. Ideas of citizenship, politics and health are often treated in the same distant and abstracted space. Reinier de Graaf, one of the of the partners at Dutch architecture practice Office for Metropolitan Architecture (OMA), speaks about this isolation in which architectural education takes place and the shock architecture students experience when they encounter

the real world outside; specifically, the lack of purchase their carefully nurtured worlds imagined during their studies have in the real world:

> Once unleashed into the real world, the architect is perplexed by an utter lack of authority, stuck in a large gap between what he thinks should happen and what he ends up doing. The more hermetic our schools, the more distant the realities of practice become. When practice is not engaged, it tends to become romanticized.
>
> (Graaf, 2015, p. 85)

Many architecture students can relate to this experience, having spent substantial amount of time drawing up wonderful speculative scenarios during their studies, only to end up sitting in a practice where their day is filled with repetitive technical tasks dictated by clients. The discussion then, is about practice; how do we form and teach practice itself? A more extended and more holistic reading of architectural practice is offered by Jacobs and Merriman:

> the stable architectural object (architecture-as-noun) is the effect of various doings (architecture-as-verb). The outcome of that doing is not simply architectural matter itself, the building and its formal qualities. Practising architecture includes material matter (walls, bricks, steel, asbestos, glass, stairs, corridors, rooms) as well as human mattering: meaning and judgement to be sure (love, hate and indifference), but also affect and atmosphere (the felt and the ambient).
>
> (Jacobs and Merriman, 2011, p. 212)

What would a pedagogy which embraces this broader understanding of practice look like, one which engages with 'architecture as a verb'. Bearing in mind Ruth Cohn's idea, that for an individual to remain healthy they need to engage with citizenship, in order to create healthy spatial practitioners, we have to educate them to be healthy citizens.

Live projects as situated learning: the Civic University

'Live projects' are a type of problem-based learning that have existed in architectural education for some time, usually sitting outside the mainstream conventions. In the last two decades they have become popular, with significant discourse and examples documented (Harriss and Widder, 2014). The projects are often devised in order to make teaching 'useful' with a close link to the realities and constraints of the non-academic world outside the university. One could describe this model as mimicking traditional architectural practice. A collective of students design and build a small (often public or civic) project for someone who needs it, and students learn by being involved in every aspect of the project. Live projects have been argued to be a form of training that "can deliver learning experiences that enable architecture students to gain specific, professional practice-ready skills and capabilities currently perceived to be lacking within the existing architecture school curriculum" (Harriss, 2015, p. 18). However, the assertion that 'live projects' are useful in making architectural practice more efficient by preparing the students to become more employable can easily re-enforce a conventional understanding of practice. This chapter will outline an extended model for live projects, one which challenges the students to explore their roles within a broader understanding of architecture while also confronting them with their own agency as citizens and as emerging practitioners.

Wembley Civic University was an experimental project undertaken with students and part of a live project entitled 'Place Agency', initially commissioned by Brent Council, for architecture students at the Royal College of Art. The client approached us to produce a study which would help generate a series of propositions for the local high street, including a budget for the students to develop and implement ideas. The resulting project, 'The Wembley Civic University' formed the brief for the following two terms of their study. 'The Wembley Civic University'

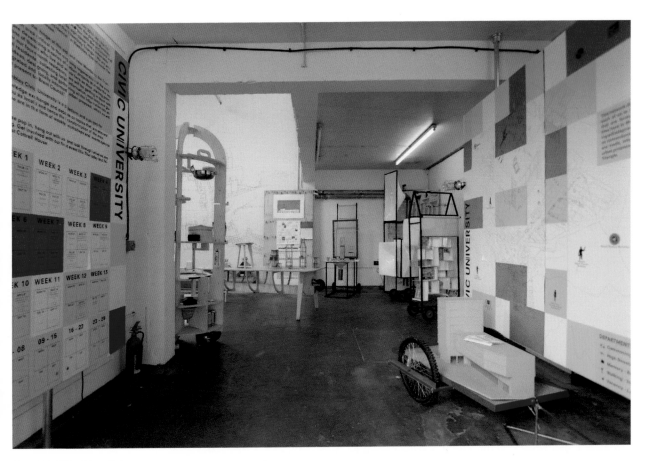

Fig. 22.1 Wembley Civic University, workspace with public programme and Civic Fragments (Andreas Lang)

was proposed as a satellite university situated in Wembley. In contrast to the main campus the Civic University would be open access and programmed entirely by the students as part of their collective and individual learning. The students controlled the budget, they wrote and organized their own curriculum and designed their learning environment (see Figure 22.1).

The proposal drew inspiration from the Artist Placement Group (APG) who were active in the 1970s and radically challenged the role of the artist and art in society.

> The APG initiated and organized 'placements' for artists in industry or public institutions.... The statement, 'Context is half the work', testifies to this spatial and ideological shift; out of the studios and into the institutions of society, from object-based work towards information, to site-specific work and to social relationships.
>
> (Hennig and Jordan, 2015, p. 11)

The Artist Placement Group used two principles which were important to the Civic University. The first principle was the 'Open Brief', a brief which does not determine a set output or outcome but allows a brief to develop as the project unfolds. This requires mutual trust between the host and the placed artist but in return allows for a more meaningful exchange. The second principle from the APG was the term 'incidental people' coined by artist John Latham to describe the role of the artist within the placement and the intention to allow the context to inform an extended understanding of their role as artists.

The pedagogical ideas behind the Civic University also drew heavily on Rancière's (2007) premise of the 'ignorant schoolmaster'. "'For Rancière, teaching

as learning process starts from two acknowledgements. First, that the teacher – the one initiating the process – is partially ignorant. But that relative ignorance doesn't prevent her or him from 'teaching', in as much as he or she still knows 'something' that can mobilise to formulate a set of ideas and initiate a discussion" (Sebregondi, Khonsari and Lang, 2014, p. 71). Within the Civic University each student proposed their own 'department' which embodied their research interest and allowed them to deliver a series of Master Classes, a designed dialogue with invited guests and audience around matters of concern for all. The Master Classes allowed the students to raise questions that no one can master on their own but to which all can collectively contribute, provoking lively discussion and gaining valuable feedback on the ongoing work in progress.

Taking control of their own education was not an easy task for the students. Having to approach possible contributors and participants to take part meant they had to leave the comfortable space of the computer screen and lead their own learning through dialogue with those that occupy the same field of discourse, or those who would be affected by their projects and ideas. It asked the students to bridge those distances and in doing so an important part of the learning took place. The continued articulation and testing of assumptions opened the project up to extensive feedback from a whole range of people, be it the peer group, or members of the public visiting the space, meeting people on the street or presenting to the client. The constant conversations not only created valuable feedback loops which helped to short-circuit often lengthy learning processes, but it also created a conversation between multiple voices. The discussion was no longer purely between the tutor and the student; instead a range of expertise was drawn on and became relevant to the formulation of a project. The project started to exist in a network of social relations facilitated by the students and their enquiry. It placed the students in a sometimes-contested space in which they had to negotiate their ideas with care and respect. Irit Rogoff (2008) describes this process as 'inhabiting a problem'. And talks about the notion of an 'embodied criticality' which "has much to do with ... our shift away from critique and towards criticality, a reflective shift, from the analytical to the performative function of observation and of participation ... meaning is not excavated for, but rather, that it takes place in the present" (Rogoff, 2008.)

The Civic University illustrated a role for both the practitioner, but also for the 'student-as-producer'; a term from Walter Benjamin suggesting how radical intellectuals should act in a time of social crisis:

> This included finding ways to enable students, readers, and audiences to become teachers, writers and actors – as producers of their own cultural and intellectual products. The wider political point was for passive consumers of culture and knowledge to transform themselves into the subjects rather than simply the objects of history and to recognise themselves in a social world of their own design.
>
> (Neary, 2011)

By opening up this context it becomes part of architectural production. This demonstrates an extended form of 'live project' which does not shy away from engaging with the complex dynamics of city-making processes but uses this often-conflicted and contradictory live space to develop propositions: considering the student as an emerging practitioner who has agency to navigate this space and learn from it, by taking a proactive role within it.

Lave and Wenger (1991) also describe this as 'situated learning' which takes place within authentic social and physical environments, not within an abstract place held at distance but one which is lived and is 'live'. The situated model of learning is part of Lave and Wenger's theory of 'communities of practice' which states that learning should not be viewed as mere transmission of knowledge but as a distinctly embedded and active process. They argue that this type of learning is stimulated by specific contexts where learning is socially situated. Lave and

Andreas Lang

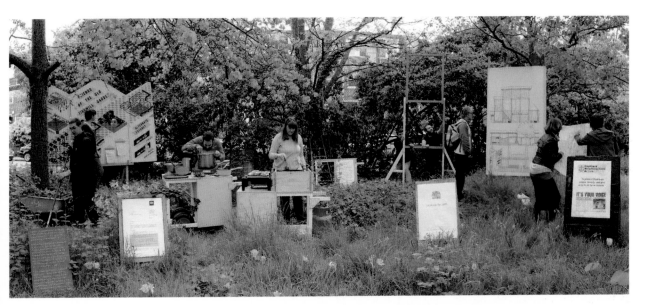

Fig. 22.2 'Common Boundaries' by Andrew Belfield. Situated Drawing with Civic Fragments performed with members of the Old Tidemill Garden (Andrew Belfield)

Wenger define 'communities of practice' as 'groups of people who share a concern or a passion for something they do and learn how to do it better as they interact regularly'. Allowing students to construct 'communities of practice' around their projects, which consist of a variety of partners and stakeolders ranging from members of the community to specialists to their peers, uses the pedagogy as "an active agent in the processes with which it was concerned, rather than through modes of detached or complacent reflection." (Colomina, 2015).

These communities of practice act as an educational tool, to ground the students' learning within practical real-life situations. Through their direct work with communities, students test their theories in practice, placing a focus on how a project can have agency for the groups the student works with. These projects are developed through Richard Skemp's (1987) theory of 'relational' as opposed to 'instructional' learning; the tutor acts as a facilitator of the learning process, opposed to defining the exact content of the curriculum. This places a greater emphasis on student-led learning and an active peer group who support one another through their studies, through peer-to-peer learning. This helps students to build a network of support for their future practice once they leave university. Learning does not belong to individuals, but to the various groupings and discourses of which they are part (see Figure 22.2).

Situated drawings

In these sorts of learning, production remains potentially invisible, especially if considered in contrast to conventional spatial methods (drawings, plans and models). Learners build relationships, open up and explore contexts, design and host events, negotiate permissions which is all very valuable and necessary, but it is removed from the conventional understanding of architectural production. If, in the words of the APG, 'context is half the work', then the method we use to access and understand these contexts needs to be valued as an important aspect of production. If, as the APG suggests, we should move from "object-based work towards ... site-specific work and to social relationships" (Hennig and Jordan, 2015, p. 2), we need to find ways to produce and capture this relational space within the discourse of architecture and spatial production.

In his essay on relational aesthetics, and in relation to relational art practice, Bourriaud (2002 [1998]) talks about the constructed relation as a form in its own right. The notion of a 'situated' drawing has been developed as a teaching

methodology which offers a tool which can be used throughout different stages of the development of a project. The situated drawing asks the students to invent a way of drawing or acting directly on site which, at times accidentally, involves actors and places which are (or can become) relevant in their project. Drawing, understood in the broadest sense, becomes a way of engaging and acting on site. As such the situated drawing is a representational device as well as an actual live situation. It has the potential to reach beyond the idea of representation and places the students as actors within the site and context of their enquiry (see Figure 22.3).

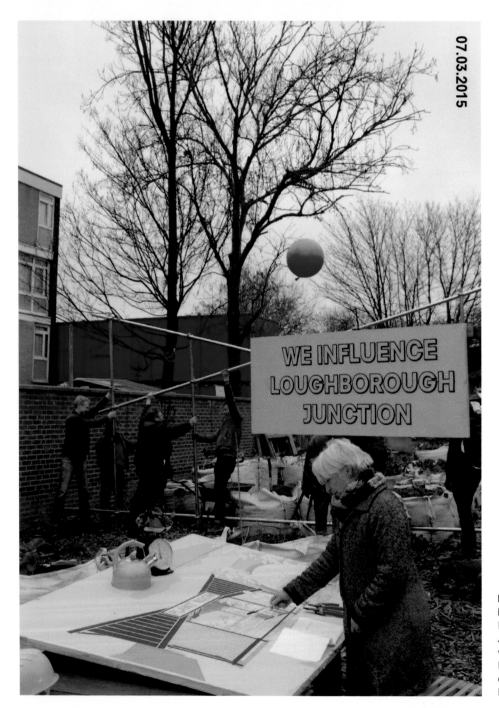

Fig. 22.3 Situated Drawing by Tom Dobson. 'We Influence Loughborough Junction'. Micro-performance with members of the Loughborough Farm community garden (Tom Dobson)

Andreas Lang

Situated drawings can also be understood as a series of micro-activist performances. Performance theorist Jon McKenzie (2005) outlines issues and current discourse that are framed by the term 'performance' in society today and offers three readings of performance which we can use to assess the situated drawing.

> 1) the challenge of efficacy, the ability of cultural performances to maintain or transform social structures; 2) the challenge of efficiency, the 'minimaxing' of organisational inputs and outputs; and finally, 3) the challenge of effectiveness, the optimising of technological functionalities (such as speed, accuracy, weight etc.).
>
> (McKenzie, 2005, p. 24)

The situated drawing has the capacity for the students to engage with all three dimensions of performance outlined above. I would add a further dimension which is that of a material culture. In the context of the situated drawing the term 'drawing' is used in the broadest possible sense. On the one hand, it allows us to draw a line of thought, bringing together key components within one image or performance. It also refers to drawing in the most literal sense, to leave a mark in order to produce a picture or diagram. In many instances, students developed props or techniques to leave physical marks on the ground which were site specific. For example, dust drawings highlighting the imminent demolition of a neighbourhood due to development. In this case the materiality of the drawing itself responded to specific material condition of the site itself.

Having experienced self-determined learning many of our students organize their own placements to immerse themselves within authentic situations for their final thesis project. The methodology of the situated drawing offered a way to produce this space of engagement. It facilitates students to make inroads into 'inhabiting a problem' (Rogoff, 2008), build trust with the groups they have chosen to collaborate with and form a wider community of practice around their topics of concern and through which the 'possible' can be reimagined (see Figure 22.4.)

In order to open the hermetic nature of architectural education and overcome the distance to the reality of practice, we need to develop pedagogies which allow students to situate themselves more strongly within the field of their enquiries and bring into stronger focus the social relations at play in their projects and the learning processes themselves. Social and situated learning promote forms of learning which puts the emphasis on group learning processes, suggesting not only healthier ways of interaction, but also methods to engage in society as active citizens. Encouraging the students to engage more directly in social dynamics of the situation by building communities of practice around their projects will allow them to 'inhabit the problem' and better understand how they can take influence from within. Collapsing this distance not only outlines the constraints of practice but will also allow the students to explore how they can develop agency within it.

Bibliography

Anderson, B. (2005) Practices of judgement and domestic geographies of affect. *Social & Cultural Geography* 6: 645–659.

Bennett, J. (2010) *Vibrant Matter: A Political Ecology of Things*. Durham, NC: Duke University Press.

Bourriaud, N. (2002 [1998]) *Relational Aesthetics*. Dijon, France: Les presses du réel.

Colomina, B. (2015) *Radical Pedagogy*. [Online]. https://radical-pedagogies.com

Edinyang, David (2016) The significance of social learning theories in the teaching of social studies education. *International Journal of Sociology and Anthropology Research* 2(1): 40–45.

Graaf, R. de (2015) I will learn you architecture! *Volume*, 16 October, p. 85.

Harriss, H. (2015) *Architecture Live Projects: Acquiring and Applying Missing Practice-Ready Skills*. PhD Thesis, Oxford Brookes University, UK, p. 18.

Fig. 22.4 Situated Drawing by Neba Sere. Mapping alternative housing models in Walthamstow, East London. The placard was used as part of a city-wide demonstration against the London housing crisis (Neba Sere)

Harriss, H. and Widder, L. (2014) *Architecture Live Projects: Pedagogy into Practice*. Abingdon: Routledge

Hennig, N. and Jordan, U. (2015) *Context is Half the Work; A Partial History of the Artist Placement Group*. Exhibition catalogue PDF [Online].

Jacobs, J. and Merriman, P. (2011) Practising architectures. *Social & Cultural Geography* 12(3): 212.

Lang, A. and Buck, H. (2018) *Forming Communities of Practice*. Central Saint Martins College of Art and Design, M-Arch Architecture Course, Unpublished.

Lave, J. and Wenger, E. (1991) *Situated Learning: Legitimate Peripheral Participation*. Cambridge: Cambridge University Press.

Lefebvre, H. (2003 [1970]) *The Urban Revolution*. Translated by R. Bononno. Minneapolis: University of Minnesota Press.

McKenzie, J. (2005) Hacktivism and machinic performance. *Performance Paradigm* 1, PDF, March, p. 24 [Online].

Neary, M. (2011) *Student as producer: reinventing HE through undergraduate research*. [Online]

Pinder, D. (2015) Reconstituting the possible: Lefebvre, utopia and the urban question. *International Journal of Urban and Regional Research* 39(1): 28–45, p. 42.

Rancière, J. (2007 [1991]) *The Ignorant Schoolmaster*. Translated by Kristin Ross. Stanford, CA: Stanford University Press.

Rogoff, I. (2008) *Smuggling – An Embodied Criticality*. PDF. [Online].

Sebregondi, F., Khonsari, T. and Lang, A. (2014) *Architecture and Activism*. [Online].

Skemp, R. (1987) *The Psychology of Learning Mathematics*. London: Routledge.

'23

'New municipalism'
A conversation with Finn Williams and Pooja Agrawal, Public Practice
Melanie Dodd and Shumi Bose

Mel Can you tell us how you define what you do, as practitioners in the public sector?

Finn It's easy to say what I'm not. I'm not technically an architect according to ARB (Architects Registration Board), I'm not technically a planner, according to the RTPI (Royal Town Planning Institute). In many ways, the kind of practice that I'm involved in both in the public sector and through Public Practice is what I'd like architecture and planning to be in the broadest sense. I once called myself a "half-architect, half-planner," which got me into trouble in both camps (laughter). We defend the use of the term "architect," but we've failed to defend the real scope of the architect's role and the value of the profession to society. And for me that's a real problem and something that needs to be challenged. In the last 30 to 40 years we've allowed the definition of what it is to be an architect to shrink, and become limited to a very constrained role. And the same is true of planning: 40, 50 years ago, planning was shaping every aspect of a place. Today, a large proportion of the profession devotes their career to securing planning consents for developments that they don't think are very good. No one enters into architecture or planning to do that. That's why we need to broaden the agency, and definition, of both professions.

Mel Are you an architect, Pooja? (laughter)

Pooja Yes, I am a qualified architect and throughout my educational career and practice I have been trying to find ways of designing 'beyond the building'. When I joined the public sector three and a half years ago, I was hesitant about starting to call myself a planner, because I work in the Regeneration Team at City Hall, and there's a separate Planning Team. There's definitely been a blurring of boundaries in terms of what we do and how we define these professions. But I also think it's dangerous for us to be really rigid and institutionalized in how we define professions, not only in terms of just architecture and planning, but in the case of all wider environmental design practices.

Finn The kind of practitioners who are our predecessors – in the London County Council, Camden Council, or Lambeth Council in the 1950s and 1960s – would have called themselves 'architect-planners'. And in many ways what we're trying to do with Public Practice is to rebuild that breadth of expertise – and ambition – for what the role of an 'architect-planner' could be. We do that by putting together cohorts of practitioners who are drawn from across a range of broader fields; people with expertise in surveying, development, planning, regeneration or conservation. And by encouraging them to work collectively, to build and broaden each other's skills.

Pooja A new generation of young practitioners are questioning the status quo in the professions. Something as fundamental as gender has become so much more fluid. I think we need to revisit such institutionalized terms such as 'architect' or 'planner', and rethink how people would want to engage, because they seem such rigid professional titles. The more accessible and open they are, the more they will attract the most talented people.

Mel I'm interested in how Public Practice describes itself as an organization. Is it a third sector organization that's sitting outside the public sector as an enabling body?

Finn Public Practice came from our own experiences of having a background in architecture, practising in the private sector, then moving into the public sector. Through this journey we got an understanding of where the gaps in the capacity of the public sector are, and how to support the public sector to plan more proactively – and a lot of that boils down to resourcing. We've had almost a decade of austerity since the 2008 financial crisis, on top of 40 years of retreat from the public sector taking a hands-on role in building homes and leading change. The cumulative impact of that is that it has become increasingly hard for local authorities to recruit and retain people with ambition, talent and skills.

 Now, for the first time in decades, ambitious local authorities are looking to start building homes again. The more enterprising councils can find the funding, but they can't find the right people. So we set up Public Practice as an independent broker to match outstanding practitioners from the private sector with extraordinary new opportunities to work within councils for the public good. In 1976, 49 per cent of all architects worked for the public sector, and now it's less than 1 per cent. We'd like to see a greater proportion of the incredible talent from across the UK's built environment sector working for all of us, on our behalf.

Pooja When we were working at the Greater London Authority (GLA) together and designing what Public Practice could be, we considered various different models: should it sit within the GLA; be associated with another existing organization; or should it be an independent not-for-profit social enterprise, which was the final decision. Being independent has helped us gain local authorities' trust, as we're politically neutral and only acting in their interests. There is a kind of nimbleness in being a social enterprise that can facilitate conversations between the public sector but also with other organizations, and with academic institutions. It's not-for-profit and publicly driven – but it's not public sector.

Finn Whether we like it or not, we are a part of a wider wave of social enterprise that's grown up in inverse proportion to the shrinking of the state. In an ideal world the job descriptions and perceptions of the public sector would be strong enough for our placement programme not to be needed. But we've got a long way to go until we get to that point. We're doing everything we can to keep expertise embedded within authorities, build their in-house capacity over the longer term, and attract people into the public sector as a whole. I think that's what distinguishes us from lots of other social enterprises. This is not a permanent solution. We see success as the placement programme no longer being necessary. But another part of our role is to help the public sector to keep pace with changing demands, pressures and challenges – whether economic, demographic or environmental – and that is always going to be needed.

Melanie Dodd and Shumi Bose

It's not easy for large public sector organizations to respond quickly to emerging challenges. That's where we can continue to be useful, by helping local authorities evolve to deal with future changes in the built environment.

Mel Yes, you are independent, but you want to support the state.

Pooja In the end our mission is to improve the quality and quality of places, and that's much broader and more fundamental.

Mel Is the research and development (R&D) side of the organization needed to fund and generate policy research that's collectively important to local authority contexts?

Pooja Yes, we can be proactive and respond quite quickly to pressing issues. For us the research and development programme is about creating really practical outcomes and actions. That is what local authorities find most useful. For example, how should councils measure the quality of the new social housing they are starting to build? If a template post-occupancy survey could be created and shared across local authorities, that is an incredibly useful resource that comes from the local authorities' demand and need, rather than being imposed by a central body like the GLA or government. This kind of cross-cutting R&D, of sharing ideas between authorities through the network of Associates, can produce a really practical body of work. It is not academic research. It's very much about

Fig 23.1 Research and development session for the first Public Practice cohort (T. Chase)

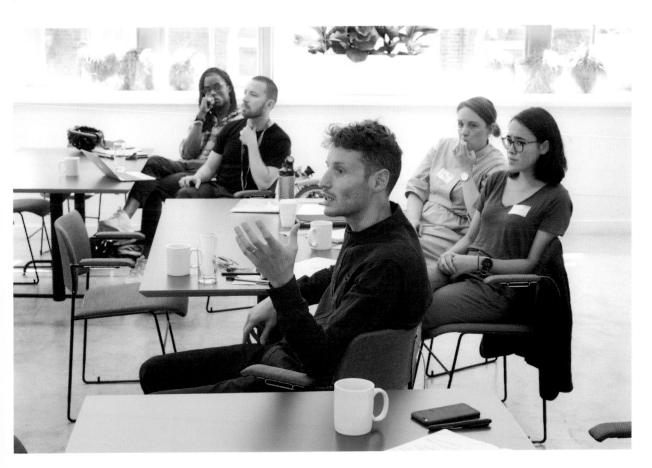

everyday practice; capturing how the Associates are addressing the barriers they come across in the day-to-day work.

Finn As a social enterprise we have a mission, which as Pooja said is to improve the quality, and equality, of everyday places. And we have a theory of change, which shows how we'll try to achieve that mission in three ways. The first pillar, currently at the core of what we do, is building public planning capacity. And yes, there will hopefully be a point in time where we have built capacity within authorities to the extent that this pillar of our model is less essential. To do that we need to change people's ideas of what it is to work in the public sector, to be a planner. That's the second pillar; transforming perceptions of public planning. The status of those two things, public service and planning, has sunk to rock bottom over the last few years. We want to make going into public service feel like a privilege, not a last resort....

 The third pillar is about enabling proactive planning. This is not just about getting good people into existing jobs within local authorities, it's actually about rewriting the job description; fundamentally changing the role of local government in the way places address and implement change. Our research and development is a big part of that. We see the research and development as a shared platform for local government that just doesn't exist currently. It happens in silos within departments; or it happens within strategic organizations like the GLA or Ministry of Housing, Communities and Local Government. But most local authorities don't have access to wider research networks, or the space and time to develop new strategic thinking themselves. It is applied research in action.

Pooja By sharing discussion with colleagues on the ground we believe there is a much longer legacy, building the solutions whilst working in a place. Many recommendations that are parachuted in just don't have that kind of lasting impact.

Finn And the research and development platform is not just for the Associates we have on the programme. It's also for their colleagues. You rarely get any time for critical reflection in day-to-day work in local authorities because you're often fire-fighting, dealing with large caseloads, or responding quickly to changing political circumstances. We hope that the Associates can also create a space for their fellow officers to get a wider perspective.

Pooja One example is a recent field trip to Brussels, organized by three of our Associates, one from Old Oak Park Royal Development Corporation (OPDC), one in London Borough of Bexley, and one in the GLA Planning Team – all investigating industrial land. Just the process of officers from those different teams and organizations travelling on the Eurostar together meant they had to speak to each other, without an agenda, for three hours. These are conversations officers just don't have the time for in their everyday jobs.

Mel What do Associates gain from being in the public sector? Do you think the architects that you place will gain as much from the public sector as they contribute?

Pooja Yes, architects can learn a lot. It's an invitation to redefine what architecture is and think about it in a much broader sense, including the actual impact it has on people who experience buildings and the built

Melanie Dodd and Shumi Bose

environment on an everyday basis, as well as wider social, political, environmental and economic considerations.

Shumi So, what do you think the Associates would get specifically from this experience?

Finn The economic model behind private practice drives architects towards the response to every question being a building. As long as fees are tied to construction costs, architects are incentivized to build more "things" to earn a living. In the public sector, you're paid a salary to come up with the best outcomes for citizens and society. That allows you to think more laterally. For example, the best way to bring people into a town centre might not be a shiny new iconic building, but simply working with colleagues to adjust the parking fees. Or the best way of improving the social housing on an estate might not be by demolishing and rebuilding it, but just working with housing colleagues to improve the maintenance regime.

Mel I was also wondering whether skills of 'speaking to people' get refreshed in this context?

Finn Yes, the architectural profession's exposure to the reality of the built environment is limited on so many levels – we're really operating in a tiny bubble. Architects only design 6 or 7 per cent of new housing in the UK, and even then, the architectural press probably only ever discuss 6 or 7 per cent of that. Most of our attention is focused on projects and clients at one end of the spectrum of socio-economic advantage. Even when architects consult the public on their projects, it's often subcontracted to a consultation consultant. On the other hand, as a public sector officer your job can involve standing in front of some boards in a train station all day, speaking to everyone who passes through; attending a public meeting and being expected to answer any question that comes from the floor; or of course responding to every kind of application that comes through the planning process. You see school extensions built entirely from portacabins, through to the most shockingly poorly designed retirement homes. Good architects can spend an entire career sheltered from these kinds of realities, and unable to influence them. And I think that's wrong. I think it should be part of our job as architects to improve these everyday places.

Pooja Just working with lots of different types of people is personally something I've got a lot out of from being in the public sector. Previously I worked in small, up-and-coming practices, with practitioners of a similar age living in similar parts of the city. Now, I'm working with people from all sorts of backgrounds, all sorts of ages. People really do enjoy going to Costa, Brent Cross and Westfield. And that's important for a large section of society, not expecting everyone to want to go to an independent coffee shop and have flat whites. As an architect, we need to rethink aspects of aesthetics and design and how these relate to class and social status as well.

Finn That's something we look for when we're selecting the practitioners for the programme. One of the most important attributes we've found is humility; where Associates recognize that they're going to learn as much as they contribute. It's those Associates who've been the most successful. Instead of arriving with the attitude that they're going to tell everyone what to do, they recognize that there are already brilliant people in local authorities, they listen to them, and they support them.

Conversation: Finn Williams and Pooja Agrawal

Mel This revaluing of the state's role in 'wealth creation' for society is emerg-
 ing strongly in current discussions from local authorities – that they are
 'insourcing instead of outsourcing' services is now common and spoken
 with pride. Are we returning to some sort of 'Golden Age' of local
 government?

Pooja As much as we're inspired by the Golden Age of the post-war period,
 we think it's important not to over-idealize it. For all the bold and inno-
 vative projects, there were clearly also a lot of problems. The push to
 deliver homes cost-effectively meant there was varying quality. And
 there was far less understanding of what public engagement meant or
 why is was important. In that sense, we're keen to define a new kind of
 'municipalism'.

Finn In many ways the biggest power shift that seems to be happening now is
 in the growth in influence of the civic sector and the agency of communi-
 ties. New technologies are giving citizens the tools, and the expectation,
 to have more of a say in local government than just one tick in the box
 every four years. And that means we can't expect the pendulum to simply
 swing back the other way. It doesn't work in one dimension any more.
 This new municipalism needs to be built with a totally different relation-
 ship to society and responsibility to communities.

Shumi Yes, so navigating how that civic sector expands out into public and
 private, maybe that leads us into a conversation about what we mean,
 when we say 'public'.

Finn We see the role of the public sector and the civic sector as two 'cogs'
 moving at very different speeds which should be working together. But
 at the moment they're completely disconnected. The public sector doesn't
 know how to engage with civic activism. And communities just don't
 know how to engage with the machinery of local government because it's
 so obscure and arcane, it was built in a different age. If we can get it right,
 we can get to a point where the civic sector looks after what they're best
 at, which is the more immediate, more direct, more personal aspects of
 environment. And the public sector can look after the broader outcomes
 of long-term planning for a wider community – where community isn't
 just your neighbours who look like you and think like you – it's the inhab-
 itants of your city, your country. This is a scale of thinking that seems to
 be lacking in politics and economics at the moment. The public sector is
 one of the only organizations that can afford to take that really long view:
 a wide geographical and social perspective.

Pooja And the public sector has the kind of tools, agencies and finance for the
 longer term. In contrast to the civic sector which can respond to more
 immediate matters.

Mel So, it is very much about scale? Without being simplistic, the scales of
 civic society might be distributed into small, scalar enterprises, groups
 and organizations that can respond and offer representation. But the
 longer durational scale of a more responsive planning policy needs to
 carry this forward?

Pooja Exactly. But another complication tends to be political cycles, which can
 be very short term. All of these different timescales need to work in order
 to create the longest legacy that has the most positive impact.

Melanie Dodd and Shumi Bose

Finn	Where it doesn't work is where public sector tries to take on what the civic sector can do much better. When I've tried to organize pop-up events, for example, trying to involve councils in direct cultural production – it's not what the public sector is cut out to do. We need to get better at recognizing what our role is and seeding power and initiative to people who are much better placed at doing that.
Pooja	But there's still more space for public sector to have more of a 'face', a direct relationship with people. For example, the need for a housing officer to live on an estate and have a very direct relationship all the residents who live there, and be able to join the dots between the various issues – like not being able to speak the language, mental health, and not being able to pay the rent. That human experience of government, of the public sector, is something which we don't really have. We need to understand the value of having direct relationships.
Mel	Are there other traditions of public service – in the UK, or elsewhere – that you draw on?
Finn	For us the inspiration for public practice has been more networked, dispersed and quite anonymous forms of practice. For example, the 'Artist Placement Group', which embedded artists in major corporations like British Steel and the Ministry of Scotland. The 'Design Research Unit', who brought the highest quality of graphic design to ubiquitous things like the British Rail system, or Watney's pubs. And then KF – or the 'Swedish Cooperative Union and Wholesale Society's Architect's Office' – a collective of the most brilliant architects in Sweden in the 1930s who put aside individual authorship and worked on the most ordinary buildings: corner shops, factories, schools, affordable housing. KF found a way of building high-quality architecture that everyone could benefit from, partly because they chose to work in a very understated and anonymous way. It's easy to romanticize radical practices that agitate against the system from the outside, but I think quietly altering the system from the inside can sometimes be a more effective form of activism.
Mel	Can the scheme work around the UK more broadly?
Pooja	Yes, with devolution, city regions are gathering more and more power to deliver housing, build infrastructure, and take decisions using a place-based approach. In that sense, there's an exciting opportunity to use the structure of the cohort to work in a networked way across a whole region.
Finn	We can make a much bigger difference beyond London. London is the only place in the UK that's already got a regional planning body. Some of these other regions which are changing very quickly have the political ambition, but don't necessarily have the breadth of practitioners to draw on, or the communities of practice at an officer level.
Shumi	The candidates that you are recruiting might say, "Well why would we be in London, there's way more to do elsewhere?"
Finn	Yes, exactly. Those are the people we want to attract to Public Practice, the people who are more motivated to work somewhere where they can really make a difference.

Socializing practice

From small firms to cooperative r
of organization

Aaron Cayer, Peggy Deamer, Shawhin Rouɑɒɑ i
and Manuel Shvartzberg Carrió

Introduction

While the vast majority of practices in design-related fields, including architecture, have been historically organized as small and precarious, their sizes have presented inherent limitations to their ability to compete with increasingly larger and economically dominant practices within capitalist markets. This relative subordination is further accentuated by pressures on design practitioners that have long promoted competition, secrecy, and profit- and production-driven labour that discourages them from sharing resources, personnel, and working cooperatively across firms and industries. Rethinking the nature of practice in small firms is part of a broader need to reconsider the value of cooperation, cooperatives, and cooperativization in cities more broadly. By viewing small firms in tandem with the social, economic, and political potentials offered by cooperative models of organization, architects and spatial practitioners may begin to foreground care over profit, use-values over exchange values, and the sharing of knowledge over private appropriation in order to create more equitable, just, and livable neighbourhoods and cities.[1]

This chapter is divided into three parts. The first examines the need for small firms to reconsider their business models, their approach to management, and their understandings of labour. By exposing their structure, their financial resources, and their means of distribution, small firms are argued to be inherently precarious. In contrast to such precarity, cooperation, cooperatives, and cooperativization begin to challenge the "everyone-go-it-alone" ethos that pervades many design fields. The second analyses the theories of cooperatives and the process of cooperativization by exploring thinkers who imagined structures of shared profits, cooperative approaches to production, and even further, a post-capitalist world based upon cooperativized cities. The last reveals how cooperative models of practice – in varying degrees – may be applied to spatial practices and small architecture firms in particular, including how these cooperativized firms can scale up beyond the production of architecture to influence and shape social relations at the city and neighbourhood scale.

By banding together with other architecture practices and those in other industries, small firms can help to ensure that capitalist development does not divide and conquer the various stakeholders of a community and instead model and promote democratic social institutions that foreground care, inclusion, and cooperation. They offer a particularly useful site of engagement with local politics that transcends siloed, profit-motivated, and production-driven work.

Small firms and their structures of practice

Historically, the definition of "small firm" has implied a range of meanings. Not only has it described a particular scale of practice and associated projects, but it also suggested a culture, ethos, and identity that carried with it an inherent mystique. While the myth of the so-called individual male creative genius, working alone in his

ng dead, the labour and values that define small firms remains uneven
ure. From so-called "idea firms" to designer boutiques to those without
on merely trying to survive, many design practitioners within them now
themselves competing for an increasingly small portion of revenue and often
ectly with firms that have a global span with thousands of employees.

Despite these challenges, small firms are by far the most frequent size of
practice within the design fields. In the United States, for example, architecture
firms comprised of fewer than 20 people make up 92 per cent of all firms – a
percentage virtually unchanged since the 1970s – though in total they represent
only 44 per cent of all architectural workers (US Department of Commerce, 2012,
Economic Census, table 5). According to new definitions put forth by the American
Institute of Architects, small firms are narrowly defined as those with fewer than
three "architectural staff employees" *or* those that are legally organized as sole
proprietorships (AIA, 2018). However, less than 12 per cent of all firms in the US
are organized as sole proprietorships, compared to 80 per cent of firms that are
organized as corporations (AIA, 2018). Thus, while small firms represent a vast
majority of practices in number, they remain constrained and limited in their ability
to distinguish themselves as structurally unique and able to compete with market
demands. As a result, they often resort to strategies of diversification, branding,
and corporate structures of practice that continue to fuel capitalist competition –
but without the legal and financial advantages that come with large corporate firms
and their economies of scale.

Beyond this, the average lifespan of small firms is far shorter than large
firms, and thus their size renders them precarious. In general, design practices
follow broader business trends, as 30 per cent of small firms fail in their first year;
50 per cent fail within the first five years, and 70 per cent fail within the first ten
years (Roche, 2014, 70; Glenn, 2018). For architecture, in particular, sociologist
Judith Blau's classic study of the economic survival of architecture firms during
the recessions of the 1970s revealed that small firms organized like large corpora-
tions and embracing an entrepreneurial spirit were more likely to survive during
economic recessions than others (Blau, 1984, 131). While economic longevity is but
one narrow metric of recognizing the "survival" of a practice, there are structural
differences between large and small firms, as well. While large firms can include
(or hire) administrative personnel – from accountants to lawyers to cost estima-
tors to contract negotiators – who help to address the complex webs of finances,
liability, labour guidelines, and management, small firms are often overburdened
by time spent determining the rules of business and the economy. As outlined by
Blau, small firms remain wedded to competition and uphold a view of practice that
privileges supply-side economics.

And finally, while small firms traditionally enter into the same design–bid–
build contracts as large firms, they come to the table with different clout. The con-
tracts upon which many depend, for instance, include inherent flaws: they assume
that both signers to the contract come as equals when they often do not; they are
based on a fear of litigation; and they disengage the architect from the contractor.
The inherent antagonism that this creates between all parties, but especially the
architect and the contractor, leads to both a psychological defensive approach to
work and barely budgeted-for legal expertise that is practised at all levels of the
profession. But for small firms that have neither the in-house legal expertise nor
the financial security to absorb badly negotiated contracts nor the range of experi-
ences to reliably identify the scope of work to be negotiated, these inherent power
flaws set up by standard contracts are exaggerated, and the negative financial pre-
carity are rendered more extreme. Integrated Project Delivery (IPD) contracts – in
which the owner, architect, and contractor equally share risk and reward, mediate
their disparate goals cooperatively, and agree to not sue one another – go a long
way to upend the irrational antagonism that comes with standard contracts, but
they do not solve the larger problem of firms competing against each other for the

rare job that comes with an enlightened and willing client and contractor or the inability of small firms in particular to attract those kinds of projects.

By sharing expertise and resources through cooperative structures, small firms may be able to spend a greater amount of time on their particular areas of expertise and creativity, displacing competition between workers in order to avoid what Marx referred to as "alienation" – the overwhelming lack of individual fulfilment in one's work, competition with co-workers, and the appropriation of the surplus value produced by workers by the owners of the means of production. Cooperative models may come in various forms and degrees of engagement for design practitioners – each with a range of implications for the institutionalized divisions, boundaries, and values of their labour. Whether one engages with cooperative forms of practice merely by sharing administrative personnel or by banding together across firms and with other industries in an effort to bring issues of sustainability, care, and inclusion to the fore of the community, each model redefines the boundaries of labour and thus challenges siloed professional work.

Cooperatives in history and theory

Architects, especially in the US after World War II, espoused an ethos of "collaboration" and sought not only to work with other architects in order to tackle larger projects and higher revenues, but also to broaden the scope of architectural practice by absorbing and merging with related professions. In this, however, collaboration and coordination were mere functions of a new, post-war corporatism in which the single firm remained intact. Many small firms embracing such rhetoric mushroomed into some of the largest practices during the second half of the twentieth century, including The Architects Collaborative, Caudill Rowlett Scott, and Skidmore, Owings and Merrill. In contrast to these collaboratives, cooperatives represent an alternative historiography – one tied to capitalist critique, democratic means of ownership, self-management, mutual support among and between workers, and socio-economic equity.

Cooperatives emerged primarily in nineteenth-century Europe immediately following the Industrial Revolution – especially in Britain and France – when skilled labourers and property owners joined together in order to protect their own labour as well as the value and quality of their goods, crops, and other offerings. As owners of large industries turned to unfair labour practices in order to maximize volumes of production demanded by industrialization – offering little pay to their workers, demanding long hours, and failing to maintain healthy work environments – workers and communities began to join together to co-own property and tools in order to maintain decent work, pay, care, and food and move toward distinctly utopian cooperative communities. While unions also grew quickly after the 1840s, especially in countries such as the United States, cooperatives were still part of larger strategies of worker protections when worker strikes failed. Workers pooled their resources and skills in order to challenge and be independent from large, increasingly incorporated businesses and factories.

Marx's early work is critical of utopian attempts to localize and exceptionalize alternatives to the totalizing nature of capitalism. His later works, however, offer more nuanced positions on cooperative and communal experiments, such as the Paris Commune of 1871. Robert Owen, the Welsh textile manufacturer who drew praise from Friedrich Engels for his efforts to improve the working and living conditions of his workers by distributing revenue equitably, was one of the most influential figures in the effort to establish alternative models of social organization along cooperative lines. In his utopian commune, the residents would not only follow the principles of cooperativization – shared profit, joint decision-making, and worker management – but be both the producers and consumers of its products. While other utopianists, such as Charles Fourier and Henri de Saint-Simon, influenced social modes of production and cohabitation, Owen was singular in specifying the basic tenets of cooperativization (Mazzarol, Limnios, and Reboud, 2011). Indeed, the

Socializing practice

difference between cooperativization and other revolutionary modes of struggle has resulted in the obscuring of cooperative thinking as a particular mode of addressing social equity, although cooperative ideology ran through the more known socialist movement. The soviets of the Soviet Union had cooperative-run and state-run collectives, and while cooperatives were initially disparaged by Lenin for their lack of class politics and their possible coexistence with private land ownership, he later saw them as essential tools for educating Russian peasants on trading power and as an essential dialectical link to socialism. Likewise, the French-initiated syndicalist movement – while much more anarchistic in its advocacy of the "general strike," rejection of electoral politics, and workers' organizations rejection of rule by the state – anticipated that, economically, wage slavery would be replaced by cooperatives, and, as Mikhail Bakunin said, would "flourish and reach its full potential only in a society where the land, the instruments of production, and hereditary property will be owned and operated by the workers themselves: by their freely organised federations of industrial and agricultural workers" (Anarcho, 2008).

Cooperatives in the practice of architecture were rare but not unheard of. In Sweden, Kooperativa Förbundets Arkitektkontor (Swedish Cooperative Union and Wholesale Society's Architect's Office) was founded in 1925 to design "new norms for the whole of Swedish society"; by the 1930s it was the largest architectural office in Sweden, attracting young architects to work anonymously on mundane building types – supermarkets, factories, and social housing. In the UK, the Design Research Unit, founded in the 1940s, insisted that design should be cooperative, should be for everyone, and be applied to unexceptional programme types at the same time that they brought together architecture, graphics, and industrial design to "recondition and redesign public utility services" (Williams, 2017). As one of the agency's founding documents claims: "Like every aspect of modern industry, design should be a co-operative activity" (McGuirk, 2010).

After the massive upheaval of World War II, the negotiation between labour unions and large corporations helped systematize the new social-democratic welfare states. While securing relatively higher standards of living for workers, this system came under attack in the 1960s and 1970s for leaving untouched capitalist aims, and new attention was paid to cooperatives. At the same time, the conceptual, political, and spatial context embraced by cooperativization expanded. In Italy, the workerism/autonomia movements insisted that capitalist exploitation now exceeded the space of the factory to encompass the whole capitalist metropolis and the definition of "worker" outstripped that of the factory "proletariat" to include middle-class, familial, and governmental systems. In European countries in general, the search for alternative political forms that cut between US capitalism and USSR communism made cooperatives a large social enterprise.

Central to this expansion was a new emphasis on reproduction. Silvia Federici, coming out of the autonomist movement, challenged the patriarchal and capitalist boundary between "productive" and "unproductive" labour, as well as reproductive labour's historical confinement to the household (Federici, 2004). (In the 1980s, Diane Elson pointed out that cooperatives have been central actors in shifting focus from the critique of capitalist production to forms of economic cooperation based on the reproduction of labour and that "the guiding thread of a socialist economy" meant reappraising the work of households and fostering mechanisms of cooperative information exchange to meet social demands (Elson, 1988, 4).) Andre Gorz proposed that "cooperative circles," encompassing both the labours of reproduction and those of production, could, if coordinated adequately, radically reduce the sphere of necessity while enlarging the sphere of autonomy to that of the city. He suggests we move beyond static definitions of agency based on the working class because technological developments mean that classic conditions of alienation, environmental devastation, and (gendered) division of labour can materially be overcome (Gorz, 1982). The economic historian of the Soviet regime, Alec Nove, citing Gorz, proposed five basic scales of activities (and corresponding social

Cayer, Deamer, Roudbari and Shvartzberg Carrió

forms) necessary to run an advanced socialist society: centralized state corporations; socialized enterprises; cooperative enterprises; small-scale private enterprise; and individuals (e.g. freelance journalists, plumbers, artists) (Nove, 1983, 396).[2]

For these thinkers, cooperatives provide two interlocking types of use-value: the fundamental labour of reproduction that allows society to maintain and transform itself – including labours of care and cultural transmission – and the work of producing a surplus that can be distributed equitably as leisure or investment in socially desired activities. But they also open up the territory, both social and spatial, in which cooperatives operate. For small architecture firms, this expanded territory, and the variety of scales within this territory, can and should be embraced.

Cooperative models of practice for architecture

The advantages and general principles of cooperative business models specify that membership in a cooperative is voluntary and nondiscriminatory; each member receives one vote (this in contrast to other corporations where the number of shares owned determines voting power); members contribute to, and democratically control, the financial resources of their cooperative; they offer autonomy and independence since they are member-led, bottom-up structures; they provide education on the principles and practices of cooperative business so that members will be good decision makers and so the general public will better understand cooperatives; they work together at the local, regional, national, and international levels to further economic democracy; and they work for the sustainable development of their communities through policies accepted by their members. In the transactional world, there are four standard business types of cooperatives:

1. *Consumer coops*, which are owned by the people who buy the goods or use the services of the cooperative; these generally apply to housing, electricity and telecommunications, credit unions, health care, childcare, among other sectors;
2. *Producer coops*, which are owned by people who produce similar types of products and collectively market them to improve their incomes; these generally apply to farmers, craftsmen, and artisans;
3. *Worker coops*, which are owned and governed by the employees of the business; these generally apply to restaurants, taxicab companies, timber processors and light and heavy industry; and
4. *Purchasing and shared services cooperatives*, which are owned and governed by independent business owners, small municipalities and state government agencies that band together to enhance their purchasing power.

These four coop types – consumer, producer, worker, and municipal – map onto four proposed types of architectural cooperatives that scale up step by step and recognize varying degrees of engagement: shared administration, shared resources, shared profit, and shared social construction. These can be seen as steps to the full, social and municipal potential of coops that take advantage of these business types but look beyond their production advantages to become an infrastructure for the workers who share the means of production and the social/civic structures in which they operate. At the same time, the particular demands that architecture and smallness put on these models begin to further radicalize them, just as they, implicitly or otherwise, radicalize the architecture profession. Just as Nove argues for the various scales at which cooperation works, these different degrees of cooperation, from the smallest, of sharing administration, to the largest, of sharing (and constructing) the commons, may also connect and scale up. The ultimate goal is to transcend privatized monetary reward altogether.

As a legally defined business structure, cooperatives are rare – a fact that testifies to their outlier status in capitalism. Indeed, as historian John Curl has argued, cooperatives have historically served as explicit models of organizing work that

ran counter to capitalist norms; capitalism has "always worked hard to weaken, discredit, and destroy [cooperatives] through waging price wars, enacting legislation that undercuts their viability, labeling them in the media as subversive and a failure, and using several other stratagems" (Scholz, 2016, 12). In the UK, for instance, there are no formal laws structuring cooperatives (Alternative Models, 2017);[3] in the US, only five states – California, Texas, Colorado, North Carolina, and Massachusetts – identify cooperatives as a business model, the majority of which recognize producer or consumer cooperatives though some have recently expanded to include worker coops. Moreover, where they do exist, architecture as a profession is effectively excluded from using the cooperative business model.[4] Thus the most common way to form a cooperative – for architects and other businesses – is the Limited Liability Company (LLC), which is the most flexible of business models. But here, too, the difficulties in hashing out a "non-cooperative cooperative" are notoriously difficult, and pro-coop organizations spend a good deal of their time advising new coop-ers how to navigate their implementation.[5]

Small firms organizing as coops are therefore entering into a process that runs counter to the logic of capitalism – whether they are politically minded or not. While we argue for the ultimate advantage of the most extreme form of an architectural cooperative – one that moves beyond worker cooperativization to embrace Gorz's larger urban agenda – we also recognize that the small firms that choose cooperativization for the most practical of reasons (saving time and money) are making the initial foray into combating capitalism's enforced competition.

1. *Architects sharing administrative duties.*
 Small firms (if not large firms as well) suffer from the need to individually establish their administrative apparatus: bookkeeping, accounting, benefits, payroll, insurance, legal advice. Not only are architects not trained in these business practices, but the administering of each takes time away from what the architect wants to do and is good at. Moreover, individual firms, when contracting for outside services or products, often pay a premium that is disproportionate to their income and purchasing power. To move beyond this, small architecture firms can adopt the consumer cooperative model in order to jointly "consume" administrative expertise and products. Multiple firms would share an accountant, a lawyer, and benefits specialist that understands the particularities of architecture; while so sharing, they would be using their increased purchasing power.

 Beyond the obvious practicality of the above, this step into cooperativism also begins to undo stereotypes of architectural work. Given that the firms paying in will need to share information about their ability to pay and their level of liability and/or generosity, transparency displaces secrecy; given that oversight of the combined administrative team will be decided jointly and responsibilities rotated, joint agreements displace competition; given that money will be collected and banked jointly, trust displaces parsimony.

 At the same time, identifying the need for this work and articulating it as a speciality undoes stereotypes of architectural administration. Those taking on these duties are no longer mere accountants, bookkeepers, etc.; they are versed in the particularities of architectural practice and, as such, move from uninformed number crunchers to knowledgeable management experts. This is a change in how they are perceived by those doing the "creative" work as well as in that team's self-identification. Especially as architecture is increasingly defined by nontraditional contracts and interdisciplinary relationships, these workers, too, transform into team-playing generalists while capitalizing on their specialist skills.

2. *Architects sharing resources (and employees).*
 Small firms have many advantages, including adapting to the needs of specific communities, unusual client programmes, and variable, flexible modes of

Cayer, Deamer, Roudbari and Shvartzberg Carrió

procurement. At the same time, this ability to be light-on-the-feet comes with limited in-house resources. The model of producer coops, originally associated with farmers who needed to band together to get access to the market, is applicable to architects who need similar clout in the Architecture, Engineering and Construction (AEC) industry and access to clients who are normally out of their reach. Sharing expertise in IT, material, financial, building performance, and procurement experience means that small firms can act like large ones.

This mode of cooperation is, again, a profound undoing of architects' immersion in capitalist competition and the particular identities that this immersion has forged. Gone is the sense that knowledge needs to be guarded to maintain an edge over the competition; gone is the idea that the pie is a zero-sum game; gone is the idea that the things shared are proprietary; and subliminally, gone is the idea that design is about form, not knowledge. Yet with this letting go of guarded knowledge may come a fundamental challenge to the idea of professional work and to the structure or role of a profession altogether – both of which are predicated on institutionalizing esoteric knowledge and gatekeeping.

The articulation of needs and the offering of help subverts characteristics that go beyond the profession of architecture. But in architecture particularly, where talents range over so many different areas, the notion of "productivity" embedded in a producer cooperative itself expands. For the staff, the network of individuals to which one has access expands the office "team" which in turn pulls in expertise that does not merely solve a designer's specific problem but can reframe the question entirely; the expanded pool of architectural workers pushes beyond mere task completion. For the firm owners, there is a change in how firms identify their "individuality." It is ironic but significant that small firms market themselves in a completely homogeneous fashion: "We care for quality design; we are interested in all aspects of the project; we are good listeners and prioritize our clients' needs; etc. etc." With shared information, a small firm can capture a specific set of proficiencies – the intersection of which may make a firm look different than other firms – and the firm's personal and organizational identity is enriched, not diffused.

3. *Architects fully cooperativizing: worker-owned within and across firms.*
 If consumer and production cooperatives are steps toward breaking the marginalization of architecture in general and small firms in particular – a marginalization caused by capitalist-imposed ideologies of competition – neither achieve the more powerful goal of moving from capital hiring labour to labour hiring capital; from maximizing the capitalist's profit to maximizing income per worker. In the worker cooperative, that is achieved. Regardless of how sharing is controlled, every worker-owner participates in decision-making in a democratic fashion, management is elected by every worker-owner, or managers are treated as workers of the firm. All shares are held by the workforce with no outside owners, each member has one voting share and workers own the means of production. A worker-owned architectural firm, like other worker-owned businesses, has many distinct business advantages: if everyone buys into the mission of the office and knows why one goes after or rejects certain work, each member works harder; if one's attention is focused on the work at hand and not on the aggravations of uneven distribution of profits, focus is better; if one is spared the division between management and labour and trusted to both organize and perform one's work, you want to give your best.[6]

 But the full advantage of a worker-owned firm comes with cooperativizing across a number of firms. Again, the business advantages of this are obvious: firms that share their profits, their production expertise, and the purchasing power have the combined financial advantages of all these three types: group discounts; access to markets and anti-monopoly forces; better information and technology; shared risk and reward; innovation; access to goods and services;

better production and procurement information; joint services; and the possibility of common facilities. The numerous tech and light industry cooperatives in the US and the UK offer examples of these advantages and the strong rejection they give to neoliberalism's call to entrepreneurially compete.[7] At a larger scale still, the remarkably successful international Mondragon Corporation, which originated in the Basque region of Spain, previews how a concerted effort to thwart the forces of capitalization moves across and past disciplinary silos. Beginning in 1956 with the production of paraffin heaters in the town of Mondragon, the worker-owned cooperative saw quickly that cooperatives in banking, retail, knowledge and related industries were essential to its larger social vision. Today, they employ over 80,000 people in over 250 companies in 100 countries (Mondragon, 2017).

Beyond the business advantages, the conceptual shift in architecture is away from not only competition but disciplinary disempowerment. The banding together of numerous worker-owned firms creates a base of cooperating forces that can stand up to the developers that currently shape our cities with projects that hold no regard for either sustainable communities or a sustainable environment.

4. *Architects and municipal cooperatives.*
The vision of worker-owned architecture firms cooperating and sharing profits builds a network with the necessary knowledge to address the urgent needs of the built environment. But one can also imagine architecture firms that operate as catalysts for entire municipalities. In this case, the cooperative model expands on the framework of purchasing and shared services cooperatives, examples of which include groups of employers that form alliances to buy health care insurance or to purchase health care services directly from hospitals and physicians; school districts that organize cooperatives to provide special education programmes as well as purchase products for member districts; hardware stores, restaurants, independent pharmacies, rural electric cooperatives, local food retailers, and natural food stores that operate as wholesalers. Architecture and design firms, too, can band together with other industries in their municipalities to ensure that capitalist development does not divide and conquer the various stakeholders of a community, and they can do so by identifying the multiple common interests that go beyond joint purchasing power. In this scenario, architects, which are generally minor players in a municipality's economy, can help to marshal the broad set of issues leading to a stable and sustainable community.

One can map an architectural narrative on top of inspiring examples, such as that of Emilia Romagna in Italy. In this region, producer, consumer, and worker cooperatives coexist with social cooperatives to ensure that the region provides for its needs without a reliance on either the capitalist global market or a corrupt state. Theirs is less a scaling up of various coops as it is an expansion of networks both horizontally and vertically, supported by complementary financial networks and strategic umbrella organizations, whose job is to ensure the cooperation among cooperatives is smooth and efficient. As the organizers of the Emilia Romagna regional coops describe it, "Cooperatives do their best in services that have a high content of relations, or in sectors of production that rely heavily on traditions and differentiation, or in sectors were ownership is fragmented and the processing of the products must be joint (typically agriculture), or in utilities" (Zamagni, 2016). While intended as a description for agriculture, this in fact describes the work of architects – including their scope of knowledge and its fragmentation. It is not unreasonable to think that the knowledge of building sustainable communities would generate the web of this network.

The diagram of sovereignty that emerges with these proposals is very different to that of the modern nation-state. This type of organization, as per

Cayer, Deamer, Roudbari and Shvartzberg Carrió

Elson's argument reviewed above, need not be a large-scale state bureaucracy, but itself can be a coordinated set of self-managed institutions: public centralization of information with common decentralization of production (Elson, 1988).[8] When considered spatially, this suggests something more like Murray Bookchin's "confederal municipalism," whereby local assemblies become the seats of sovereignty, while confederal institutions coordinate the cooperation between cities (Bookchin, 1992). Such a system might appear abstract or utopian, yet many examples already exist across the world.[9] Architecture should make use of these already-existing models of cooperativization that would each, in its own way, allow the discipline to shift from a purely competitive and alienating mode of practice, to one that foregrounds care, cooperation, and social reproduction.

Conclusion

Since at least the orthodox Marxist theory of Rosa Luxemburg, cooperatives have been viewed as contradictory and ineffective revolutionary vehicles that tend to disintegrate under the pressure of competitive markets (Luxemburg, 1986). As described throughout this chapter, however, Marxist feminists have convincingly argued that foregrounding and supporting the social reproduction of labour through cooperative organizing is an important revolutionary project for protecting non-market spaces and social relations. Analysing how cooperative models of work can be fought for and defended in the present is thus not a utopian fetish, but a concrete mode of struggle.

More recently, cooperatives have formed worldwide and have become effective as anti-capitalist means of organizing that have combated critical urban issues – from labour exploitation to housing shortages and inequalities to climate change. In Europe alone, there are presently over 250,000 worker cooperatives, which include 5.4 million people, and there are nearly 800 million people across the world who are part of cooperatives (European Commission, 2018). While architects have been limited by law and professional structures that, in some cases, prevent complete cooperativization, small firms seeking to form cooperatives may reframe the architecture profession as a whole by challenging its very definition and role. They may better connect architecture to other to industries, to structures of municipality, and to the forms of social reproduction that the capitalist ordering of the profession has historically hindered.

While sociological studies of the architecture profession, and professions in general, have long revealed the ways that specific codes of conduct, licensure, examinations, education standards, and exclusive member societies attempt to establish a monopoly over a sector of work to specific groups, cooperative structures of practice – especially those that demand full cooperativization at the scale of municipalities – challenge the siloed nature of professions and demand reconsideration. As an example, Magali Sarfatti Larson's (1979) analysis of architecture practice informed the jurisdictional model of professions that she and Andrew Abbott (1988) described in the 1980s. In this model, professions such as architecture, like the practices they organize, compete for control of a scope of work or a segment of an industry (e.g. the building industry), even though it has never been entirely possible in architecture. Mary Woods's (1999) history of the architecture profession in the US similarly accounts for the ways in which architects and their firms vied for market control in a capitalistic relationship between work, clients, and profession. The state's control of architecture's licensure builds on its commitment to public safety, yet the process for licensure has evolved in a way that not only marginalizes the profession's ranks along gendered, racial, and class lines, but also supports a culture of competition among architects, secrecy, elitism, and classism.

Through cooperativization, the control points of professional work are able to be more carefully manipulated, since cooperatives require different institutional frameworks of legitimation and intellectual property – such as foregrounding care

Socializing practice 253

over profits, use-values over exchange values, and the sharing of technical knowledge rather than its private appropriation. Cooperativization thus implies a rethinking of the institution of licensure and the legitimation of expertise; if not through de-professionalization, then at least through a radical reexamination of what a profession of architecture – and other professional design fields – might look like. Ultimately, this means reconfiguring not only the modes of sovereignty (institutionally, politically) over architectural work, but also their very meaning and scale of operation – from what counts as "productive" work, to what constituency gets to decide it. Such a reorientation of the profession, and of architectural expertise and knowledge, would therefore position architects to participate in the cooperative reproduction of space and social relations that includes not only the design and construction of cities, but their maintenance, as well.

Notes

1 This text has benefited greatly from the efforts of many, especially those within a working group focused on cooperativizing small firms within The Architecture Lobby, including: Karina Andreeva, Michael Abrahamson, Michael Cohen, Gabriel Cira, Palmyra Geraki, Ashton Hamm, James Heard, David Hecht, A.L. Hu, Daniel Jacobs, Brandt Knapp, Austin Kronig, Ivan Kostic, Will Martin, Ben Prager, Shawn Protz, Priyanka Shah, and Brittany Utting.
2 Nove's work was criticized by Elson (op. cit.) as relying on a productivist and male celebration of the market. In contrast, she advocated the "socialization of markets," seeking to elevate household and community concerns to the level of productive industries.
3 Much contemporary work is being done, however, to redress this.
4 In California, for example, architecture corporations must be registered as professional corporations that are organized under the General Corporation Law, in contrast to cooperatives, which are organized under the Corporations for Specific Purposes Law. Thus, while there is no formal law preventing architecture corporations from cooperativizing, there are legal barriers to doing so. The authors wish to thank Ashton Hamm and James Heard for this detailed example. See Section 7 of the Architects Practice Act and Section 13401 the California Corporation Code.
5 See, for instance: https://democracycollaborative.org/sector/worker-cooperatives; https://institute. coop; and https://usworker.coop
6 In many large architecture and engineering firms, from Arup to Gensler, employee-ownership is practised. But the degree to which the distribution of shares and decision-making abides by the kind of democratic principles central to cooperatives is less clear.
7 For tech, see for example GitHub, Plausible Lab cooperatives, and The Network of American Tech Workers Cooperatives. For other industries, see Co-operatives of UK, the United States Federation of Worker Cooperatives, and the Network of Bay Area Worker Cooperatives (NoBAWC, pronounced No Boss). For general business/legal advice on setting up a cooperative, see Peggy Fogarty-Harnish's "How Cooperatives Work: Creative Models to Increase Profits," https://usworker. coop/home-3/
8 For Elson (1988, 23), "A fully open information system between enterprises is, however, a key feature of socialized markets; and so are long-term links between buyers and sellers, which help to stabilize an enterprise's environment. Socialized markets, then, would be much more compatible with industrial democracy than are markets organized by enterprises."
9 In Spain, for example, municipalist forces currently run the country's largest cities, including Barcelona and Madrid. See: www.ciudadesdelcambio.org; https://guanyembarcelona.cat/ lets-win-barcelona/; http://municipalrecipes.cc/; *Municipalist Manifesto*, from the meeting for "Municipalism, Self-Government and Counterpower," held in Málaga from 1–3 July 2016.

References

Abbott, Andrew. 1988. *The System of Professions*. Chicago: University of Chicago Press.
AIA. 2018. *Small Firm Compensation Report*. Washington, DC: American Institute of Architects.
Alternative Models of Ownership: Report to the Shadow Chancellor of the Exchequer and Shadow Secretary of State for Business, Energy and Industrial Strategy. 2017. Report commissioned by UK Labour Party.
Anarcho. 2008. "The Revolutionary Ideas of Bakunin." (July) https://anarchism.pageabode. com/anarcho/the-revolutionary-ideas-of-bakunin
Blau, Judith R. 1984. *Architects and Firms: A Sociological Perspective on Architectural Practice*. Cambridge, MA: MIT Press.
Bookchin, Murray. 1992. *Urbanization Without Cities: The Rise and Decline of Citizenship*. New York: Black Rose Books.

Elson, Diane. 1988. "Market Socialism or Socialization of the Market?" *New Left Review* I/172 (November–December).

European Commission. 2018. "Cooperatives." (20 November). https://ec.europa.eu/growth/sectors/social-economy/cooperatives_en Accessed 20 November 2018.

Federici, Silvia. 2004. *Caliban and the Witch: Women, the Body and Primitive Accumulation*. Brooklyn, NY: Autonomedia.

Glenn, Deborah Snoonian. 2018. "The Future of Practice." *Architectural Record* (June). https://continuingeducation.bnpmedia.com/courses/multi-aia/the-future-of-practice/2/ Accessed 8 November 2018.

Gorz, André. 1982. *Farewell to the Working Class: An Essay on Post-Industrial Socialism*. London: Pluto Press.

Larson, Magali Sarfatti. 1979. *The Rise of Professionalism: A Sociological Analysis*. Berkeley: University of California Press.

Luxemburg, Rosa. 1986 [1900]. "Co-operatives, Unions, Democracy." *Social Reform or Revolution?* London: Militant Publications.

Mazzarol, Tim, Elena Mamouni Limnios, and Sophie Reboud. 2011. "Co-operative Enterprise: A Unique Business Model." Future of Work and Organisations, *25th Annual ANZAM Conference* (December). Wellington, New Zealand.

McGuirk, Justin. 2010. "Design Research Unit: the firm that branded Britain." *The Guardian*. https://www.theguardian.com/artanddesign/2010/oct/12/design-research-unit-branding-britain

Mondragon Corporation. 2017. "Annual Report 2017." https://www.mondragon-corporation.com/en/about-us/economic-and-financial-indicators/annual-report/s

Nove, Alec. 1983. *The Economics of Feasible Socialism*. London: Harper Collins.

Roche, Cullen. 2014. *Pragmatic Capitalism: What Every Investor Needs to Know about Money and Finance*. New York: Palgrave Macmillan.

Scholz, Trebor. 2016. "Platform Cooperativism: Challenging the Corporate Sharing Economy." New York: Rosa Luxemburg Stiftung.

US Department of Commerce. 2012. *Bureau of the Census, Economic Census, 2012, Subject Series: Professional, Scientific, and Technical Services*.

Williams, Finn. 2017. "We Need Architects to Work on Ordinary Briefs." *Dezeen* (4 December). https://www.dezeen.com/2017/12/04/finn-williams-opinion-public-practice-opportunities-architects-ordinary-briefs-ordinary-people/

Woods, Mary. 1999. *From Craft to Profession: The Practice of Architecture in Nineteenth-Century America*. Berkeley: University of California Press.

Zamagni, Vera. 2016. "Learning from Emilia Romagna's Cooperative Economy." *The Next System Project* (18 February). https://thenextsystem.org/learning-from-emilia-romagna Accessed 1 November 2018.

Contributors

Cany Ash, Ash Sakula

Cany Ash co-founded Ash Sakula Architects with Robert Sakula in 1994 to pursue cultural urban development projects through diverse means, working with communities, arts organizations, enlightened developers, public bodies and self-initiated projects. The practice was Supreme Winner in the 2016 Housing Design Award for the Malings, a new neighbourhood on the banks of the River Ouseburn in Newcastle and in 2017 its Wickside project in Hackney Wick was Overall Winner in the New London Architecture Awards. Currently the practice is working with councils and developers in London to create high-density, tenure-blind living in convivial spaces for people to meet each other: challenging the concept of residential buildings as people storage, playing to investors' rules in unaffordable London. Alongside the architectural work Ash Sakula has pursued 'constructive propaganda' through a series of projects captured in short films and websites.

Tricia Austin

Tricia Austin is a PhD supervisor, author and design researcher. She is Course Leader of MA Narrative Environments at Central Saint Martins, University of the Arts London. The postgraduate programme pioneers collaborative practice among architects, spatial designers, communication designers and curators in the development of novel proposals for critical, socially engaged cultural and urban environments. Tricia has lectured in Europe, Asia and South America and led a number of collaborative projects with universities and governmental organizations across the world. From 2011 to 2013 Tricia was the UK lead on EU-PA, a two-year, EU-funded, multidisciplinary project to develop culture-led city regeneration methodologies, involving multiple stakeholders and producing exemplar case studies. Most recently Tricia co-edited *The Future of Museum and Gallery Design: Purpose, Process and Perception* (2018) and provided a chapter 'The Designer's Role in Museums that Act as Agents of Change'.

Markus Bader, raumlabor

Raumlabor was started in 1999 as a collective form of spatial and urban practice. It currently has nine members: Markus Bader, Andrea Hofmann, Jan Liesegang, Christof Mayer and Benjamin Foerster-Baldenius, Matthias Rick († 2012), Francecso Apuzzo, Axel Timm, Frauke Gerstenberg, Florian Stirnemann. Through practice raumlabor is continuously developing and exploring an extended concept of architecture and space beyond the built object. The works are engaged in specific contexts, building spaces of sharing, relations, new imaginaries and prototypical set-ups for urban change. raumlabor was honoured with the Berlin Award 2015 – Heimat in der Fremde; the Core77 Design Awards 2017 – Built Environment; the Curry Stone Design Prize 2017 – Social Design Circle; and the Global Award for Sustainable Architecture 2018 – Architecture as an agent of civic empowerment. Markus Bader studied Architecture in Berlin and London. Since 2016 he has been professor at the Institute of Architecture and Urban Design at the University of the Arts, Berlin, Germany. www.raumlabor.net

Juliet Bidgood

Juliet Bidgood is an architect/urban designer who works at a range of scales from the tactical to the material to realize built projects or advise on the development of places. Research is part of her process of making work and all projects proceed to some degree as a process of enquiry. She is interested in exploring how we: imagine spaces and futures, relate to history and the environment and create meaningful agency for citizens. Most recent projects include: Glastonbury Instant City and CIAM6 Cities Re-imagined. Based in Somerset, she was a Senior Adviser at the Commission for Architecture and the Built Environment (CABE) and a founding partner of the award-winning practice muf Architecture/Art. She chairs the Bristol Urban Design Forum and a Housing Excellence Design Review Panel for the South West. An experienced RIBA Client Adviser and project enabler she is a contributor to the RIBA Client Advisers Steering Group. She teaches urban design and architecture at Cardiff University.

Shumi Bose

Shumi Bose is an editor, teacher and curator based in London. She teaches histories and theories of architecture at Central Saint Martins and at the Architectural Association, and has worked for several architectural institutions in London and New York. Shumi was a curatorial collaborator for the 2012 Venice Architecture Biennale, where she edited *Common Ground: A Critical Reader* with Sir David Chipperfield. Recent publications include *Real Estates: Life Without Debt* (2014) and *Places for Strangers* (with mæ architects, 2014). She co-curated 'Home Economics', the British Pavilion for the Venice Architecture Biennale in 2016, with Jack Self and Finn Williams.

Oscar Brito

Oscar Brito is a senior lecturer at the Spatial Practices programme at Central Saint Martins, University of the Arts London, and co-founder of the design and research practice Studio X. Oscar's academic career has been developed at different universities throughout the UK, such as the University for the Creative Arts (UCA Canterbury) and the University of Sheffield before joining Central Saint Martins. Oscar's teaching and research investigate the issues and potentials of the production of the public space as a complex and unstable articulation of heterogeneous agents and conditions that often create contested territories of social, cultural and political exchange and interaction. Oscar has been developing his research in contexts subjected to conflicting conditions of stagnation and regeneration such as Caledonian Road, Croydon and Somers Town in London, and Palermo in Italy.

Aaron Cayer

Aaron Cayer is an Assistant Professor of Architecture History at the University of New Mexico. Prior to New Mexico, he taught architecture history and theory courses at California State Polytechnic University, Pomona, and he was a Senior Research Associate at cityLAB, which is an urban research center with UCLA's Department of Architecture and Urban Design, from 2012 to 2017. He co-founded the Los Angeles chapter of the Architecture Lobby in 2016, as well as the New Mexico chapter in 2018. He received his PhD in Architecture from the University of California, Los Angeles, as well as undergraduate and graduate degrees in architecture from Norwich University in Vermont. His current research focuses on the histories and theories of postwar corporate architecture practices as they overlap with those of labour, capitalism and urban political economies.

David Chambers and Kevin Haley, Aberrant

Aberrant Architecture is a multi-award winning, collaborative studio of designers, makers and thinkers whose projects introduce new and unexpected ways of experiencing everyday life, founded by David Chambers and Kevin Haley in 2010.

Combining storytelling and research at the heart of their practice, Aberrant takes a playful approach to producing spatial experiences that are both meaningful and beautiful. Aberrant's participatory form of practice places the needs of people at the centre of the problems they address and the opportunities they create. Aberrant design interactive architecture, interiors, public art, exhibitions and installations, building close relationships with the communities in which they operate. Aberrant has exhibited work at international architecture exhibitions at the Venice Biennale of Architecture, Gwangju Design Biennale, Sao Paulo Biennial and the Hong Kong & Shenzhen Bi-City Biennale, and held the first architecture residency at the Victoria and Albert Museum (V&A). Their work has been collected by the V&A and the Museum of Art in Rio de Janeiro. They have published a book on the CIEP schools project in Rio de Janeiro, *Wherever You Find People: The Radical Schools of Oscar Niemeyer, Darcy Ribeiro, and Leonel Brizola* (2016).

Teddy Cruz and Fonna Forman, Estudio Teddy Cruz + Fonna Forman

Teddy Cruz (MDes Harvard) is a professor of Public Culture and Urbanism in the UCSD Department of Visual Arts. He is known internationally for his urban research of the Tijuana/San Diego border, advancing border neighbourhoods as sites of cultural production from which to rethink urban policy, affordable housing, and public space. Recipient of the Rome Prize in Architecture in 1991, his honours include the Ford Foundation Visionaries Award in 2011, the 2013 Architecture Award from the US Academy of Arts and Letters, and the 2018 Vilcek Prize in Architecture.

Fonna Forman (PhD Chicago) is a professor of Political Theory and founding director of the Center on Global Justice at the University of California, San Diego. A theorist of ethics and public culture, her work focuses on human rights at the urban scale, climate justice in cities, border ethics, and equitable urbanization in the global south. She is known internationally for her revisionist research on Adam Smith, recuperating the ethical, social, spatial and public dimensions of his thought. She is a vice-chair of the University of California Bending the Curve Report on climate change solutions; and serves on the Global Citizenship Commission, advising UN policy on human rights in the 21st century.

Teddy Cruz and Fonna Forman are principals in Estudio Teddy Cruz + Fonna Forman, a research-based political and architectural practice in San Diego, investigating issues of informal urbanization, civic infrastructure and public culture, with a special emphasis on Latin American cities. Blurring conventional boundaries between theory and practice, and merging the fields of architecture and urbanism, political theory and urban policy, visual arts and public culture, Cruz and Forman lead a variety of urban research agendas and civic/public interventions in the San Diego–Tijuana border region and beyond. In 2012–13 they served as special advisers on civic and urban initiatives for the City of San Diego and led the development of its Civic Innovation Lab. Together they lead the UCSD Community Stations, a platform for engaged research and teaching on poverty and social equity in the border region. Their work has been exhibited widely in prestigious cultural venues across the world, including the Museum of Modern Art, New York; the Yerba Buena Center for the Arts, San Francisco; the Cooper Hewitt National Design Museum, New York; Das Haus der Kulturen der Welt, Berlin; and M+ Hong Kong.

Peggy Deamer

Peggy Deamer is Professor Emeritus of Architecture at Yale University and principal in the firm of Deamer, Studio. She is the founding member and the content coordinator of the Architecture Lobby, a group advocating for the value of architectural design and labour. She is the editor of *Architecture and Capitalism: 1845 to the Present* and *The Architect as Worker: Immaterial Labor, the Creative Class, and the Politics of Design.* She is co-editor of *Building in the Future: Recasting Architectural Labor; BIM in Academia;* and *Re-Reading Perspecta.* Articles by her have appeared in *Log, Avery Review, e-Flux* and *Harvard Design Magazine* amongst other journals.

Her work explores the relationship between subjectivity, design and labour in the current economy.

Ursula Dimitriou

Ursula Dimitriou is a practising architect and researcher. She holds a Diploma in Architecture Engineering from NTUAthens, an MA in Art and Architecture from UPC in Barcelona and a PhD on Commons and Public Space from the department of Visual Cultures of Goldsmiths University. Her research interests include design as a political tool, urban insurgencies, grassroot practices, theatrical and ephemeral interventions in urban space, participatory design and social sustainability. She has presented her research and films at numerous conferences (Princeton University, the Bartlett School of Architecture, UCL, Architectural Association, Oxford Brooks, Royal Geographers annual conference, among others) and published in journals and collective books. Ursula has been practising architecture in Athens, Barcelona and London and since 2011 she has taught design at Central Saint Martins and the University of Westminster. She is the co-director of SYN (https://studiosyn.co.uk/), an interdisciplinary design studio based in London, operating in the fields of spatial design, art, activism, research and education.

Melanie Dodd

Mel Dodd is an architect and academic – educated at University of Cambridge and with a PhD By Practice from RMIT University (2011). She has led architecture programmes at a range of institutions since 1995 including London Metropolitan University/CASS, RMIT University in Melbourne, and the Spatial Practices Programme at Central Saint Martins, where she is currently Associate Dean Knowledge Exchange. Her teaching, practice and research interests focus on the relationships between social and political infrastructures and built environments. Her pedagogical focus is on the 'joined-up' relationship between teaching and practice explored in her book *Live Projects: Designing with People* (2012). She has curated major events and exhibitions, and was Creative Director of the 2010 RAIA National Architecture Conference in Sydney – 'extra/ordinary'; and most recently was co-curator of the 'Fundamentals' Debates Series at Central Saint Martins, with Oliver Wainwright, 2017–2019.

Liza Fior, muf Architecture/Art

Liza Fior is co-founder of muf Architecture/Art, together with Katherine Clarke. Since 1994 muf have established a reputation for pioneering and innovative projects that address the social, spatial and economic infrastructures of the public realm. The practice philosophy is driven by an ambition to realize the potential pleasures that exist at the intersection between the lived and the built. The creative process is underpinned by a capacity to establish effective client relationships that reveal and value the desires and experience of varied constituencies. muf authored Villa Frankenstein, the British Pavilion at the Venice Biennale, 2010, which took Ruskin and Venice itself as a means to examine how detail can inform strategy. Awards for muf projects include the 2008 European Prize for Public Space (a first for the UK) for a new 'town square' for Barking, East London. Liza has co-authored *This is What We Do: a muf manual*, and has been a Visiting Professor at Yale.

Carl Fraser

Carl Fraser completed his diploma in Architecture (Part II) at the Architectural Association in 2007. He completed his PhD at the University of Sheffield in 2016 on 'Protest in Contested Public Space'. His work investigates the cultural and social development of alternative practices in their relation to our understanding of urban spaces of cultural exchange. He is a member of the White Rose Society and has been a contributing speaker at the Theoretical Currents II conference series (Lincoln University, 2012) and the Text Cities series (University of Hertfordshire, 2015). He

has also been an organizer and contributor in the Common Grounds (II) series (2012), The Lines of Flight series (University of Sheffield, 2012) and the Mapping Agencies international workshop (Faculté d'architecture de l'ULB, 2013).

Daisy Froud

Daisy Froud is a strategist in brief-development, community engagement and participatory design. She devises tools and processes that enable diverse voices to meaningfully contribute to design decision-making, and to shaping the future of places and spaces in intelligent, imaginative and equitable ways. Having started her career in community-led regeneration and environmental campaigning, from 2003 to 2014 Daisy was a founding director of architecture practice AOC, which built a reputation for "a committed engagement with communities, clients and parts of the city" (FT, 2008). AOC was twice shortlisted for the Young Architect of the Year Award, while in 2014 Daisy was shortlisted for The AJ's Emerging Woman Architect of the Year Award. Daisy is a Teaching Fellow at the Bartlett School of Architecture, in the history and theory of spatial politics. In 2011 she completed a visiting professorship at Yale focusing on participatory design. Daisy sits on the advisory Design Panel for High Speed 2 and is a Built Environment Expert for Design Council CABE, an Academician of the Academy of Urbanism, and a Mayoral Design Advocate, advising on community engagement, to the Mayor of London.

Anna Hart and Tilly Fowler, AiR

AiR makes art in the everyday bringing landscapes, people and ideas into productive collision through staying in a place. The studio was founded at Central Saint Martins in 2007, becoming an independent community interest company in 2016. AiR is a studio of place. AiR researches, commissions and produces art in the everyday – responding intimately to local places and those who live and work there, bringing landscapes, people and ideas into productive collision to prompt new ways of being, doing and making together, and finding space for the unknown, unexpected and the overlooked. Over four hundred works have been realized in public spaces in north and east London with key projects including A Million Minutes in Archway, Tidal Twirlings in North Woolwich, Unannounced Acts of Publicness in King's Cross and PACK_ITON in Islington. Tilly Fowler and Anna Hart devised and realized the King's Cross Walking Club in October 2015–October 2016. Tilly is now a public gardener whilst Anna continues to lead AiR's projects. www.airstudio.org

Nicolas Henninger, EXYZT

Nicolas Henninger was part of the group of five who started EXYZT in 2003 as a diploma project in Paris La Villette. During 12 years of 'EXYZT-ense', he led the collective in many of its ventures across Europe: from collaborations with raumlabor in Berlin in 2005 for Der Berg, to self-initiated LABICHAMPI project in ex-military base in Latvia, going to Warsaw to land an UFO or an island in Madrid, as well as many projects and collaborations in the UK from 2008 onwards in London, Birmingham, Liverpool and Bristol. After his collaboration with muf Architecture/Art on the 'Dalston Eastern Curve Garden' in 2009, Nicolas moved to London. Since then he's run architecture and construction workshop OfCA (Office for Crafted Architecture) with one of his ex-EXYZT colleagues Daya Bakker.

Andreas Lang, Public Works

Andreas Lang is Course Leader in M ARCH Architecture at Central Saint Martins and has taught Architecture at numerous institutions since 2001 including the Architectural Association, Sheffield University, Royal College of Art and Umeå School of Architecture in Sweden. He is co-founder of public works, a non-profit critical design practice that occupies the terrain between art, architecture and research. Working with an extended network of interdisciplinary collaborators, public works aims to re-work spatial, social and economic opportunities towards citizen-driven

development and improved civic life. The practice, set up in 2004, uses a range of approaches, including public events, campaigns, the development of urban strategies and participatory art and architecture projects across all scales. Andreas's work has been exhibited widely in architectural exhibitions such as the prestigious Venice Biennale (2012) as part of the British Pavilion, the Change British Architecture exhibition at RIBA (2013), and he was included in the Guardian's portrait of key players in British Architecture (2012). In the art context, he has exhibited in established venues such as the Serpentine Gallery (2004), Folkestone Triennial (2008), the British Art Show (2005/06) and the Irish Museum of Modern Art (2016).

Xavi Llarch Font, Suzanne O'Connell and Mariana Pestana, The Decorators

Xavi Llarch Font is a spatial designer who studied at Elisava School of Design and Engineering in Barcelona and received and MA in Narrative Environments from Central Saint Martins. In 2010 he co-founded The Decorators, an interdisciplinary art and architecture collective based in London. The Decorators work on spatial design projects that aim to reconnect the physical elements of a place with its social dimension. Their clients include local authorities and cultural institutions, with work ranging from context-specific engagement strategies and public realm interventions, to exhibition design and interactive interiors. Relevant projects include Ridley's Temporary Restaurant (2011), Chrisp Street On Air (2014), Le Jardin Essentiel (2016) and Hayes Landmark Features (2017). Xavier has taught interior and spatial design at Chelsea College of Arts and is currently an associate lecturer on the MA Narrative Environments course at Central Saint Martins.

Suzanne O'Connell is passionate about re-connecting people with the spaces that they live and work in. A landscape architect with an MA in Narrative Environments and a co-founder of the Decorators based in London, she has for the last 8 years successfully led a large number of projects in the public realm. These include the renovation of ten shop fronts on Hoe street, Walthamstow, a movable garden for Alexandra Palace and a Portas Pilot funded project at Chrisp Street, a research project aimed at promoting Chrisp Street market at the heart of the community in Poplar. Suzanne is an associate lecturer on the MA Landscape Architecture course at Greenwich University.

Mariana Pestana is a Portuguese architect and curator. She works between Lisbon and London, where she co-founded the collective The Decorators, a practice that rehearses possible futures through curatorial projects and interventions in the public realm. Mariana lectures on spatial design at Central Saint Martins and Chelsea College of Arts, and Design Interactions at the Royal College of Arts. She recently curated The Future Starts Here, at the Victoria and Albert Museum and Eco Visionaries: Art and Architecture After the Anthropocene at MAAT. Mariana has a PhD in architecture & fiction from the Bartlett School of Architecture.

The Decorators is a multidisciplinary design collective founded by Suzanne O'Connell, Xavi Llarch Font, Carolina Caicedo and Mariana Pestana. With backgrounds in landscape architecture, interior architecture and psychology, The Decorators work on spatial design projects that aim to reconnect the physical elements of a place with its social dimension. They employ a methodology that builds on the social and cultural makeup of a site to create new experiences that can prompt interaction or shape communal memory. They support this by designing infrastructures for social interaction. These include physical elements that choreograph and set the stage for a multitude of possible uses. Their clients include local authorities, museums, curators and brands, and their work ranges from context specific engagement strategies and public realm landscapes, to exhibition design and interactive interiors.

Eva Pfannes and Sylvain Hartenberg, OOZE

OOZE architects was founded in 2003 by Eva Pfannes and Sylvain Hartenberg in Rotterdam, the Netherlands. *Eva Pfannes* is director of OOZE Architects,

Rotterdam, operating between the fields of art, architecture and urbanism. She studied at Stuttgart State Academy of Art and Design, and at the Bartlett School of Architecture, University College London (UCL), spending several years in practice (with Zaha Hadid, Maxwan and Studio Makkink-Bey). She was tutor and guest critic on many occasions and taught Public Space at the Eindhoven Design Academy. *Sylvain Hartenberg* studied in Strasbourg at the ENSAIS and in London at the Bartlett with Prof. Peter Cook. He worked in Paris for Architecture studio and in London for Terry Farell and Sheppard Robson. He has been a guest critic at the Bartlett, AA, and North London Polytechnic. In 2015 they were Practitioners in Residence at Central Saint Martins, University of the Arts London (UAL). The design and research projects of OOZE combine an elaborate understanding of ecological processes, with technological expertise and deep insights into socio-cultural behaviour. The cyclic processes found in nature underpin each intervention and integrate the human scale within a holistic urban strategy. Their work has been realized, exhibited and recognized worldwide, winning the Dutch Basis Prix de Rome for Architecture in 2006, and in 2017 the LafargeHolcim Awards Bronze for Latin America for Água Carioca – Urban Circulatory System in Brazil and the UK Landscape Institute Award for best 'Design for a Temporary Landscape'. OOZE is currently working on the Water as Leverage programme of the Dutch Government and 100 Resilient Cities in Chennai, India.

Damon Rich and Jae Shin, Hector
Hector is an urban design, planning and civic arts practice led by co-founders Jae Shin and Damon Rich, who work on designs for public places, neighbourhood plans and development regulations, trying to learn from traditions of popular education and community organizing to build collective understanding and action. *Jae Shin* is a designer who recently served as an Enterprise Rose Architectural Fellow at the New York City Housing Authority (NYCHA), where she facilitated efforts to define and implement design principles for preserving and rehabilitating New York City's public housing. *Damon Rich* PP AICP is a designer and urban planner who previously served as planning director and chief urban designer for the City of Newark and was the founder of the Center for Urban Pedagogy (CUP), an internationally recognized nonprofit organization that uses art and design to increase meaningful civic engagement.

Shawhin Roudbari
Shawhin Roudbari is an assistant professor in Environmental Design at the University of Colorado Boulder. He studies contentious political engagement by design professionals. Through in-depth interviews, participant observation and analysing texts, Shawhin investigates ways activists shape and organize power towards justice causes – particularly those grappling with race, class and gender inequities. While the focus of his work is on counter-hegemonic movements by professionals, Shawhin's research has led him to study the globalization of architecture's institutions and community-engaged design. And though his focus is on architects, these enquiries have led him to consider the work of planners and civil engineers, as related spatial professions whose work, institutions and activism often overlap with designers'. Shawhin's work contributes to histories and theories of activism in the spatial professions and relies on ethnographic methods.

Manuel Shvartzberg Carrió
Manuel Shvartzberg Carrió is a PhD candidate in Architecture and a Graduate Fellow of the Institute for Comparative Literature and Society at Columbia University, where he also teaches the final thesis for the Master's programme in Critical, Curatorial, and Conceptual Practices in Architecture. His doctoral project, *Designing 'Post-Industrial Society': Settler Colonialism and Modern Architecture in Palm Springs, California, 1876–1973*, was the Graham Foundation's Carter Manny Award finalist

in 2018. The dissertation examines how architecture and infrastructure helped construct a discourse and a techno-politics of economic growth and settler-colonial sovereignty, as well as theories and practices of decolonization across the Americas. He is a contributor and co-editor for Aggregate's 'Systems and the South' project, and is currently a Fellow at the University of Michigan's Mellon programme in Egalitarianism and the Metropolis. Since 2015 he has been the Architecture Lobby's Research Coordinator.

Jeremy Till

Jeremy Till is an architect, educator and writer. As an architect, he worked with Sarah Wigglesworth Architects on their pioneering building, 9 Stock Orchard Street, winner of many awards including the RIBA Sustainability Prize. As an educator, Till first taught at Kingston University before moving to the Bartlett, UCL, where he was degree course director. He then moved to be Head of School of Architecture at the University of Sheffield, before being Dean of Architecture and the Built Environment at the University of Westminster. In 2012 he was appointed as Head of Central Saint Martins and Pro Vice-Chancellor (Research) at the University of Arts London. As a writer, Till's extensive work includes the books *Flexible Housing*, *Architecture Depends* and *Spatial Agency*, all three of which won the RIBA President's Award for Research. He curated the UK Pavilion at the 2006 Venice Architecture Biennale and also at the 2013 Shenzhen Biennale of Architecture and Urbanism. Wiki: https://en.wikipedia.org/wiki/Jeremy_Till

Donna Turnbull

Donna Turnbull is a Community Development practitioner and has lived in London since the 1980s. The city has been the subject of study and work: as a jobbing artist, an active resident, a student of urban design, and a development worker, on a variety of collaborative projects with people who want to influence urban policy and gain social benefits from the development of urban space. Donna worked with the Deptford Discovery Team during the 1990s, and is a resident of Peckham and member of Peckham Vision. She currently works with Voluntary Action Camden specializing in planning, policy, and social and environmental justice projects.

Jeanne van Heeswijk

Jeanne van Heeswijk is an artist who facilitates the creation of dynamic and diversified public spaces in order to "radicalize the local." Her long-scale community-embedded projects question art's autonomy by combining performative actions, discussions and other forms of organizing and pedagogy in order to enable communities to take control of their own futures. Her recent project 'Philadelphia Assembled' joins art and civic engagement in the city of Philadelphia. Shaped by hundreds of collaborators, it tells a story of radical community building and active resistance. Challenging, inspiring and as big as the city, Philadelphia Assembled asks: how can we collectively shape our futures?

Alex Warnock-Smith

Alex Warnock-Smith is an architect, urbanist and academic. Alex is Course Leader for BA (Hons) Architecture at Central Saint Martins, University of the Arts London, and was formerly a Course Master at the Architectural Association Graduate School, and a Design Fellow at the University of Cambridge. Alex is founding Director of Urban Projects Bureau, a multidisciplinary design and research practice specializing in architecture, urbanism, spatial strategy and design. Urban Projects Bureau was selected to research and exhibit in the British Pavilion at the 13th Venice Architecture Biennale 2012, the Ideas To Change British Architecture exhibition at RIBA 2013, and was included in the Guardian's portrait of key players in British Architecture 2012. UPB also features in the Architecture Foundation's 'New Architects 3' publication, showcasing "Britain's best emerging practices."

Finn Williams and Pooja Agrawal, Public Practice
Public Practice is a not-for-profit social enterprise launched in 2018 that enables spatial practitioners to work earlier upstream, and shape the decisions that shape the built environment. The organization's mission is to build the public sector's capacity to improve the quality, and equality, of everyday places. It does this by placing outstanding built environment experts (Associates) on year-long placements within forward-thinking public authorities. The Associates are diverse in terms of disciplines, ages and backgrounds. They include architects, planners, surveyors, community engagement specialists and practitioners who don't fit into any one field. About 90 per cent of the placements is spent embedded within an authority. Roles are designed to cut across silos, introduce new ways of working and enable authorities to deliver change that wouldn't have happened otherwise. The remaining 10 per cent is dedicated to a programme of collective research and development. This research aims to share emerging knowledge and practice across authorities. It offers a platform for pragmatic solutions to the day-to-day challenges faced by local government.

Index

Abbott, A. 253
Aberrant 4, 171–6
abstraction 8, 10–11, 17, 25, 67; abstract space 91, 93–4, 96; and Canning Town Caravanserai 101, 103; and civic practice 227, 230; and disruptive praxis 194; and Hector Design 212, 218; and Hinsley 74; and socializing practice 253; and solidarity 223; and spatial narratives 158; and van Heeswijk 121
accessibility 24–7, 29–32, 36, 41, 95, 148, 162, 199, 207
accountability 72, 190, 201
activism 1, 3, 7, 9–10, 14; and civic practice 233; community activism 45–55; and disruptive praxis 192, 196–7; and Froud 58; and Glastonbury Festival 143; and Hinsley 67, 72, 75; and new municipalism 242–3; and politics of space 18, 21; and protest 27, 29; and spatial narratives 162; and tactical practices 87, 95
Actor-Network Theory 173
Adam Khan Architects 60–2
Adbusters 161
administration 71, 152, 154–5, 173, 246–7, 249–50
affordable housing 218, 243
Afghanistan 203
Africa 166
agency 1–2, 5, 10, 12–17, 25; and activism 53; and civic practice 227–8, 230–1, 233; and The Decorators 184; and disruptive praxis 192, 195–6, 198, 200–1; double-agency 18, 95–6, 204; and EXYZT 77, 81; and Froud 57–8; and Glastonbury Festival 146; and Hector Design 211, 218; and King's Cross Pond Club 115–17; and new municipalism 237, 242; and raumlabor Berlin 147, 155; and socializing practice 248; spatial agency 11, 87–8, 90, 93, 147, 204, 219; and spatial narratives 157, 163; and tactical practices 87–8, 92–3, 99; and van Heeswijk 121, 125
Agrawal, P. 5, 237–43
AiR 3, 131–5
Alavanos, G. 39
alienation 107, 192, 247–8, 253
'Allmende Kontor' 152
allotments 103, 107–8

Alternative für Deutschland (AfD) 189
American Institute of Architects (AIA) 246
anarchism 39–40, 50, 58–9, 68, 248
anthropology 64, 198, 209
apps 162
Arab Spring 27
ARCH+ 147
Arch One 109
Archigram 138, 144
Architects Collaborative 247
Architects Registration Board (ARB) 237
Architects Registration Council UK (ARCUK) 67, 71–2
Architects Revolutionary Council (ARC) 71
Architects for Social Housing (ASH) 7
Architectural Association (AA) 68, 159, 220
architectural production 12, 14, 221, 230–1
Architecture, Engineering and Construction (AEC) 251
Architecture Foundation 80–1, 83, 139
Architecture Lobby 5
Arendt, H. 7, 9, 167
Argent PLC 120, 160
Arnstein, S. 88, 90
Artist Placement Group (APG) 229, 231, 243
Ash, C. 3, 101–11
Ash Sakula 3, 101–11
assemblages 173
assemblies 35, 39–40, 137, 140, 253
assessment 221, 223
Association of Community Design 218
Association of Community Technical Aid Centres (ACTAC) 71–3
Atelier Chan Chan 165
Athens, Greece 2, 35–43
atomization 103
audiences 17, 64, 137, 140–1, 143–4, 157, 162, 172–3, 183, 230
augmented reality (AR) 162
August Festivals 109
August Riots 23
Aureli, P.V. 64
austerity 23, 49, 87–8, 95–6, 192, 194, 205, 238
Austin, T. 4, 157–70
authoritarianism 87
autonomists 248
autonomy 17, 28, 35, 40–1, 137, 145–6, 191, 248–9